VALENTINO

VALENTINO

THEMES AND VARIATIONS

PAMELA GOLBIN

WITH A FOREWORD BY VALENTINO

RIZZOLI
NEW YORK

CONTENTS

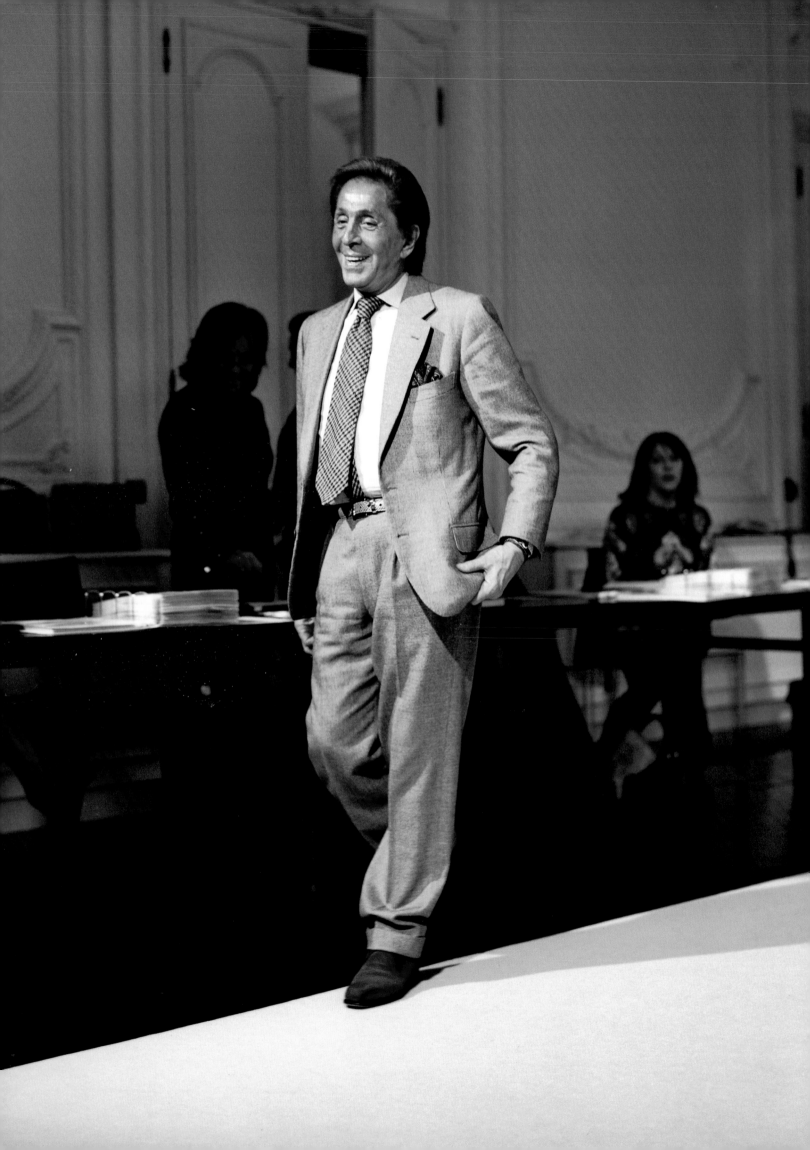

I have always considered my work as the one of a writer. Over the years I wrote only one story, the one of my style, where each COLLECTION represents a single CHAPTER, with all of its emotions, ideas, and motifs. The looks may change with every chapter, but the main characters are the same, as are the people and THINGS that inspire me.

This is A story with the same protagonist throughout. The fashion elements and themes evolve as the story line progresses, but the woman behind the pleats, the embroideries, the bows, remains the same.

The title of this exhibition, "Themes and Variations," explains my fashion concept. The loyalty to a personal style that ignores the outside demands. This is an approach I followed by instinct, and one that, I hope, served me well for almost fifty years.

VALENTINO *Rome, 2008*

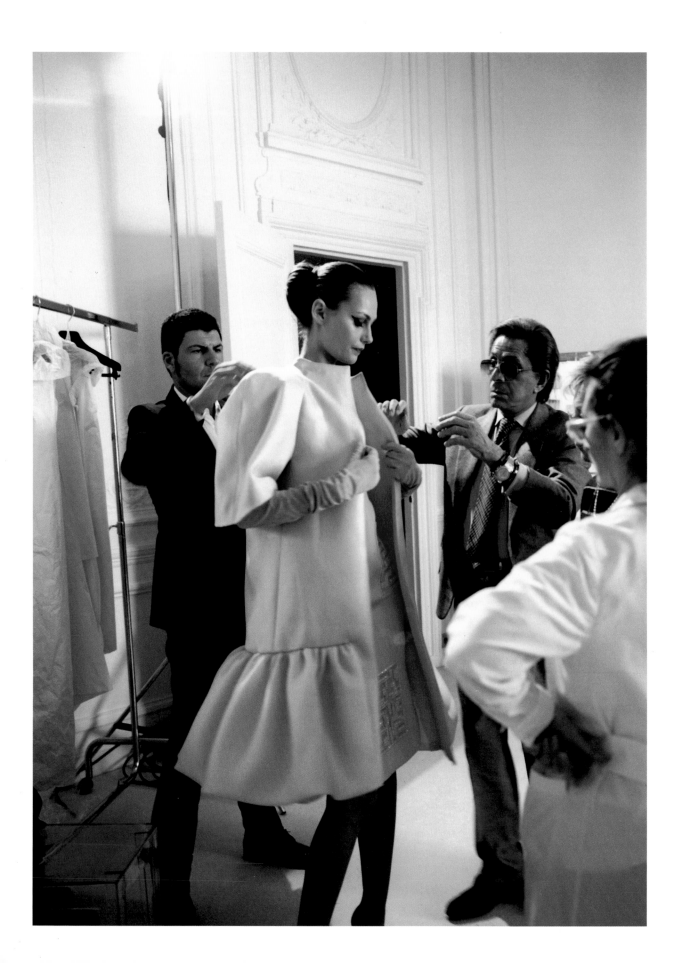

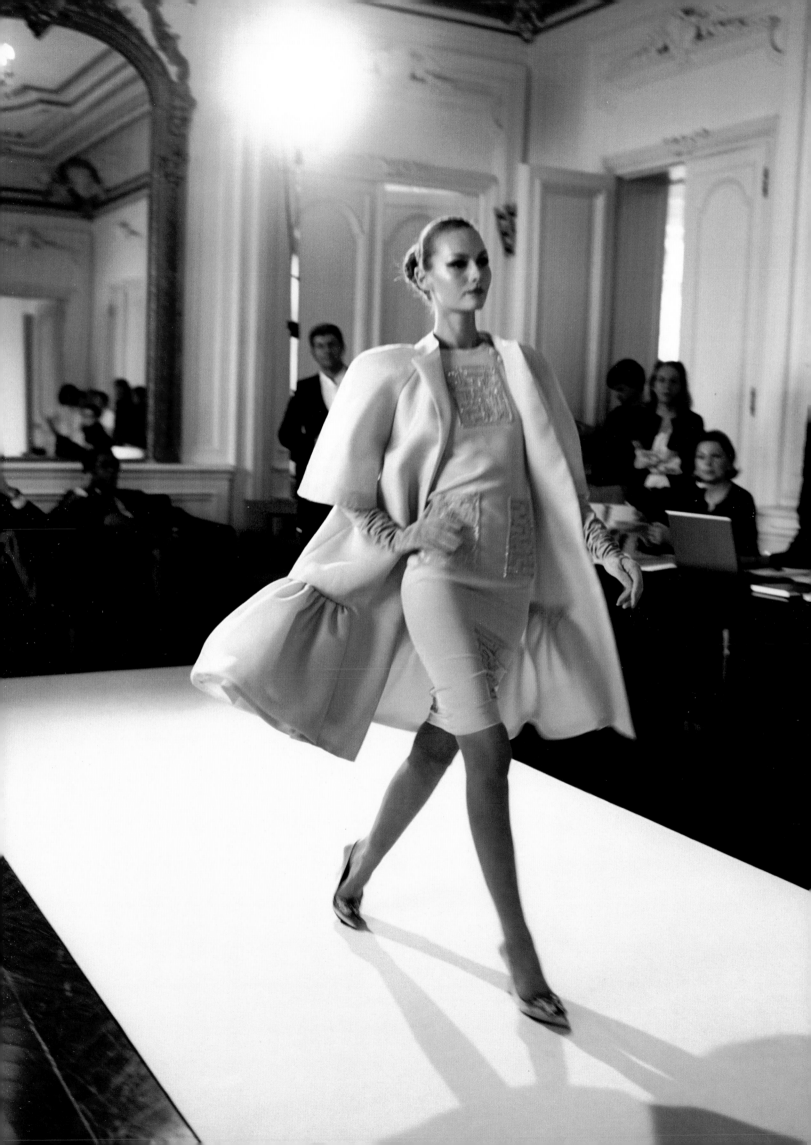

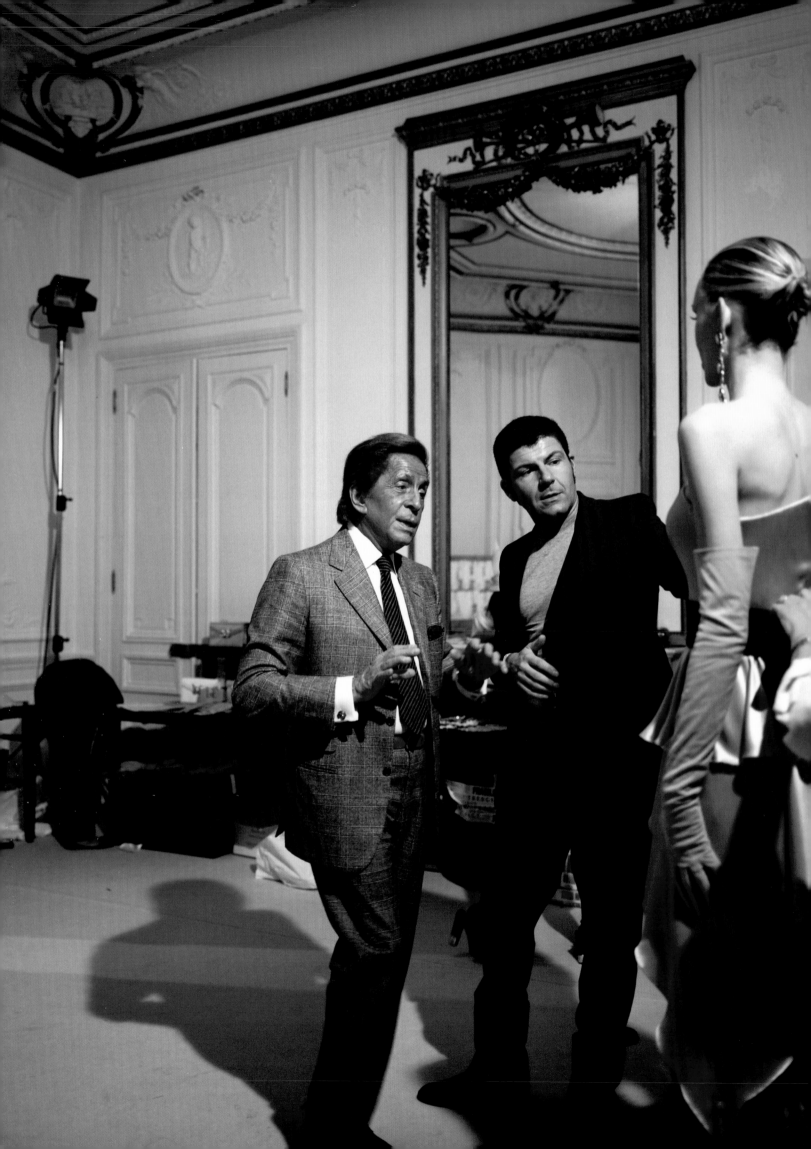

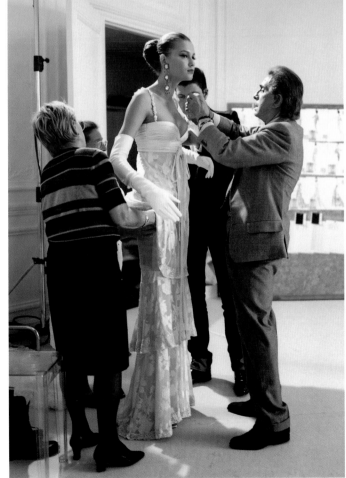

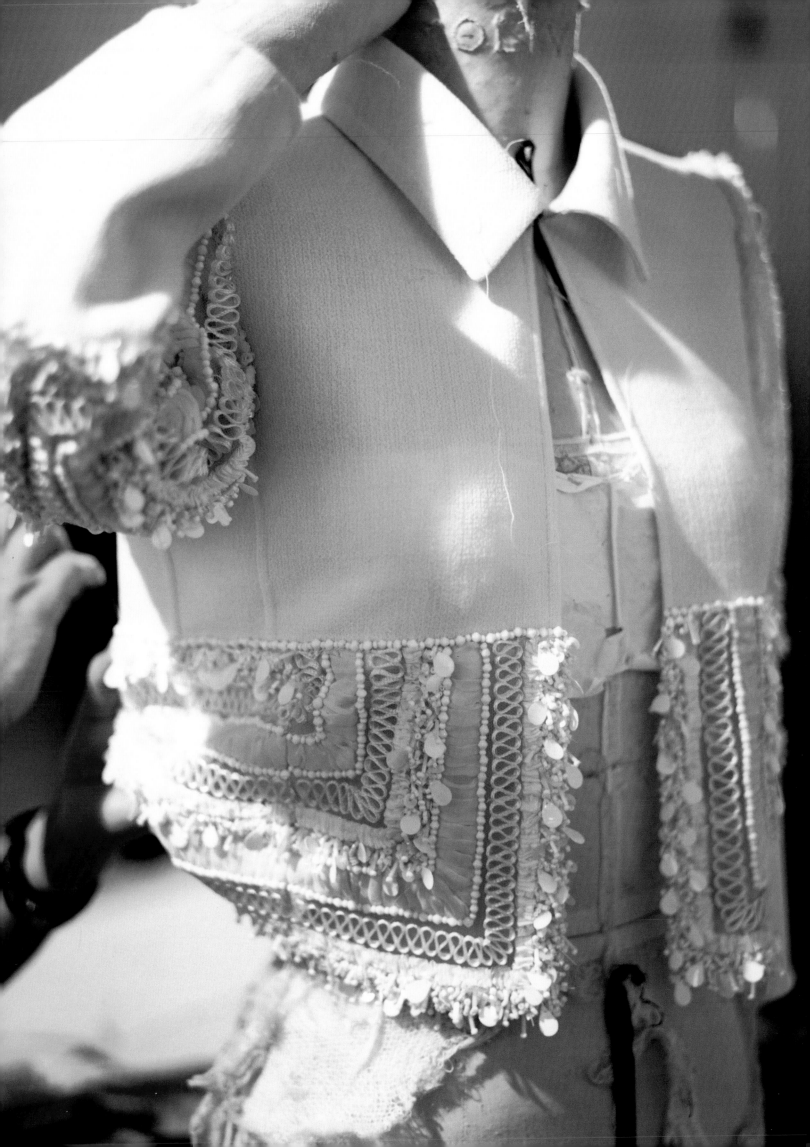

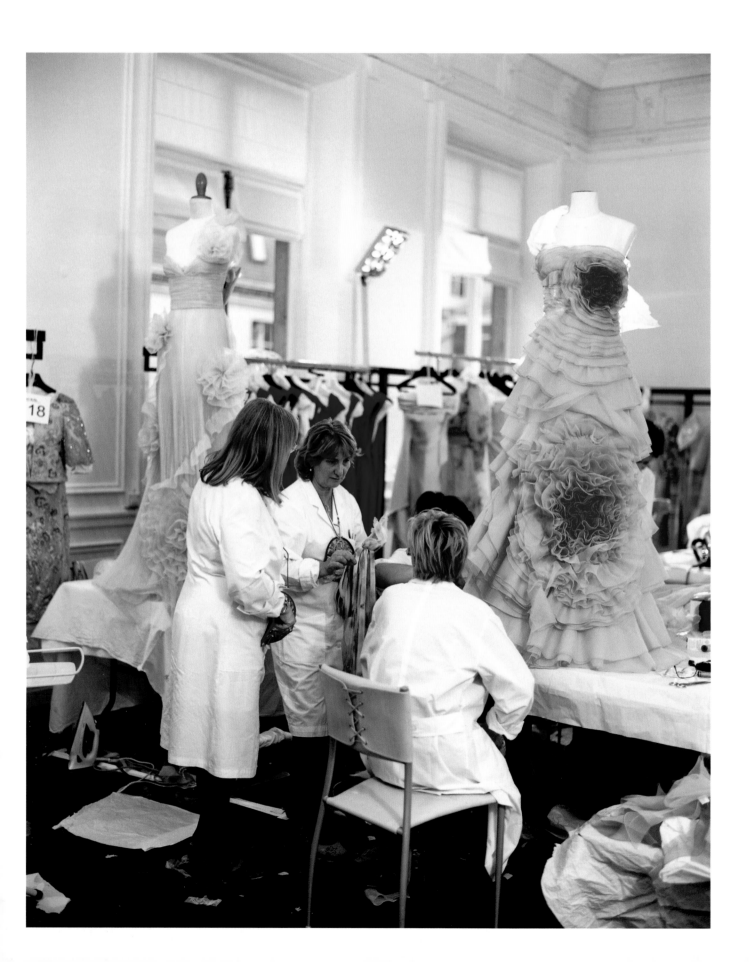

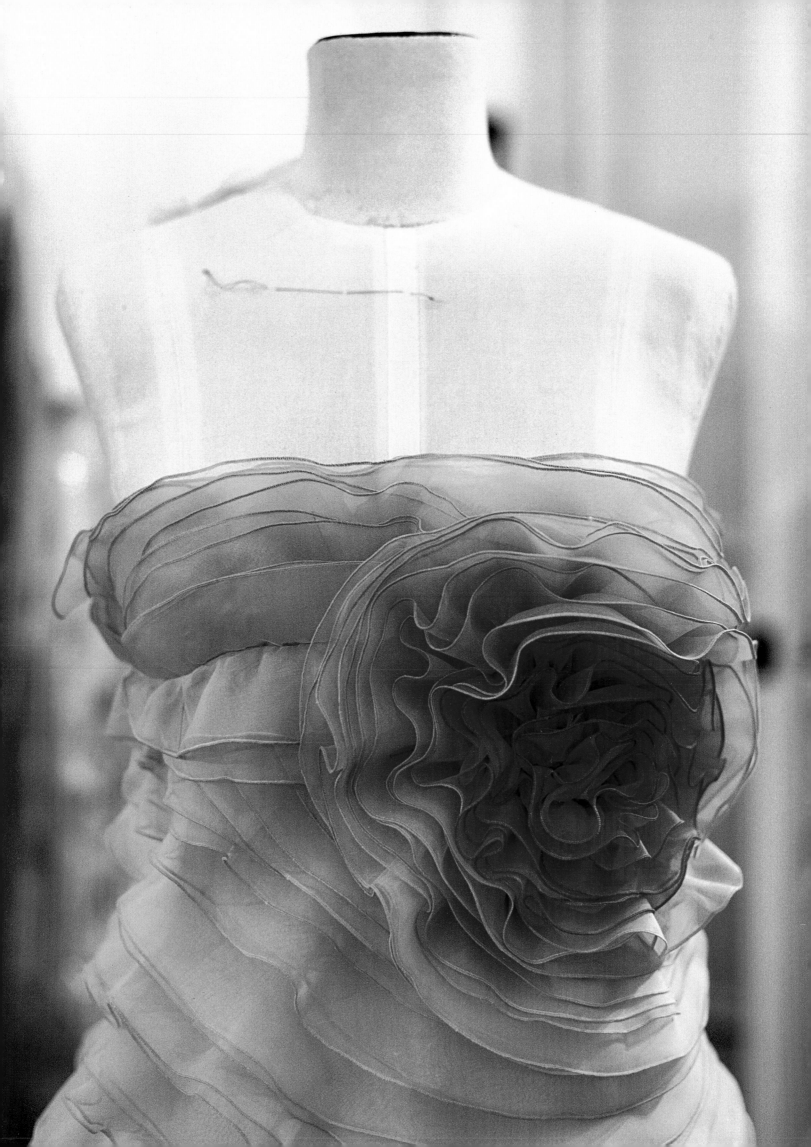

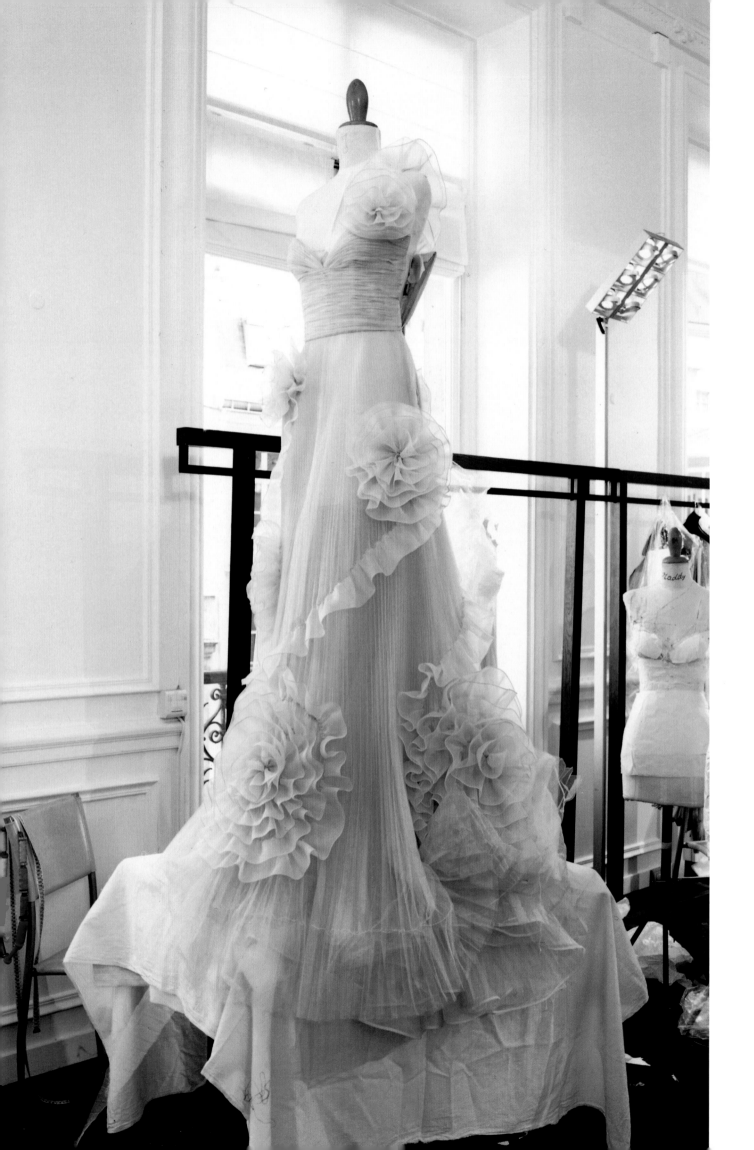

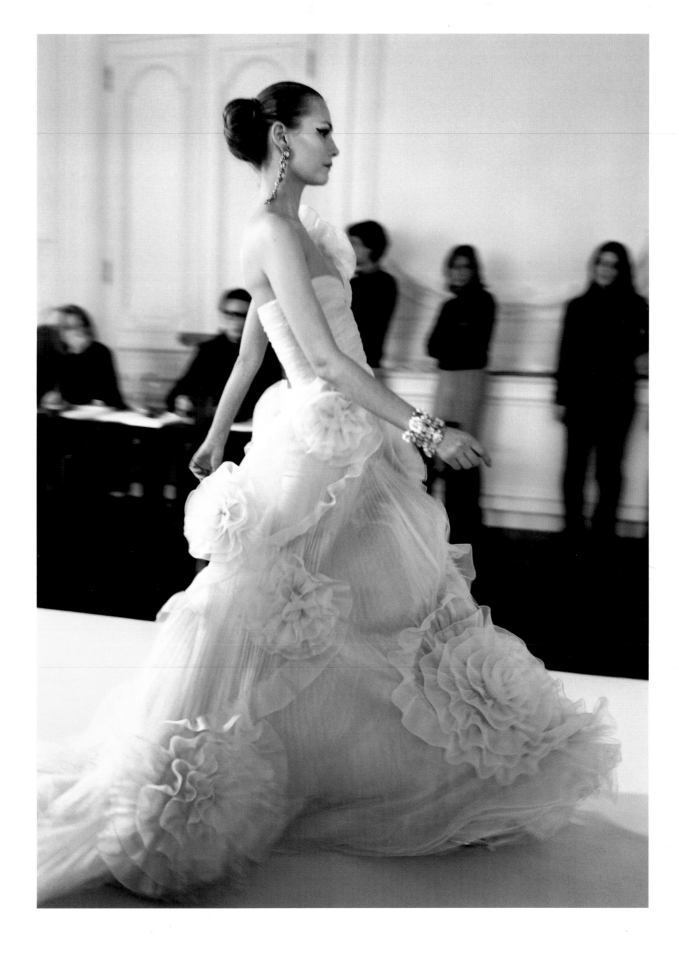

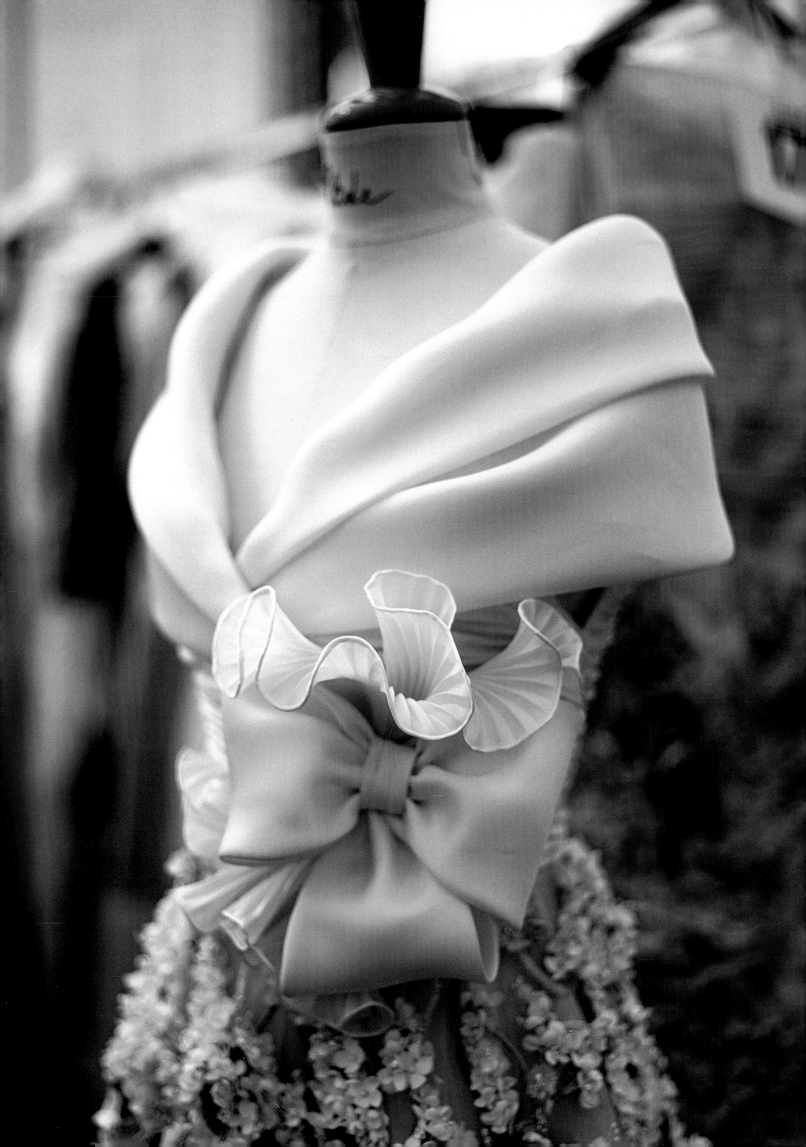

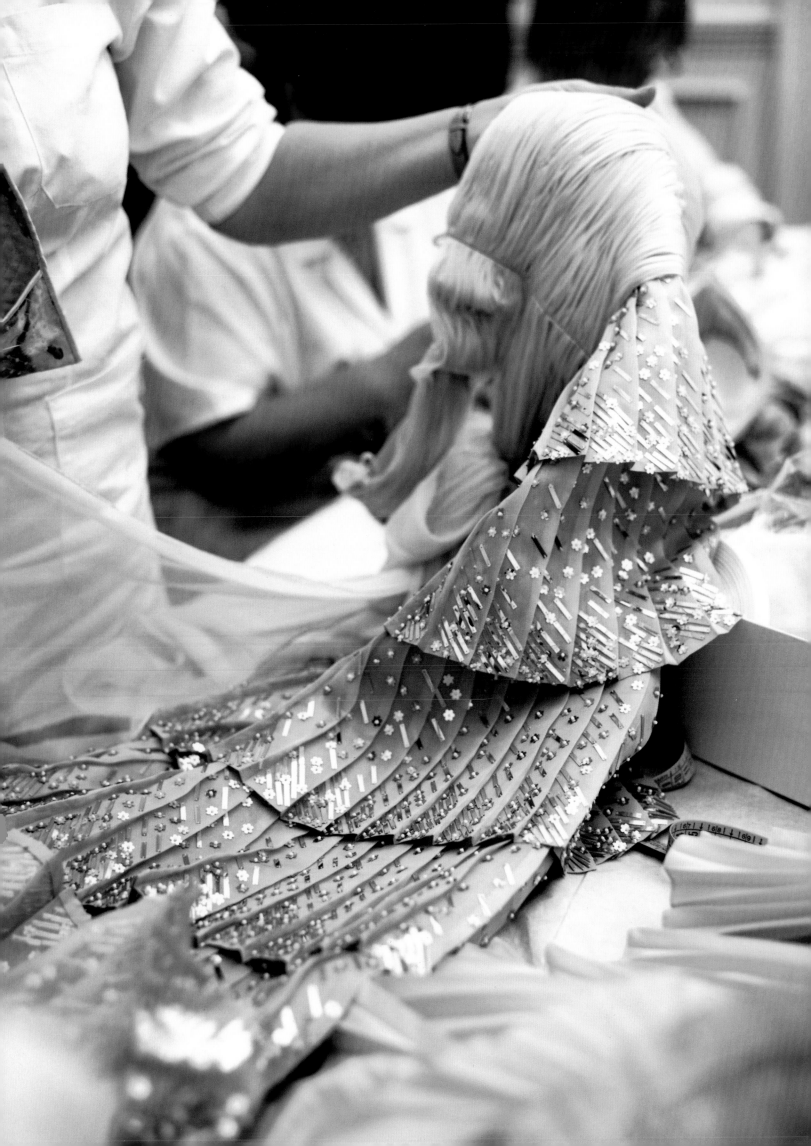

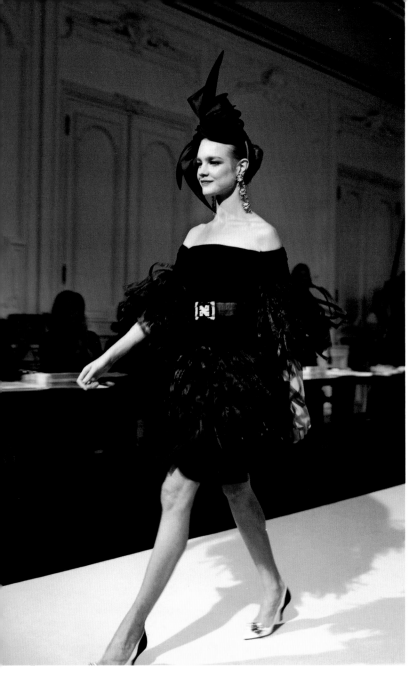

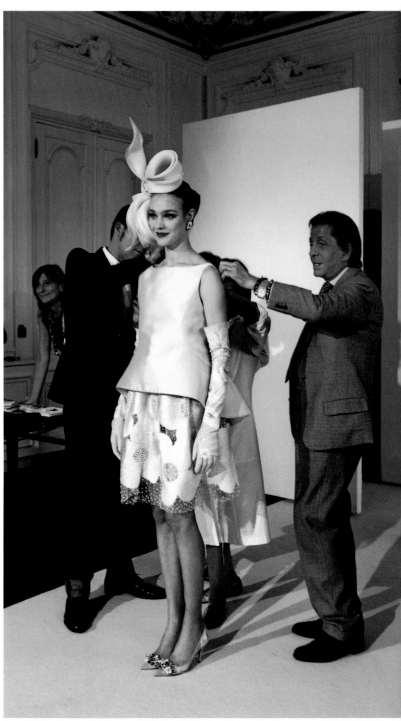

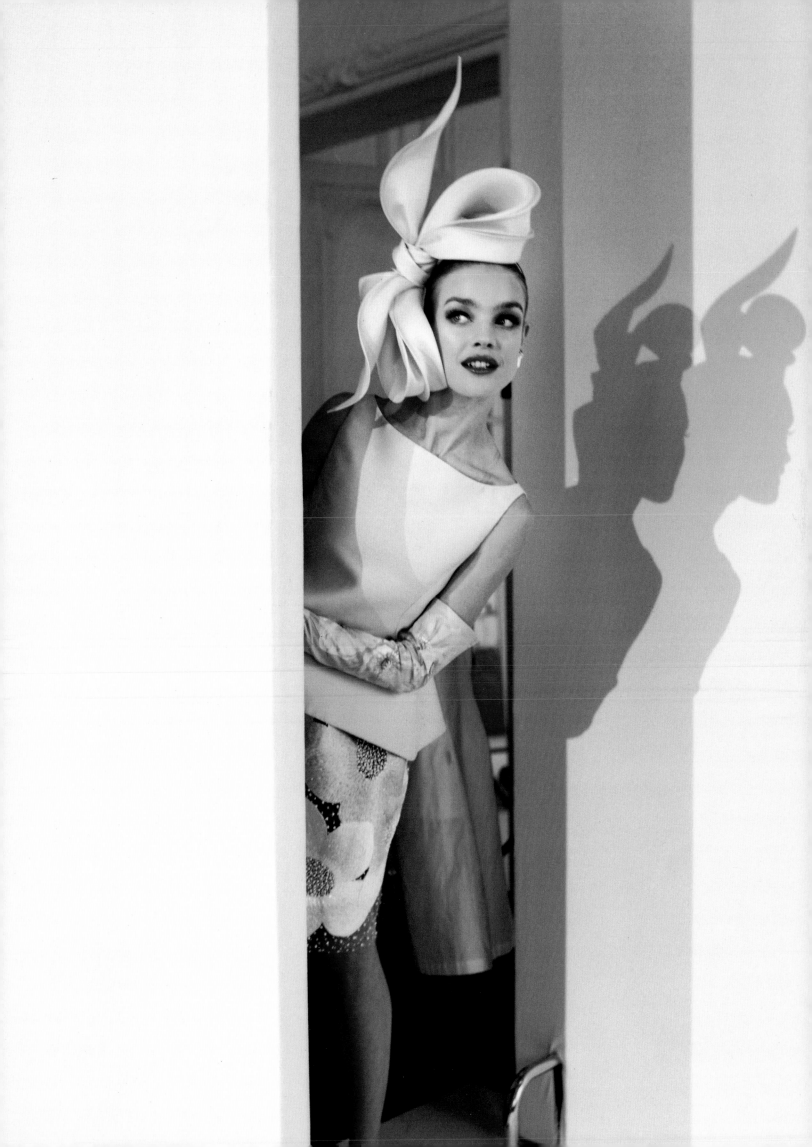

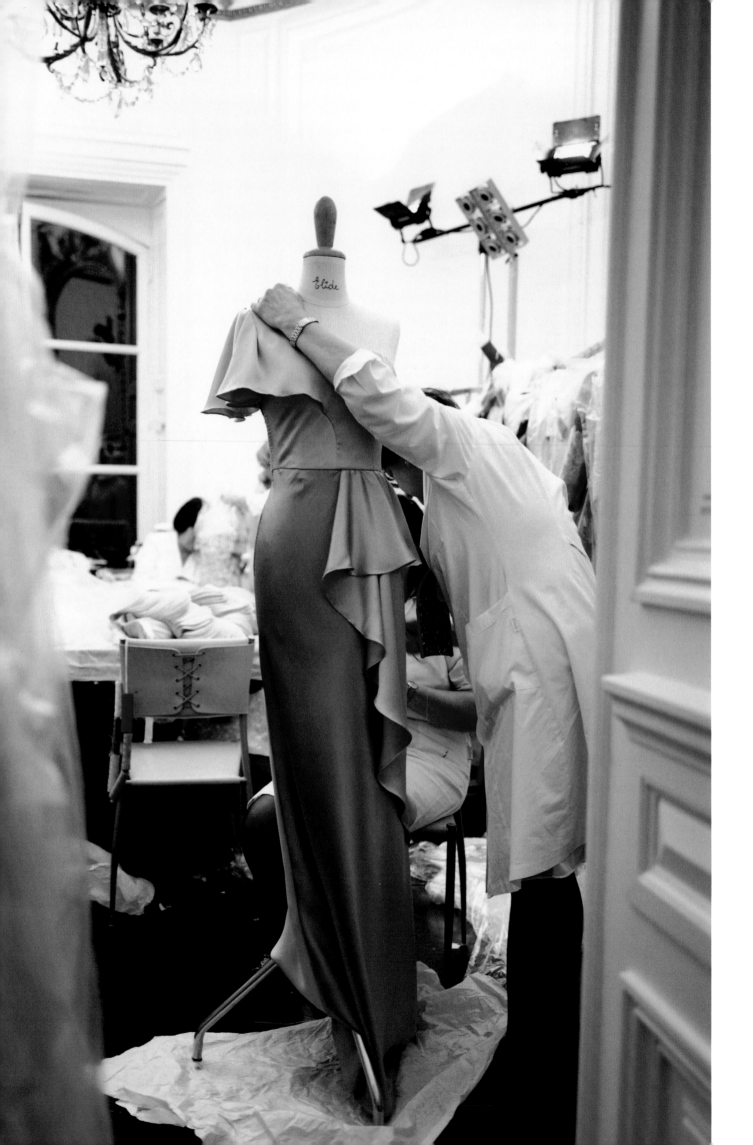

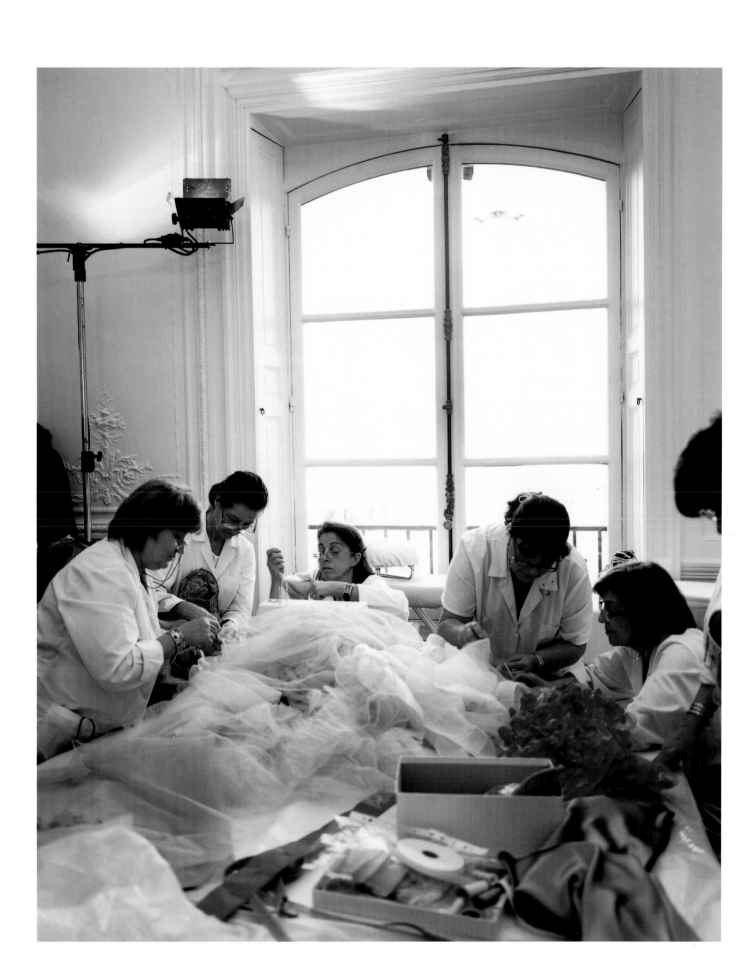

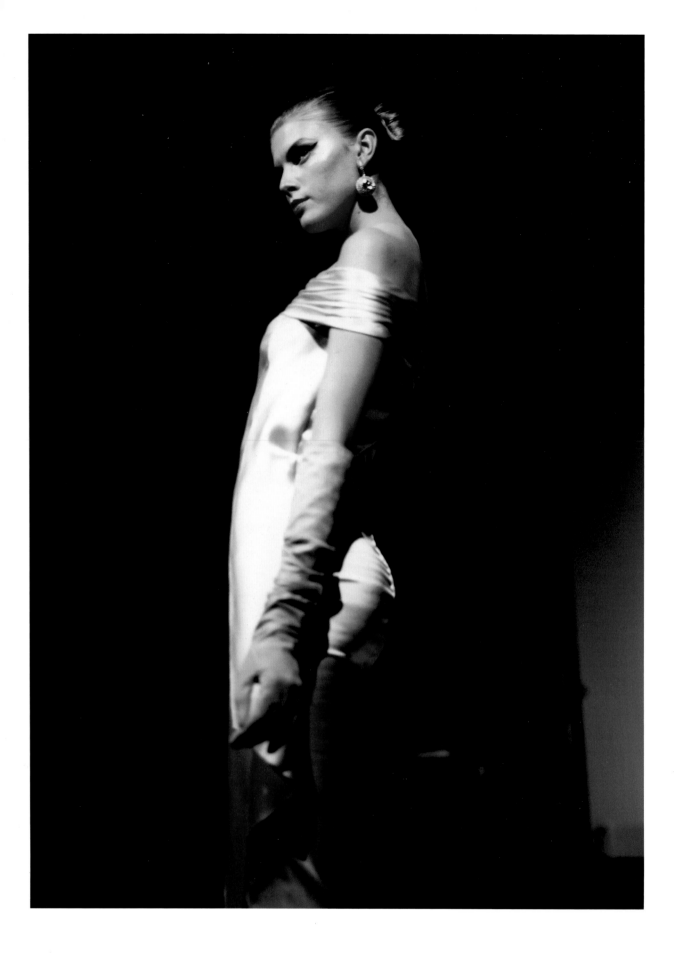

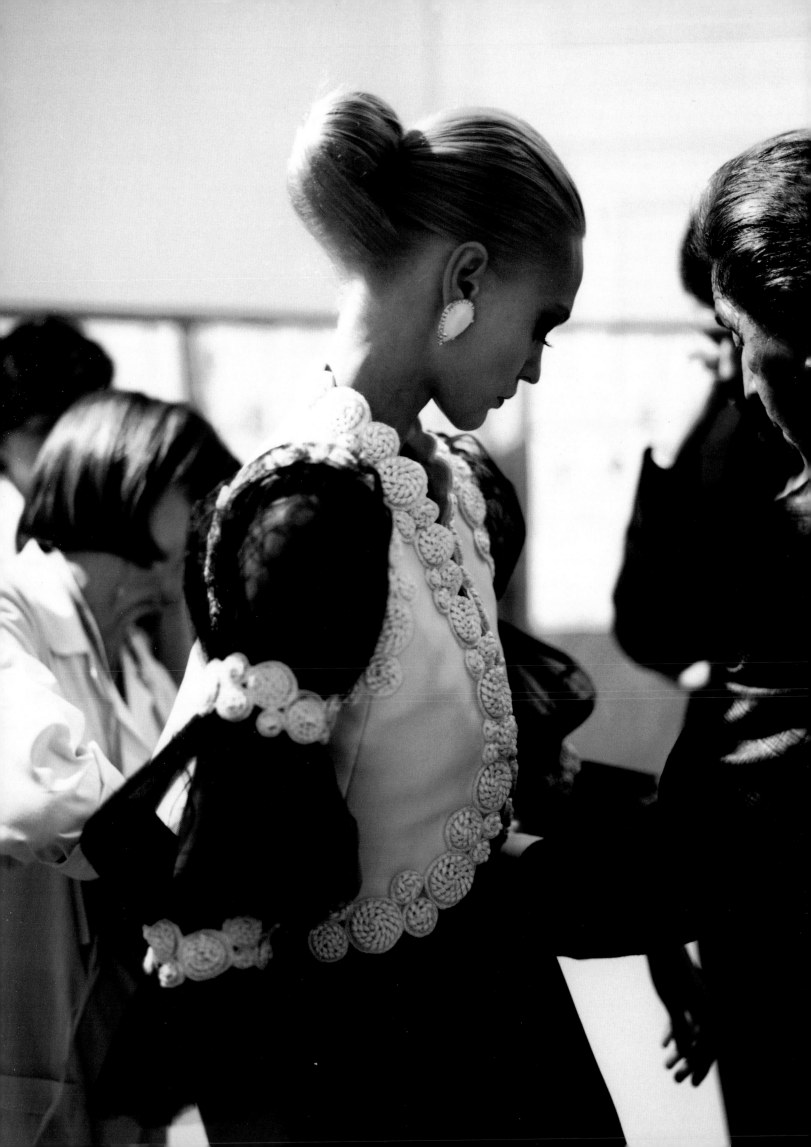

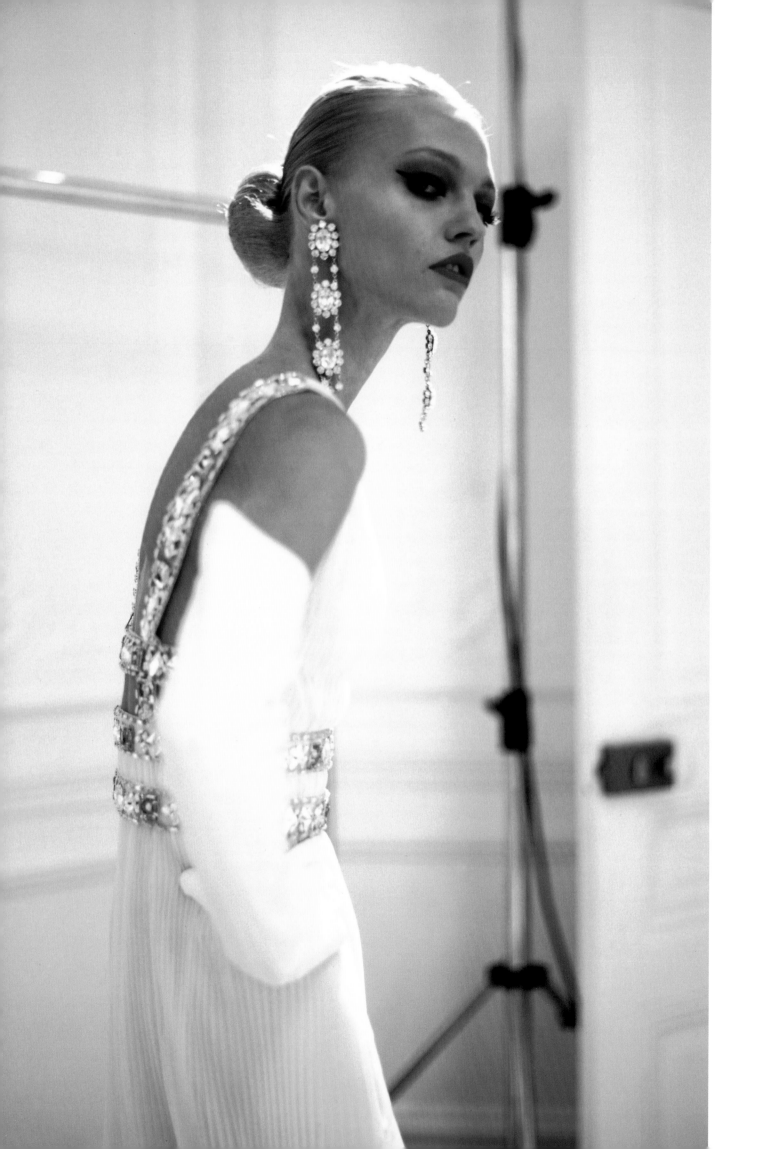

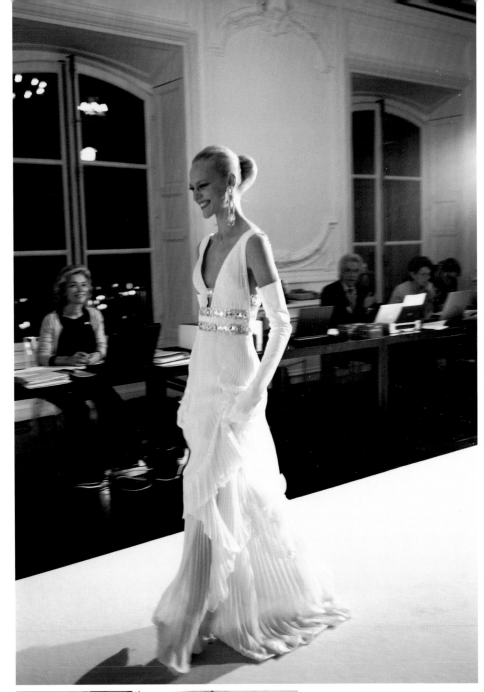

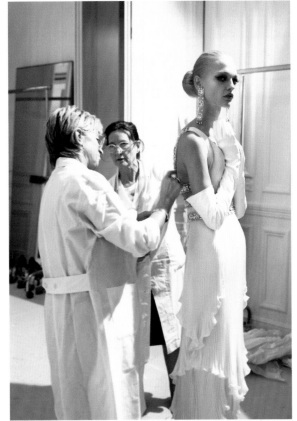

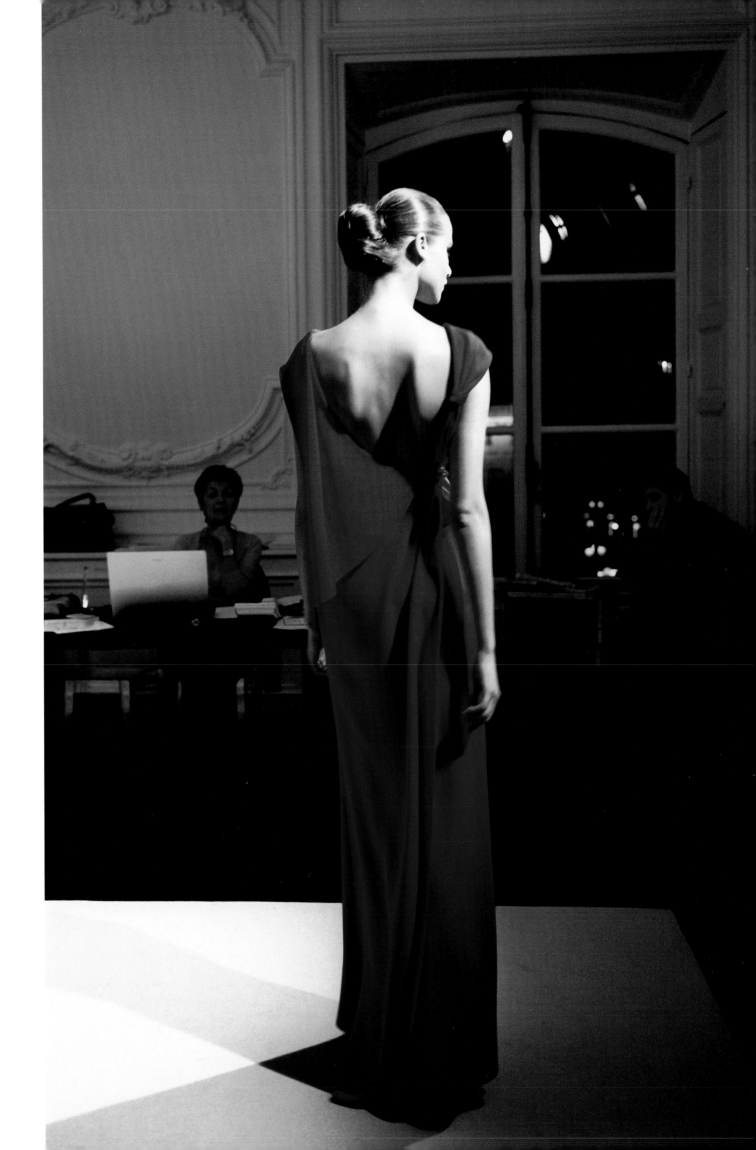

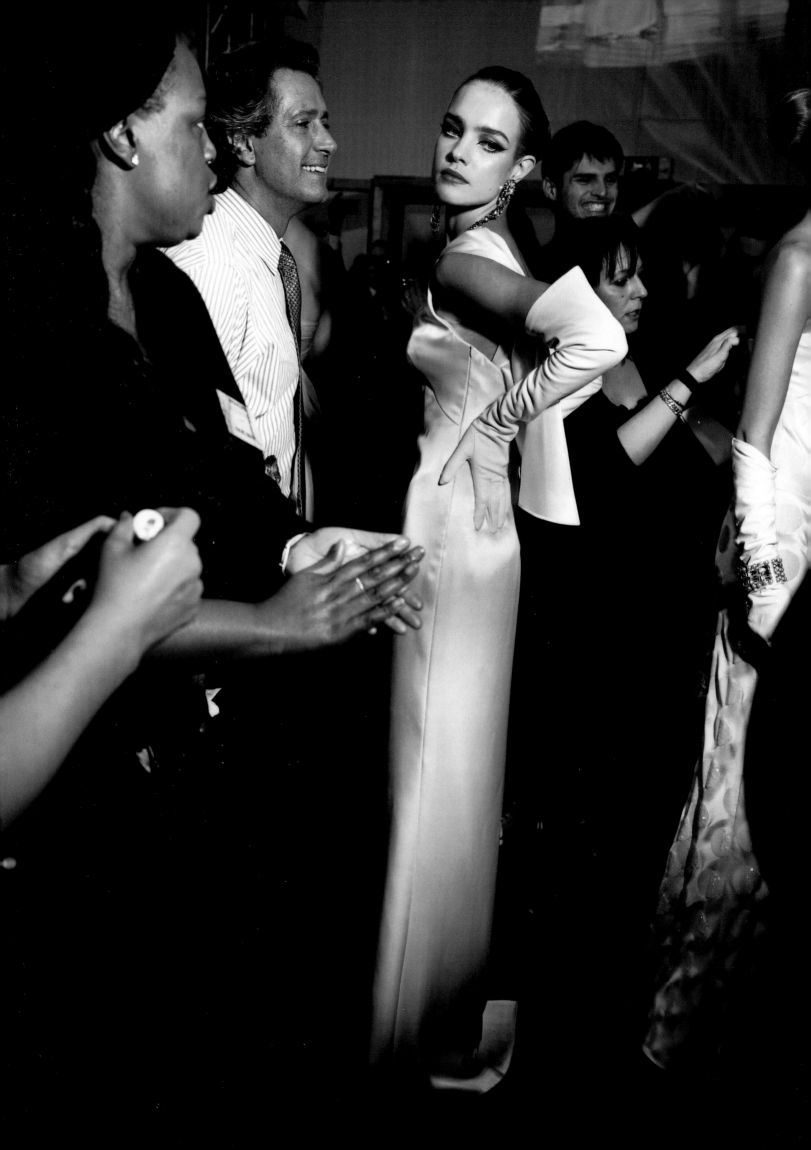

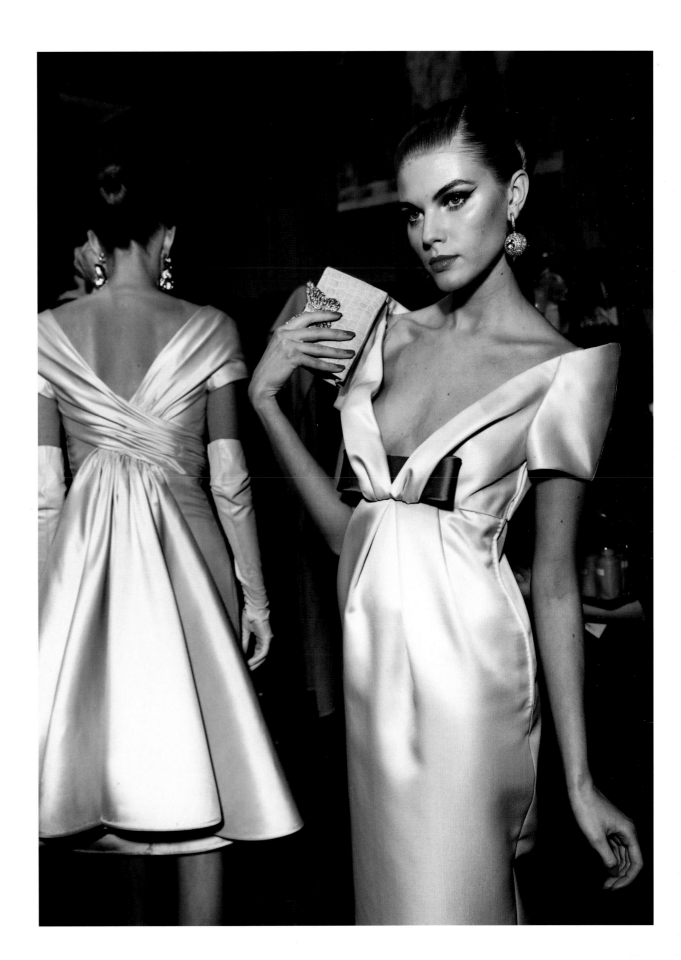

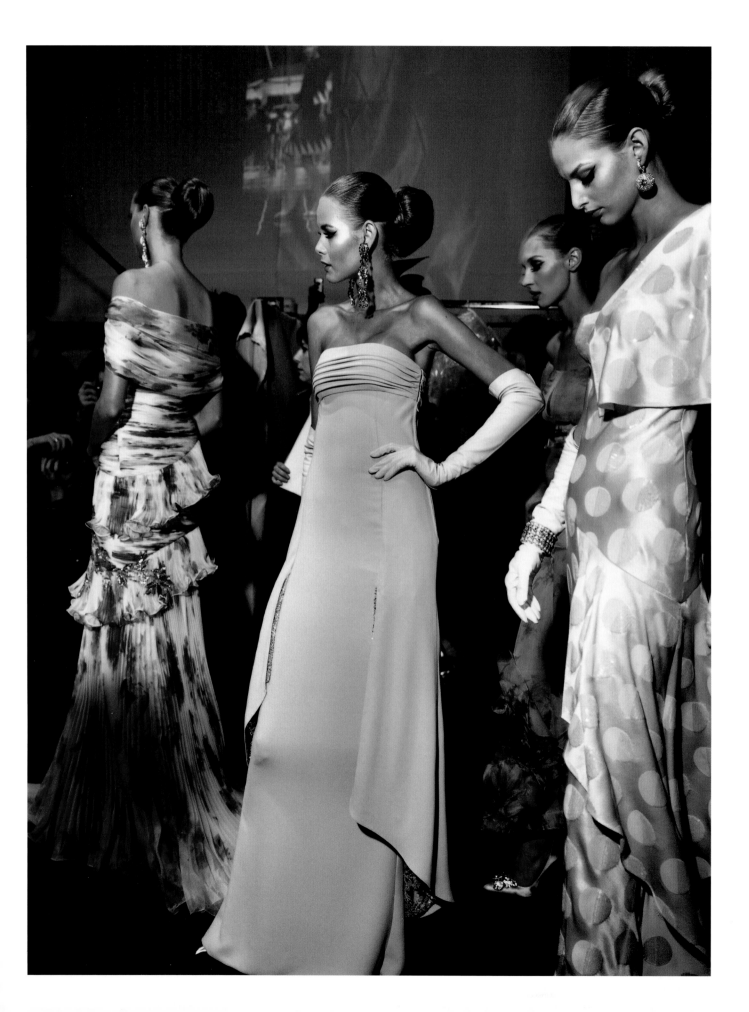

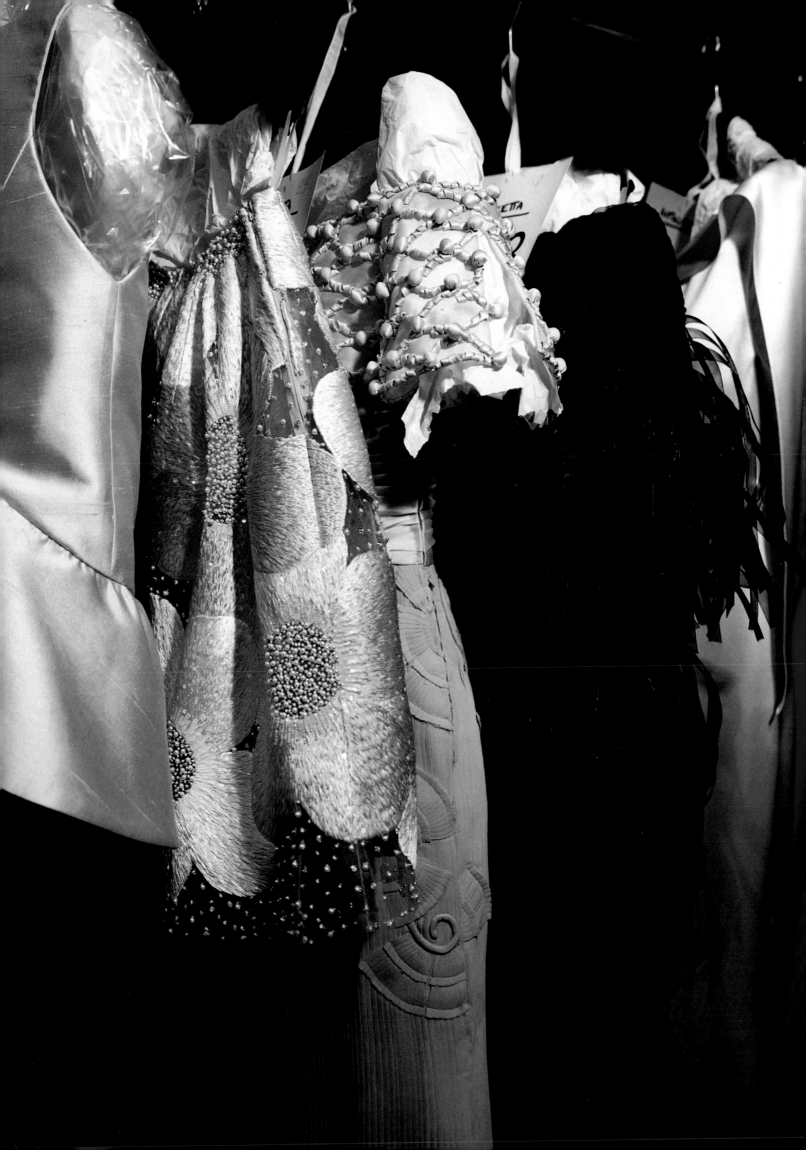

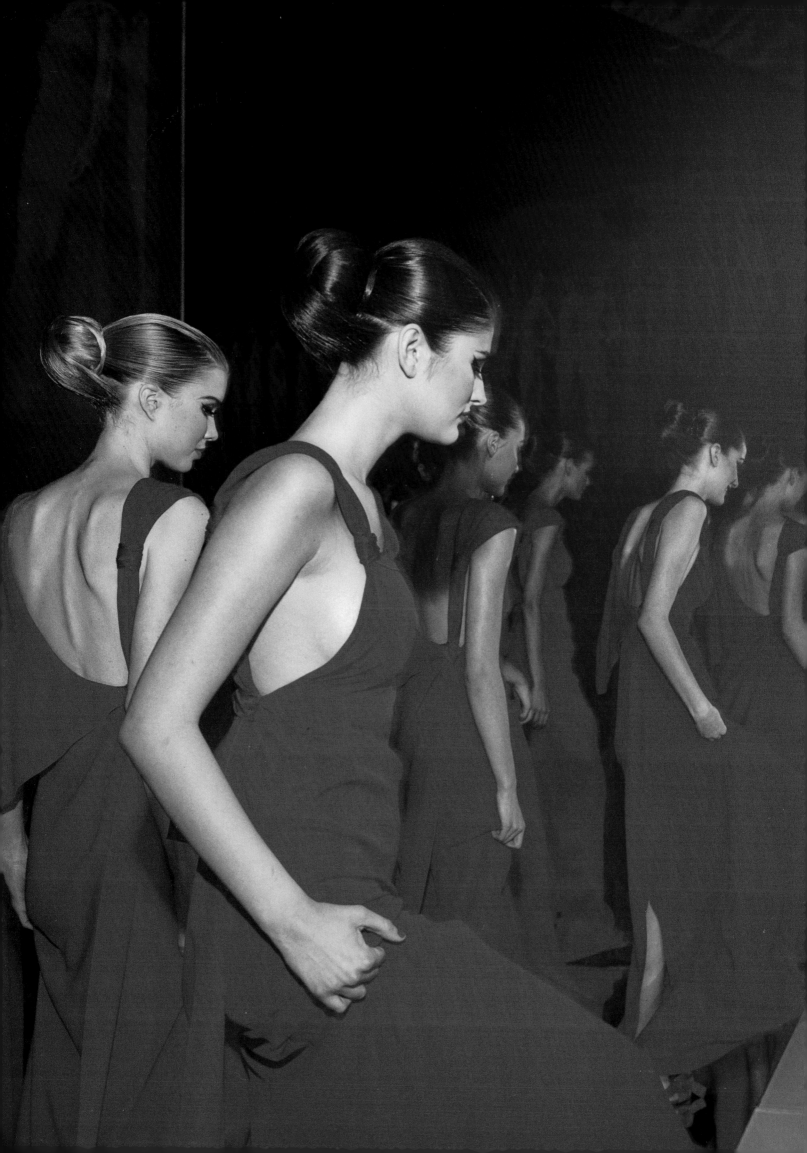

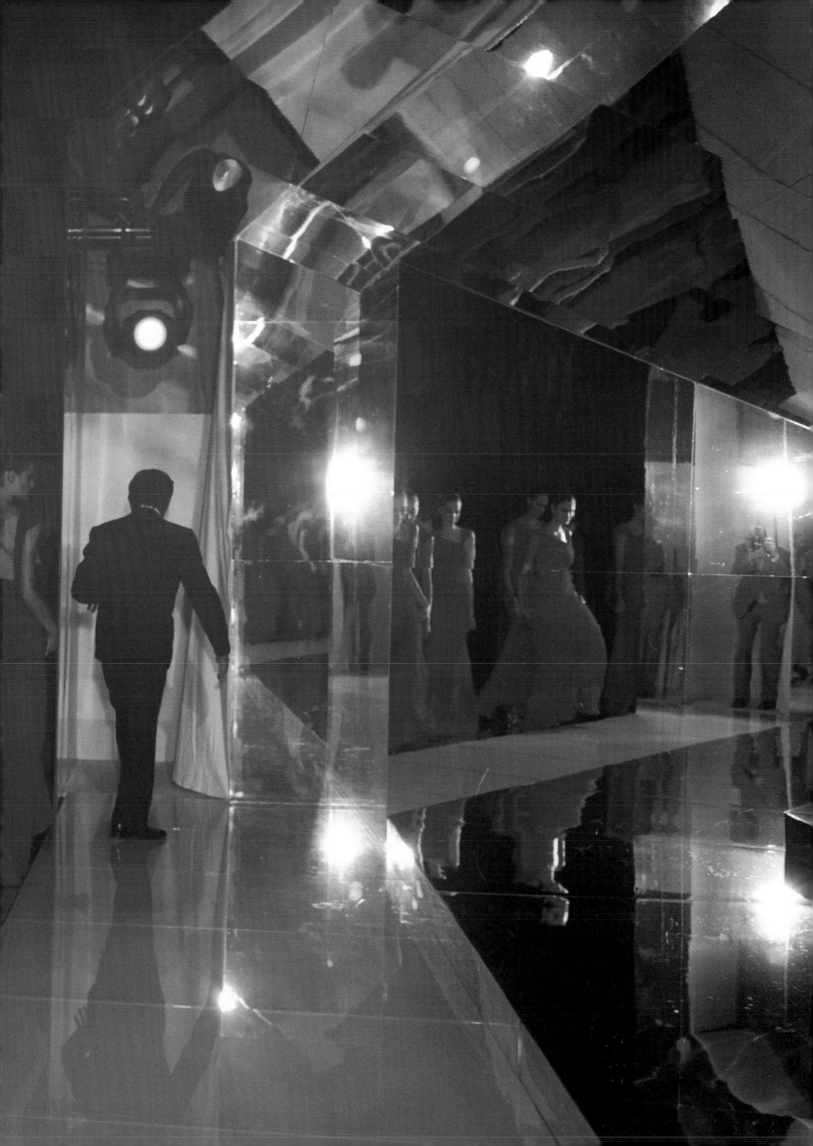

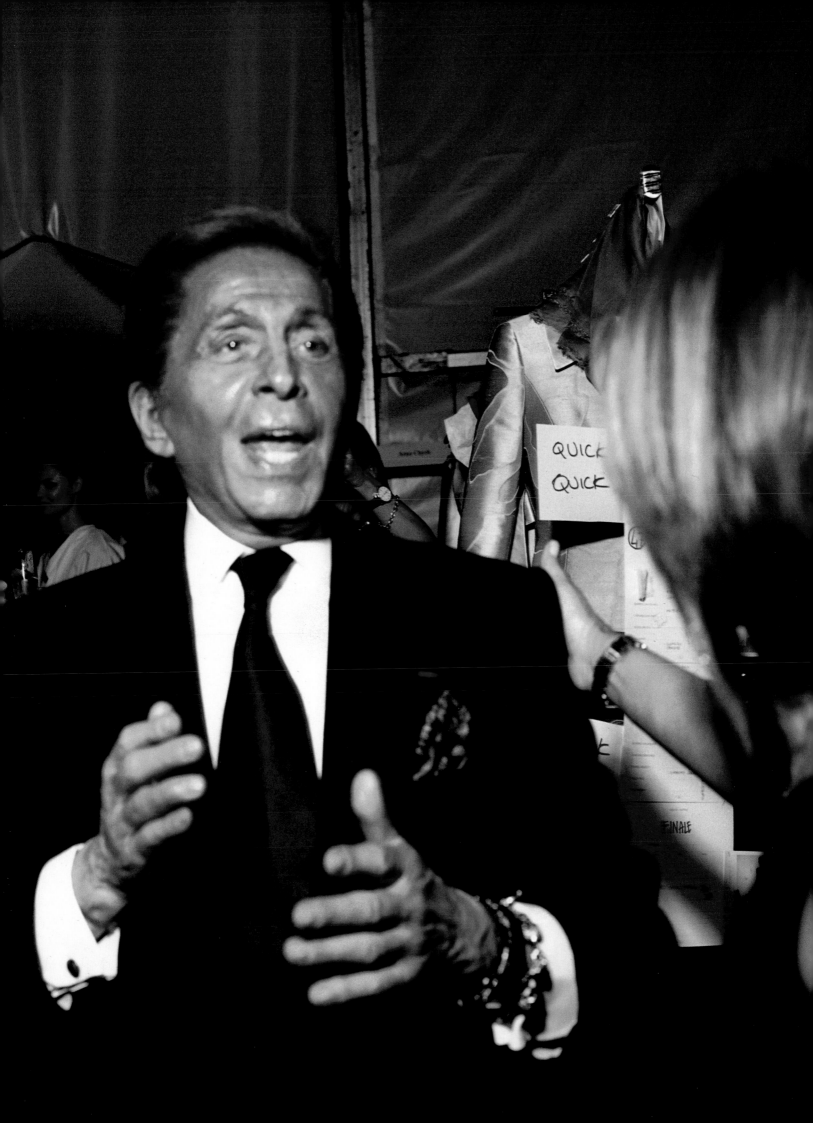

THEMES

I am never wrong wrong, and never was in all my career.[1]

Valentino always adhered to consistently high standards of excellence and design, combining unparalleled craftsmanship with a remarkably rich stylistic vocabulary. Graphic and understated, his style nevertheless has a unique vivacity that distinguishes it from designs of a severe, frigid minimalism. Valentino consistently designed with traditional techniques, initially developing all of his collections in preliminary sketches. He would decide on a general outline and its proportions, and then define the width of shoulders, the height of the waist, the type of sleeve, and so on. He progressively refined the design, selecting specific collars, drapings, and carefully chosen lengths.

Rigorously methodical in his elaboration of magnificent, recurrent themes—be they decorative or more technical in character—he continues to develop them in highly imaginative ways.

Floral designs, for instance, are among the preferred motifs of his vast repertory. "I have paid homage to all the flowers that I love so much through my creations of fabrics and dresses: that was my way of thanking all these marvels that have given me so much pleasure."[2] Adapted to changes in taste, Valentino's flower motifs were printed, encrusted, stylized, shaped, painted, or embroidered in delicate expressions of an exemplary feminine grace and sophistication.

His animal prints were repeatedly revised, assuming surprising forms in countless new interpretations. Such stylized motifs as giraffe, zebra, leopard, and tiger patterns served to underscore his designs' sinuous curves, as well as the dynamic shape of their silhouettes.

Equally daring in the use of geometric motifs, he used such forms in unexpected combinations of bright colors that testified to the fashion house's refined technical expertise.

In order to produce faithful reproductions of Valentino's sketches, an incredibly high degree of virtuoso craftsmanship was required of his Roman ateliers. With masterful precision, crepes and silk chiffons were pleated, ruffled, and braided to produce silhouettes as light as they were airy, without any loss of the form's essential volume.

In a special technique known as *budellini*, fine cordons are cut on the bias and set atop a piece of tulle or organza to create a unique contour. To underscore the flawless cut of his designs, Valentino enhances them with the juxtaposition of colored feathers and other vivid accents. He gives life to the way women move and walk with such delicate nuances of ornamentation, distinguishing each with an unmistakable allure.

The craftsmanship Valentino mastered in his youth accounts for his creation of an oeuvre successfully designed to pay tribute to the quintessentially active, generous, and self-assured contemporary woman.

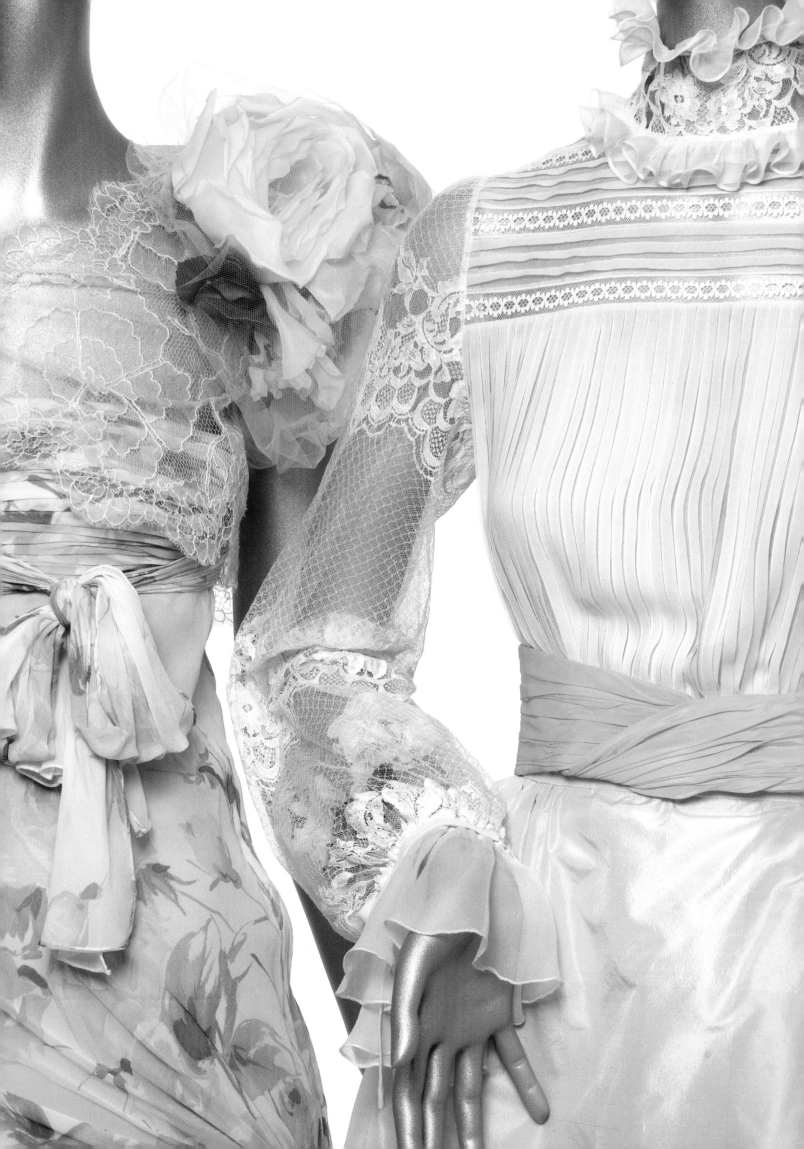

SPRING/SUMMER 2007, MODEL 102

EVENING ENSEMBLE: DRAPED AND KNOTTED EMPIRE DRESS AND SHEATH MADE OF
WHITE CHIFFON PRINTED WITH BOUQUETS OF ROSES; BOLERO MADE OF CAUDRY LACE
AND CREAM-COLORED TULLE, PUFFED-UP SLEEVES ADORNED WITH SILK ROSES.
FABRIC: GENTILI & MOSCONI AND SOPHIE HALETTE. FLOWERS: PAGLIANI-BRASSEUR.

All dresses are from the haute couture collections at the Valentino Archives except where noted.

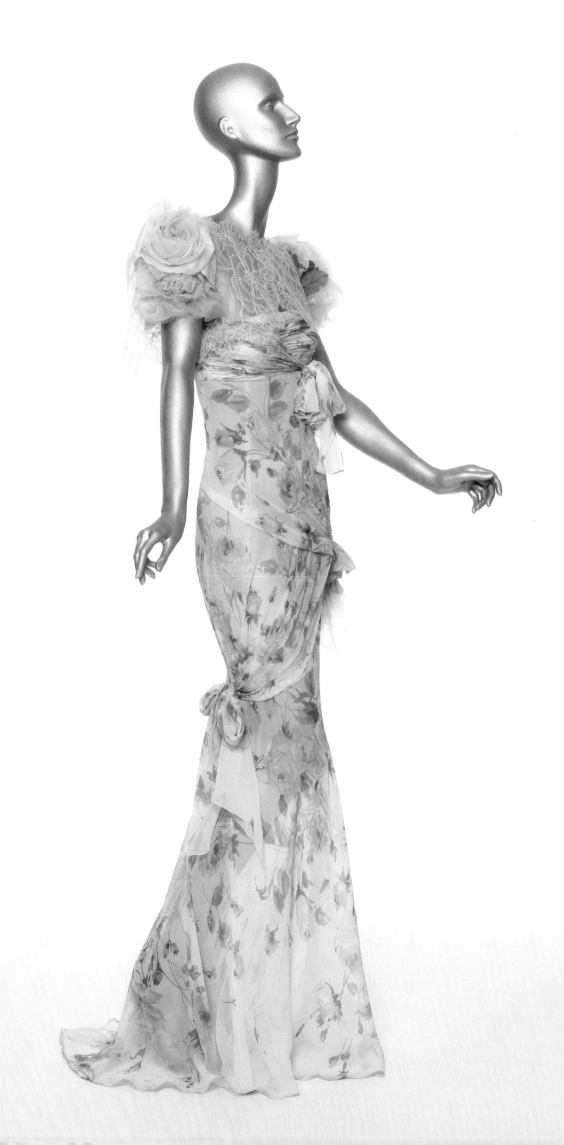

SPRING/SUMMER 1966, MODEL 170

OPPOSITE, LEFT: DAYTIME ENSEMBLE: CHASUBLE OF COTTON SATIN WITH BLACK
AND WHITE GIRAFFE PRINT, KIMONO SLEEVES, WHITE COTTON SATIN LINING;
TROUSERS AND HOOD MADE OF CREAM-COLORED SILK PONGÉE. FABRIC: TARONI.

FALL/WINTER 1967, MODEL 172

OPPOSITE, RIGHT: DAYTIME ENSEMBLE: ANKLE-LENGTH COAT, RAGLAN SLEEVES
AND HORN BUTTONS; BLACK SILK JERSEY TUNIC; BELL BOTTOM TROUSERS
MADE OF WOOL GABARDINE IN A BEIGE AND BROWN TIGER-SKIN PRINT; BELT MADE
OF GILT CHAIN AND BLACK PATENT LIZARD SKIN. FABRIC: CLERICI-TESSUTO.
COLLECTION: BARONESS FIONA THYSSEN-BORNEMISZA.

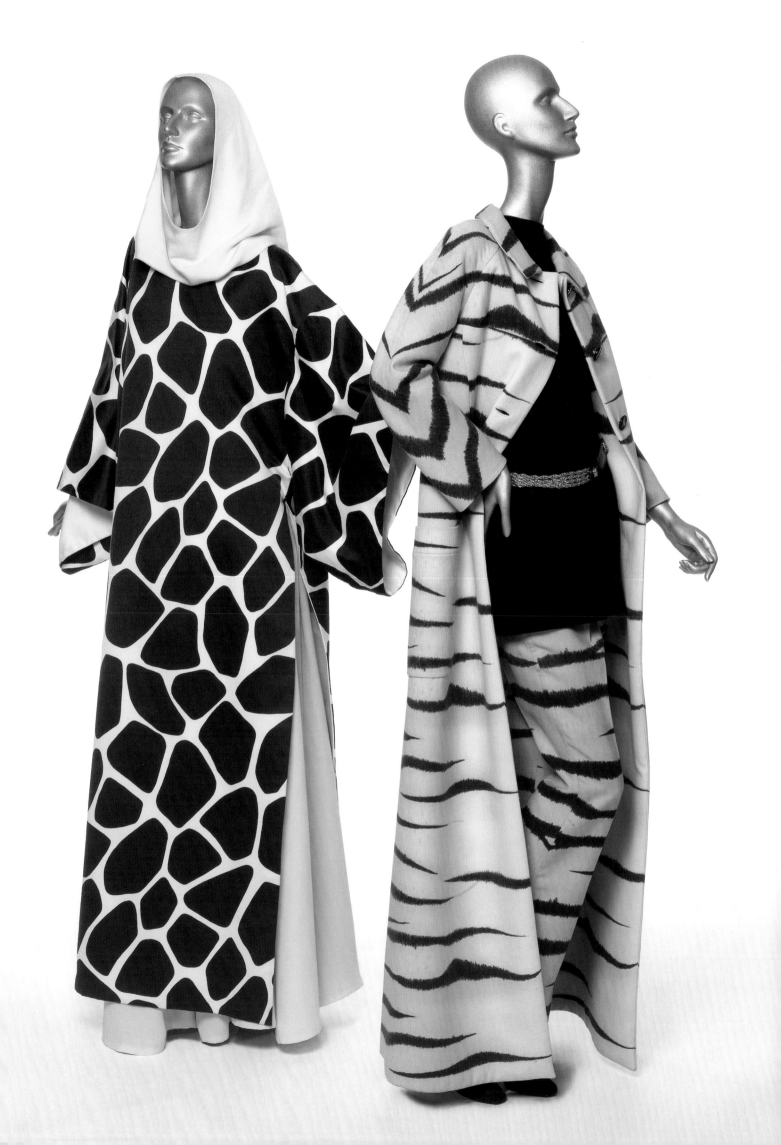

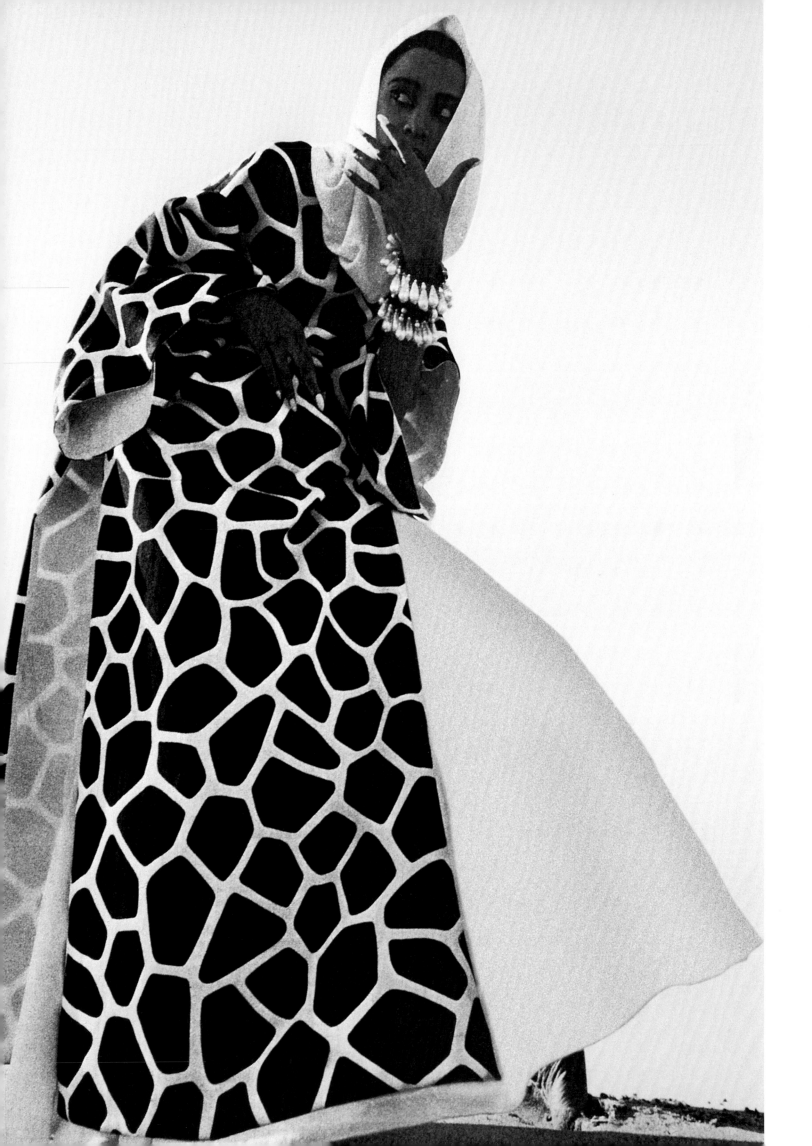

PHOTOGRAPHER: MARC HISPARD

SPRING/SUMMER 2003, MODEL 130

STRAPLESS EVENING DRESS WITH LOW-SET DRAPED PALE CRIMSON CHIFFON
SLEEVES, A TRAIN WITH APPLIQUÉ PLEATED CRIMSON TAFFETA ROSETTES AND RED
STRASS IN THEIR CENTERS, AND PINK AND GREY TAFFETA ROSETTES IN ITS LINING.
FABRIC: BUCHE-GUILLAUD. EMBROIDERY: MARABITTI.

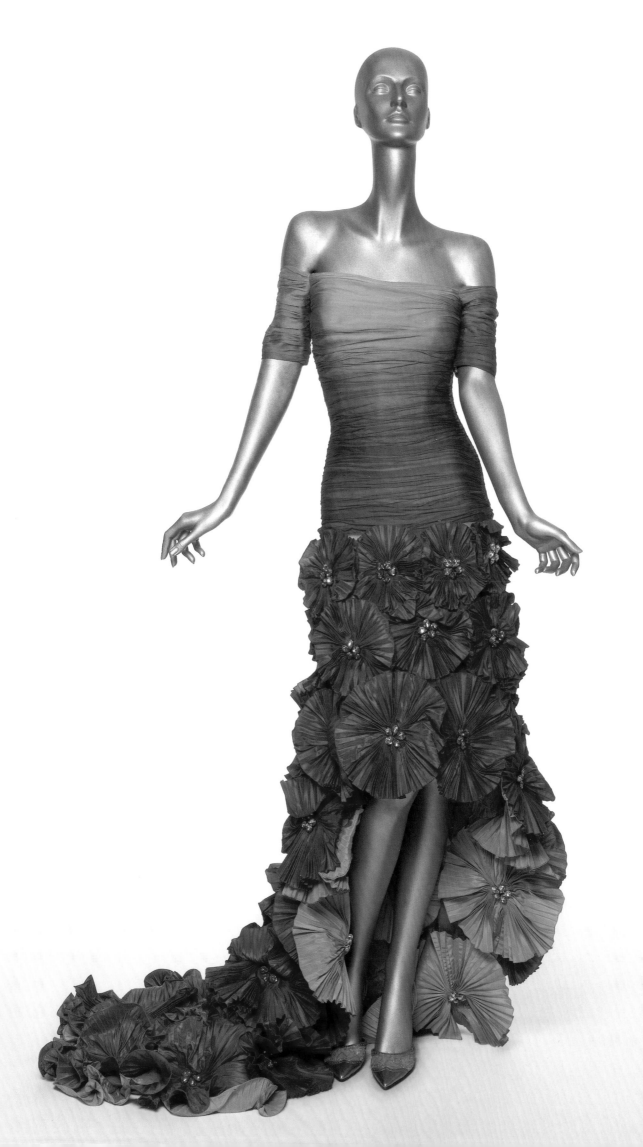

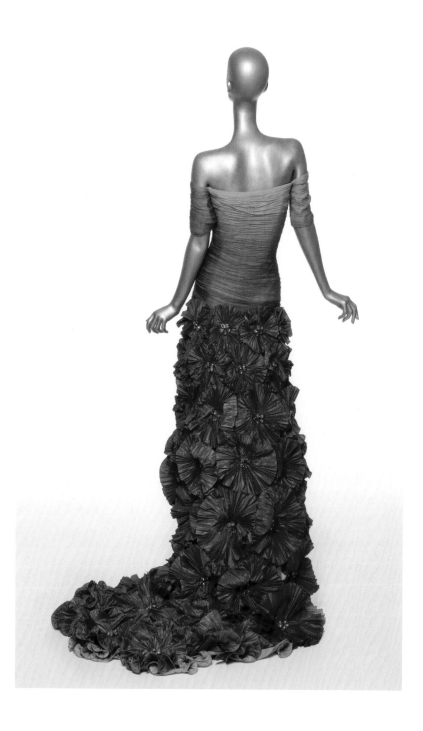

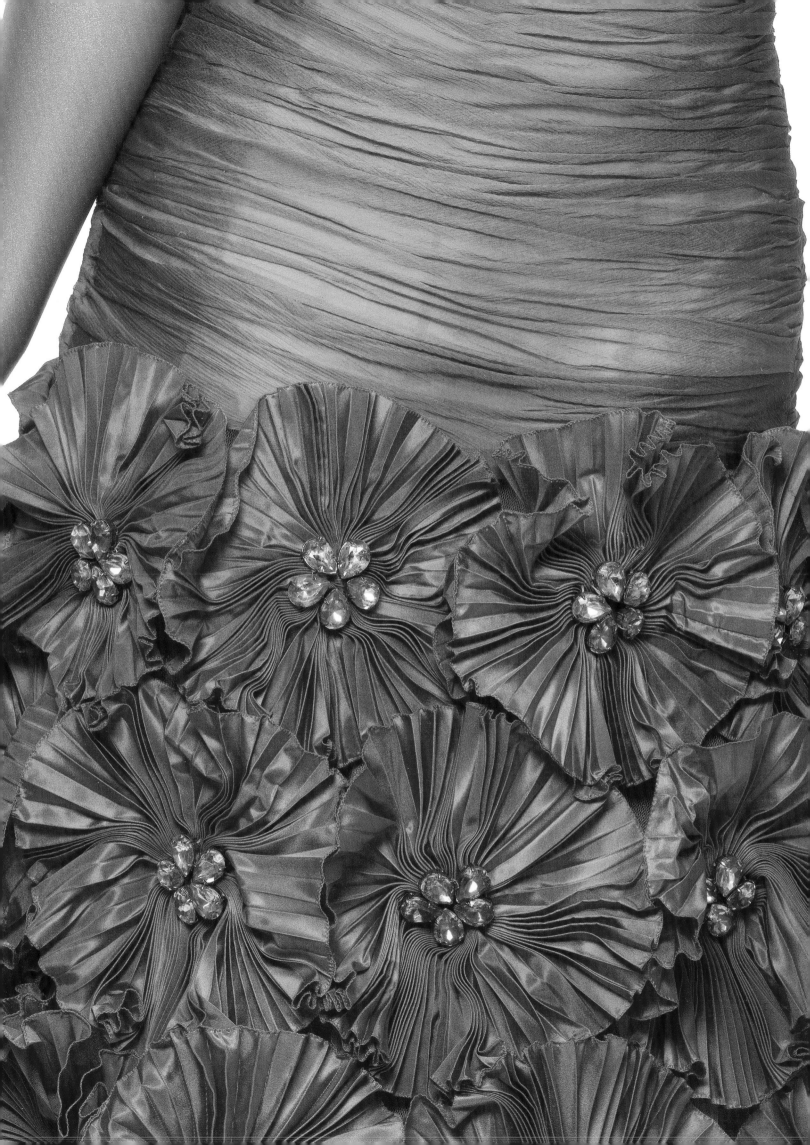

FALL/WINTER 1968, MODEL 234

WHITE SATIN EVENING GOWN WITH DELFT BLUE PRINT, LONG SLEEVES, ENCRUSTED HIGH

BELT AND SKIRT MADE OF SHIRRED PANELS, PLEATED TRAIN. FABRIC: TARONI.

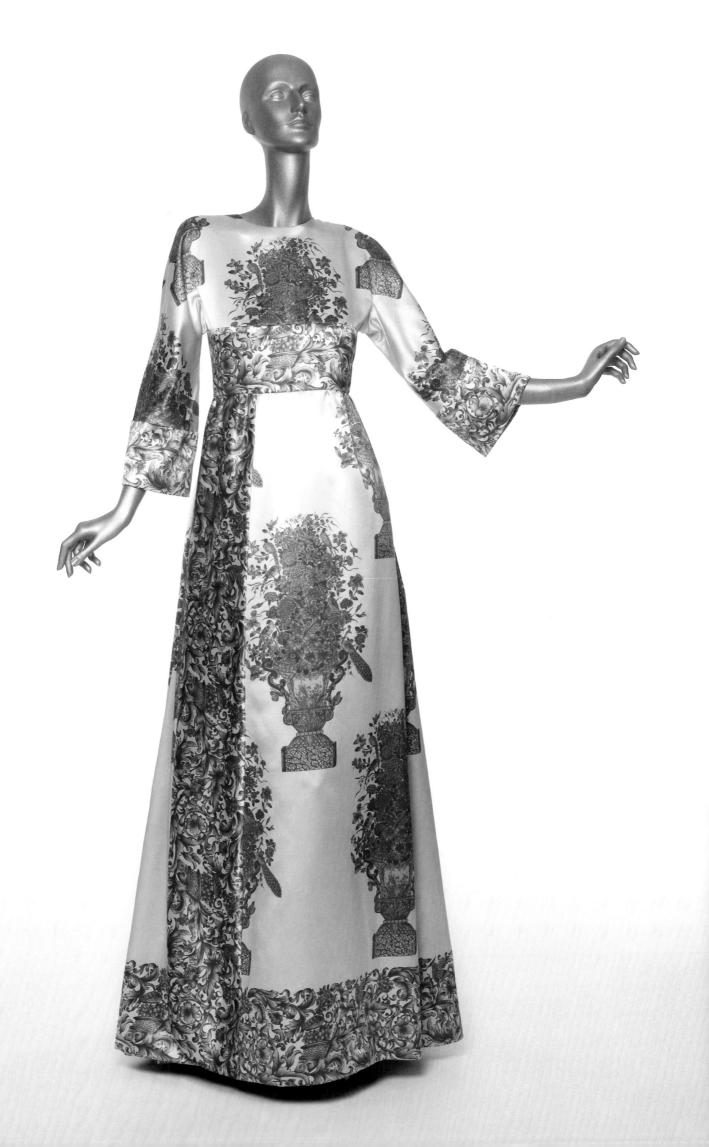

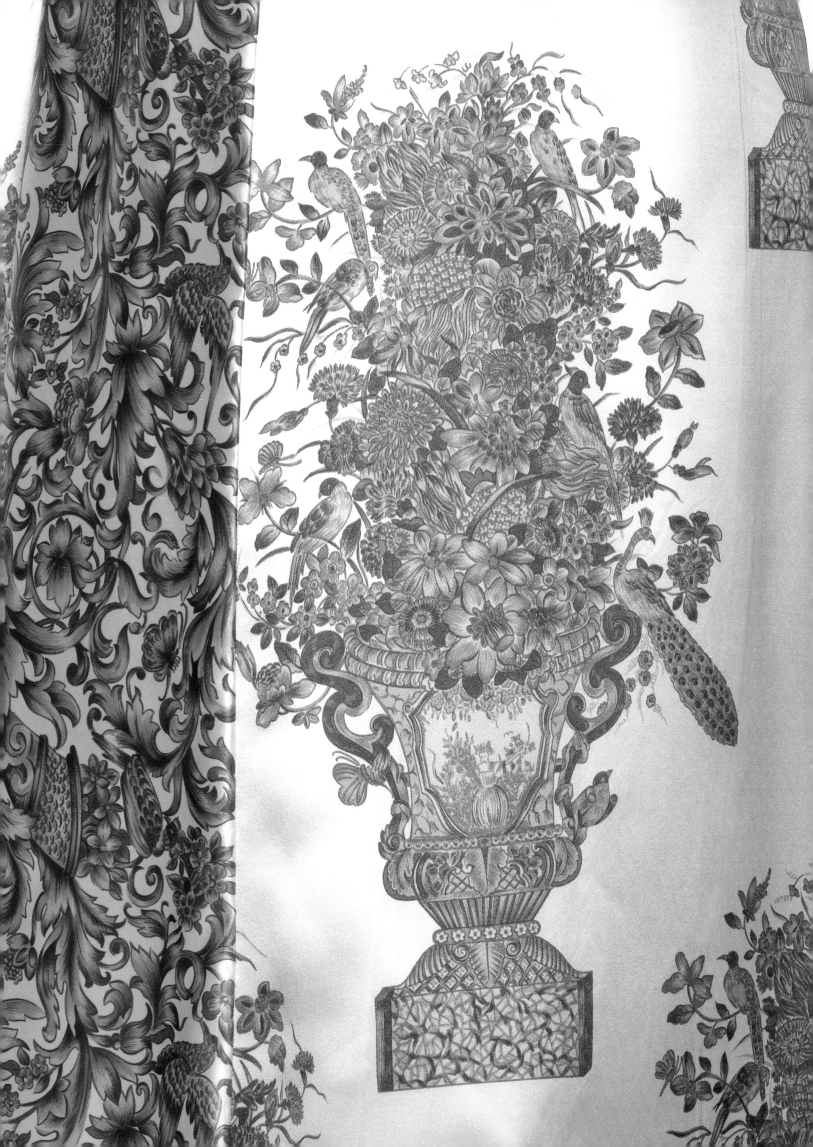

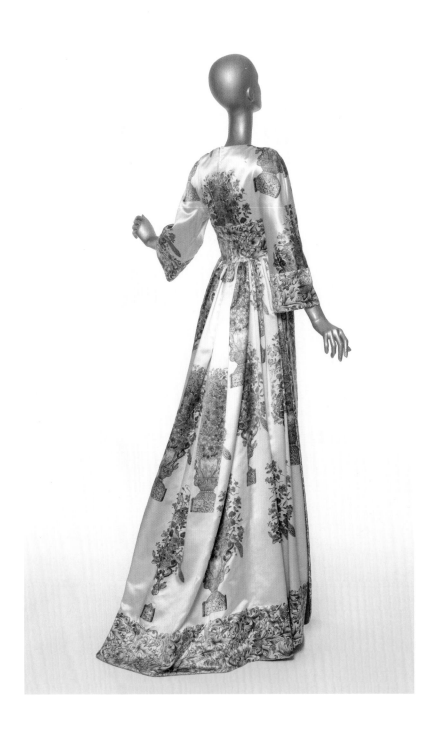

PHOTOGRAPHER: HENRY CLARKE

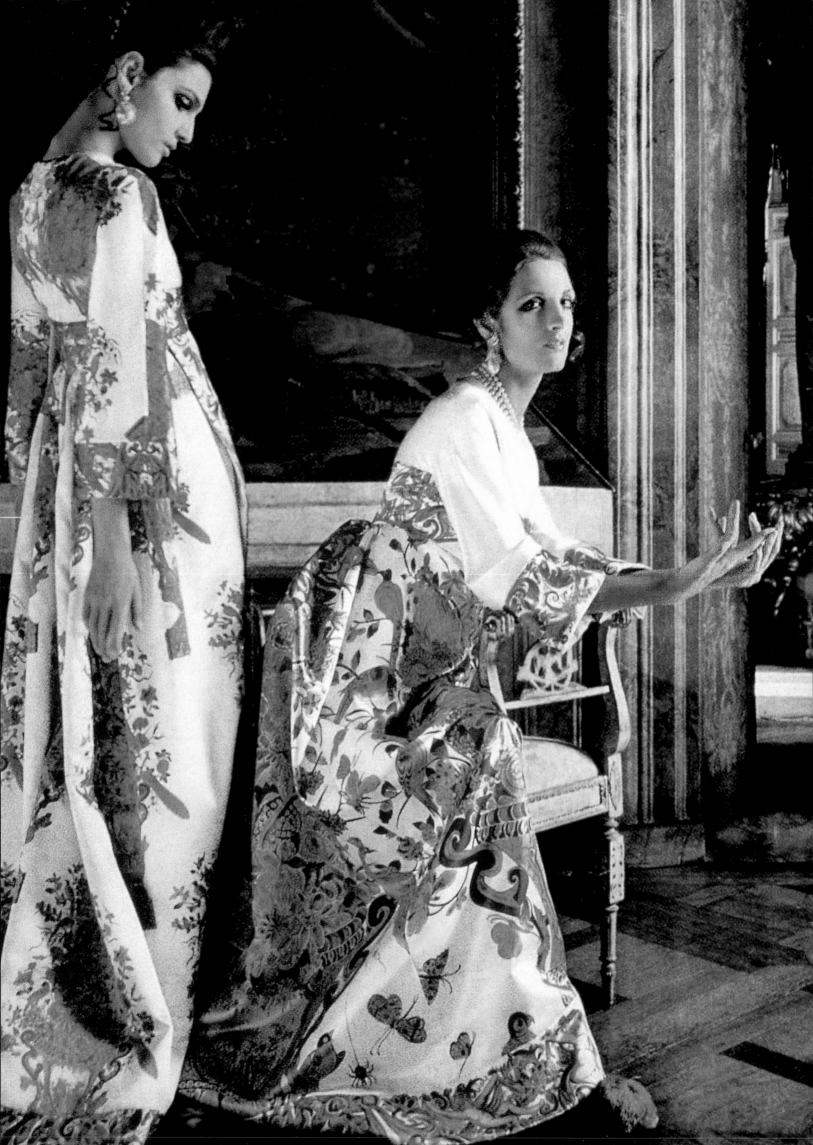

SPRING/SUMMER 1988, MODEL 252

EVENING GOWN MADE OF ORGANZA AND SILK VOILE PRINTED WITH PINK ORCHIDS,

BATWING TOP, DRAPED BELT AND HIGH COLLAR WITH ROUND KNOTS, SHIRRED WAIST,

PETTICOAT PIPED IN PINK SATIN. FABRIC: RATTI.

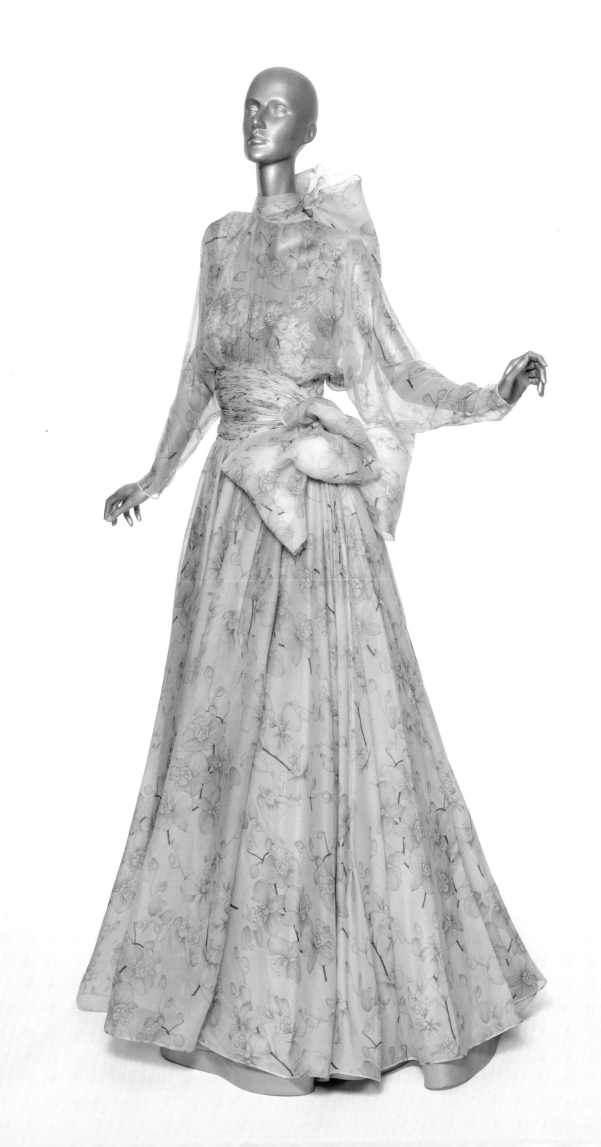

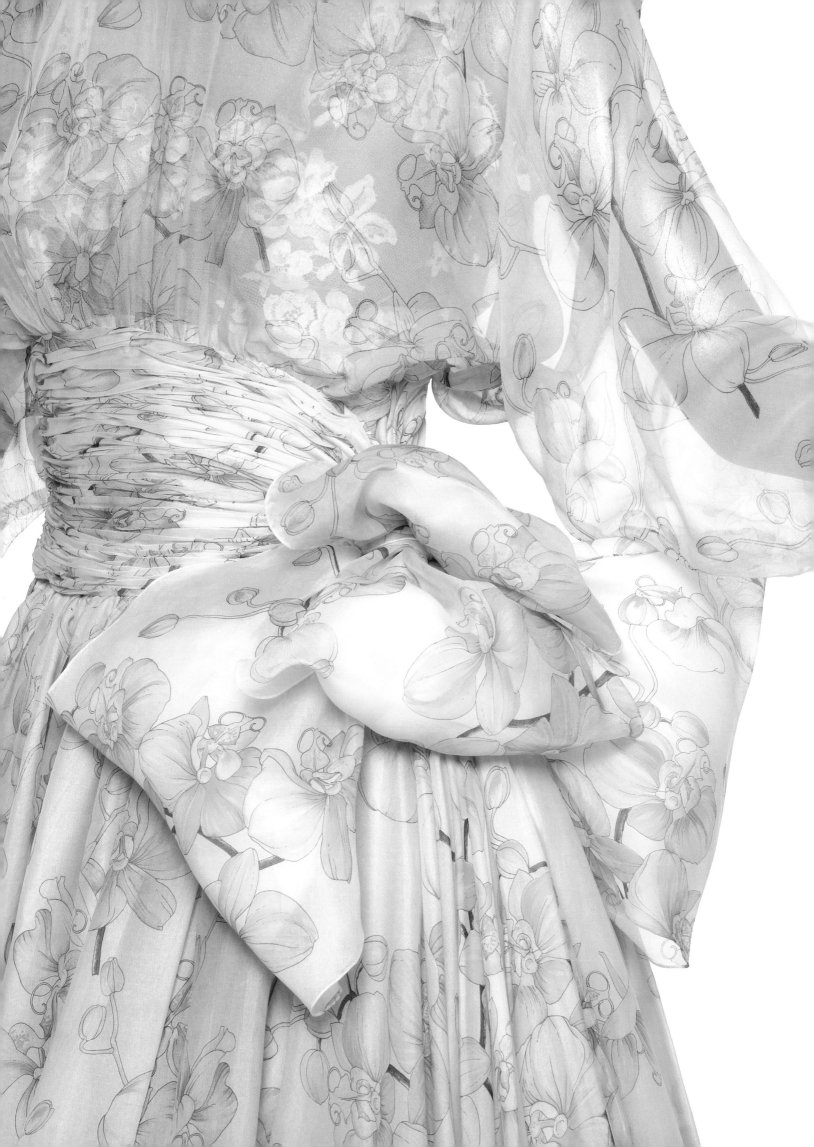

SPRING/SUMMER 1988, MODEL 252

SPRING/SUMMER 2008, MODEL 184

STRAPLESS EVENING GOWN MADE OF SILK VOILE APPLIQUÉD WITH SILK VOILE RUFFLES

AND COROLLAS IN GRADUATED SHADES OF PINK. FABRIC: CLERICI-TESSUTO.

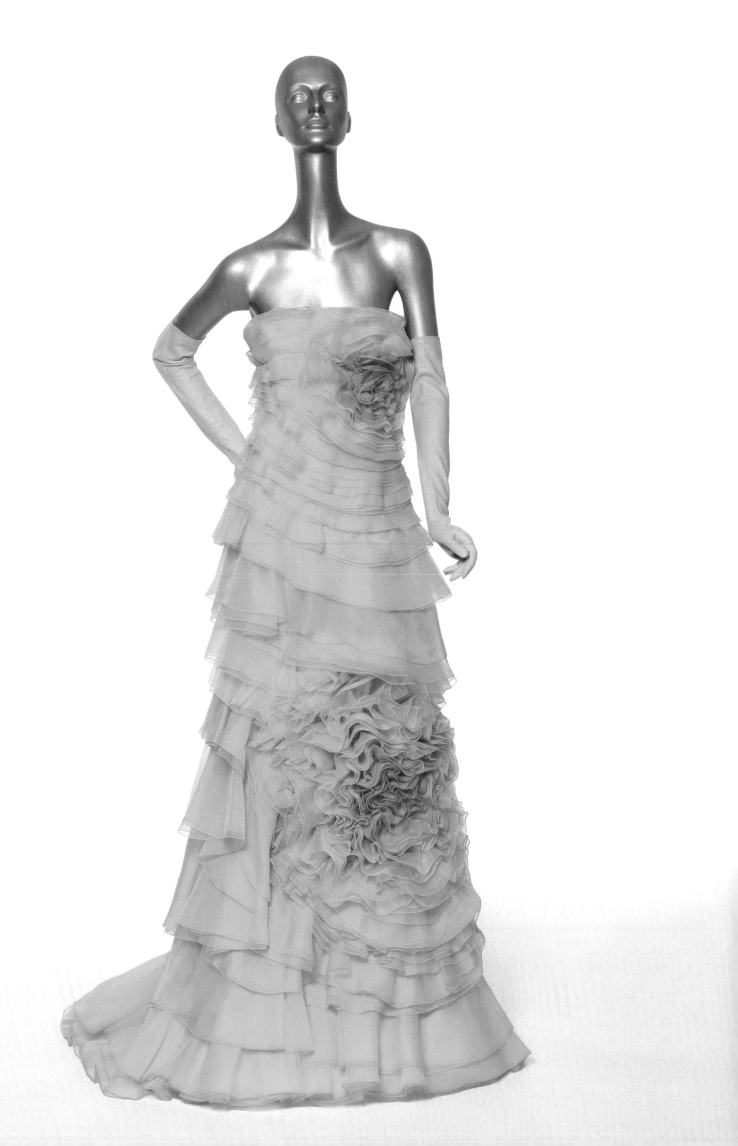

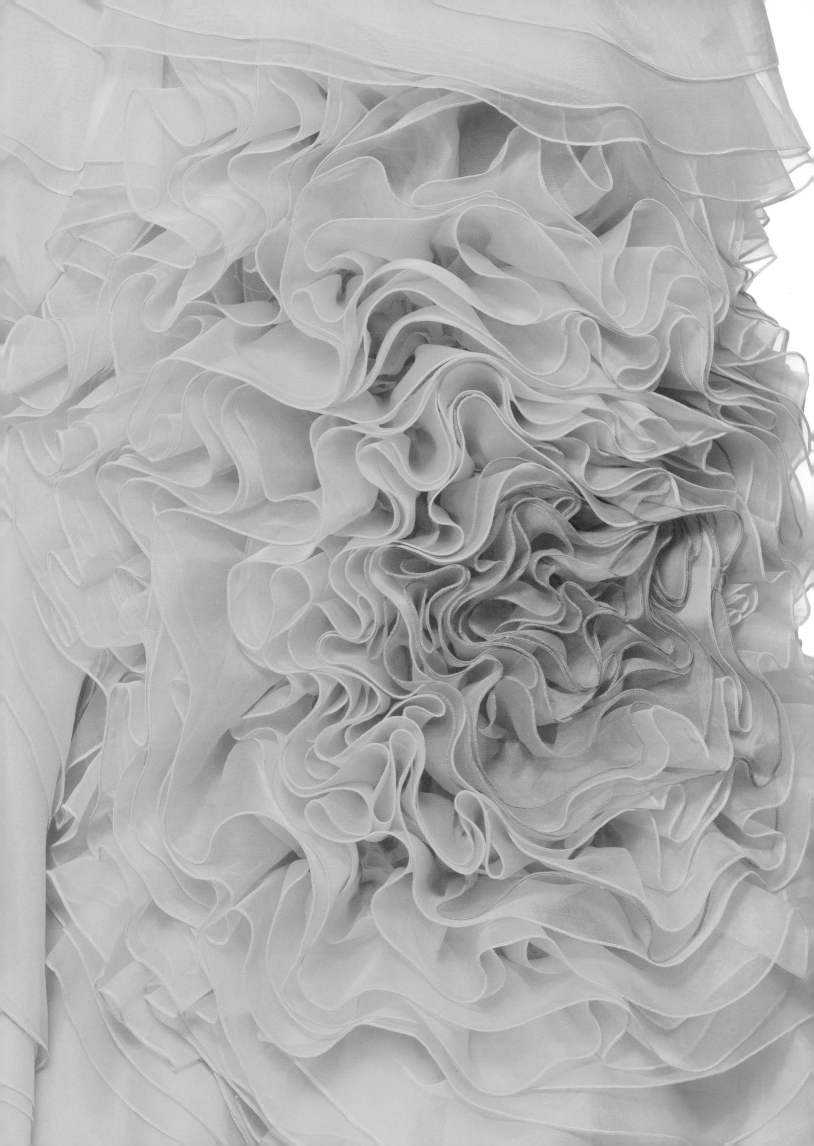

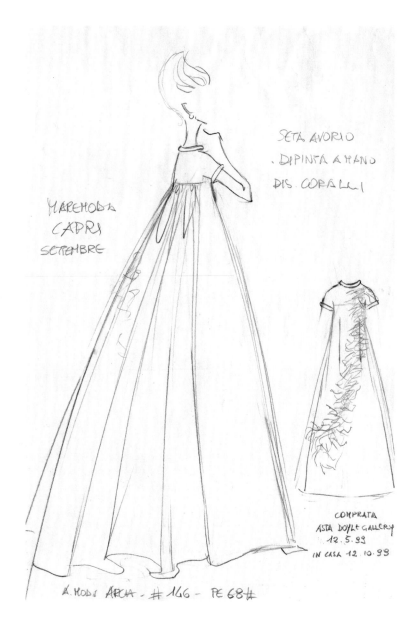

SETA AVORIO
. DIPINTA A MANO
DIS. CORALLI

MARCHIODO
CAPRI
SETTEMBRE

COMPRATA
ASTA DOYLE GALLERY
12.5.99
IN CASA 12.10.99

A. MODO ARCA - #146 - PE 68#

THEMES ORNAMENTATION

SPRING/SUMMER 1968, MODEL 146

EVENING GOWN MADE OF IVORY COLORED SILK SERGE HAND-PAINTED IN A CORAL MOTIF, SHORT

RAGLAN SLEEVES AND ROUND PIPED COLLAR, SHIRRED TRAIN. HAND-PAINTED FABRIC: FORNERIS.

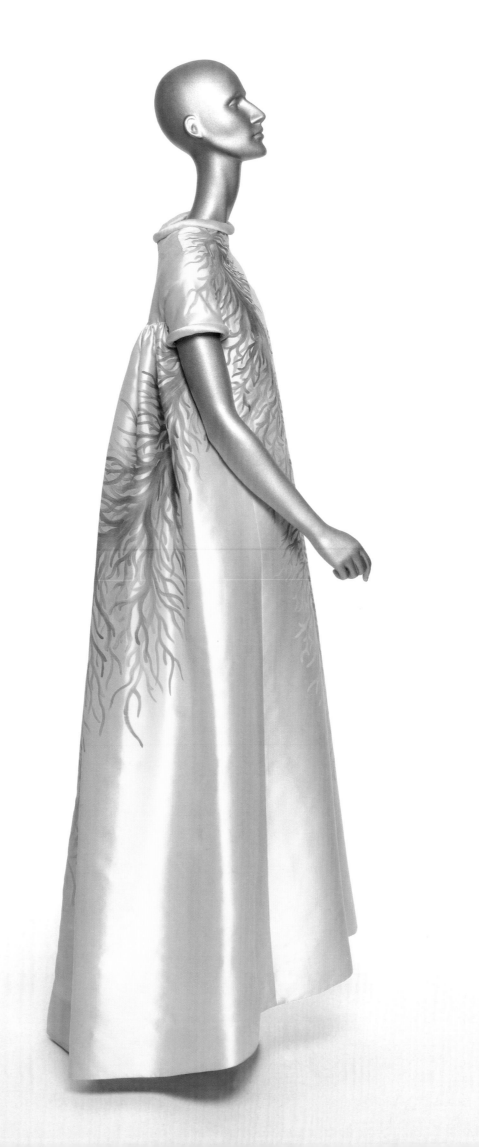

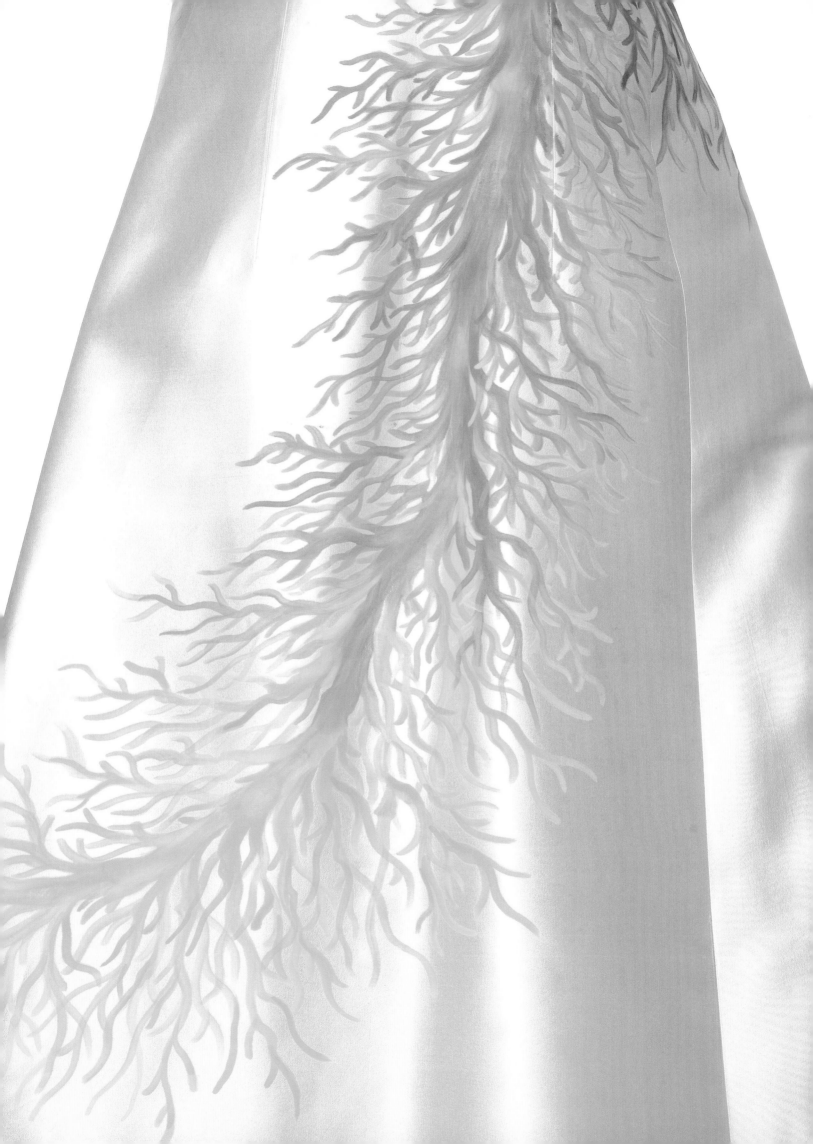

SPRING/SUMMER 1968, MODEL 146

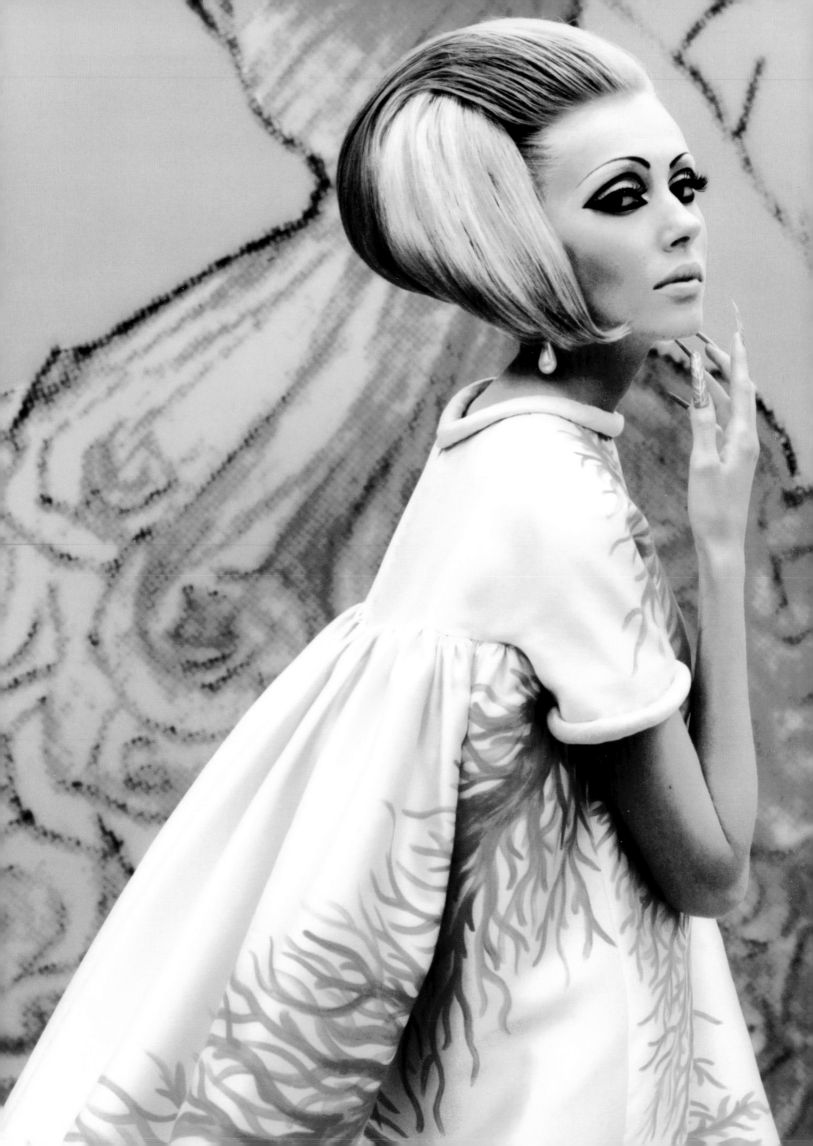

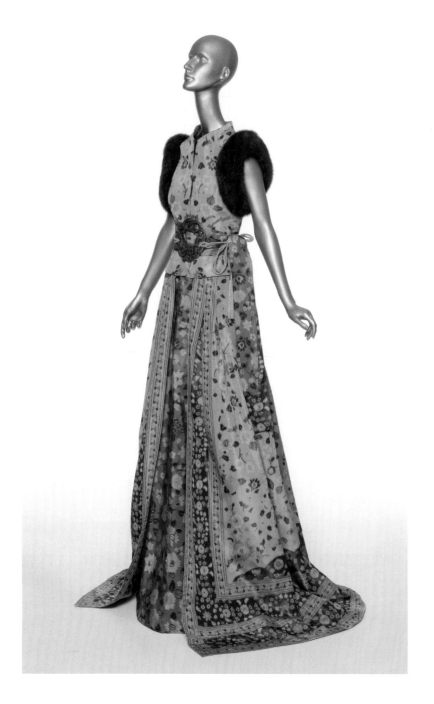

FALL/WINTER 2002, MODEL 166

EVENING ENSEMBLE: BODICE MADE OF FAILLE PRINTED IN YELLOW FLOWERY MOTIF AND
ARMHOLES BORDERED IN MINK; LONG SKIRT MADE OF RED FAILLE, MATCHING YELLOW
TRAIN, KNOTTED RED BELT UNDERNEATH A BUCKLED BRONZE CORD AND BRAIDED TASSEL.
FABRIC: GENTILI & MOSCONI. FURS: CIWIFURS.

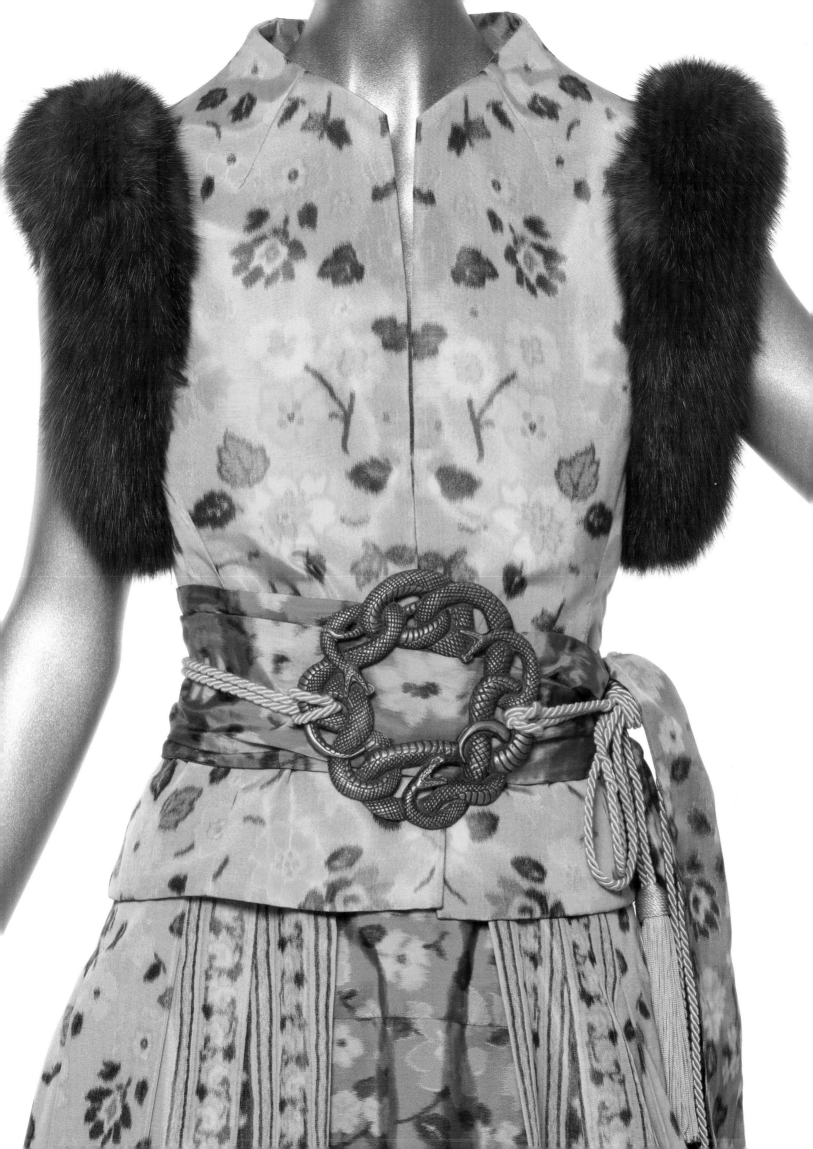

FALL/WINTER 1990, MODEL 184

EVENING ENSEMBLE: SHORT LOW-WAISTED DRESS WITH PINK CHIFFON SHIRRED SKIRT,
AND TOP SCALLOPED AND EMBROIDERED WITH SEQUINS AND IRIDESCENT TUBULAR BEADS
IN A MOTIF TAKEN FROM BACCARAT CRYSTALS; WIDE PINK SATIN COAT WITH PADDED LINING
INCRUSTED WITH THE SAME MOTIF IN BEIGE, PINK AND FUCHSIA SATIN STITCHED ON IN
SILK FUCHSIA BRAIDING.FABRIC: CLERICI-TESSUTO. EMBROIDERY: LESAGE AND PINO GRASSO.

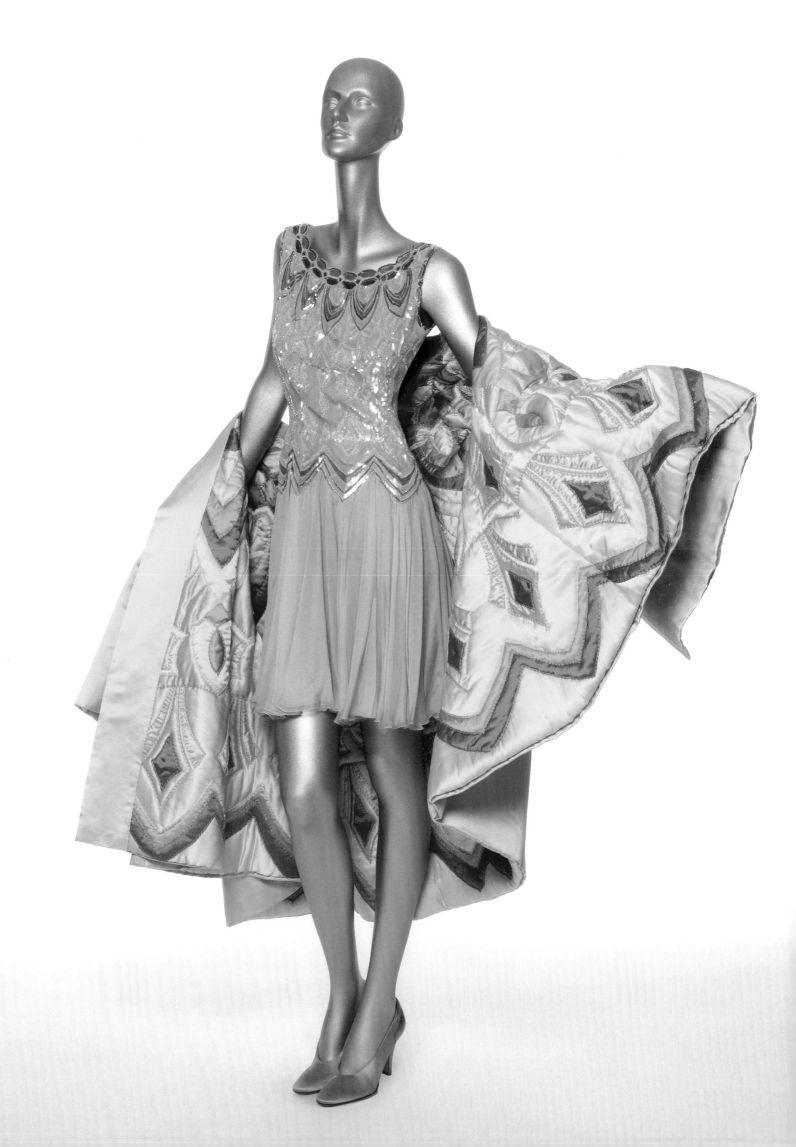

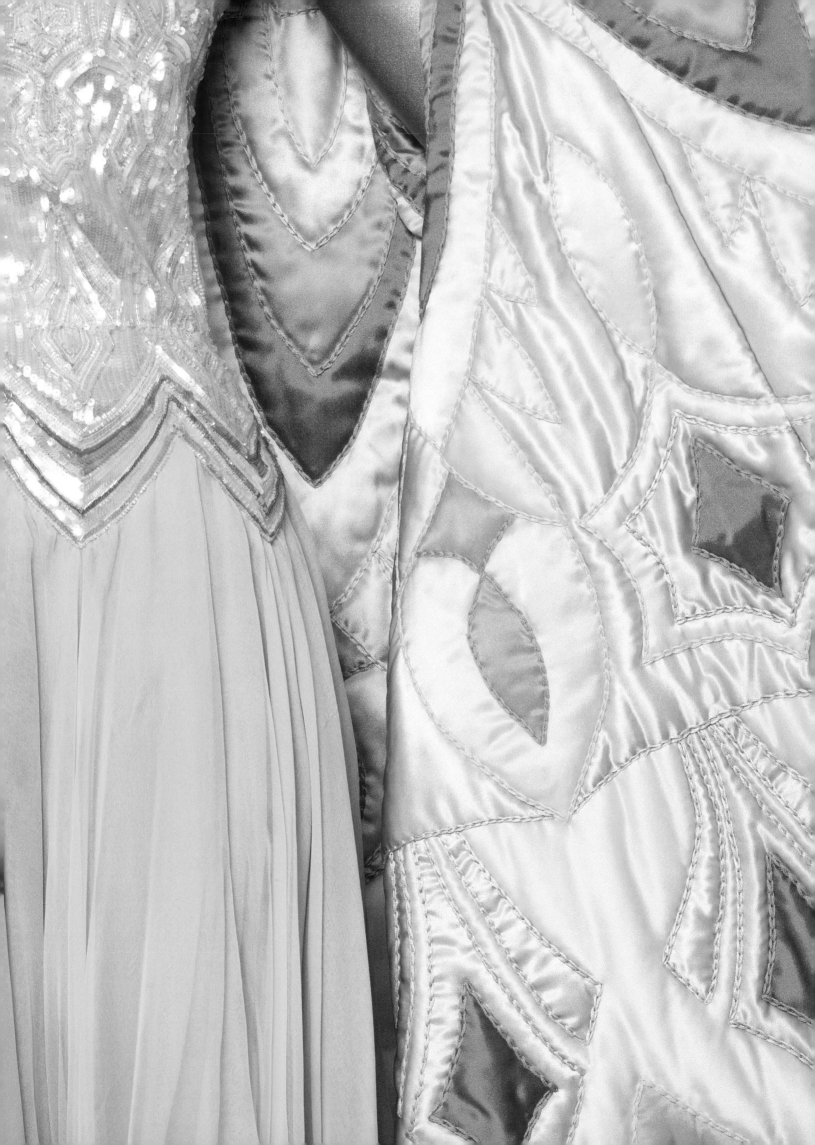

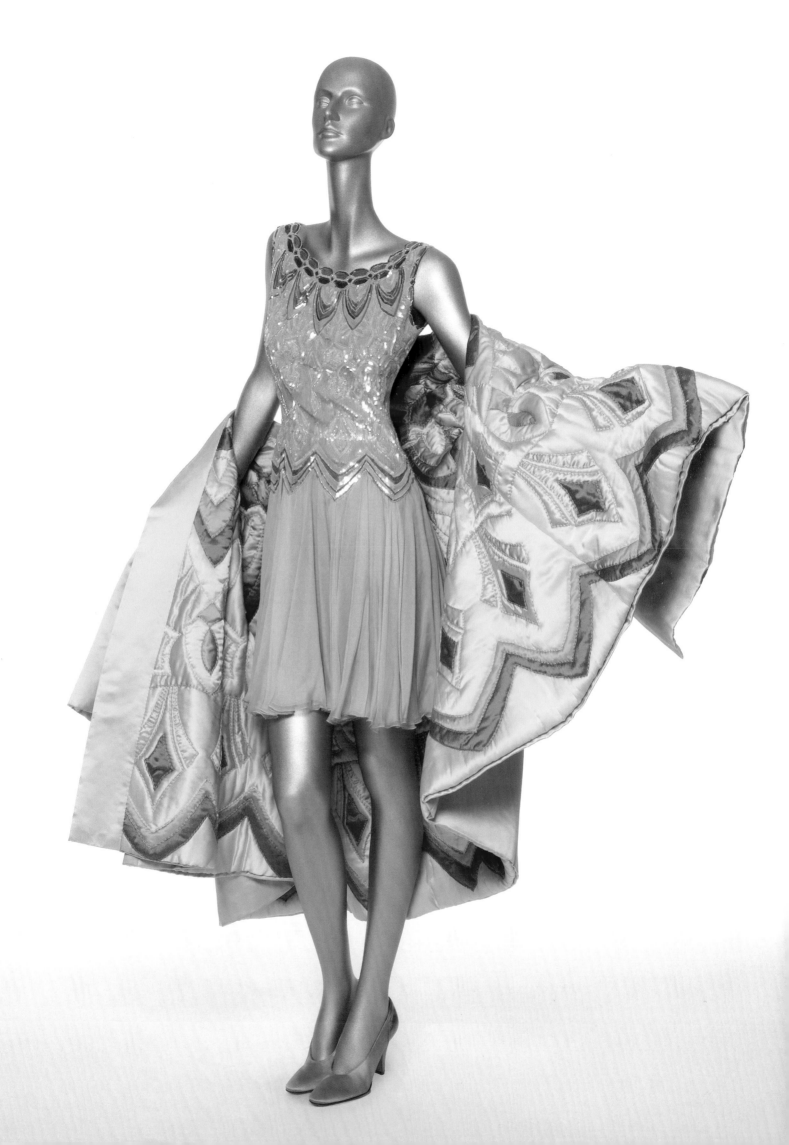

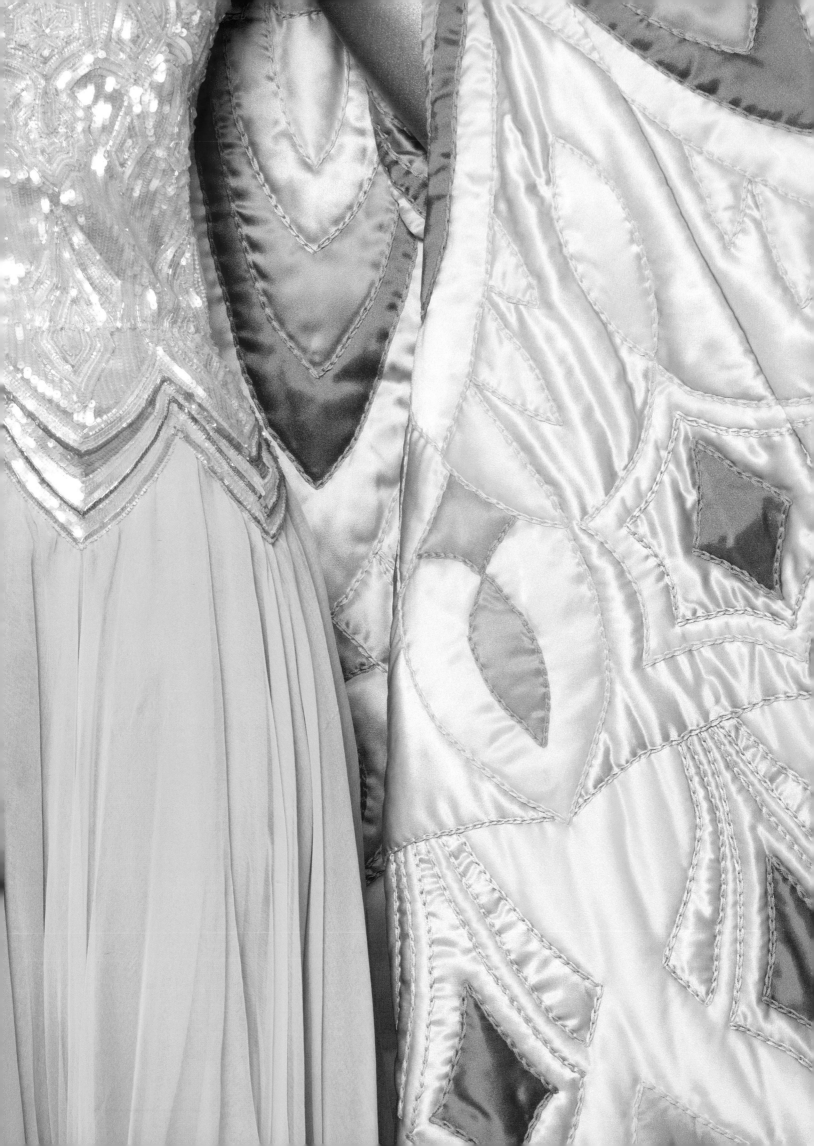

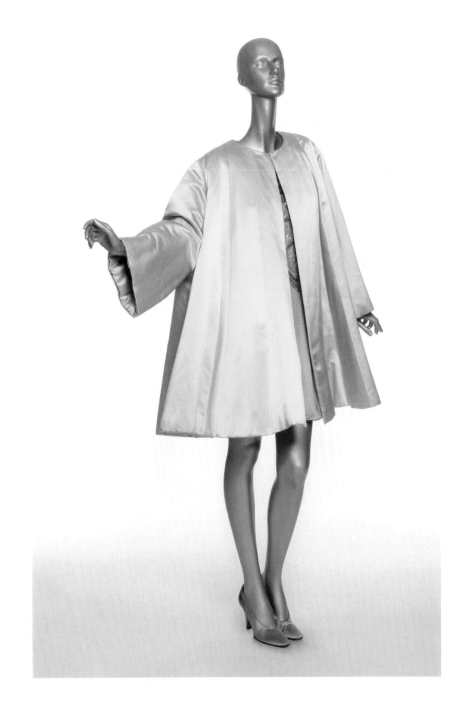

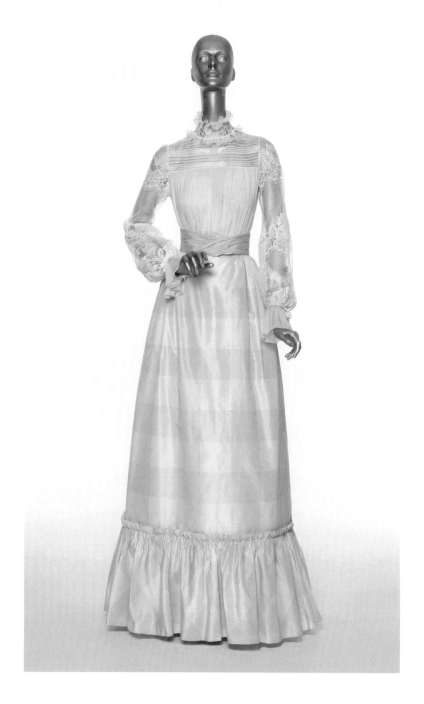

SPRING/SUMMER 1972, MODEL 286

EVENING ENSEMBLE: BODICE MADE OF PLEATED AND SEWN CREPE GEORGETTE AND
VALENCIENNES LACE, PUFFED-UP LONG SLEEVES IN WIDTHS OF WHITE LACE, LONG SKIRT
OF GIANT PINK SHANTUNG GINGHAM AND DRAPED CANDY PINK TAFFETA BELT.
FABRIC: TARONI AND RIECHERS. COLLECTION : BARONESS DENISE THYSSEN-BORNEMISZA.

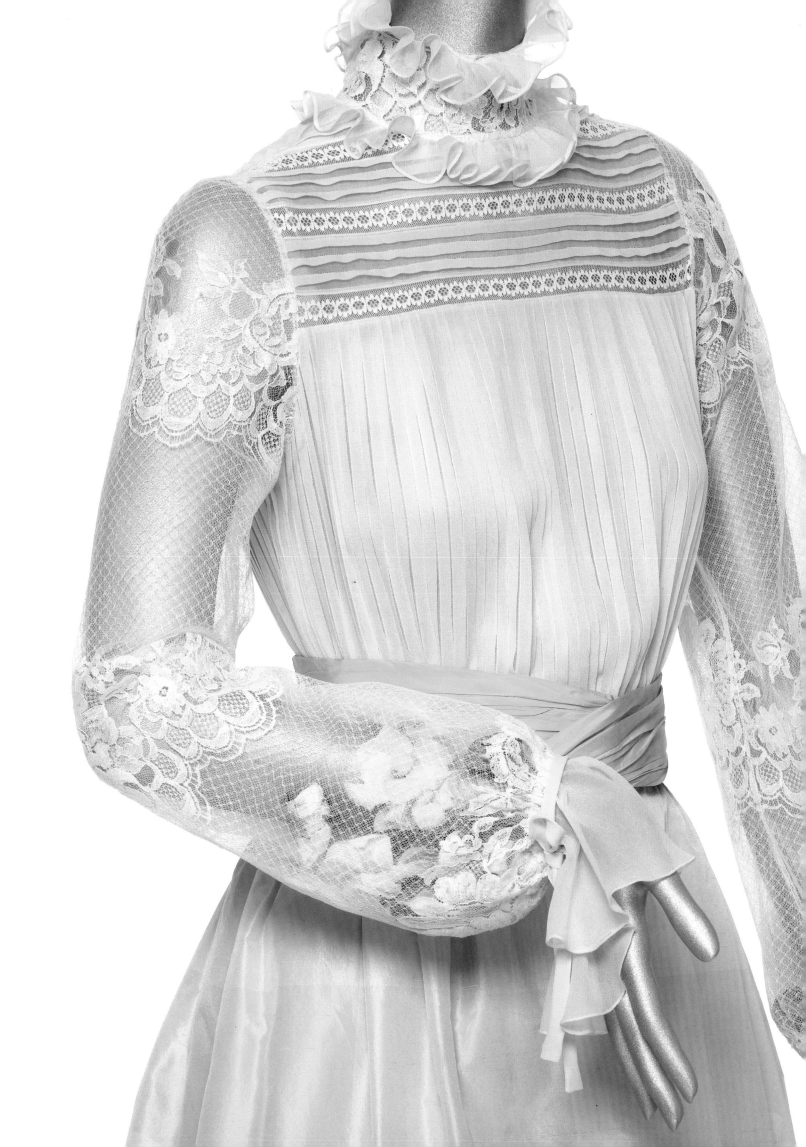

FALL/WINTER 1990, MODEL 94

DAYTIME ENSEMBLE: SHORT LOOSE DRESS MADE OF BRIGHT BLUE SILK CREPE SHIRRED

AT THE ROUND DRAPED NECK; MATCHING WIDE COAT MADE OF RATINÉ ENCRUSTED WITH

GREEN AND MAUVE DOTS IN A MOTIF TAKEN FROM BACCARAT CRYSTALS. FABRIC: GANDINI.

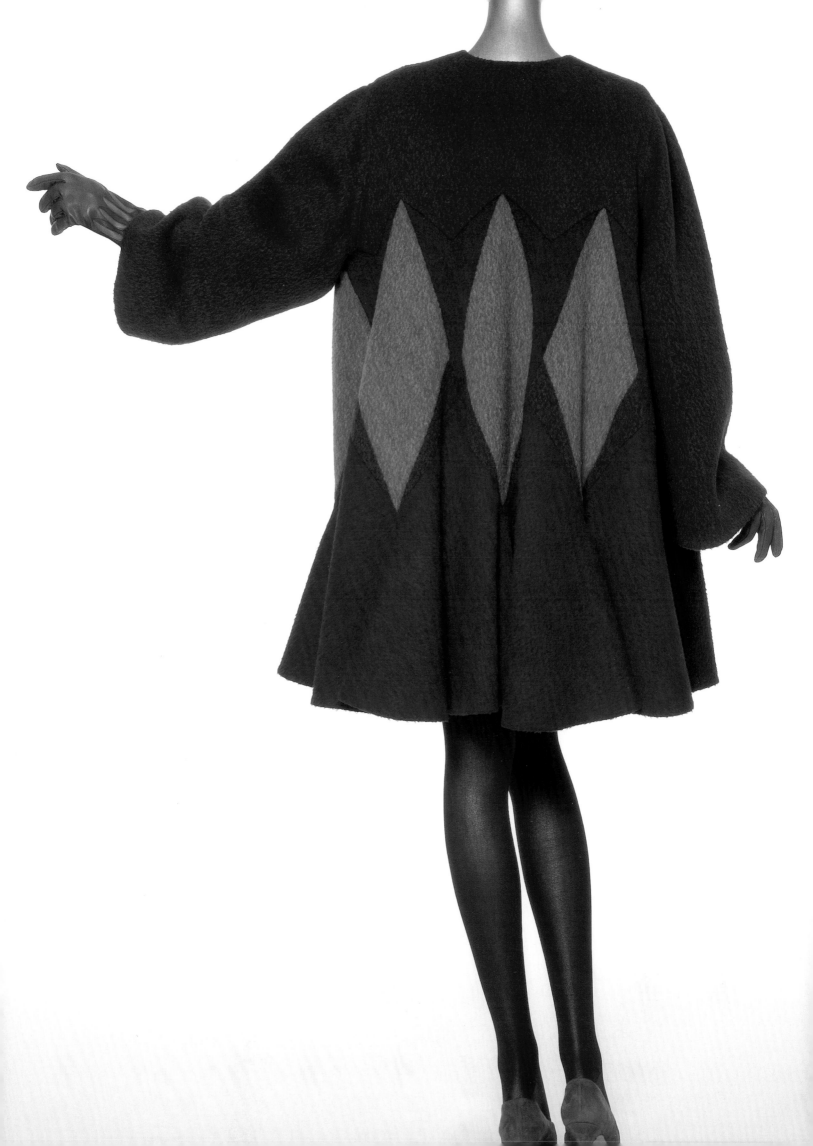

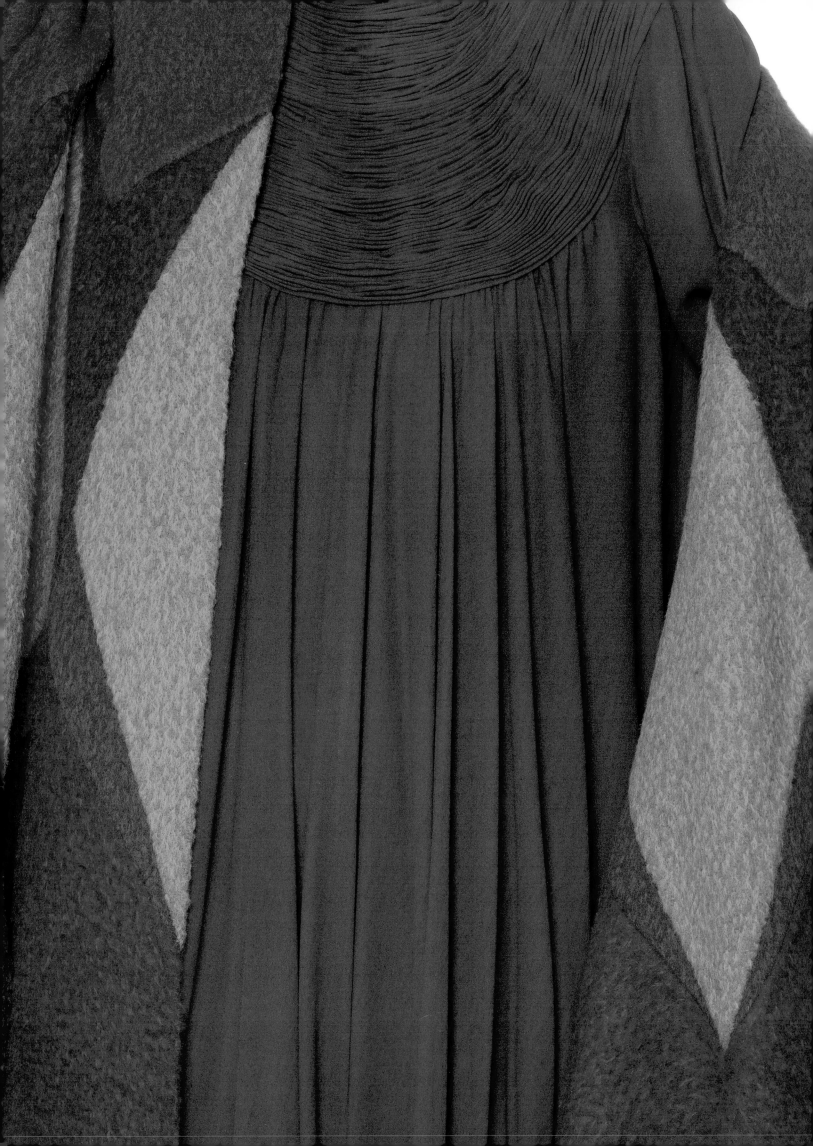

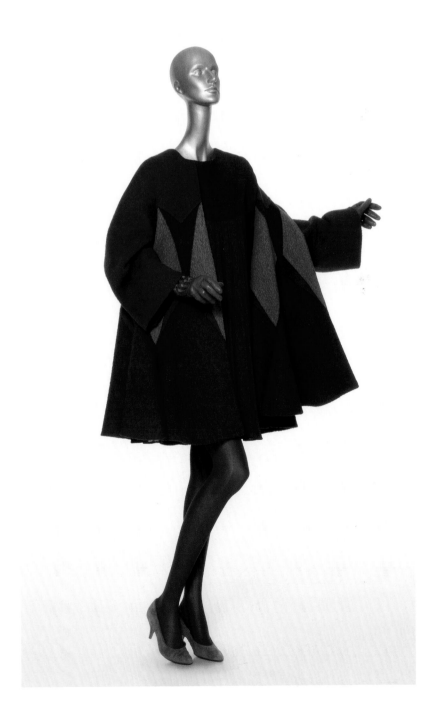

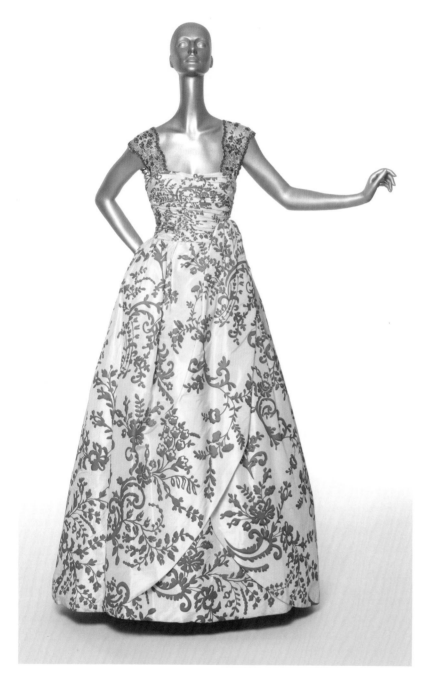

THEMES ORNAMENTATION

SPRING/SUMMER 1998, MODEL 186

EVENING ENSEMBLE: WHITE SILK TAFFETA GOWN PAINTED WITH RED BOUQUETS AND
WREATHS, DRAPED BODICE AND SKIRT, STRAPS EMBROIDERED WITH RED THREAD,
PEARLS AND STRASS; MATCHING SHAWL STRIPED WITH EMBROIDERY, AND FRINGES.
FABRIC: TARONI, HAND-PAINTED BY ROBERTO NICCOLI.

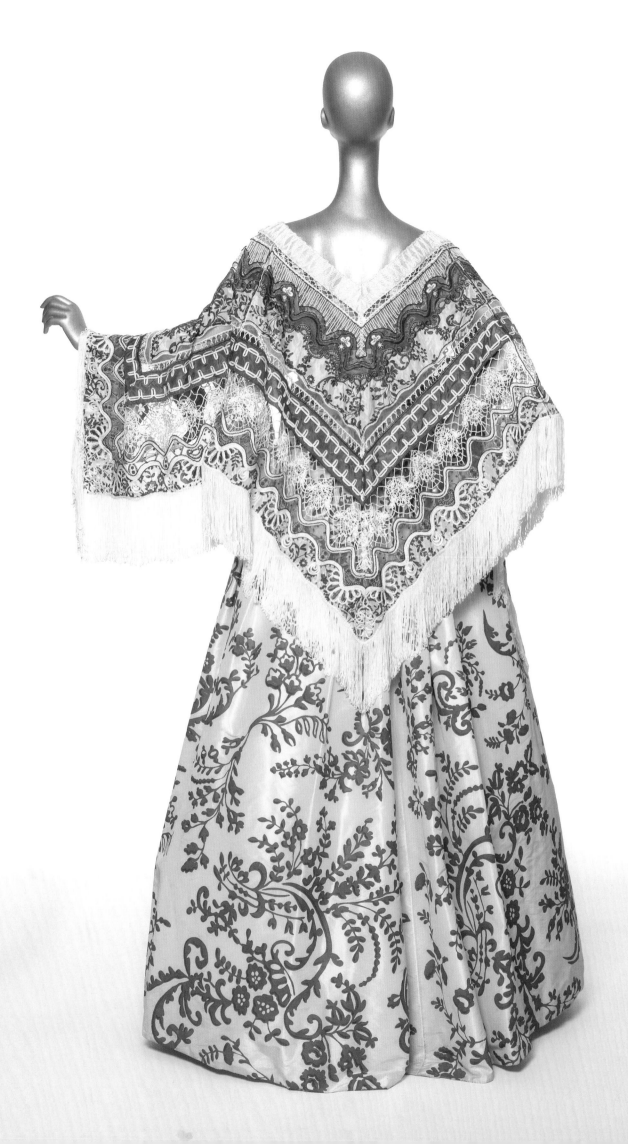

SPRING/SUMMER 1971, MODEL 238

CREAM-COLORED ORGANZA EVENING GOWN WITH POPPY AND STALK OF WHEAT PRINT,
BODICE WITH RIBBED SHOULDERS, SKIRT PLEATED AT THE HIPS, RED, YELLOW AND CREAM
PETTICOATS, BELT AND THE HAT'S RIBBON IN SILK RED JERSEY ADORNED WITH BOUQUETS
OF TEXTILE FLOWERS MIXED WITH NATURAL STALKS OF WHEAT. FABRIC: RATTI.

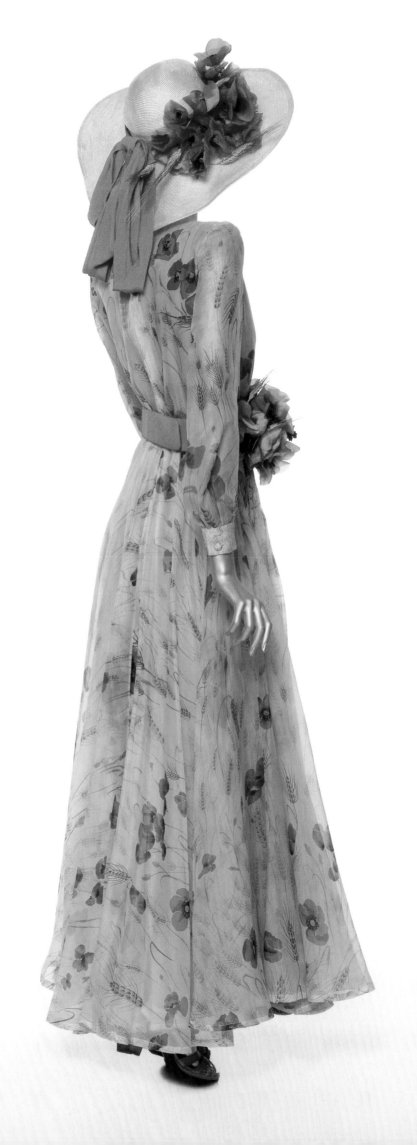

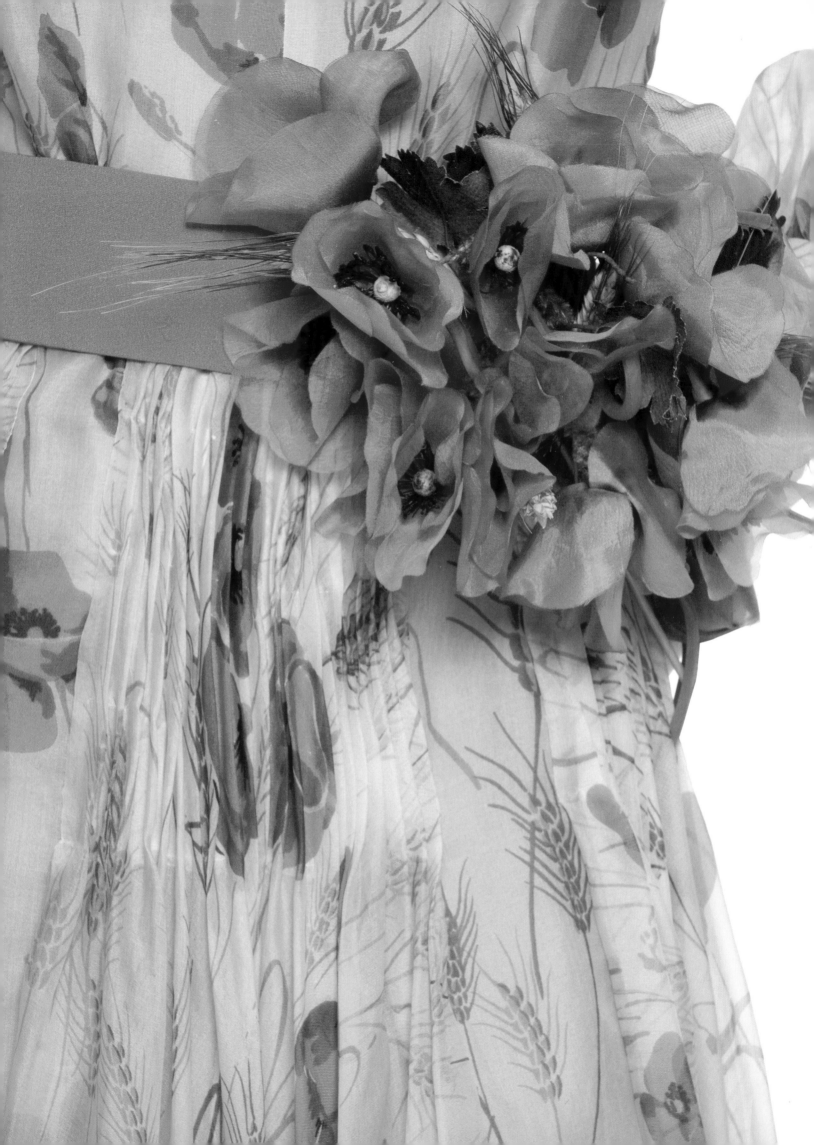

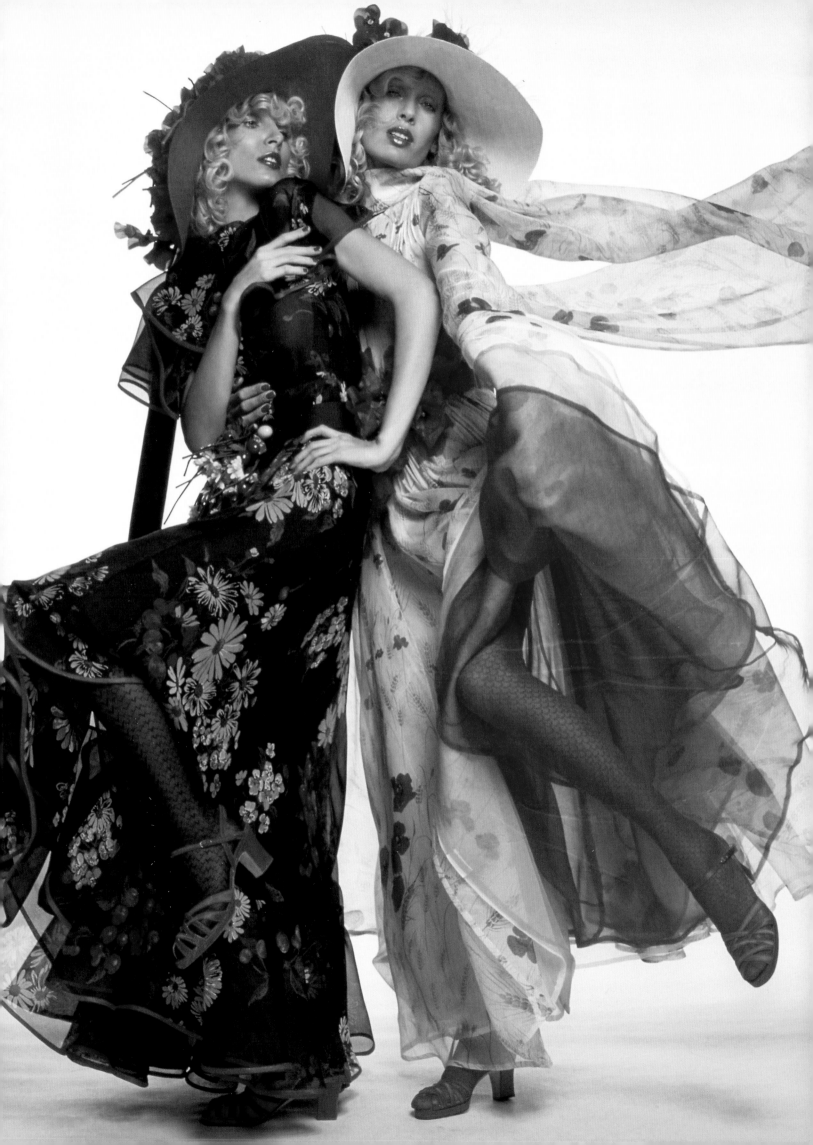

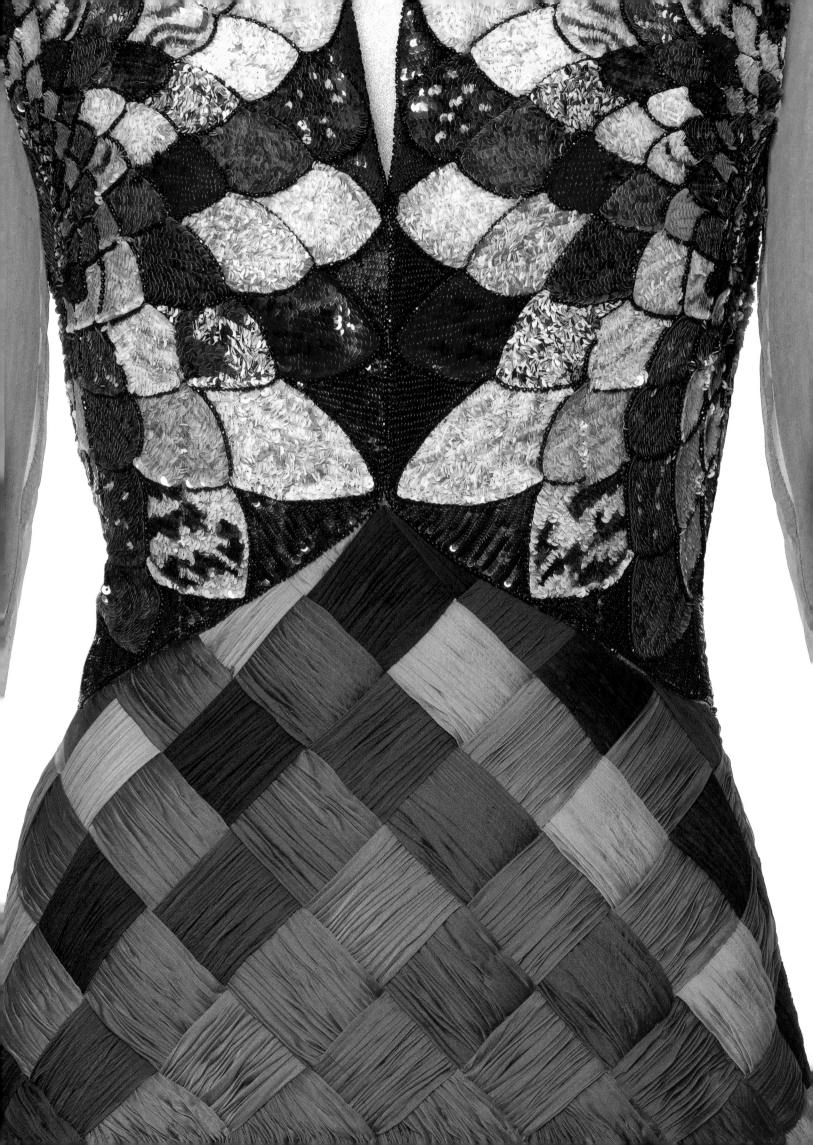

THEMES TECHNIQUE

FALL/WINTER 1990, MODEL 238

EVENING DRESS IN SILK VOILE IN NAVY, EMERALD GREEN, GREY, BRONZE, BROWN AND ORANGE
PANELS CUT ON THE BIAS, SHIRRED AND DIAGONALLY CROSSED ON THE HIPS AND OPENING UP ON A
FLARED SKIRT, TOP MADE OF GREY SILK VOILE EMBROIDERED WITH A ROSACE OF IRIDESCENT SEQUINS
IN A POLYCHROME MARBLE MOSAIC MOTIF. FABRIC: SFATE & COMBIER. EMBROIDERY: PINO GRASSO.

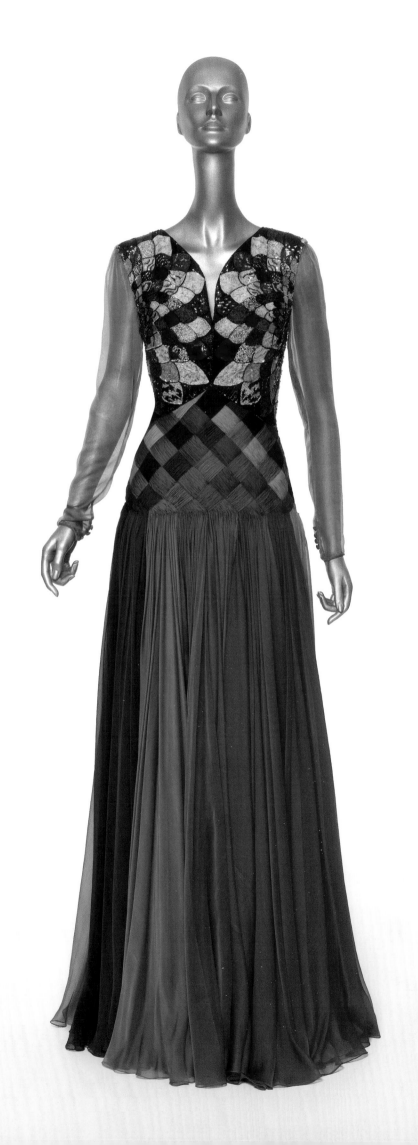

SPRING/SUMMER 1969, MODEL 252

EVENING ENSEMBLE: JACKET AND TROUSERS MADE OF PLEATED ORANGE SILK RADIATING OUT

FROM THE NECK AND WAIST. FABRIC: TARONI. COLLECTION: COMPTESSE INGE CACCIAGUERRA.

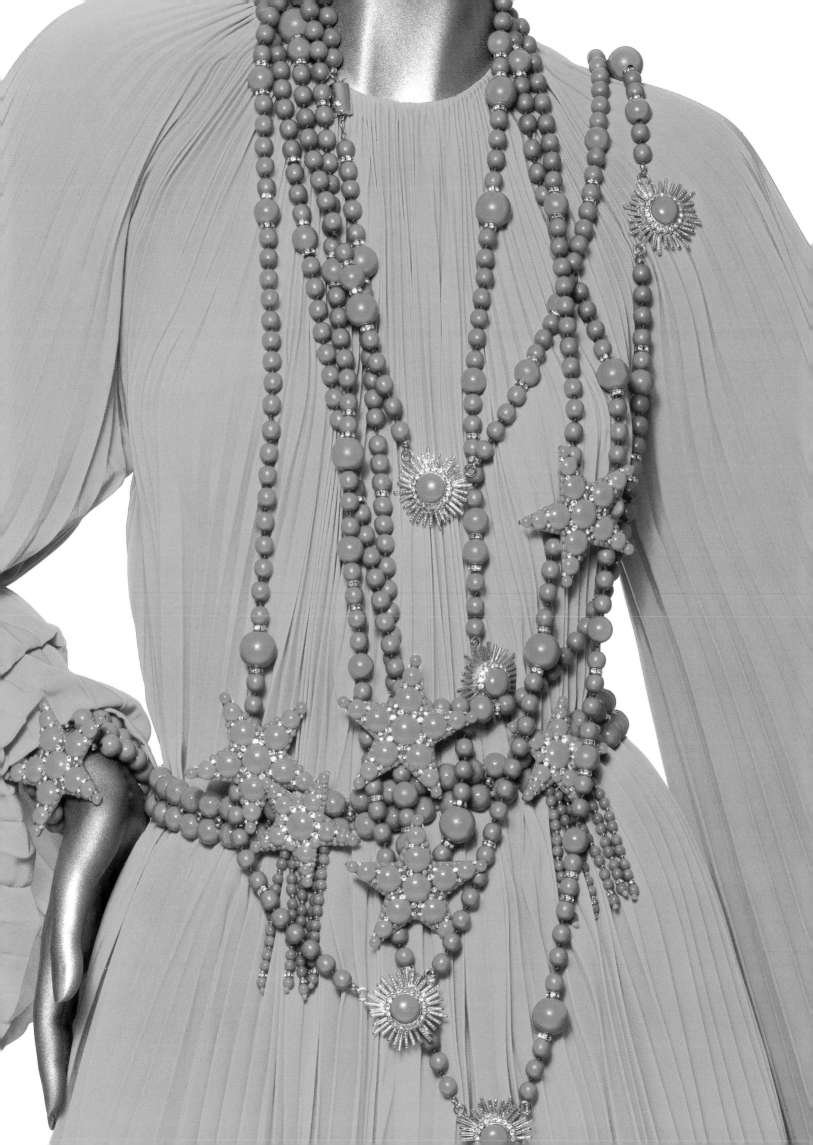

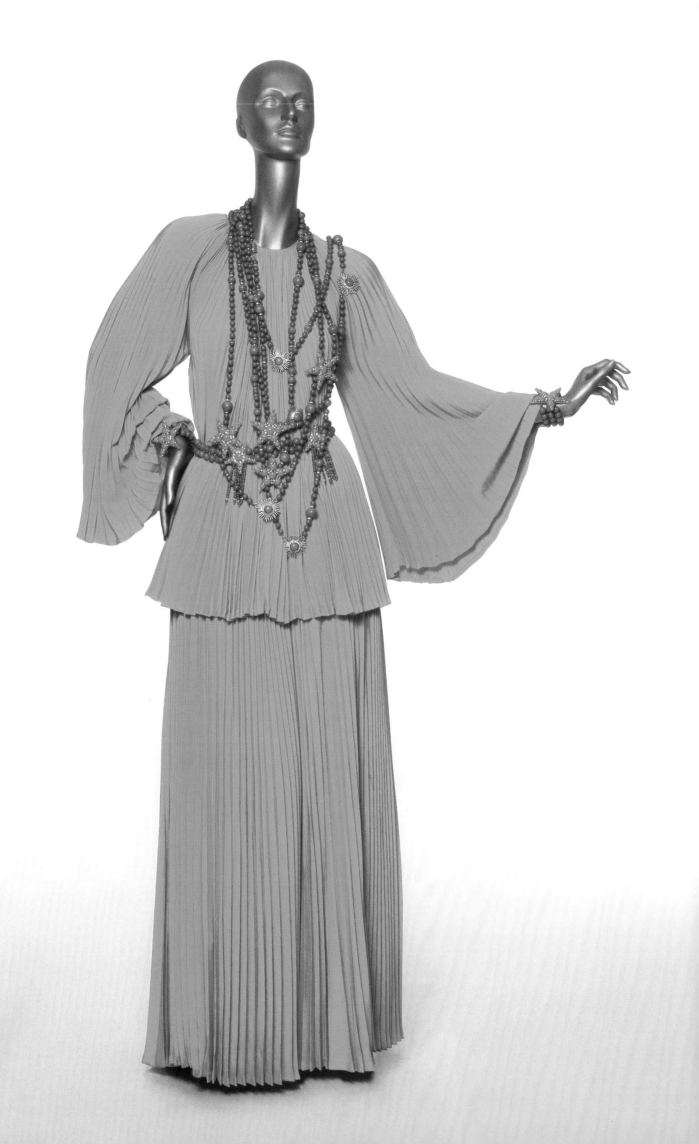

FALL/WINTER 1990, MODEL 246

LONG EVENING GOWN MADE OF PURPLE CHIFFON DRAPED AT THE WAIST,

APPLIQUÉD WITH PLEATED SILK VOILE RUFFLES, EGRET FEATHERS ON THE BODICE.

FABRIC: BIANCHINI-FERRIER. FEATHERS: LEMARIÉ.

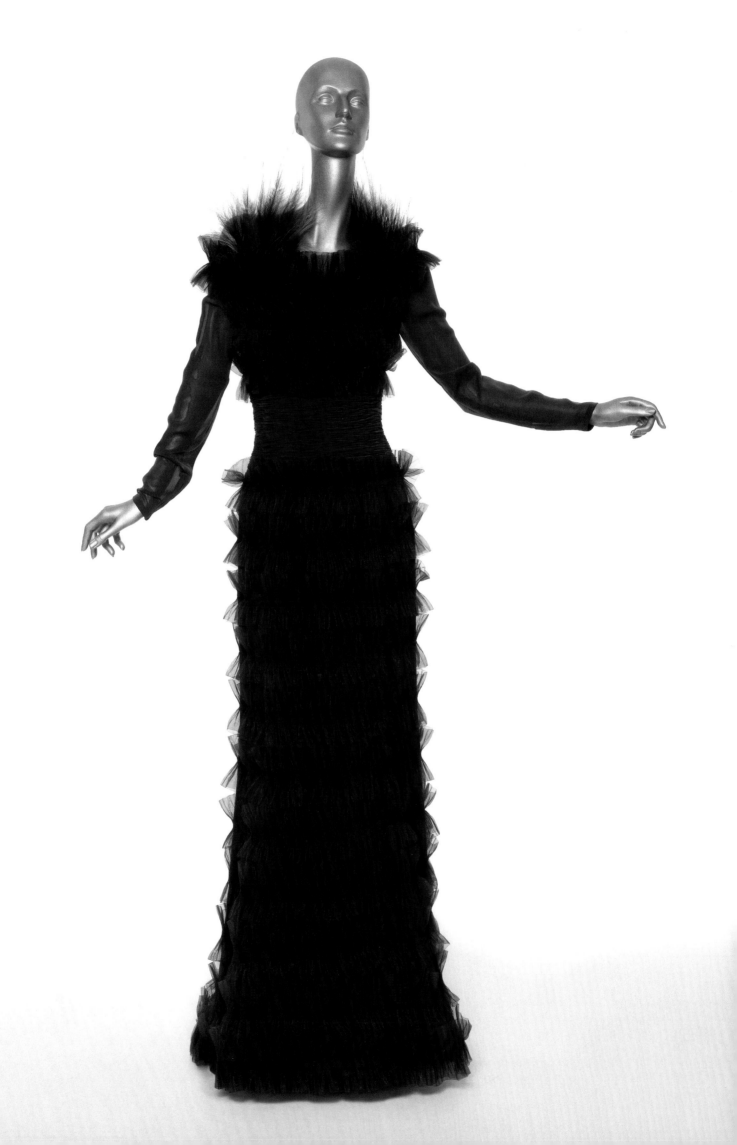

FALL/WINTER 1986, MODEL 240

EVENING GOWN MADE OF DRAPED VIOLET, PINK, GREY AND ROSY BEIGE SILK CREPE,
APPLIQUÉD STRAPLESS TOP IN A CROSSOVER COMPOSITION THAT PLUNGES DOWN ON
THE LEFT SIDE, GATHERED SKIRT THAT FLARES OUT IN PANELS CUT ON THE BIAS, COLLAR
IN PURPLE CREPE, WITH LONG SLEEVES AND HIGH DRAPED COLLAR. FABRIC: GANDINI.

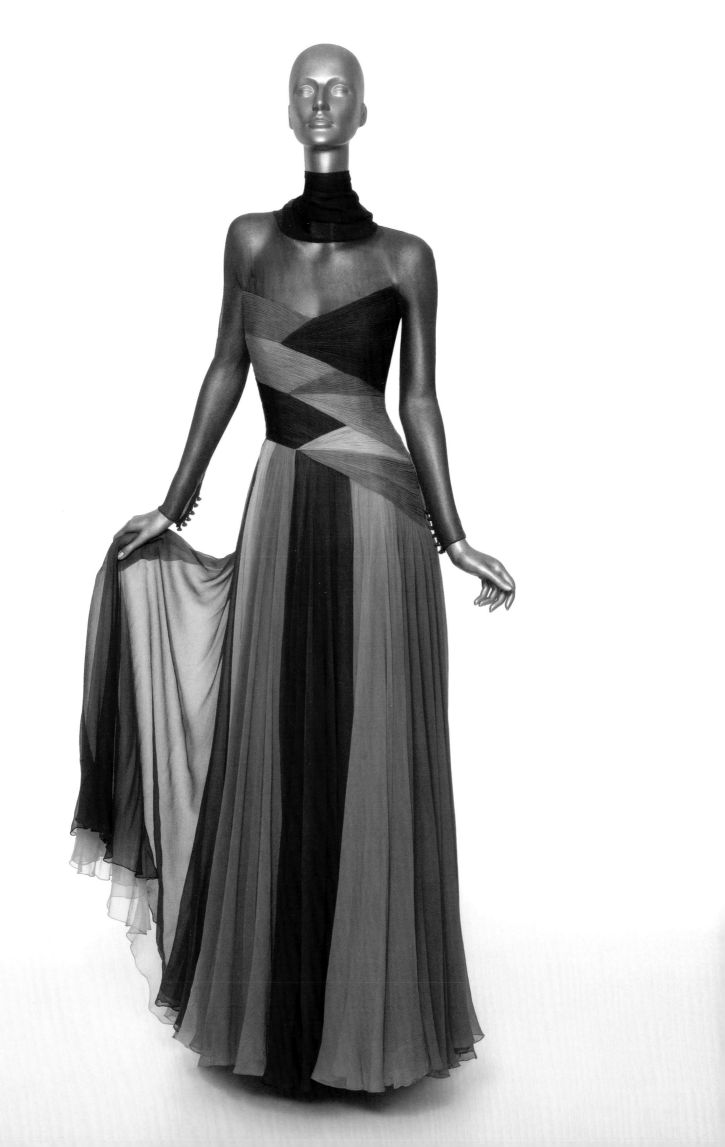

SPRING/SUMMER 1993, MODEL 188

EVENING GOWN ENTIRELY APPLIQUÉD IN BEIGE SILK CREPE BRAIDS ACCORDING TO
THE "BUDELLINI" TECHNIQUE IN CONCENTRIC MOTIFS ON THE BODICE AND SLEEVES,
IN VERTICAL BANDS ON THE HIPS AND IN FRINGES WITH MOTHER-OF-PEARL TIPS ON
CREAM-COLORED PLEATED CHIFFON PEEPING OUT. FABRIC: CLERICI-TESSUTO.

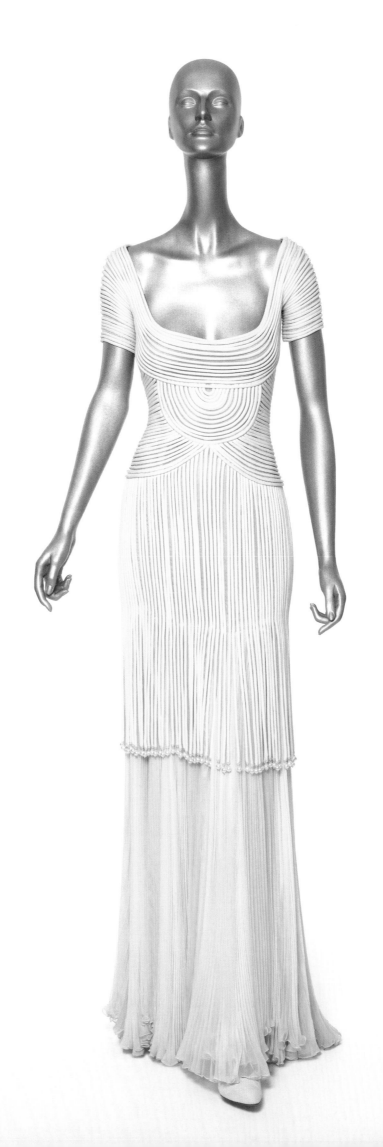

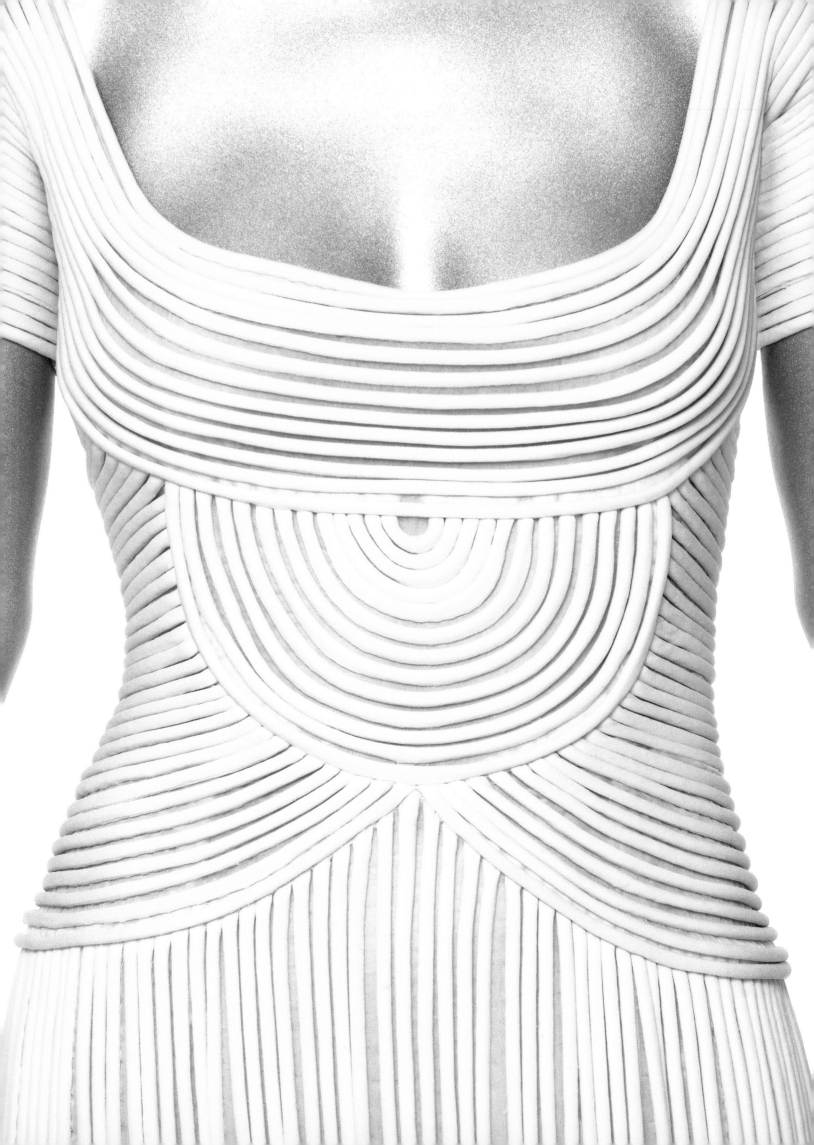

SPRING/SUMMER 2008, MODEL 98

EVENING SUIT MADE OF PALE PINK TULLE APPLIQUÉD WITH AN ORIGAMI IN PINK FAILLE
EMBROIDERED WITH IRIDESCENT PINK GLASS BEADS, KNOTTED HALF BELT, OVERSTITCHED
PINK SATIN COLLAR AND CUFFS. FABRIC: BUCHE-GUILLAUD. EMBROIDERY: PINO GRASSO.

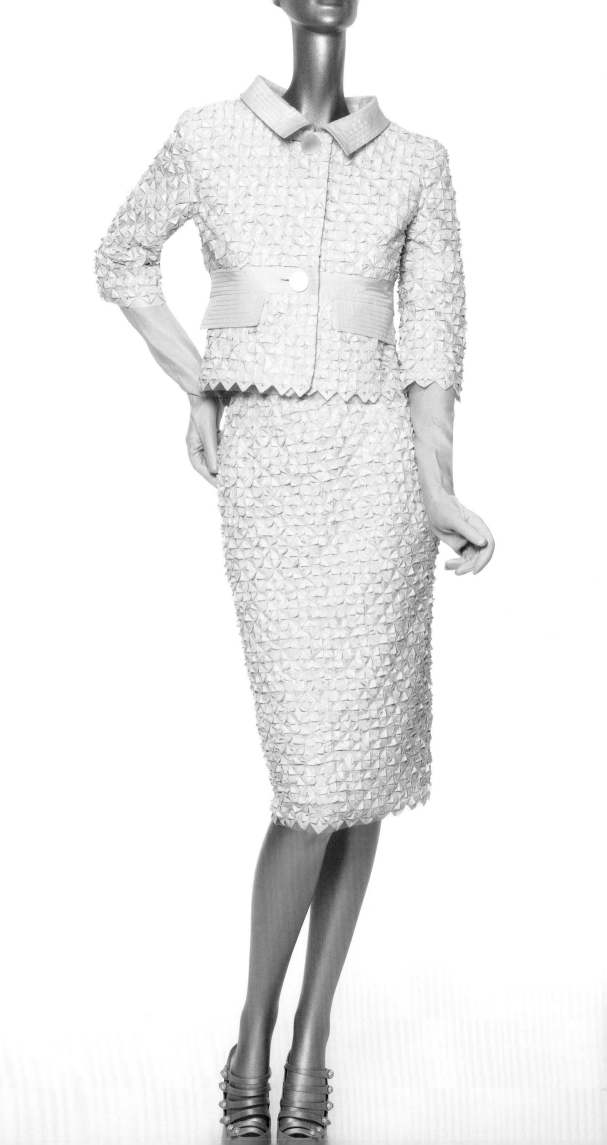

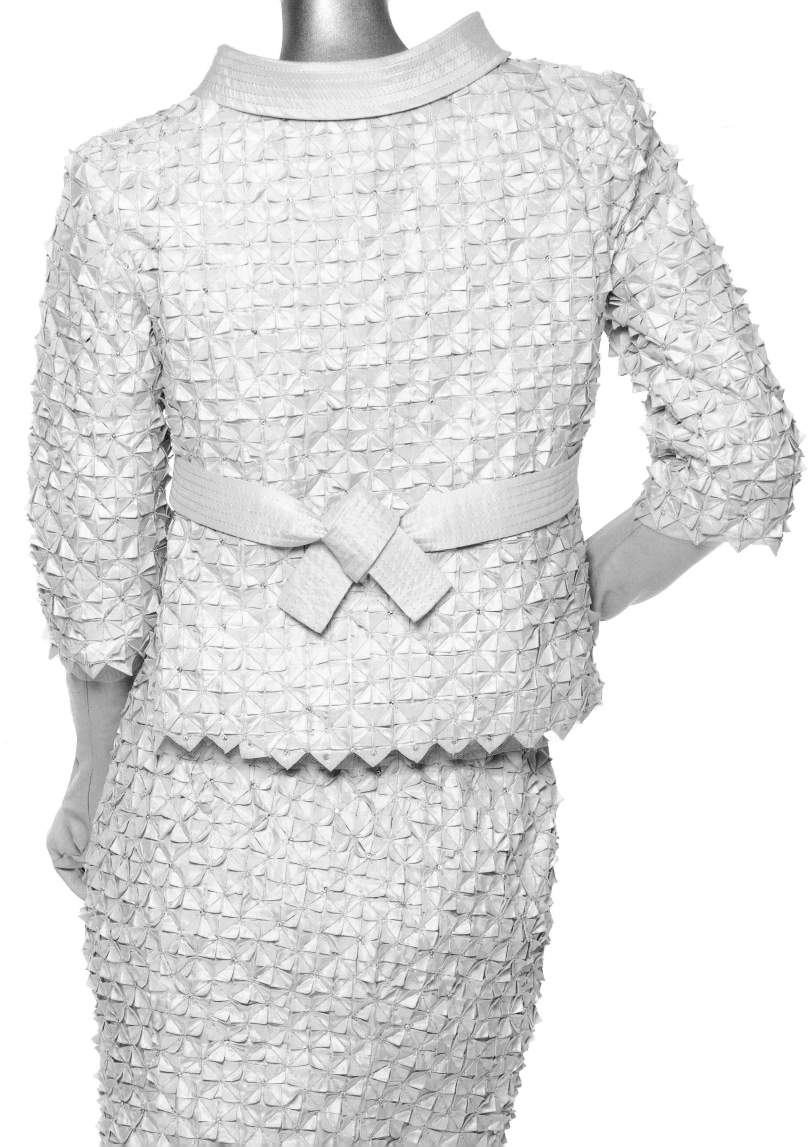

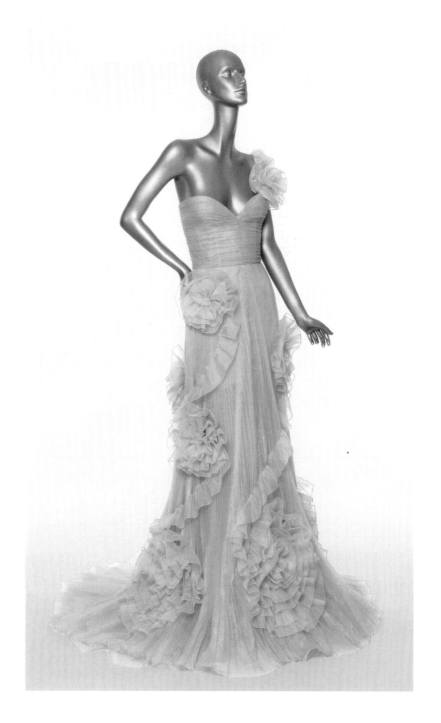

THEMES TECHNIQUE

SPRING/SUMMER 2008, MODEL 182

ASYMMETRIC EVENING GOWN MADE OF PALE BLUE PLEATED AND DRAPED TULLE,

AND APPLIQUÉ OF MATCHING SILK VOILE RUFFLES AND COROLLAS. FABRIC: HUREL.

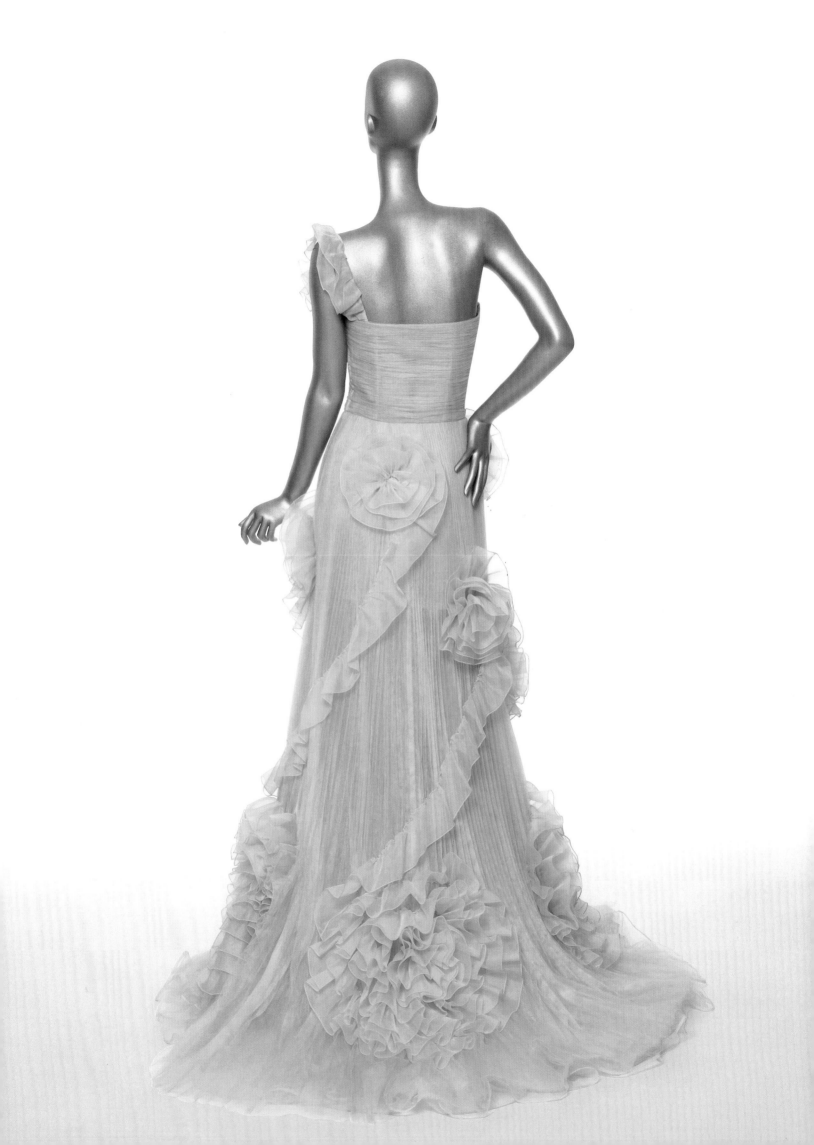

FALL/WINTER 2007, MODEL 108

FLESH-COLORED EVENING GOWN EMBROIDERED WITH OSTRICH FEATHER FRINGES IN A

CAMAÏEU OF PINKS ALTERNATING WITH BANDS OF PINK BEADS AND LINES OF WHITE STRASS.

FABRIC: SOPHIE HALETTE. EMBROIDERY: SHAMEEZA. FEATHERS: GALEOTTI.

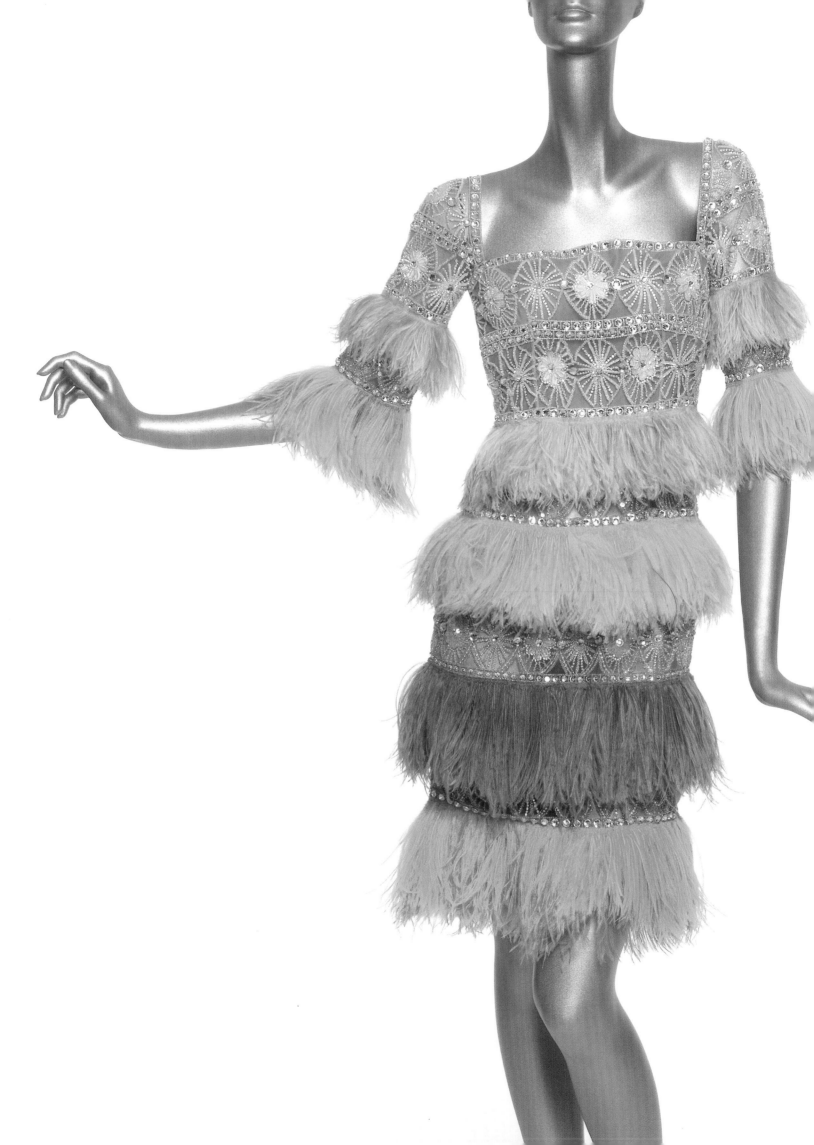

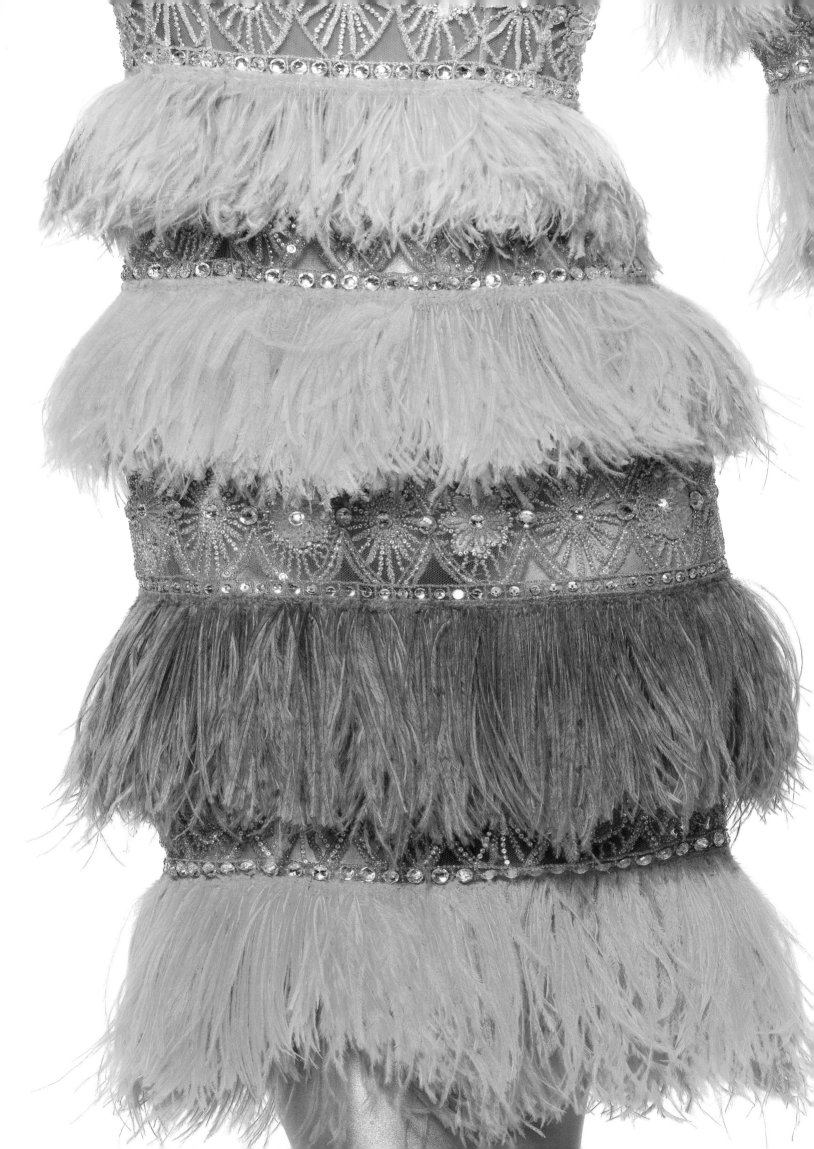

VARIATIONS VOLUME

SPRING/SUMMER 1959, MODEL 79 "FIESTA"

STRAPLESS COCKTAIL DRESS OF DRAPED TULLE, SKIRT DECORATED WITH

MATCHING BUTTON ROSES. FABRIC: HUREL.

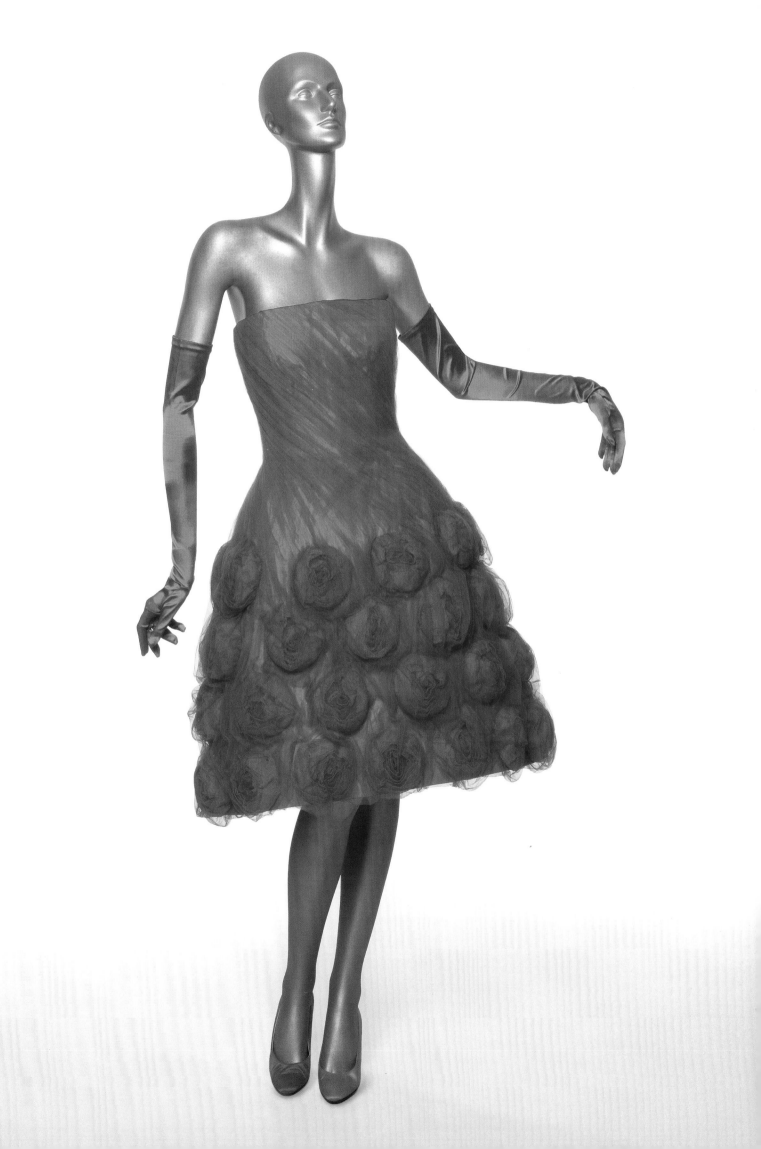

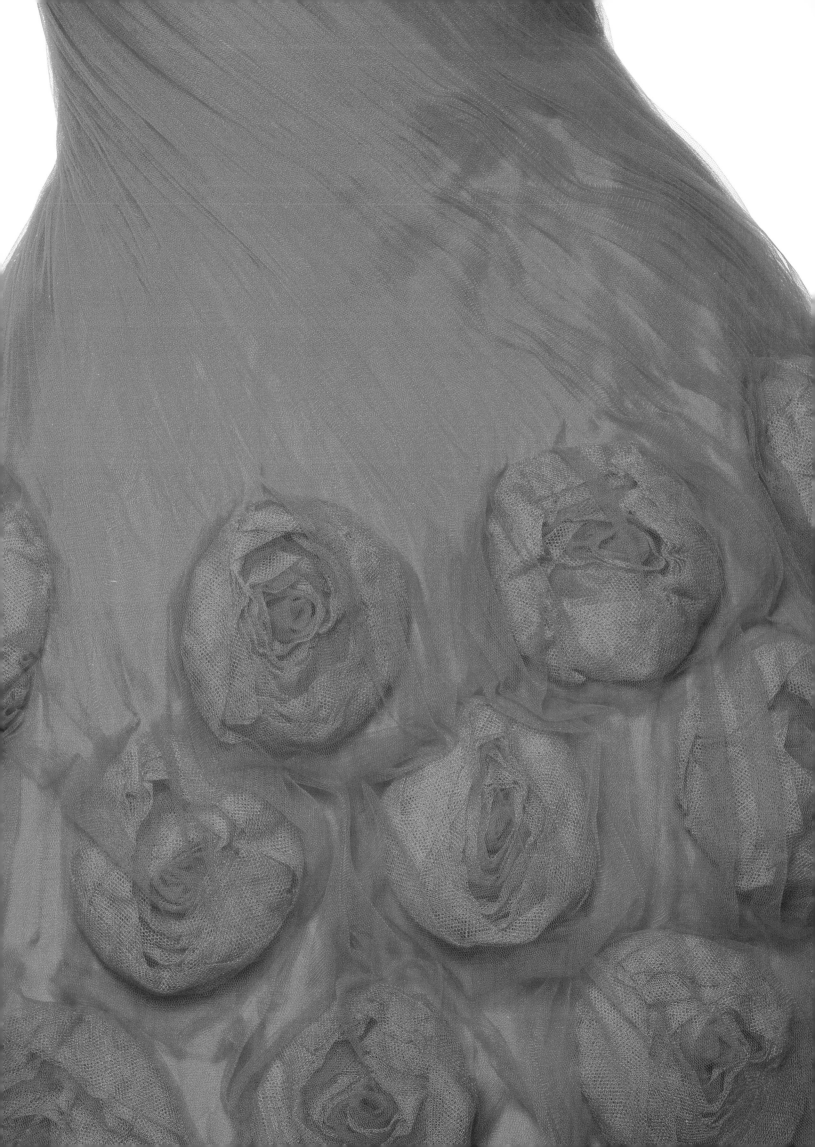

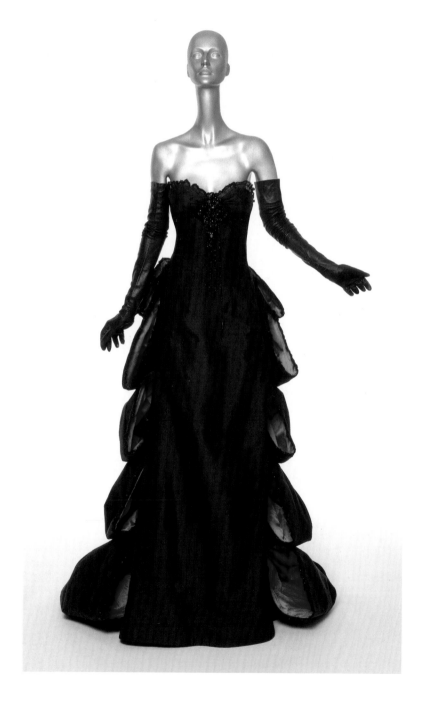

VARIATIONS VOLUME

FALL/WINTER 2004, MODEL 142

STRAPLESS BLACK SHANTUNG EVENING GOWN PIPED WITH BLACK LACE AND BLACK
BEAD AND SEQUIN EMBROIDERY, TOP EMBROIDERED WITH BLACK BEADS AND FRINGES,
TRAIN AND CASCADE LINED IN RED SATIN. FABRIC: BUCOL.

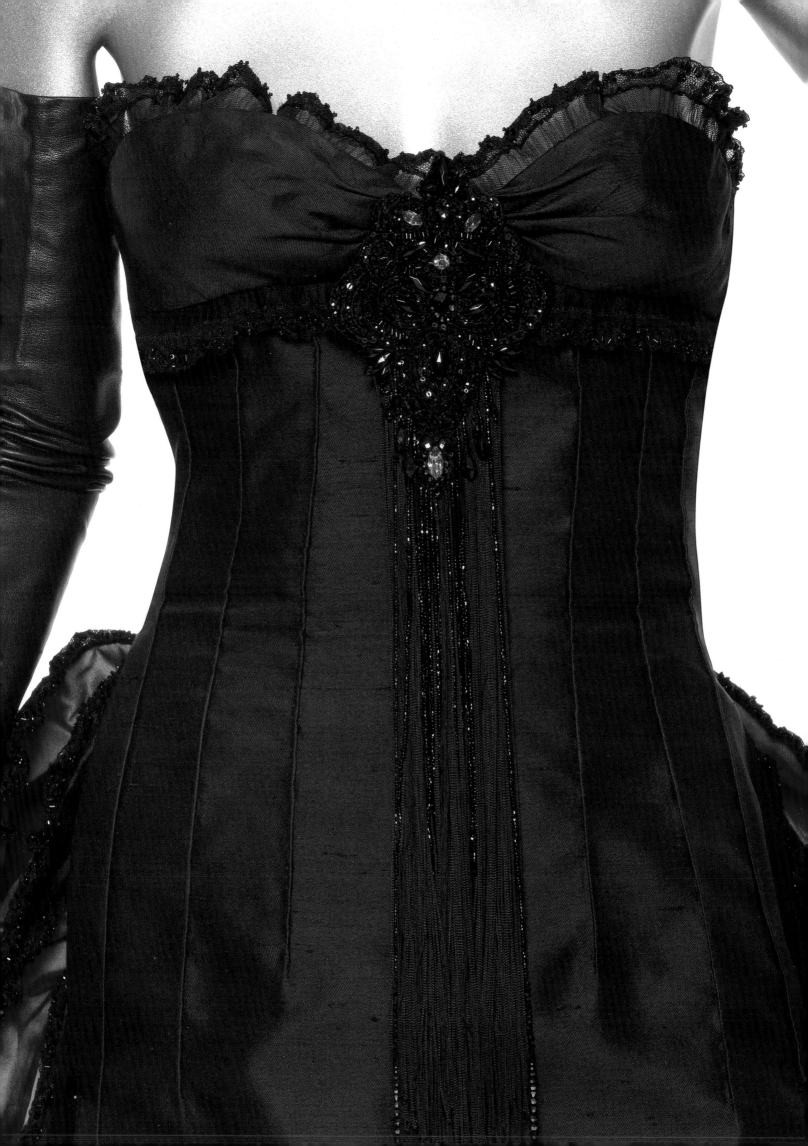

SPRING/SUMMER 1961, MODEL 60

SHEATH COCKTAIL DRESS OF BLACK SILK CREPE, BLACK CHIFFON BABY DOLL

TRIMMED WITH A SHIRRED TULLE BOA. FABRIC: CLERICI-TESSUTO.

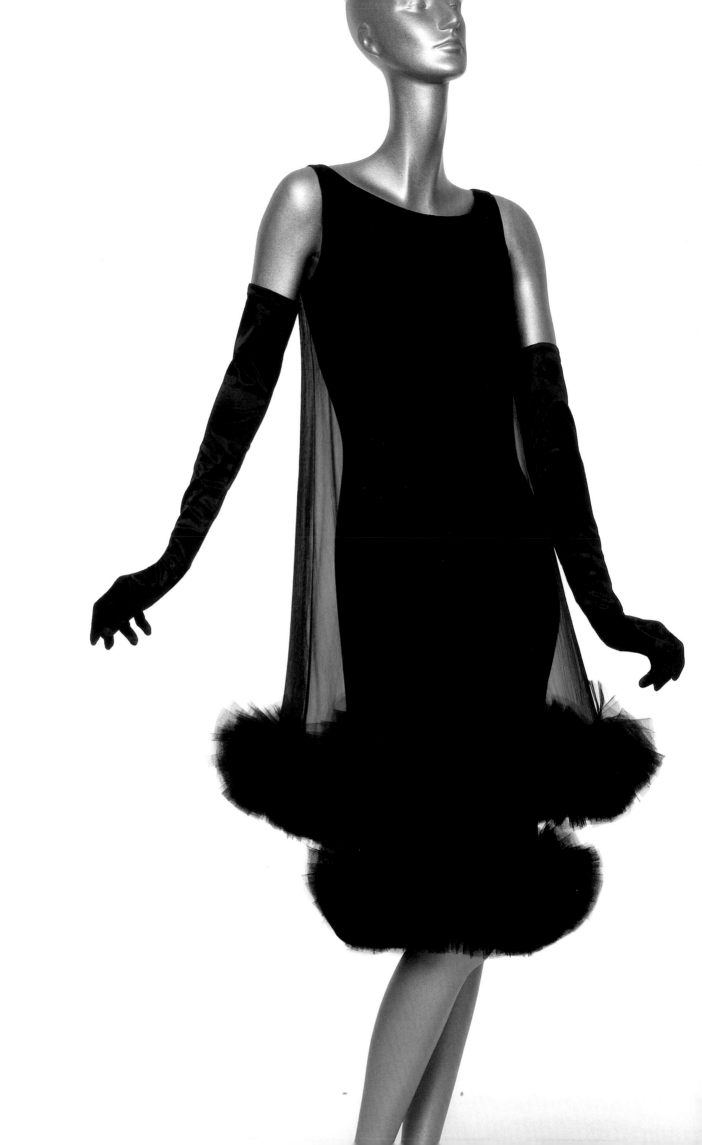

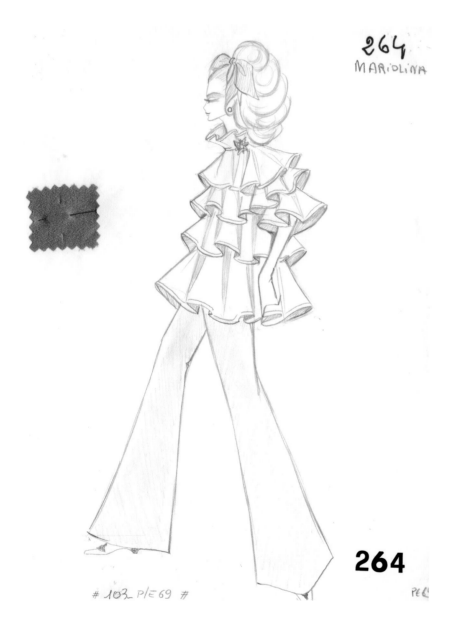

264
MARIOLINA

264

#103 P/E 69 # PE

SPRING/SUMMER 1969, MODEL 264

EVENING ENSEMBLE: WHITE ORGANDY TUNIC CONSISTING OF CONCENTRIC

FLOUNCES THAT FORM A CAPE; TROUSERS MADE OF CORAL- COLORED CHARMEUSE

LINED IN MATCHING CHIFFON. FABRIC: TARONI.

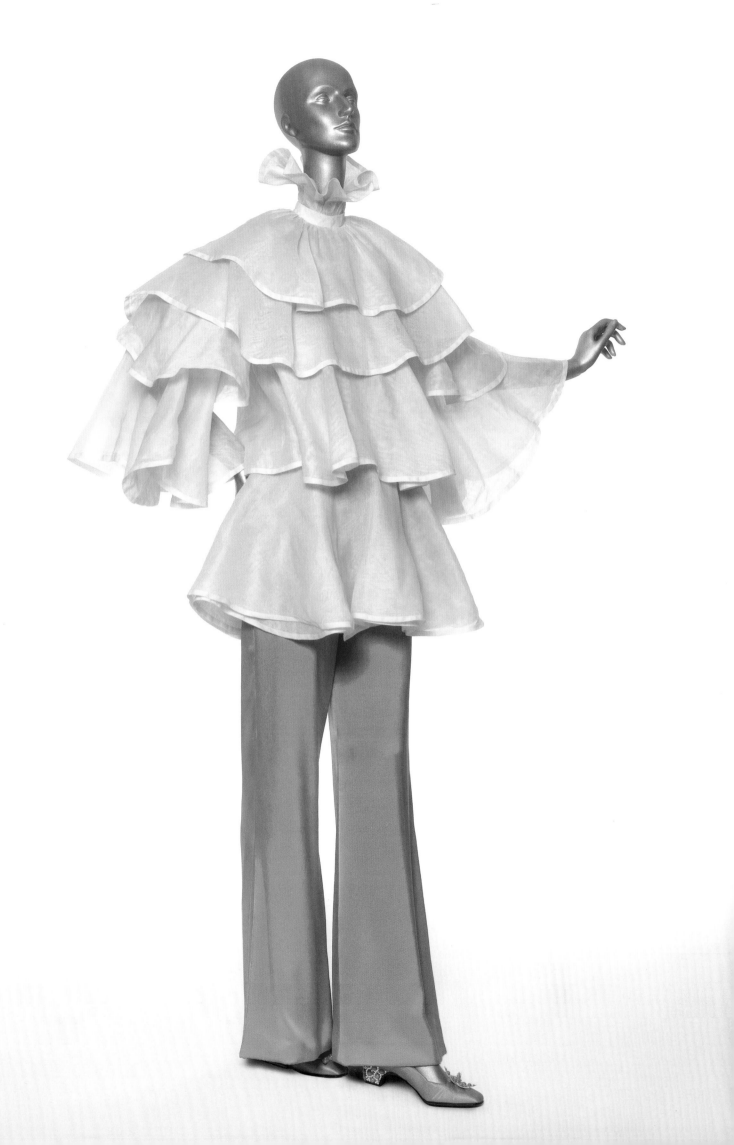

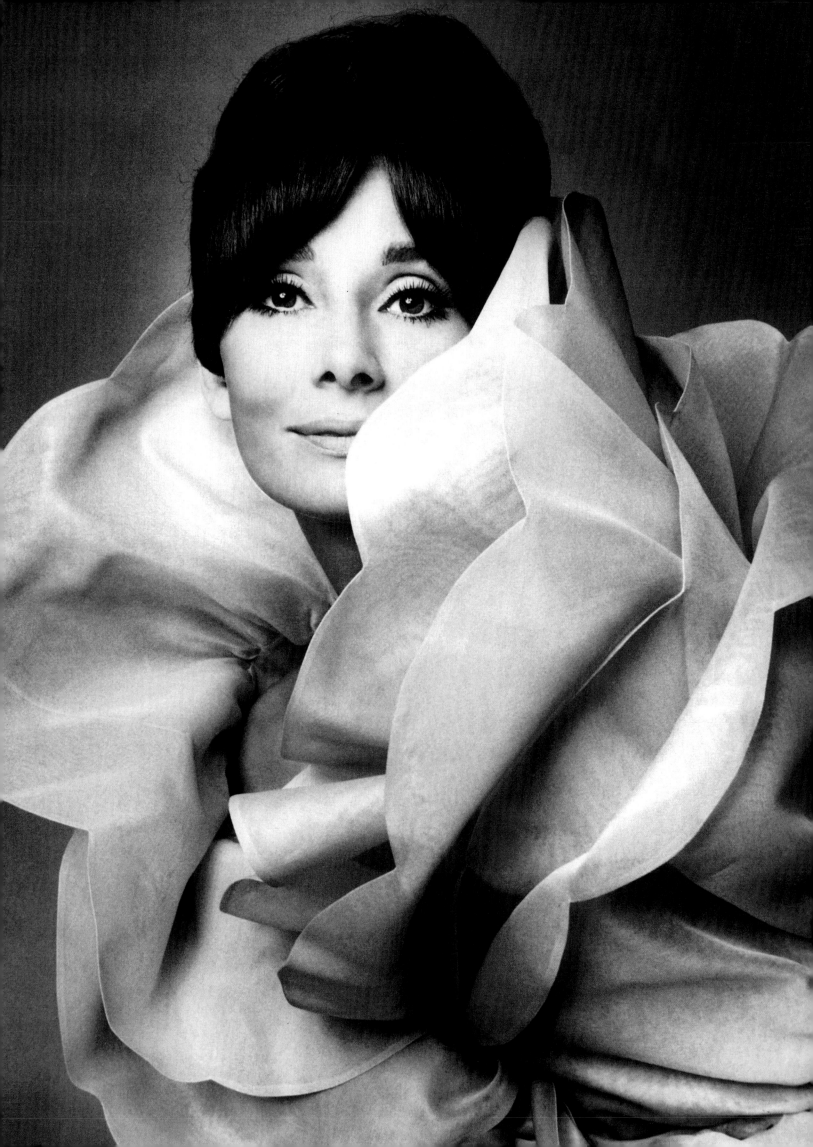

FALL/WINTER 2004, MODEL 134

EVENING DRESS IN THE FORM OF A BLACK TULLE SHEATH EMBROIDERED WITH BLACK
BEADS, SEQUINS AND BRAIDS, STRAPLESS BODICE MADE OF BLACK DRAPED TULLE WITH
APPLIQUÉ BLACK LACQUER ORGANDY ROSE, WHITE TAFFETA TRAIN PIPED WITH A RUFFLE.
FABRIC: TARONI. EMBROIDERY: MARABITTI. FLOWERS: PAGLIANI-BRASSEUR.

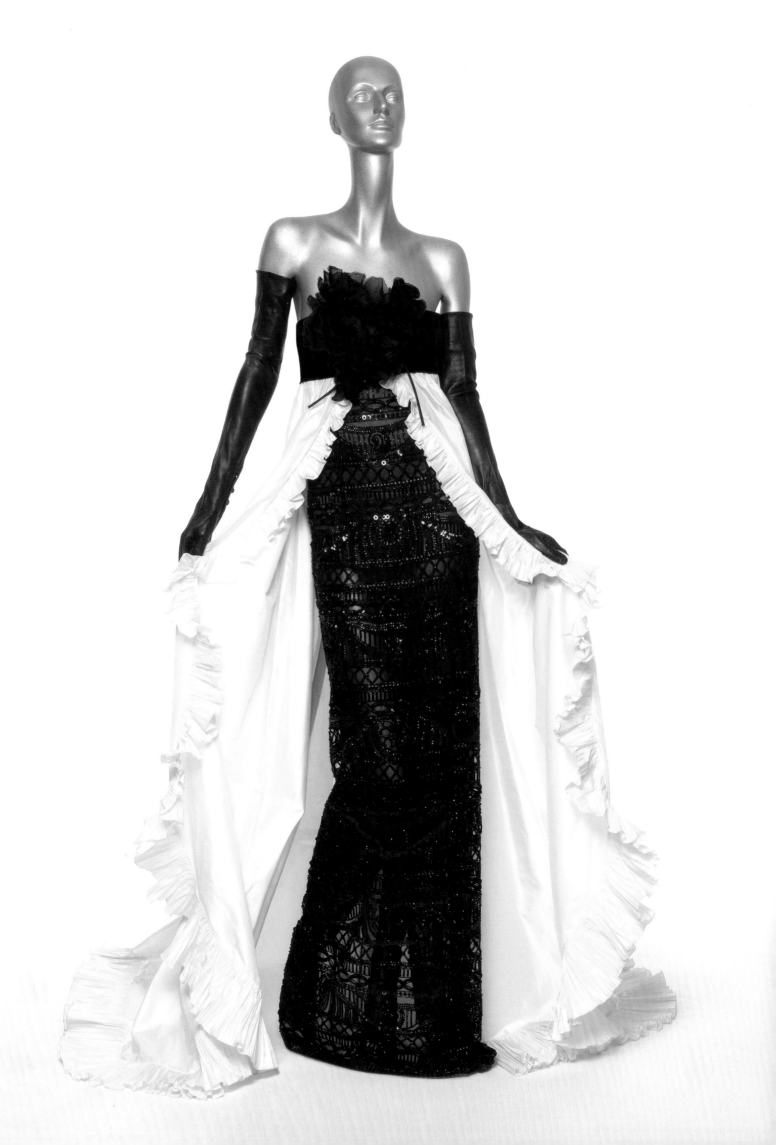

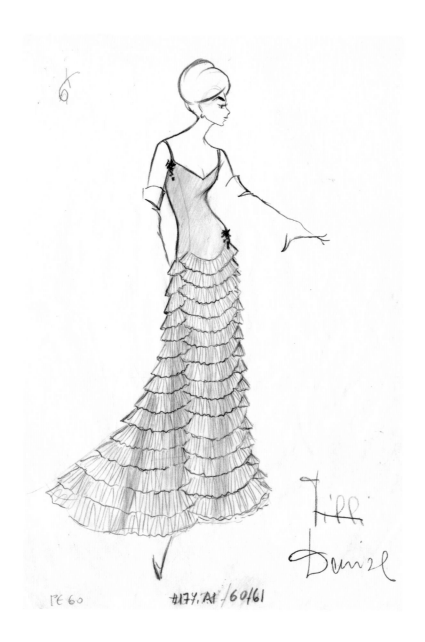

PE 60 #177.A1/60/61

VARIATIONS VOLUME

FALL/WINTER 1960, MODEL 177 "LUCKY"

EVENING DRESS WITH TRAIN AND BOLERO OF BLACK SILK VELVET WITH APPLIQUÉ
PLEATED BLACK TULLE RUFFLES. FABRIC: CLERICI-TESSUTO.

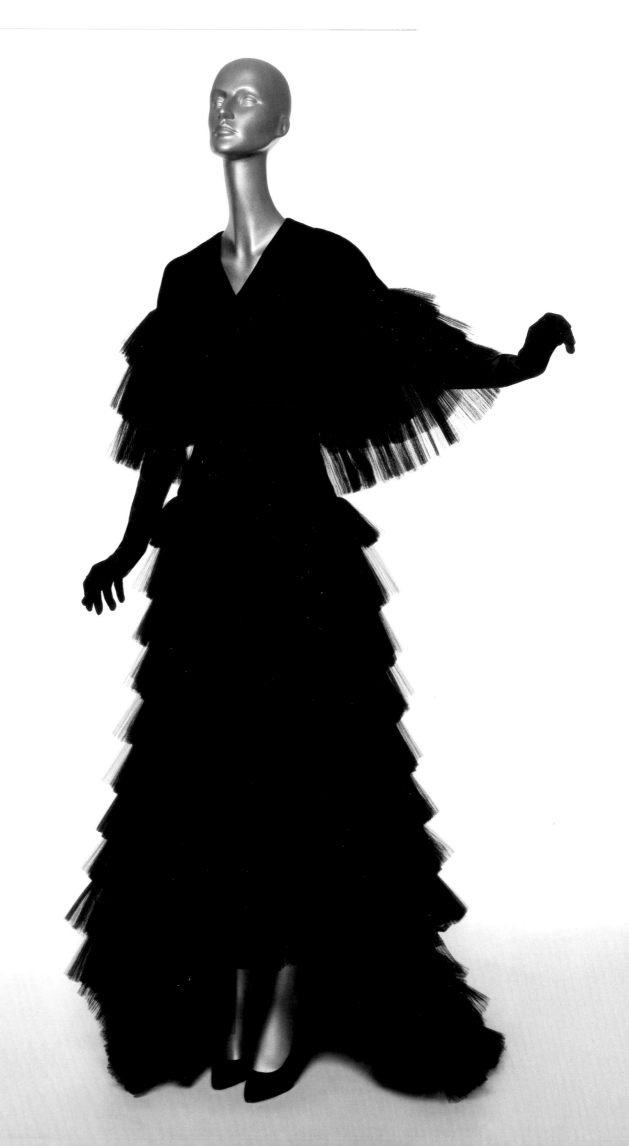

FALL/WINTER 2007, MODEL 170

EVENING ENSEMBLE: EMPIRE DRESS WITH DRAPED BODICE, SHEATH WITH RIBBED
DARTS AND TRIANGULAR TRAIN MADE OF PINK SILK CREPE; CAPE ENTIRELY COMPOSED
OF PINK ORGANDY PETALS. FABRIC: OSTINELLI. EMBROIDERY: PINO GRASSO.

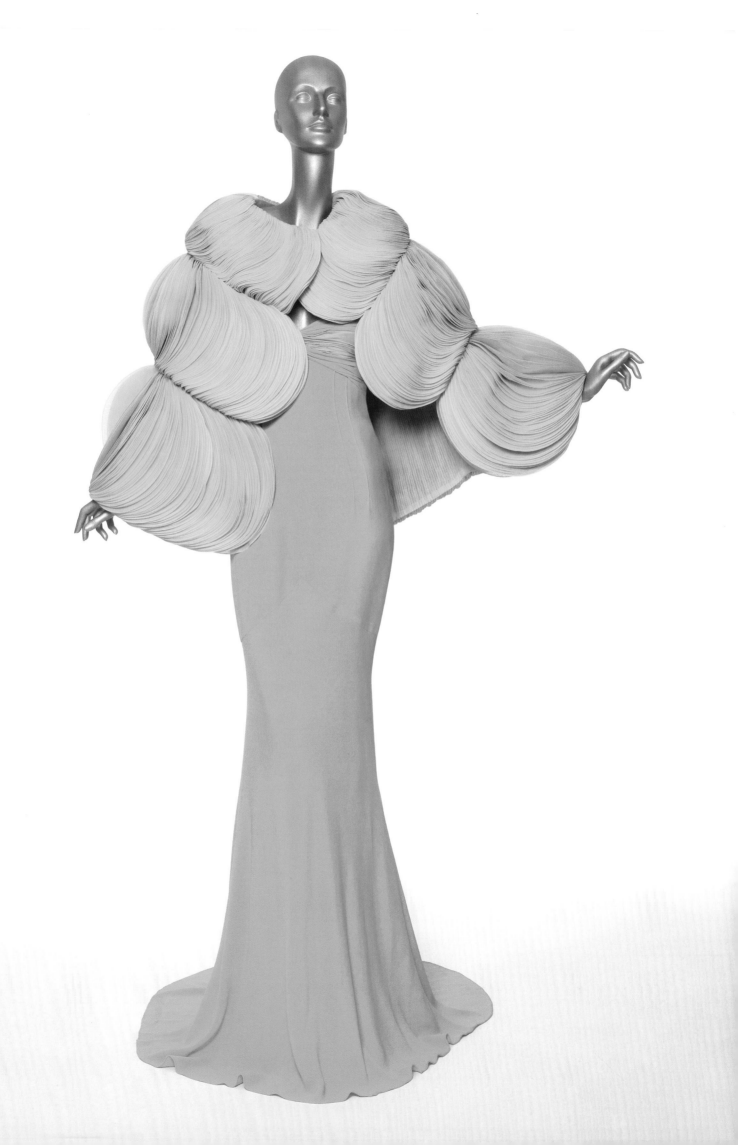

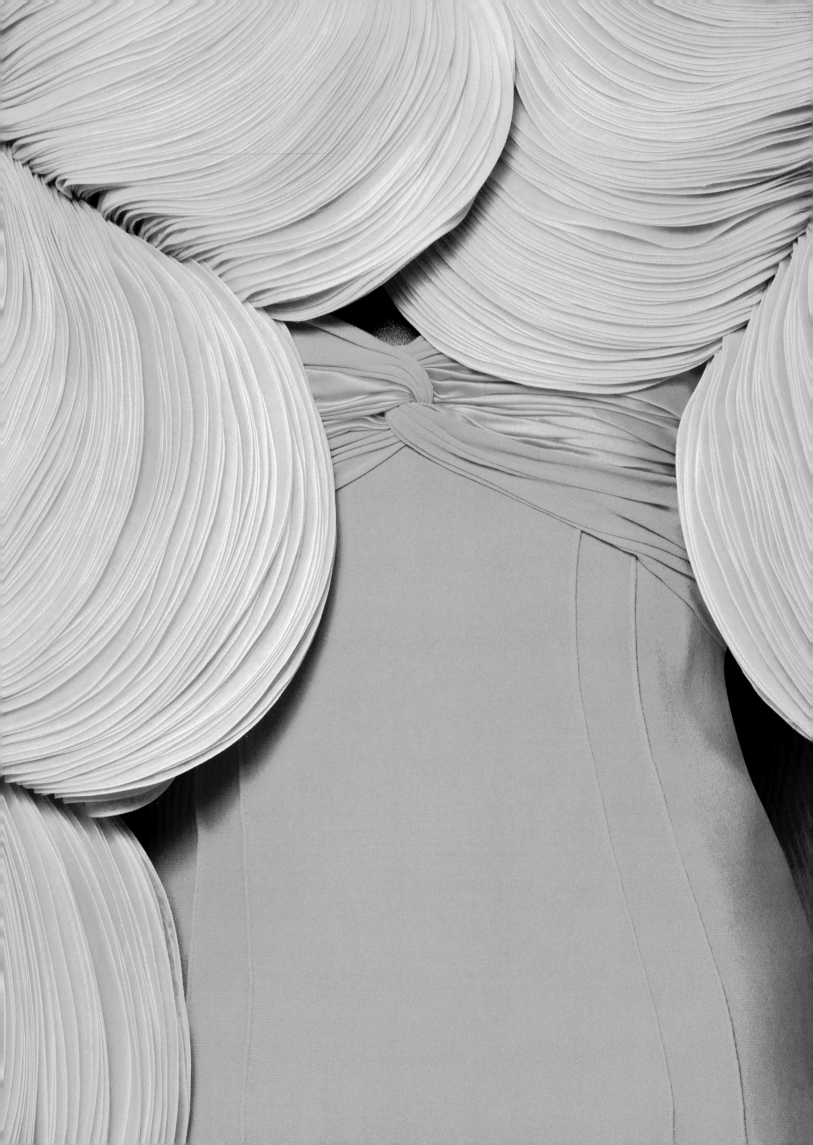

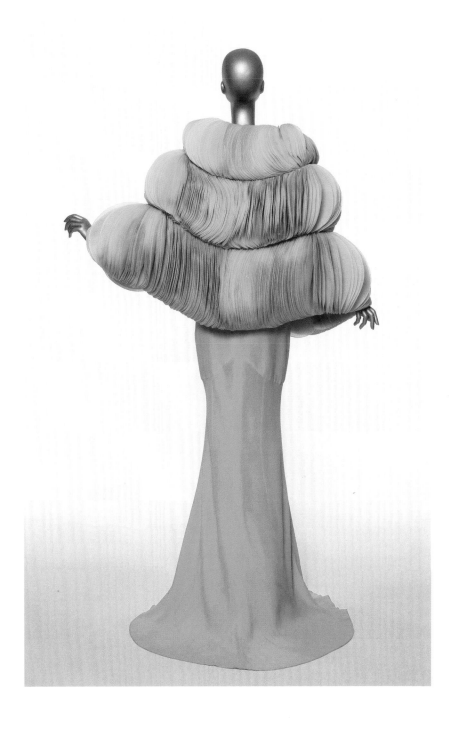

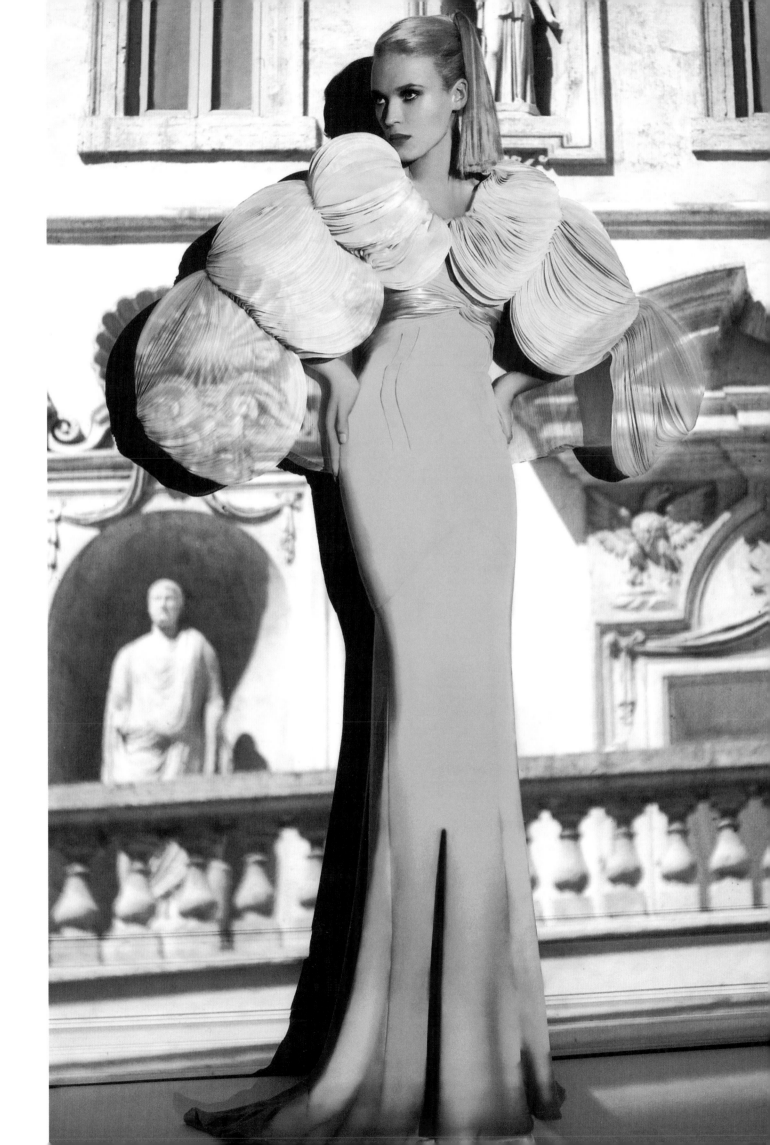

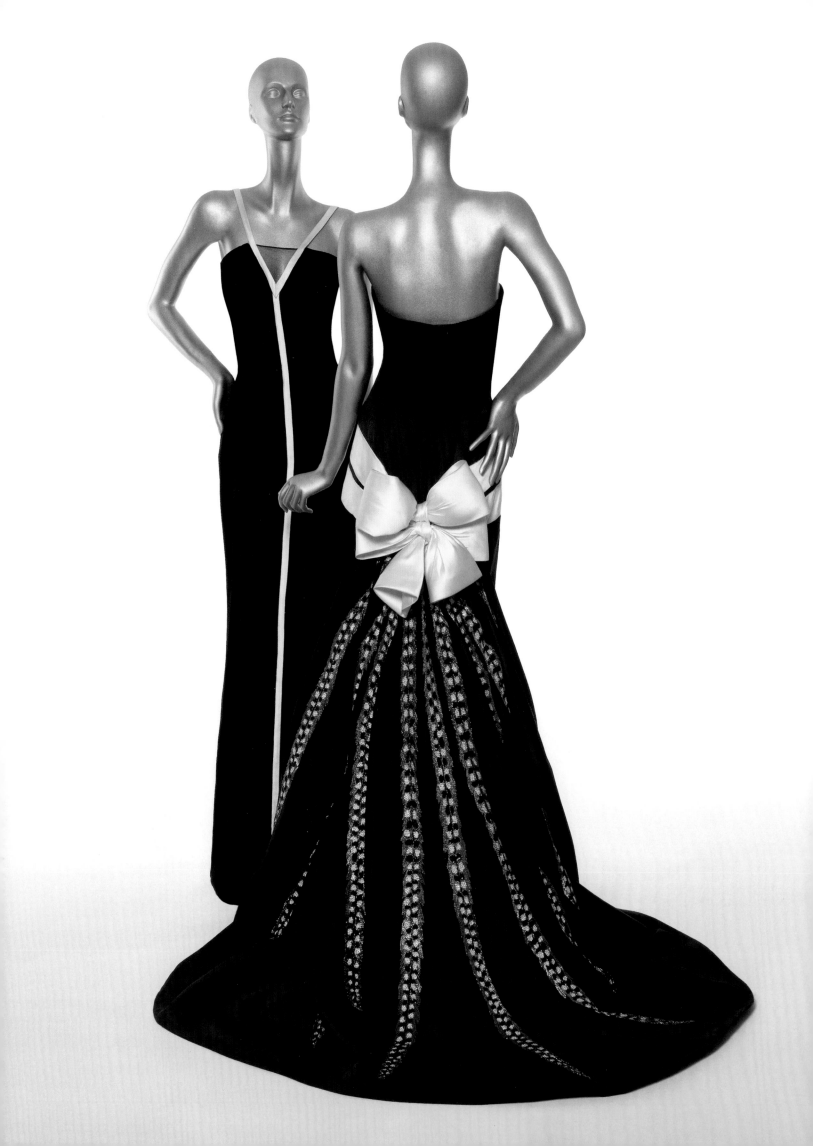

VARIATIONS LINE

FALL/WINTER 1992, MODEL 218

BLACK VELVET EVENING GOWN WITH APPLIQUÉ WHITE SATIN RIBBONS THAT PIPE AND
STRIPE THE BLACK TULLE BIBS AND TRAIN. FABRICS: TARONI AND BIANCHINI-FERRIER.

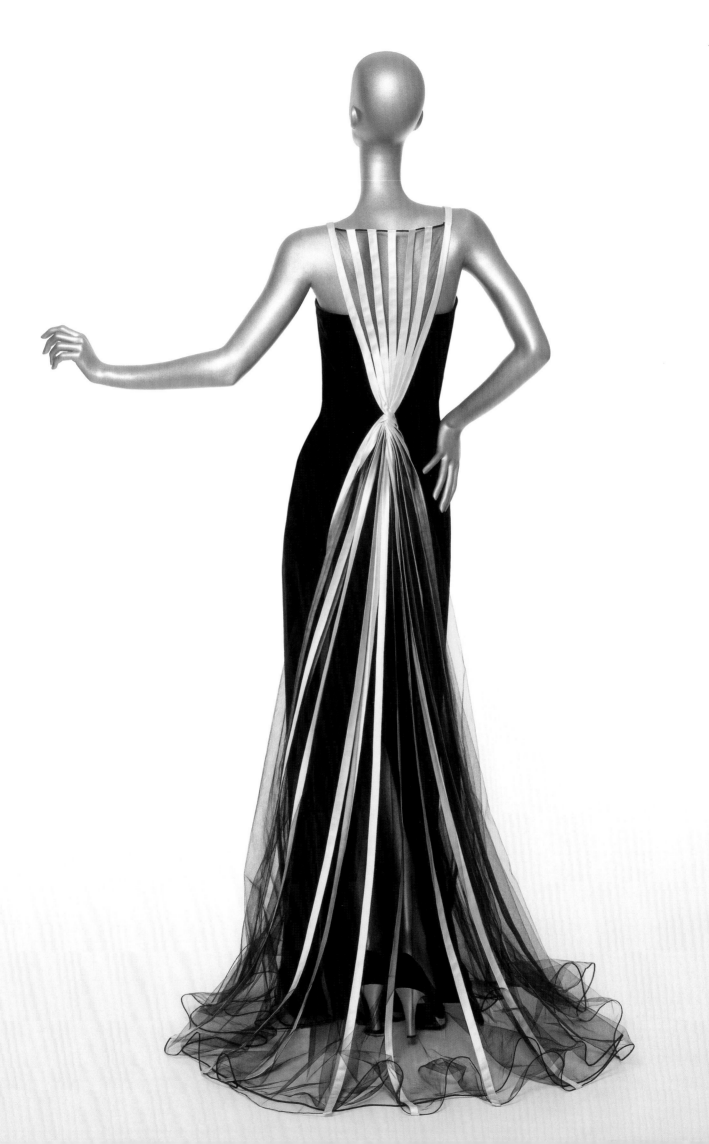

87 - P/E 66

SPRING/SUMMER 1966, MODEL 87

BLACK SILK CREPE DAYTIME ONE-PIECE PANTSUIT ENCRUSTED WITH TRIANGLES OF
WHITE SILK CREPE, WIDE COLLAR AND SHORT SLEEVE BORDERS MADE OF WHITE CREPE.
FABRIC: FORNERIS. COLLECTION: PRINCESS LUCIANA PIGNATELLI.

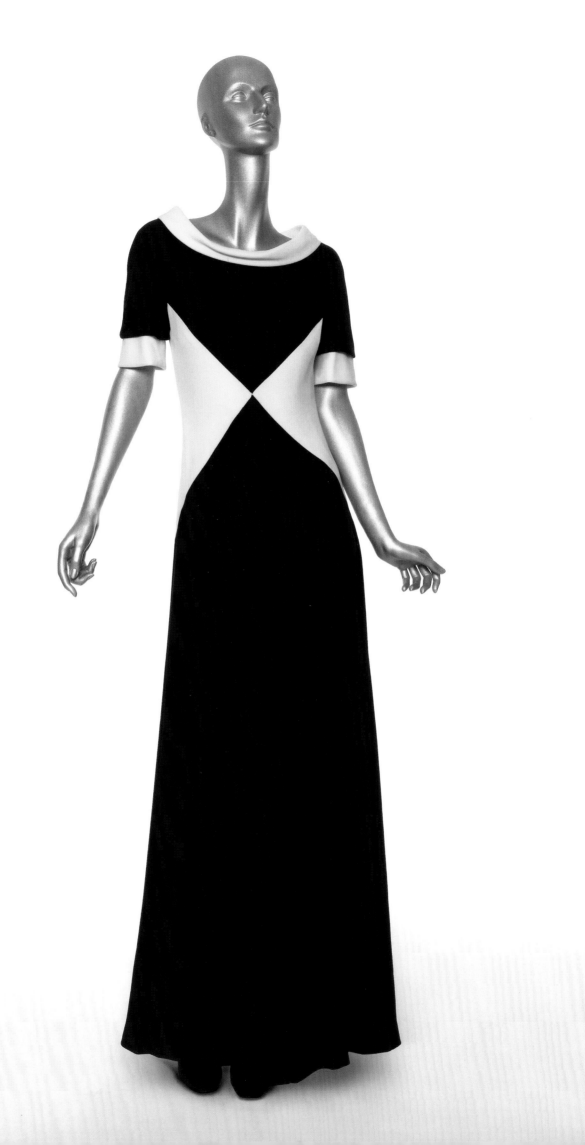

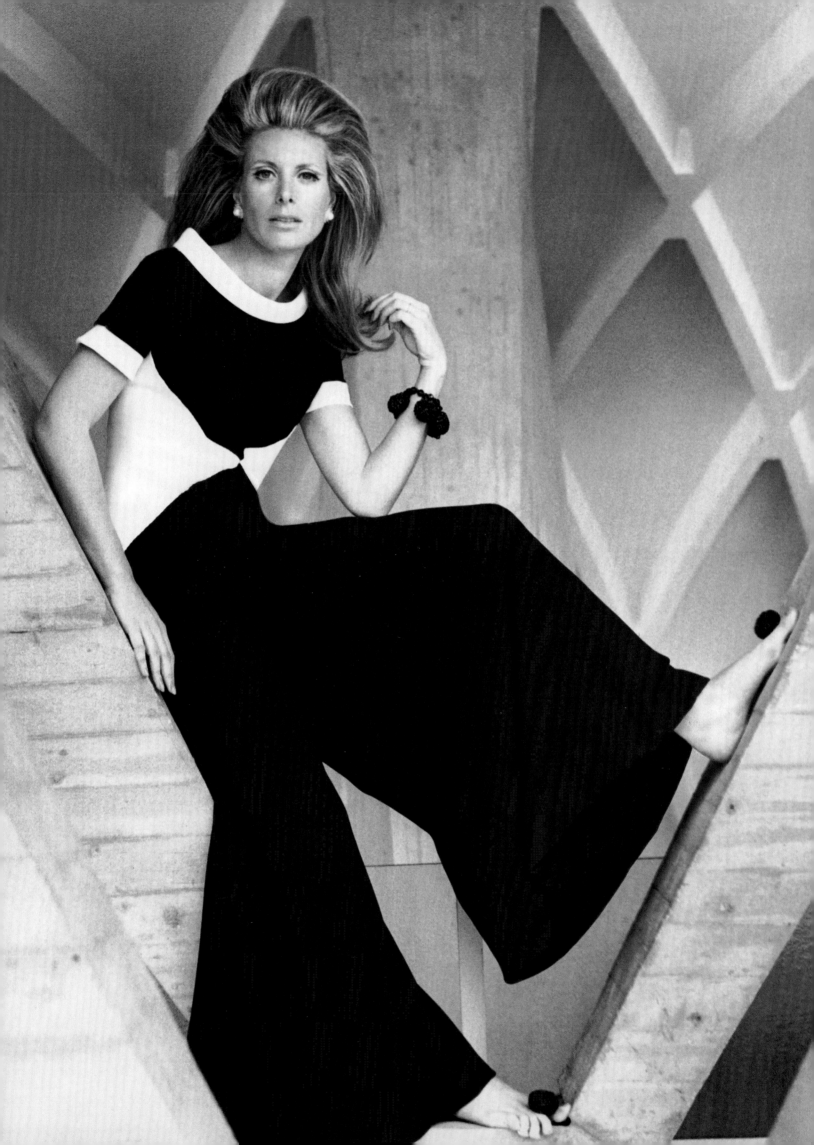

SPRING/SUMMER 2008, MODEL 136

LEFT: BLACK SHANTUNG COCKTAIL SUIT IN PANELS OF FABRIC CUT ON THE BIAS LINED
IN WHITE SHANTUNG THAT SPILLS OUT OF THE CUFFS AND SKIRT. FABRIC: TARONI.

SPRING/SUMMER 2008, MODEL 138

RIGHT: COCKTAIL SUIT MADE OF IVORY SILK DAMASK IN PANELS OF FABRIC CUT ON
THE BIAS THAT ARE LINED IN BLACK SATIN AND SPILL OUT OF SLEEVES AND SKIRT,
BLACK SATIN BELT AND BUCKLE WITH STRASS APPLIQUÉ. FABRIC: TARONI.

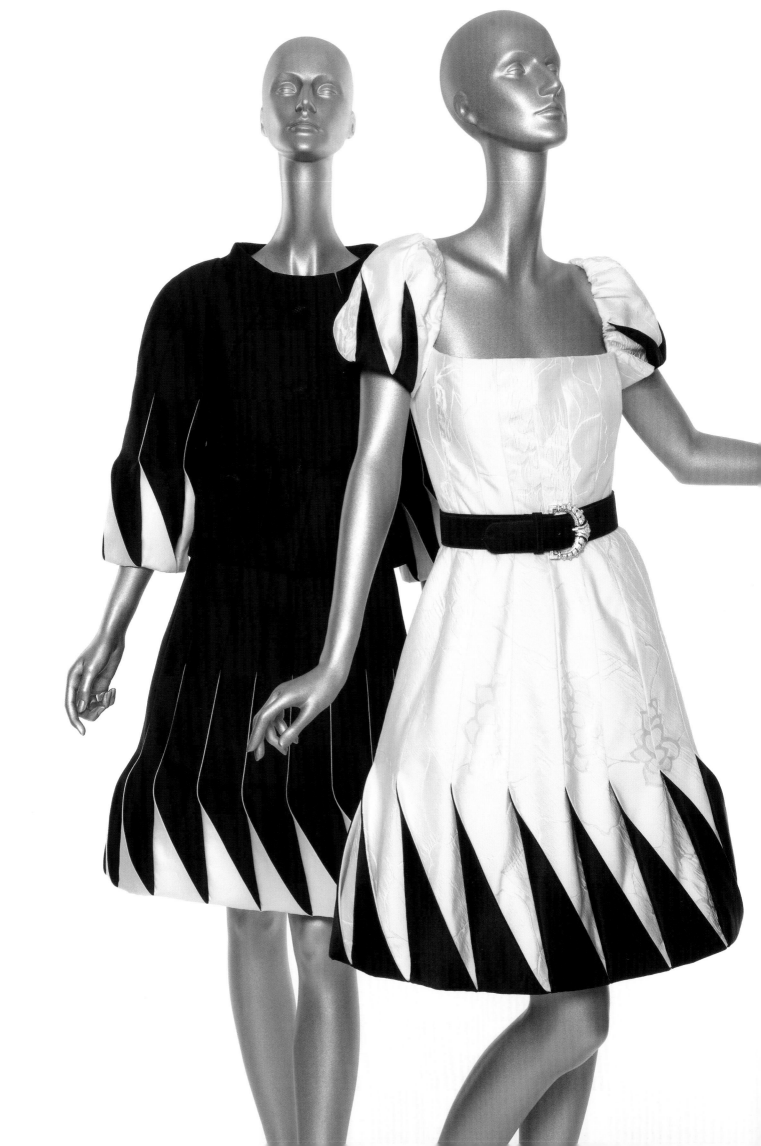

FALL/WINTER 2005, MODEL 62

DAYTIME COAT MADE OF IVORY WOOL WITH A STREAKING MOTIF EMBROIDERED IN BLACK
SEQUINS, COLLAR, CUFFS AND HALF BELT APPLIQUÉD WITH BLACK VELVET LACES ENDING
IN BLACK BEADY FRINGES AND PENDANTS. FABRIC: LUIGI VERGA. EMBROIDERY: MARABITTI.

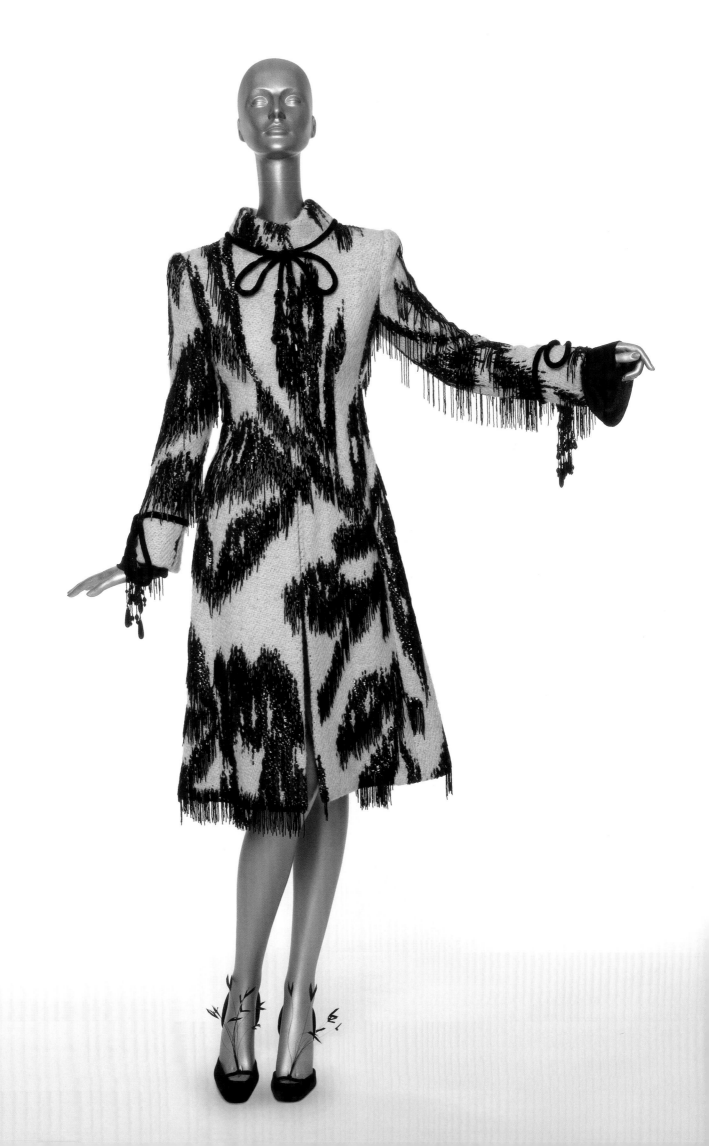

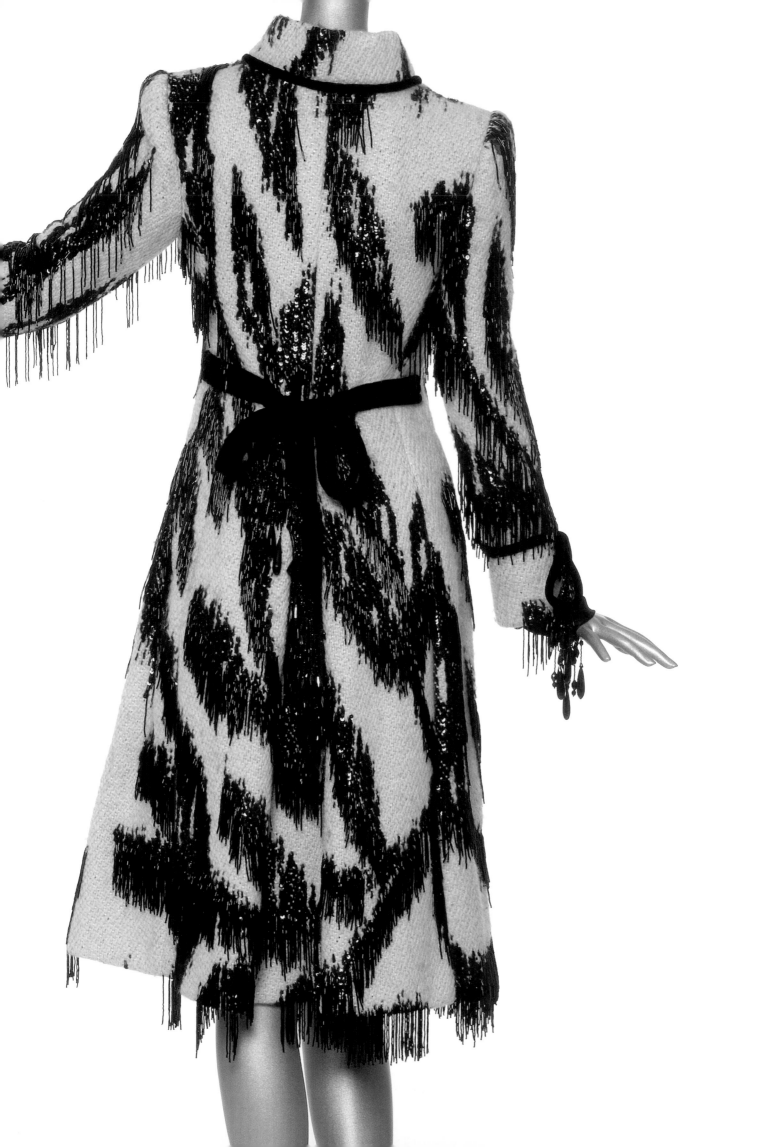

FALL/WINTER 2005, MODEL 62

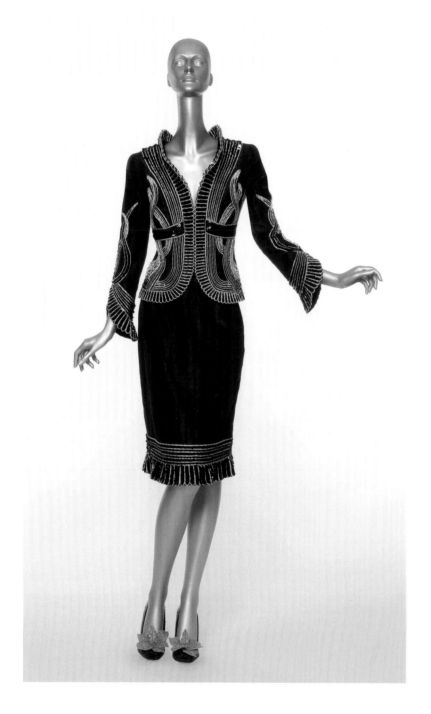

SPRING/SUMMER 2005, MODEL 72

COCKTAIL SUIT MADE OF STRIPED OTTOMAN WITH FACING AND COLLAR EMBROIDERED IN
BEIGE LAMÉ PIPING, SEQUINS AND BEADING, SPLIT AND BRAIDED LIGHTLY RUFFLED CUFFS
AND HEM LINED IN THE SAME OTTOMAN FABRIC. FABRIC: TARONI. EMBROIDERY: HUREL.

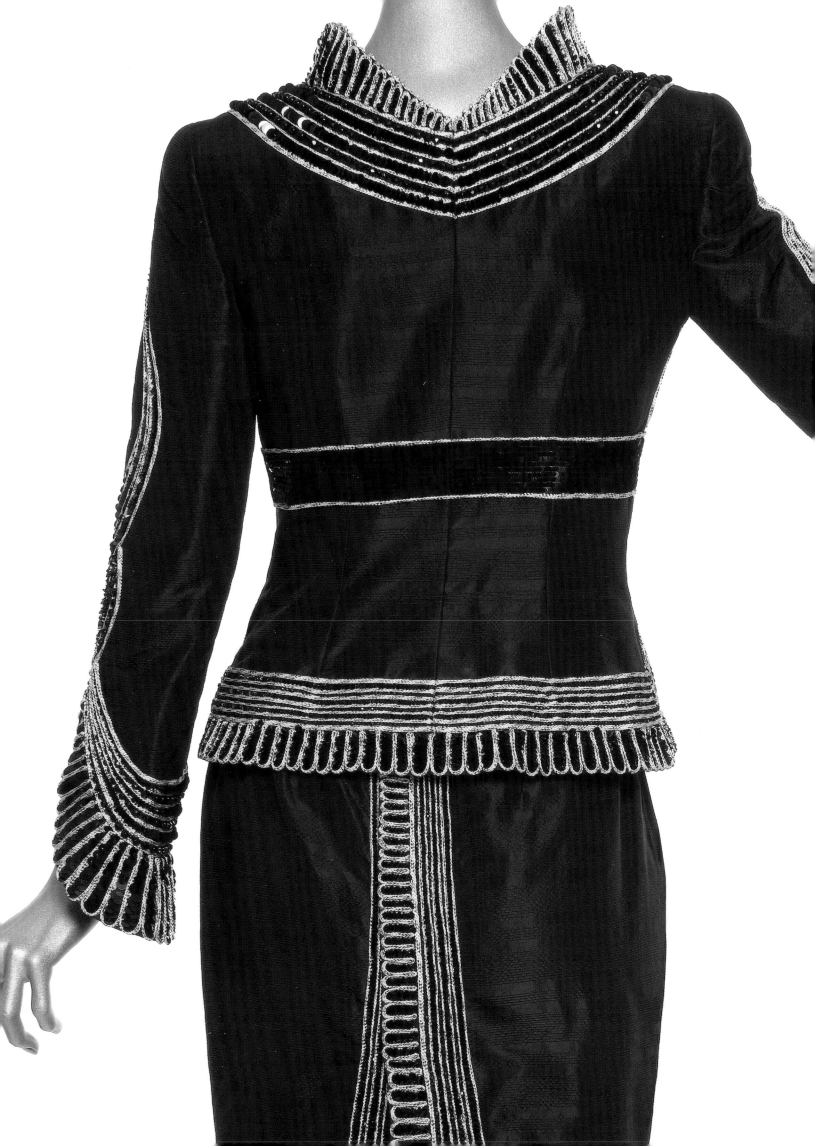

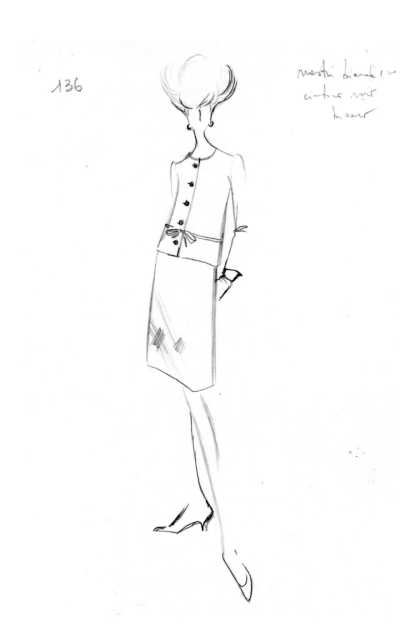

136

VARIATIONS LINE

FALL/WINTER 1965, MODEL 136

COCKTAIL SUIT MADE IN A WEAVE OF BLACK AND WHITE VELVET, JERSEY AND VALENCIENNES
LACE RIBBONS CUT ON THE BIAS, COSTUME JEWELRY BUTTONS MADE OF BLACK PEARLS
AND STRASS, KNOTTED BELT OF BLACK SILK VELVET. FABRIC: FORNERIS.

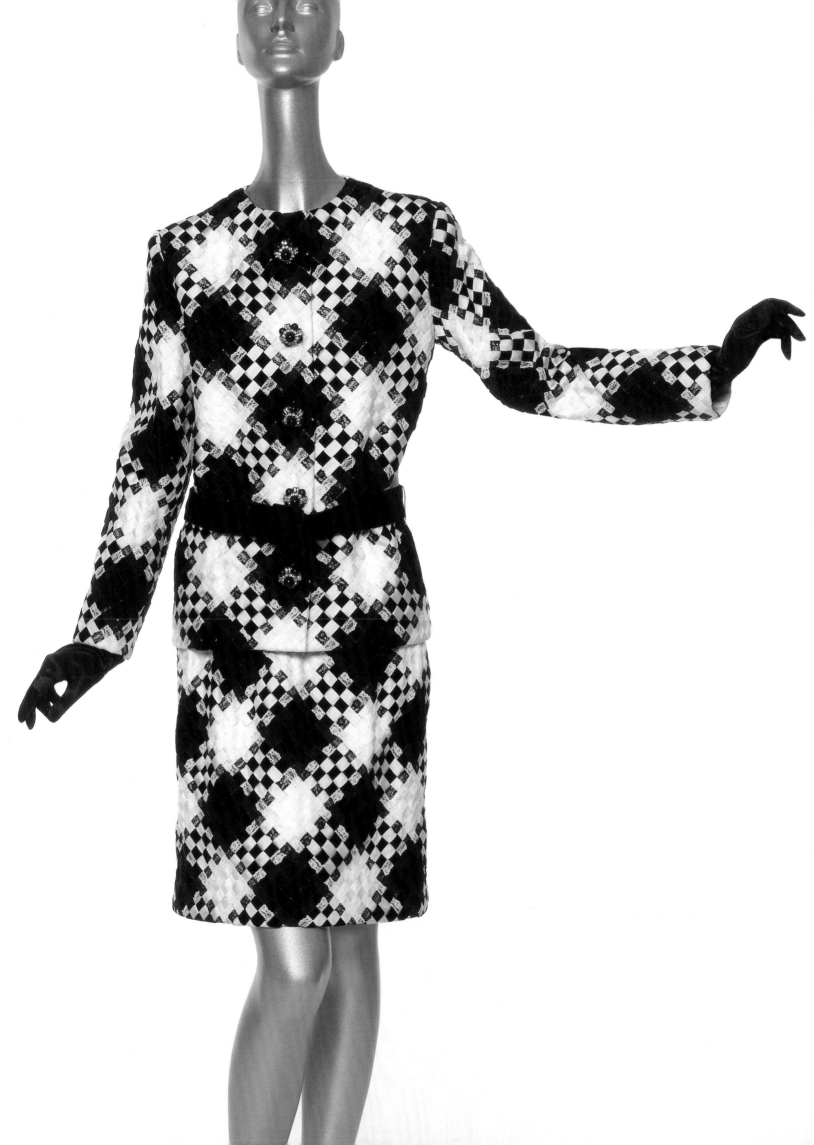

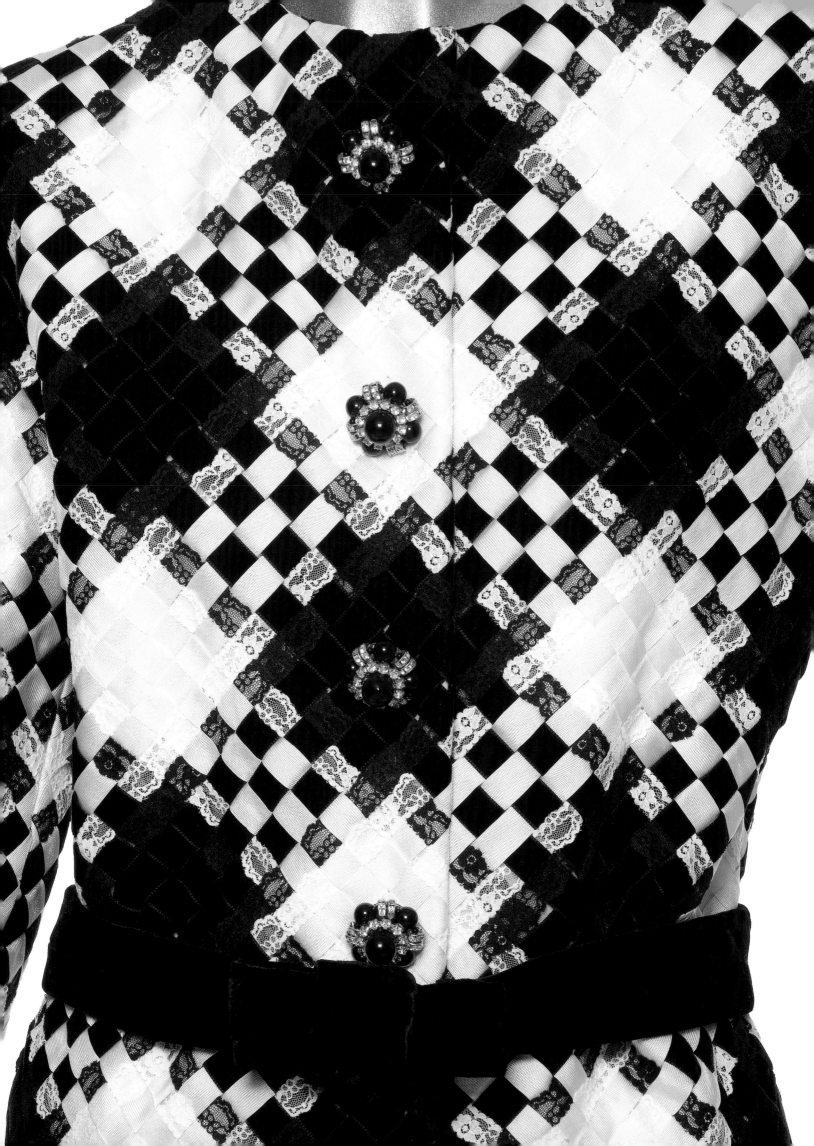

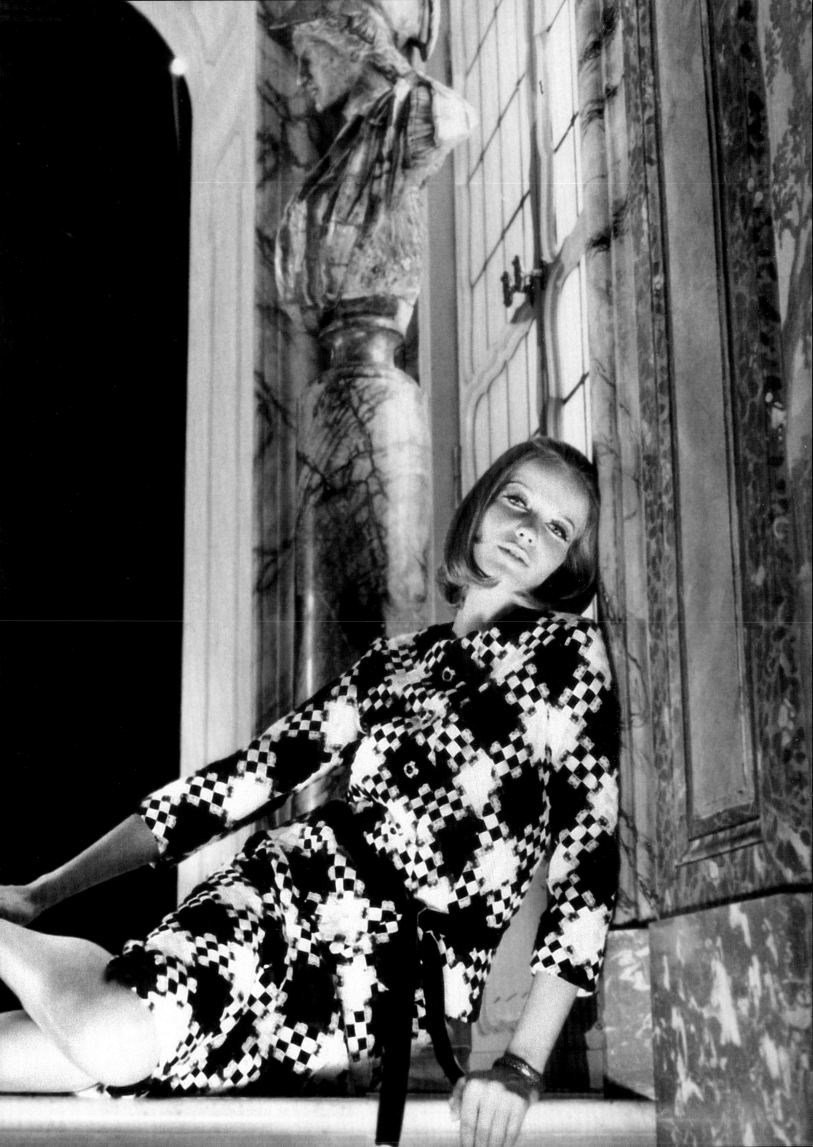

FALL/WINTER 1992, MODEL 198

EVENING GOWN WITH BLACK VOILE TOP APPLIQUÉD WITH CROSSED-OVER BLACK SATIN
RIBBONS IN FRONT AND AROUND THE WAIST, FLOUNCED TULLE SKIRT WITH HERRINGBONE
APPLIQUÉ OF MATCHING RIBBONS. FABRICS: TARONI AND BIANCHINI-FERRIER.

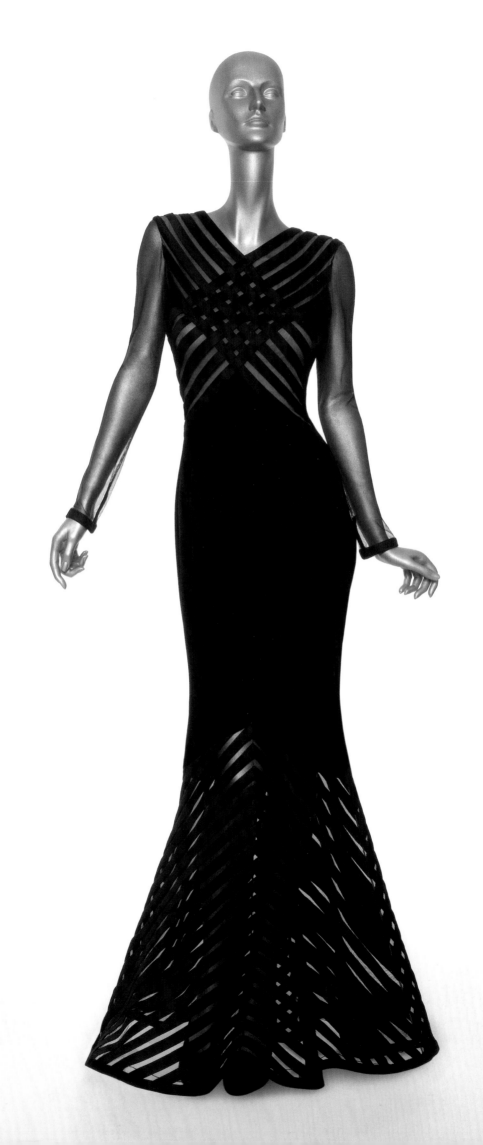

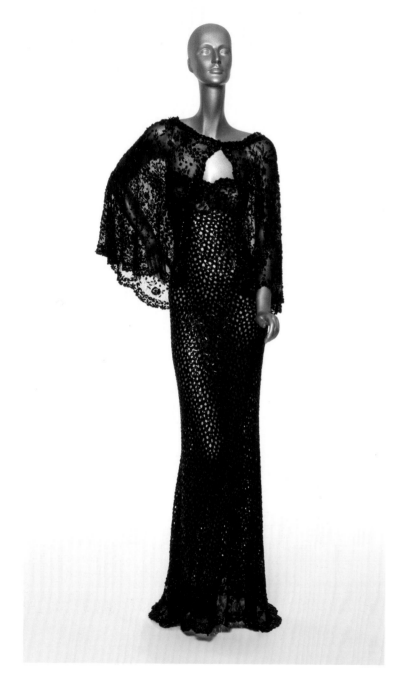

VARIATIONS LINE

FALL/WINTER 2002, MODEL 130

EVENING ENSEMBLE: STRAIGHT EMPIRE DRESS WITH NARROW STRAPS

AND SHAWL MADE OF BLACK GUIPURE EMBROIDERED WITH BLACK SEQUINS

AND TUBULAR BEADS. FABRIC: DARQUER. EMBROIDERY: HUREL.

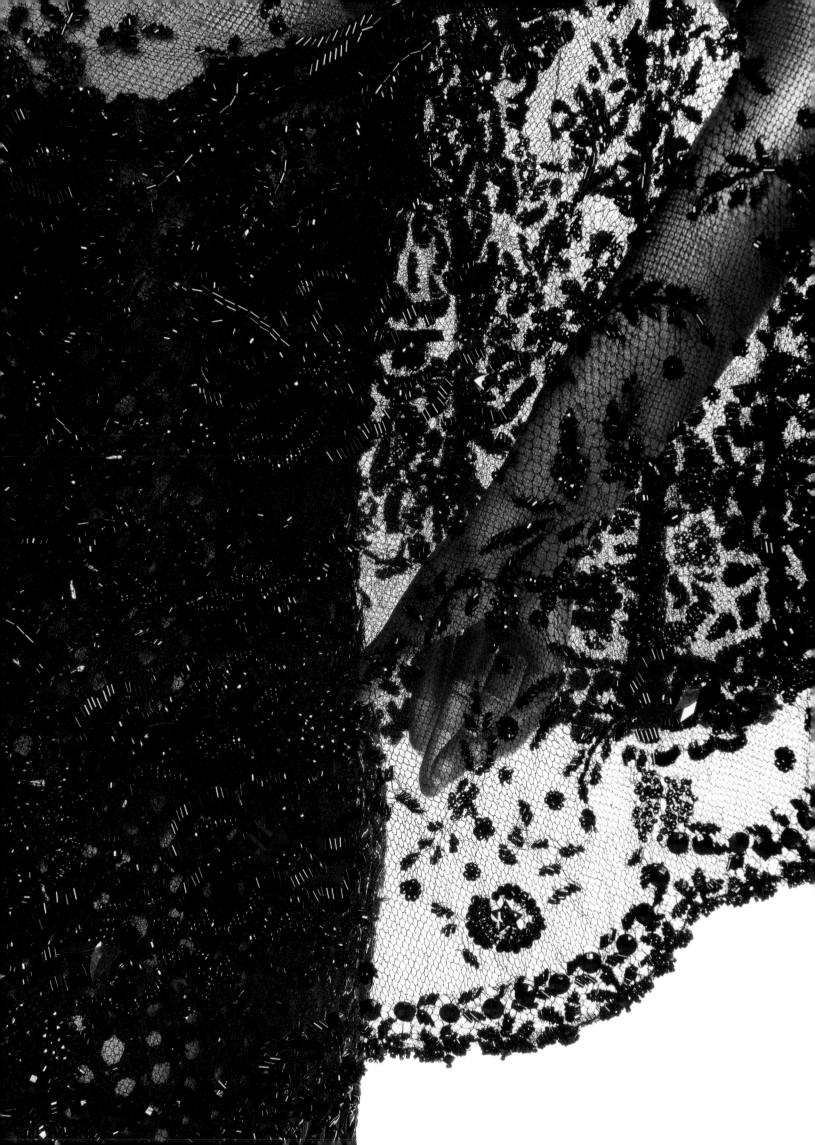

FALL/WINTER 2005, MODEL 126

STRAPLESS BLACK SATIN EVENING GOWN WITH APPLIQUÉ WHITE SATIN RIBBONS
AND TWO ROUND BOWS, TRAIN MADE OF SHIRRED PLEATS AND EMBROIDERED WITH
TUBULAR BEADS, STRASS, AND SEQUINS FOR A FEATHERY CASCADE EFFECT.
FABRIC: TARONI. EMBROIDERY: MARABITTI.

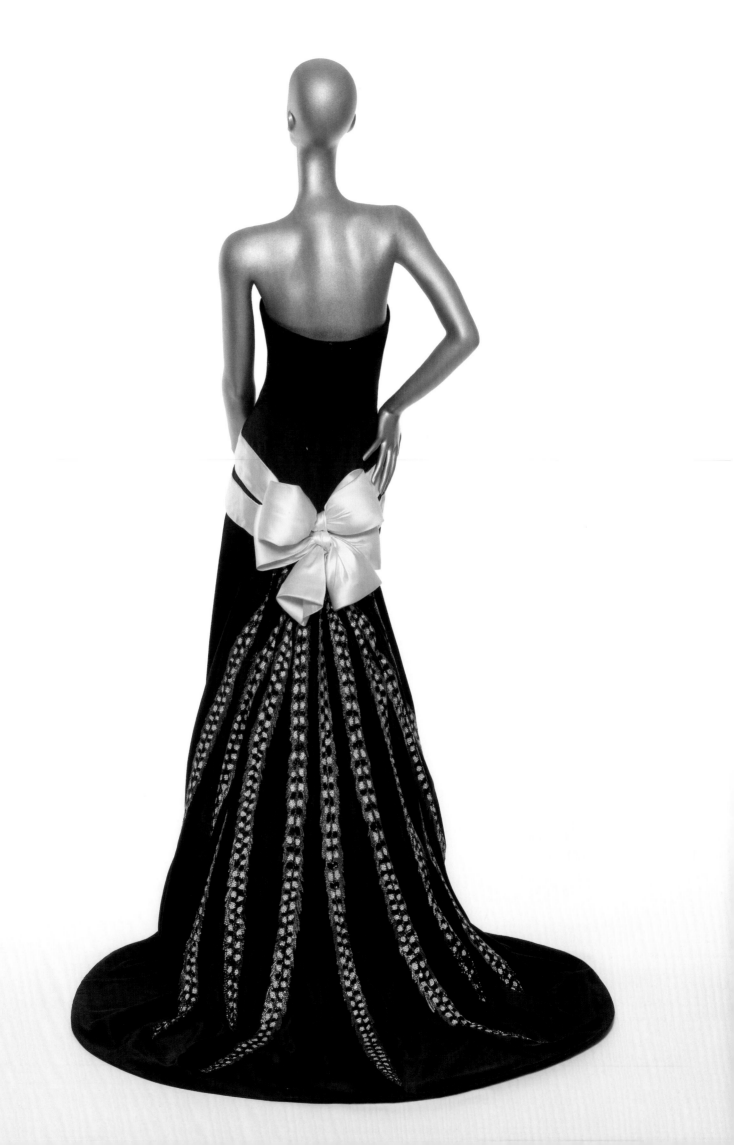

SPRING/SUMMER 1988, MODEL 288

EVENING DRESS, TOP MADE OF BLACK DRAPED CREPE GEORGETTE, SKIRT MADE
OF BLACK GAZAR OPENWORK MEDALLIONS EMBROIDERED IN STRASS OVER
A GOLDEN YELLOW SATIN PETTICOAT. FABRIC: CLERICI-TESSUTO.

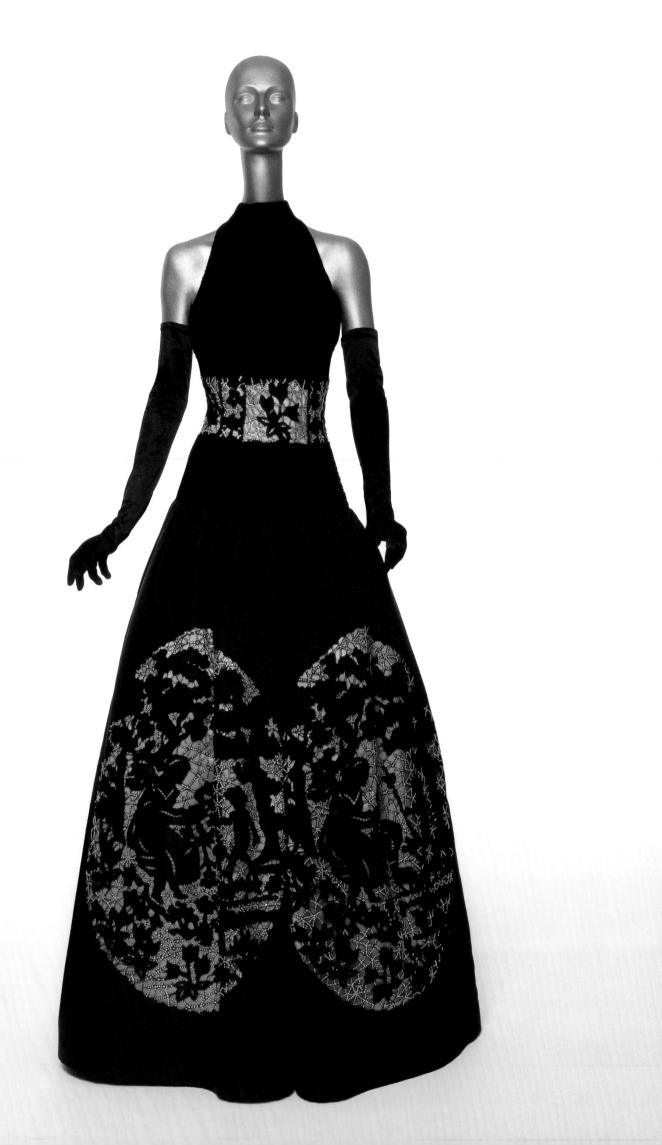

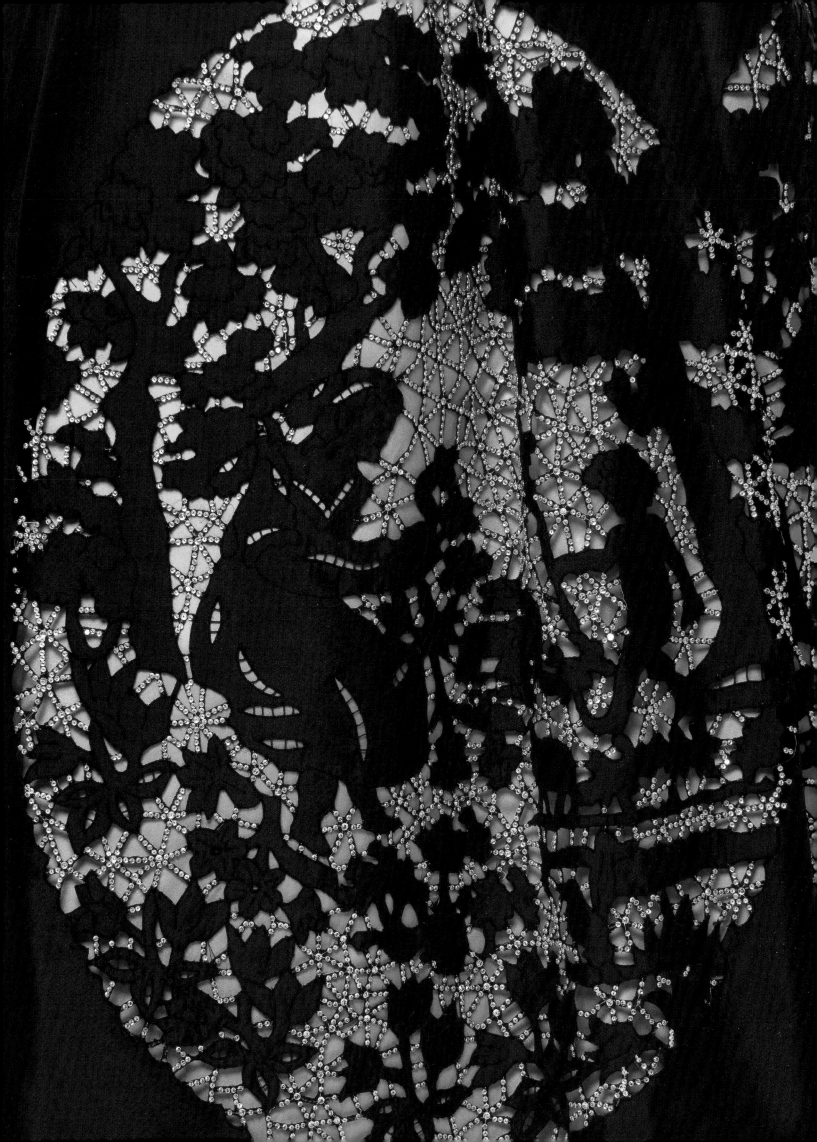

SPRING/SUMMER 1991, MODEL 242

EVENING DRESS MADE OF BLACK SILK CREPE WITH BLACK CHIFFON BAREBACK
EMBROIDERED IN WHITE IRIDESCENT TUBULAR BEADS THAT CROSS DOWN OVER THE
HIPS AND DOWN TO THE TRAIN. FABRIC: TARONI. EMBROIDERY: MARABITTI.

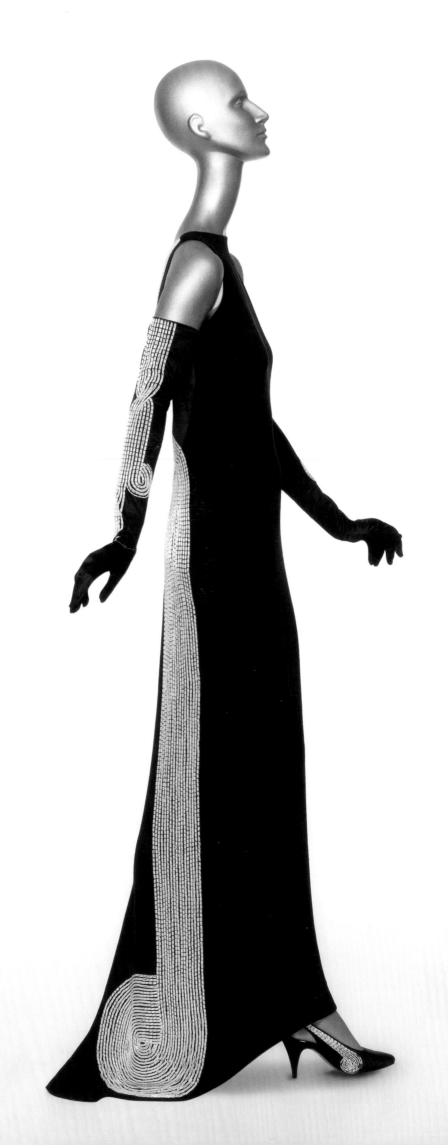

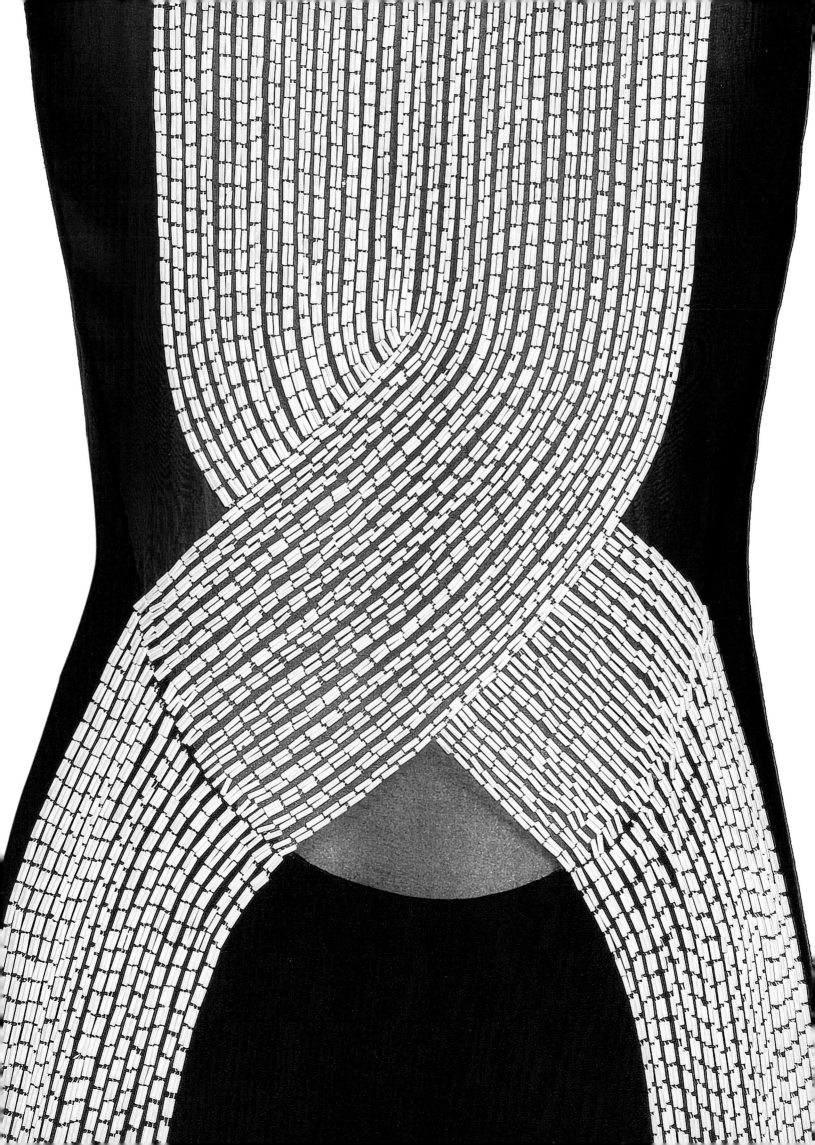

SPRING/SUMMER 1991, MODEL 242

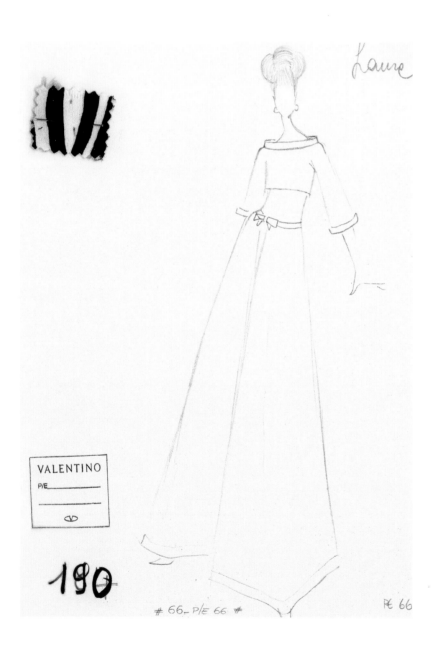

VALENTINO
P/E _____

ⱱ

190

66 _ P/E 66 # PE 66

Laura

VARIATIONS LINE

SPRING/SUMMER 1966, MODEL 190

COCKTAIL ENSEMBLE: MINI BODICE WITH RAGLAN SLEEVES, WHITE COTTON COLLAR, AND
TROUSERS OF BLACK ZEBRA PRINT COTTON; FLAT KNOTTED BELT. FABRIC: TARONI.

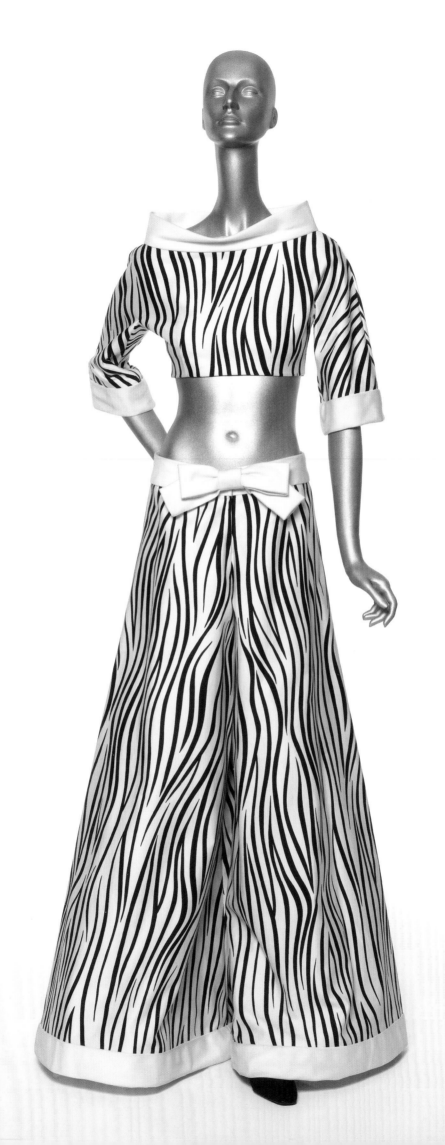

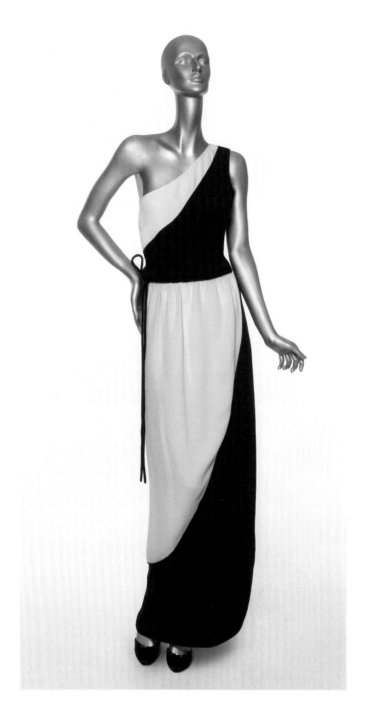

VARIATIONS LINE

SPRING/SUMMER 1982, MODEL 234

ABOVE & OPPOSITE, LEFT: EVENING DRESS MADE OF WHITE FLUTED CREPE
INCRUSTED WITH OVERSTITCHING OF BLACK CREPE MOTIFS, SHIRRED
SPLIT SKIRT MOUNTED ON AN ASYMMETRICAL BODICE, WAIST BELTED WITH
BLACK CREPE STRING. FABRIC: CLERICI-TESSUTO.

SPRING/SUMMER 1967, MODEL 196

OPPOSITE, RIGHT: EVENING ENSEMBLE: SPLIT CHASUBLE WITH ASYMMETRICAL
DÉCOLLETÉ IN WHITE OTTOMAN WITH BLACK POLKA DOTS AND CUT ON
THE BIAS; ONE PIECE PANTSUIT WITH PUFFED-UP LONG SLEEVES AND COLLAR
DRAPED IN MATCHING PRINTED SILK CHIFFON. FABRIC: TARONI.

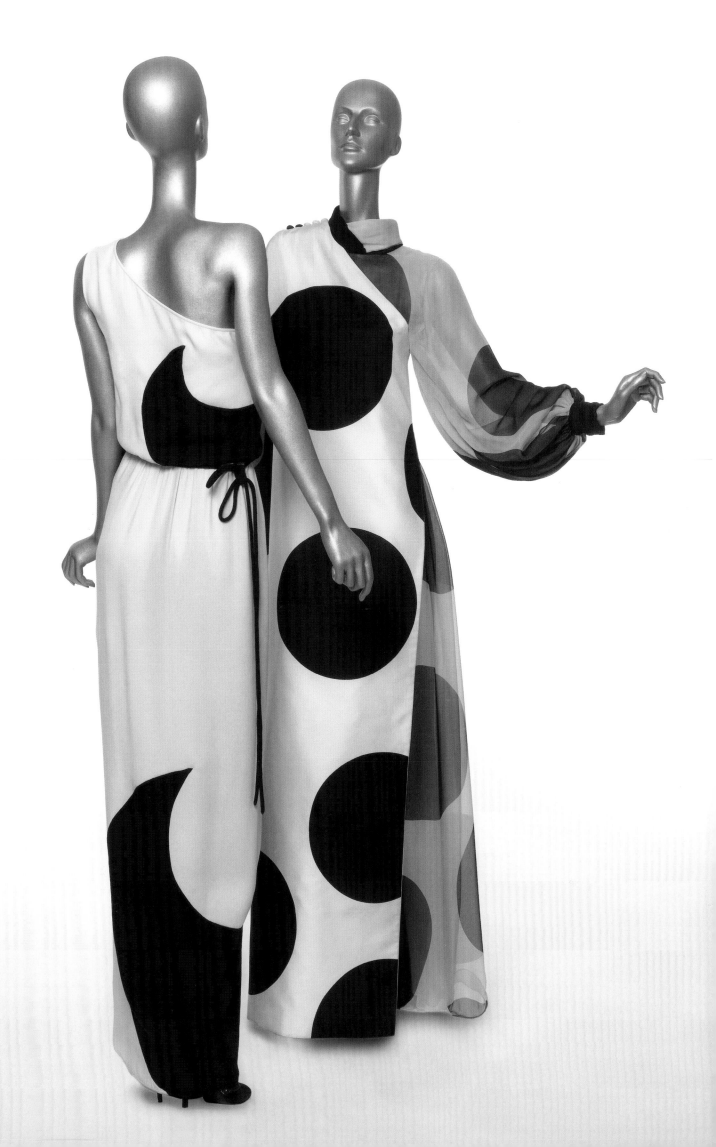

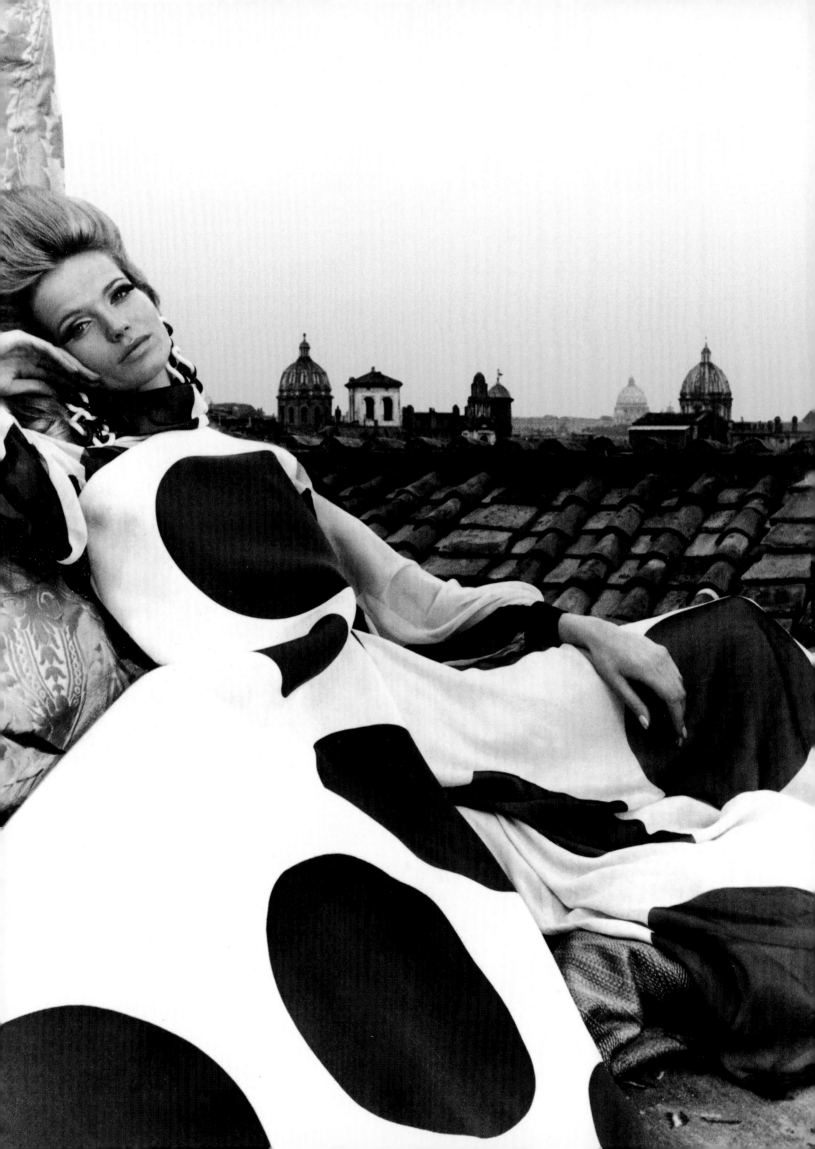

PHOTOGRAPHER: FRANCO RUBARTELLI

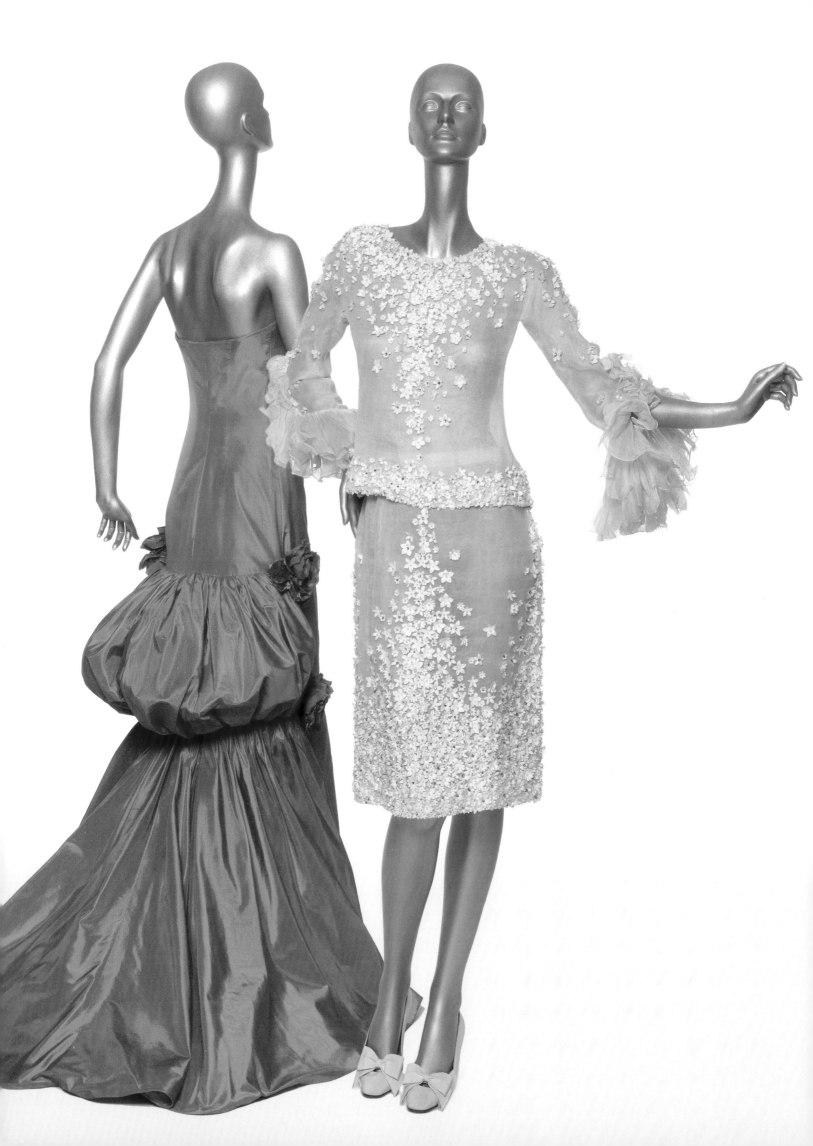

VARIATIONS SURFACE

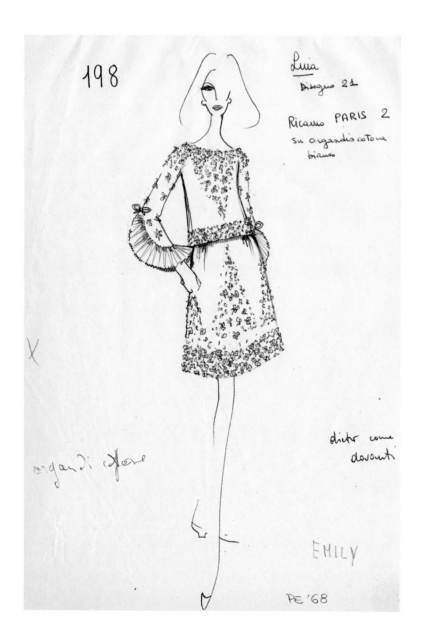

VARIATIONS SURFACE

SPRING/SUMMER 1968, MODEL 198

DAYTIME ENSEMBLE: ORGANDY BODICE AND SKIRT EMBROIDERED WITH PEARLS,

STRASS AND FLOWERLETS MADE OF STARCHED LINEN, CUFFS MADE OF WIRED AND

PLEATED ORGANDY RUFFLES. FABRIC: FORNERIS. COLLECTION: AUDREY HEPBURN.

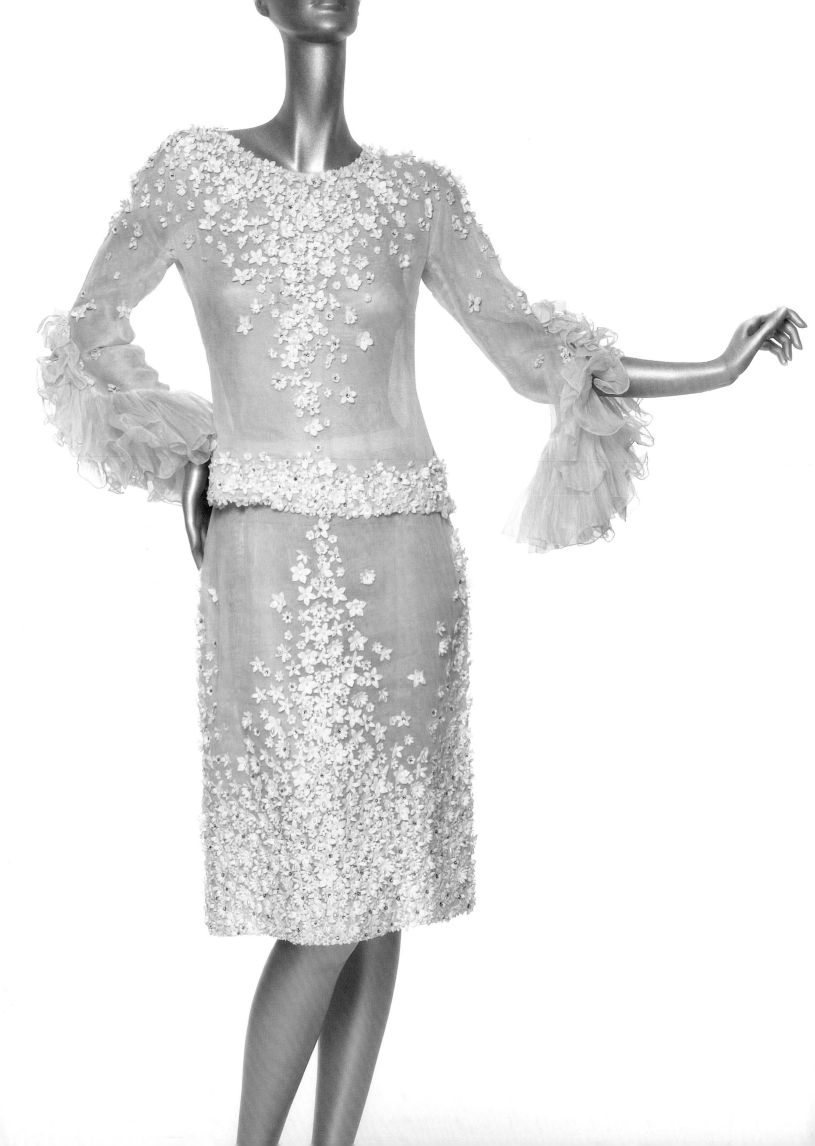

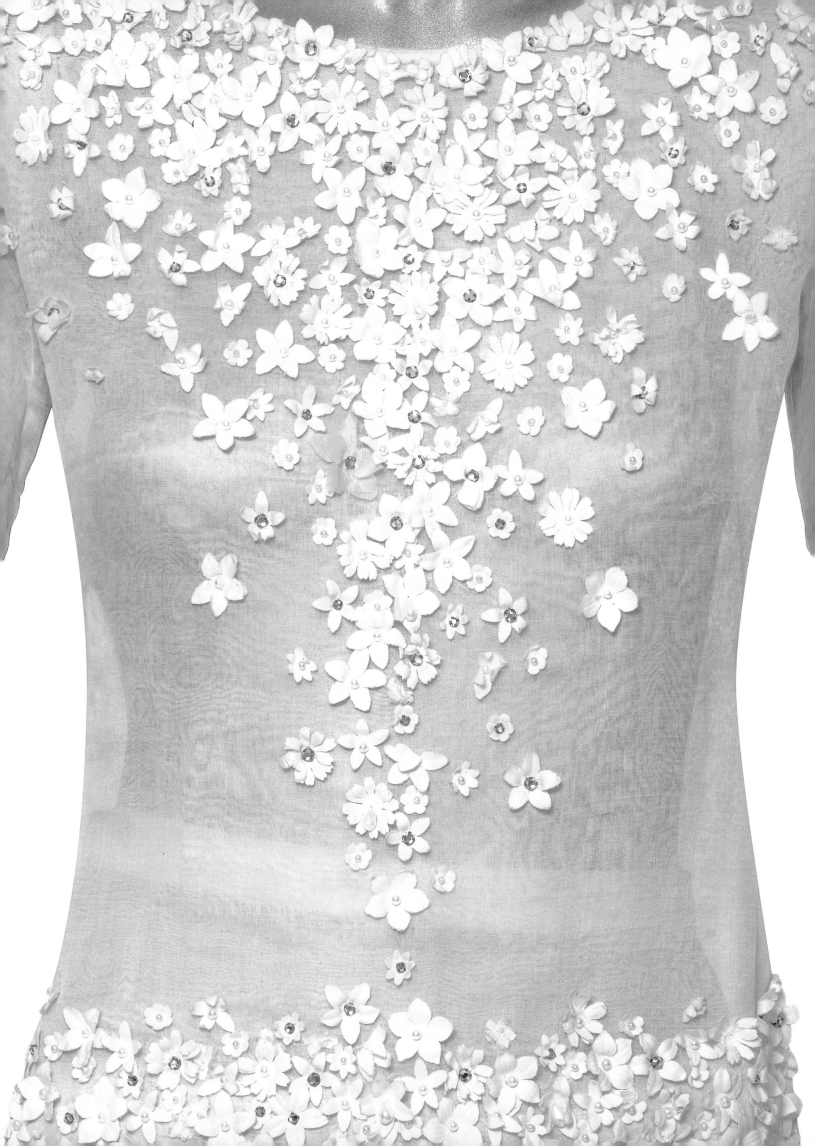

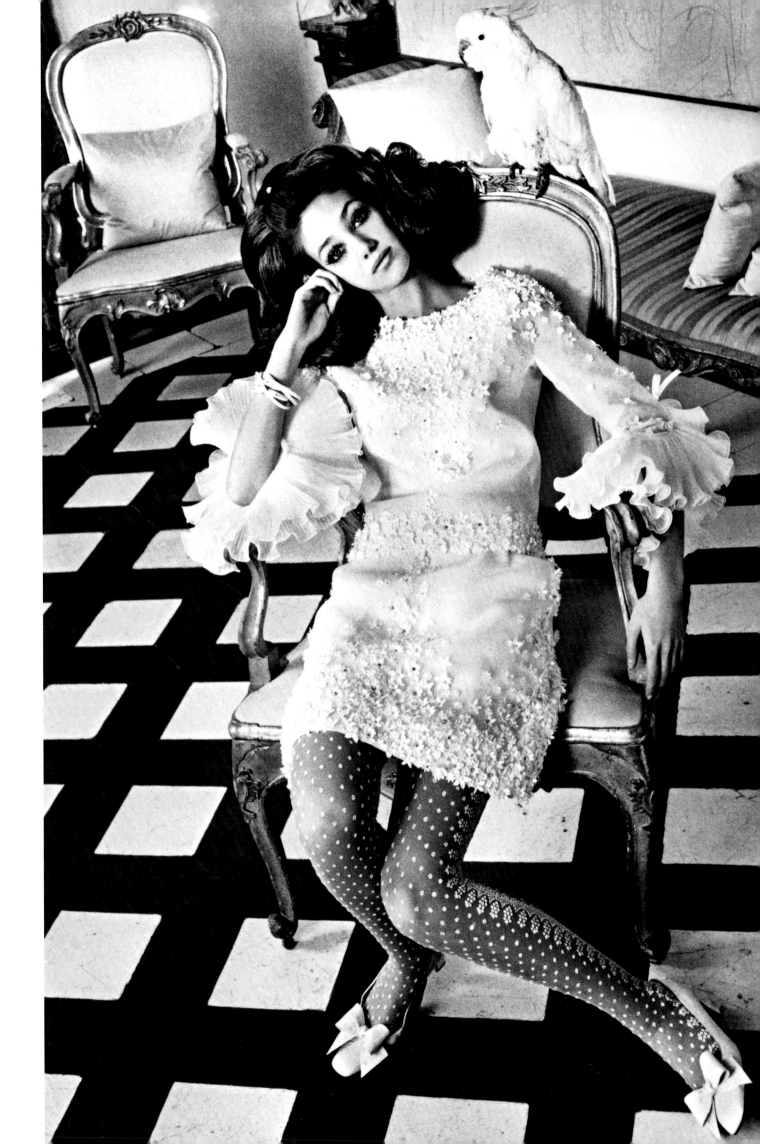

FALL/WINTER 2002, MODEL 164

RED TAFFETA STRAPLESS LONG EVENING GOWN, TRAIN GATHERED INTO A POUF APPLIQUÉ
WITH TAFFETA AND VELVET ROSES, PETTICOAT PIPED IN RED FAILLE PRINTED WITH
FLOWER MOTIF. FABRIC: TARONI AND GENTILI & MOSCONI. FLOWERS: PAGLIANI-BRASSEUR.

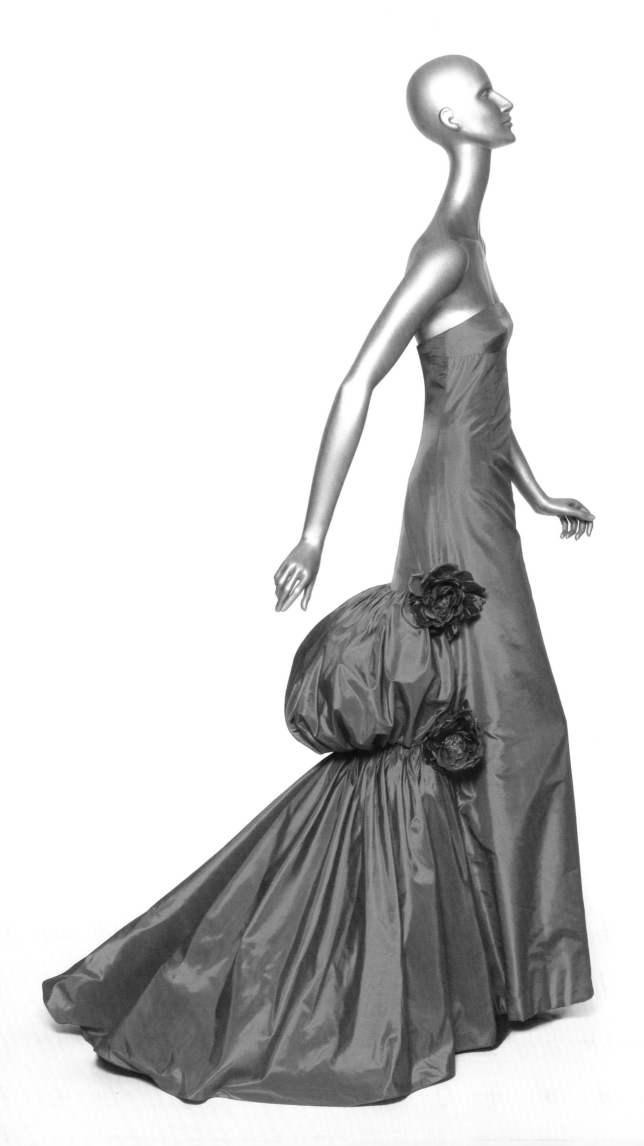

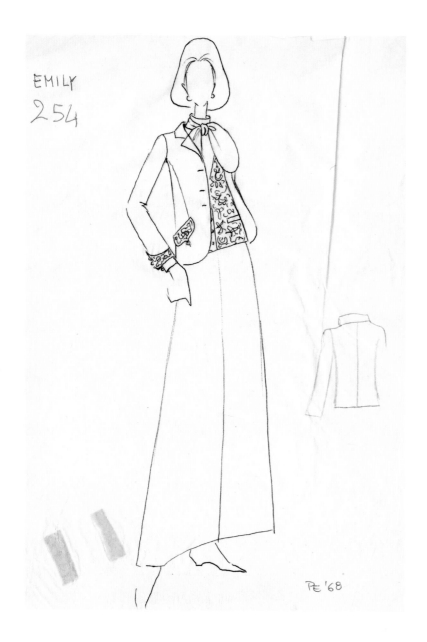

EMILY
254

PE '68

SPRING/SUMMER 1968, MODEL 254

EVENING SUIT MADE OF WHITE COTTON SERGE WITH A JACKET AND VEST EMBROIDERED WITH
BRAID, PEARLS AND STRASS, COSTUME JEWELRY BUTTONS WITH STRASS APPLIQUÉ; BLOUSE
MADE OF CREAM-COLORED PONGÉE, WHITE PONGÉE LAVALLIÈRE. FABRICS: FORNERIS AND TARONI.

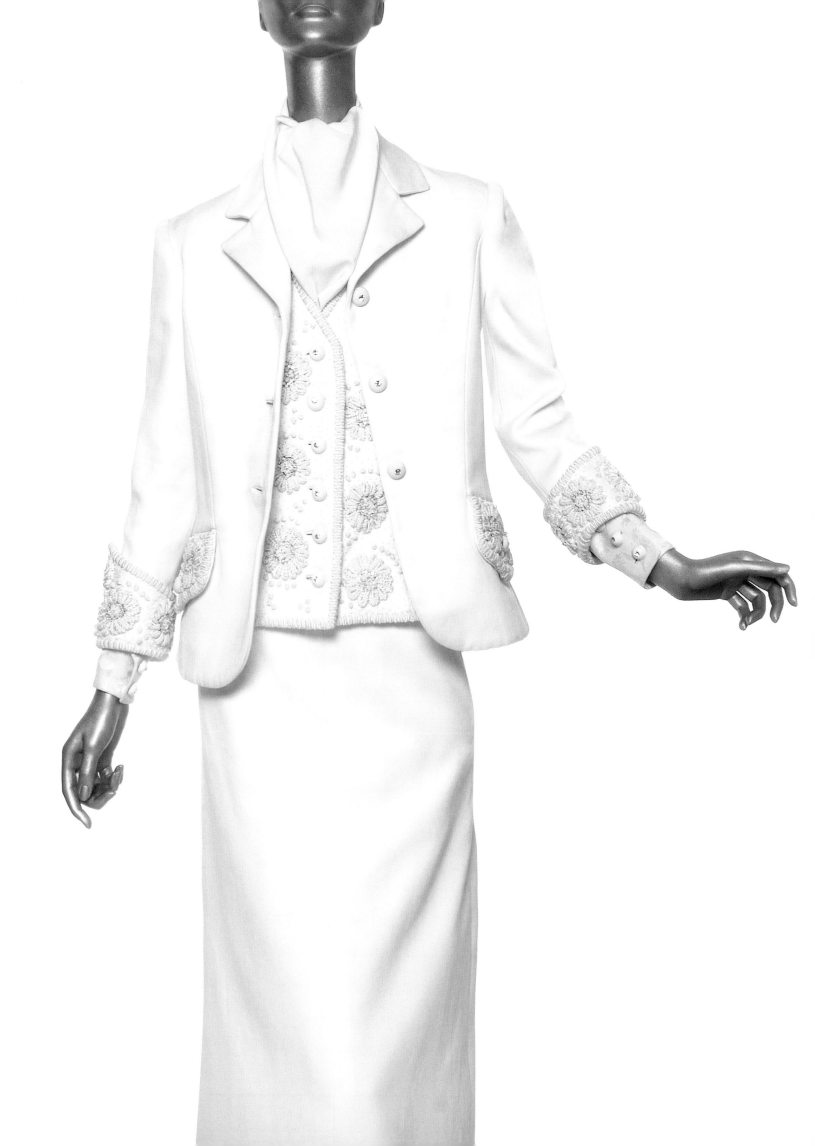

PHOTOGRAPHER: HENRY CLARKE

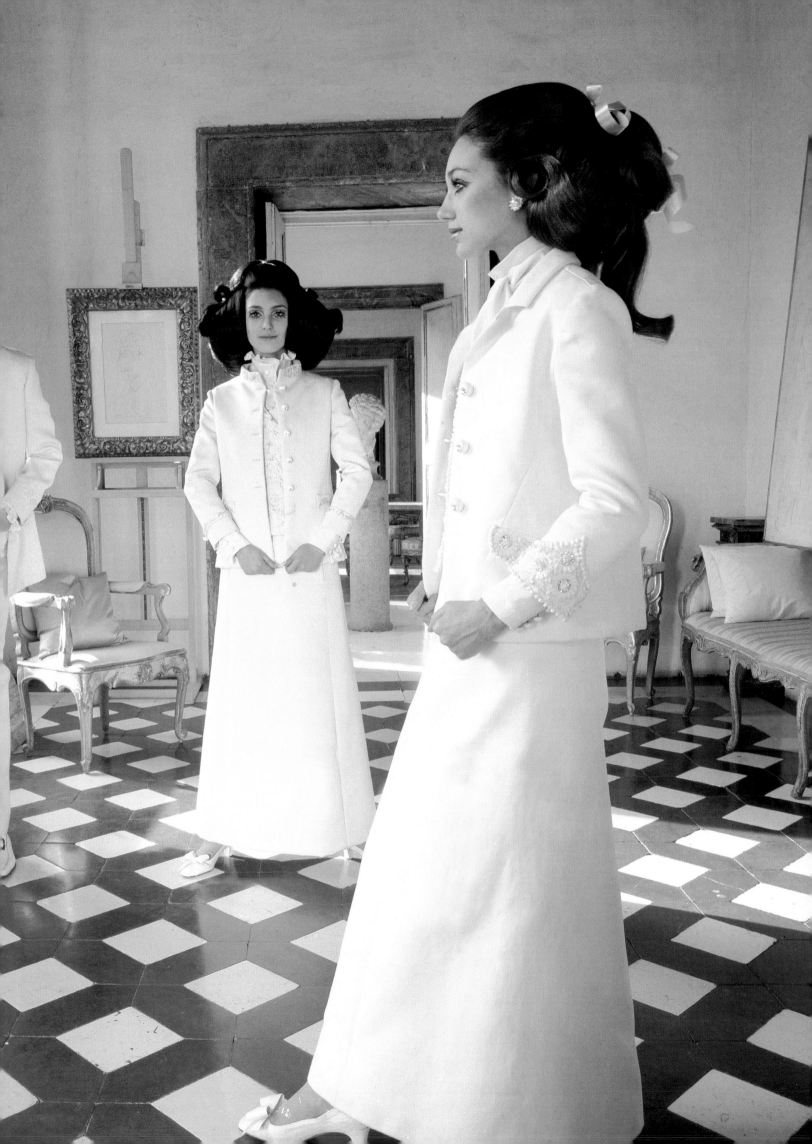

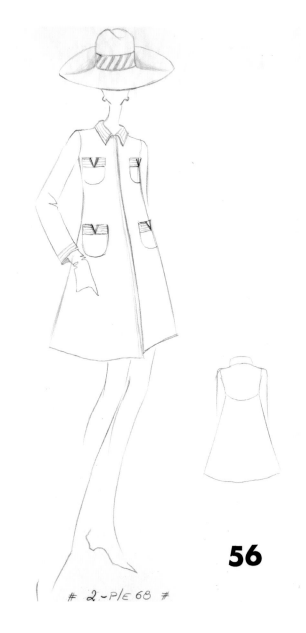

2 - P/E 68

56

SPRING/SUMMER 1968, MODEL 56

DAYTIME COAT MADE OF CREAM-COLORED GABARDINE LINED WITH WHITE SILK

TAFFETA, MOUNTED POCKETS WITH OVERSTITCHING AND ENCRUSTED WITH

V SHAPES IN GILDED METAL. FABRIC: AGNONA.

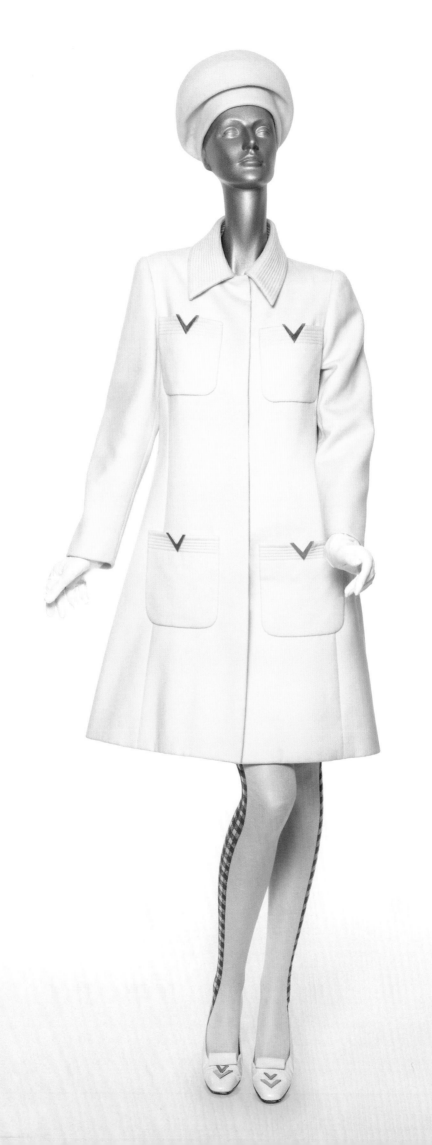

SPRING/SUMMER 1999, MODEL 172

EVENING GOWN MADE OF RED SILK CREPE, AMPLE BODICE WITH BATWING

SLEEVES HELD TOGETHER BY A YOKE GATHERED AT THE WAIST OVER A STRAIGHT

SKIRT WITH TRAIN. FABRIC: CLERICI-TESSUTO.

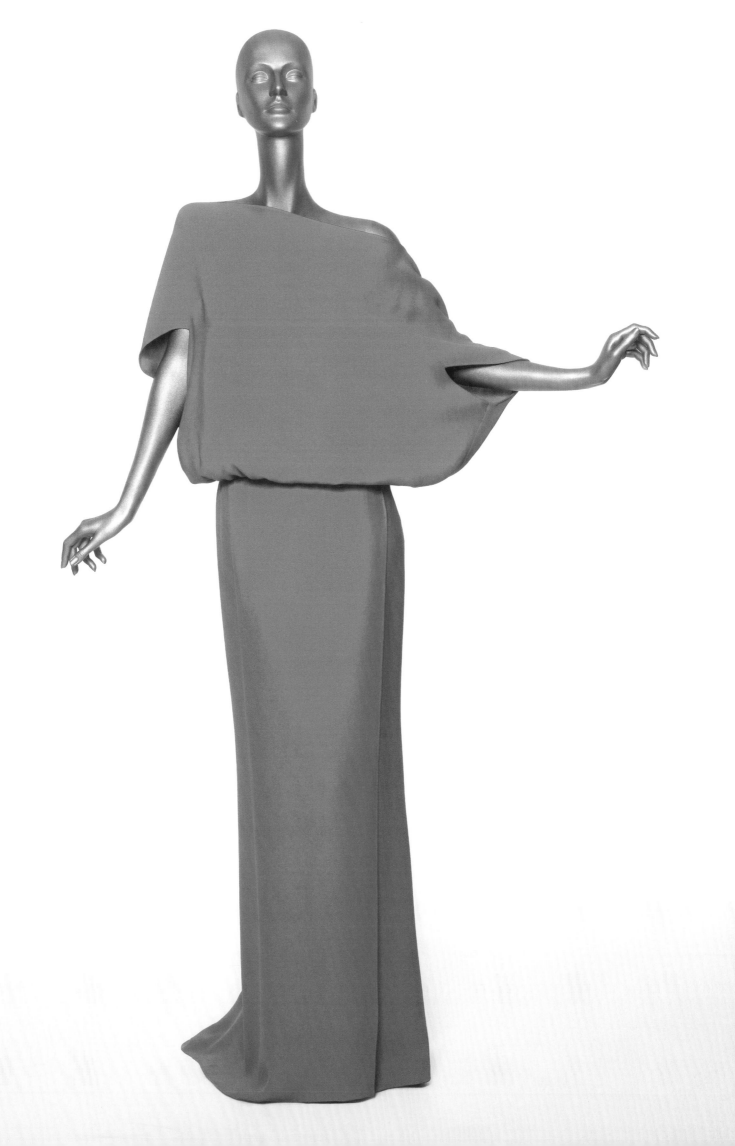

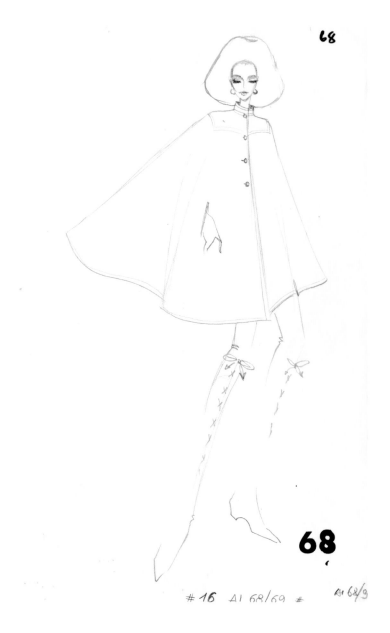

68

68

#16 AI 68/69 # AI 68/9

FALL/WINTER 1968, MODEL 68

DAYTIME ENSEMBLE: DRESS MADE OF CREAM-COLORED WOOL JERSEY WITH LONG SLEEVES,
HIGH WAIST, NO COLLAR, TWO SPLIT POCKETS; CIRCULAR CAPE MADE OF CREAM-COLORED
WOOL AND SHOULDER YOKES WITH OVERSTITCHING. FABRIC: AGNONA.

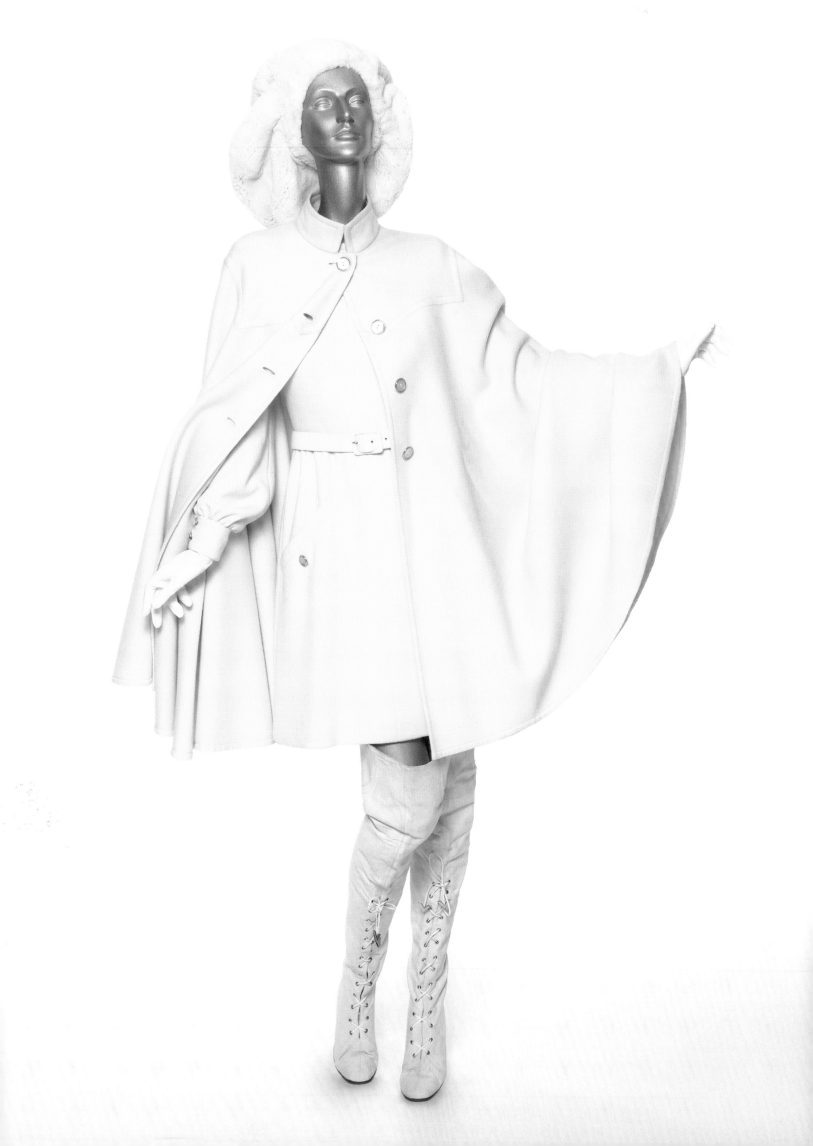

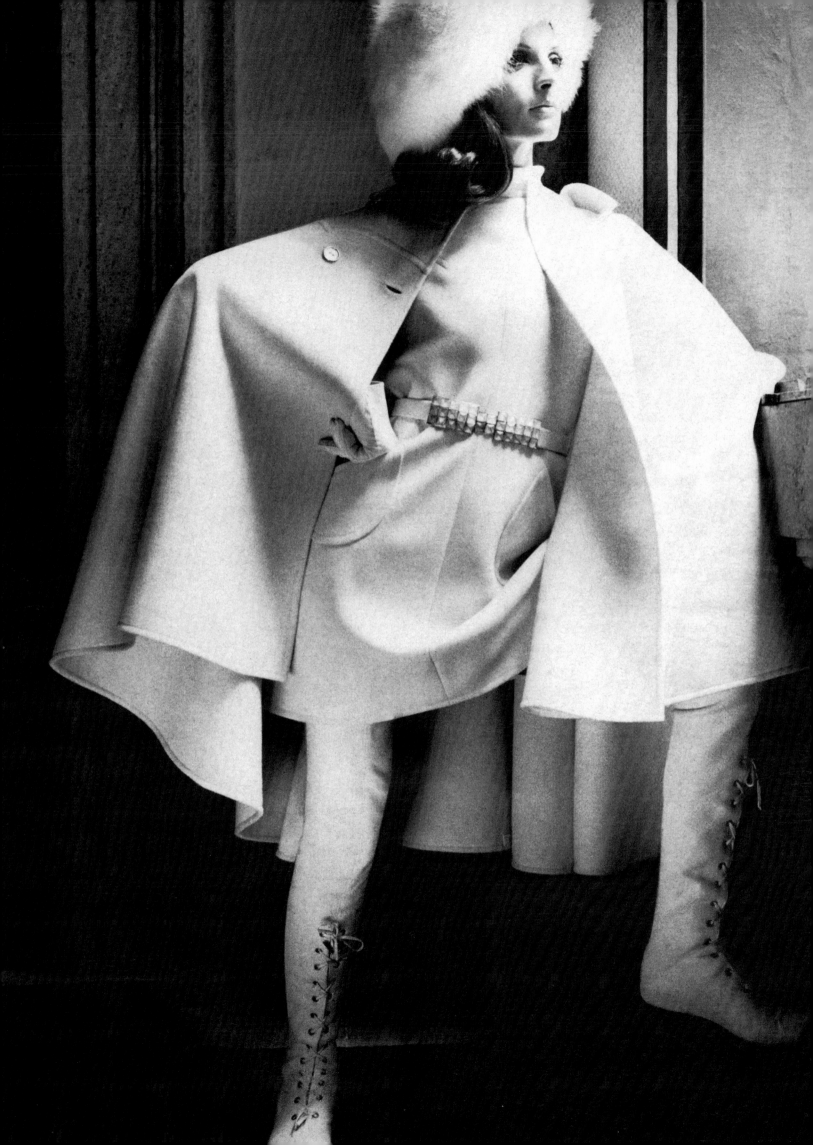

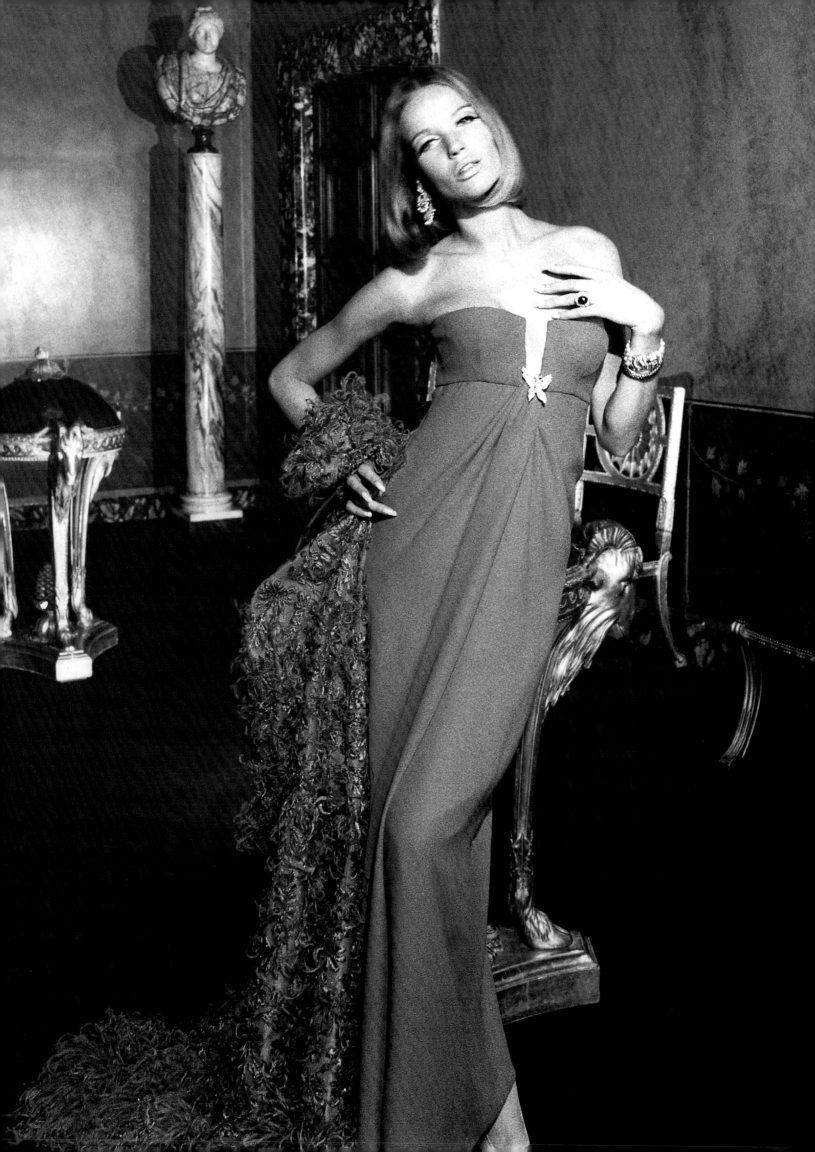

I was never and am not a revolutionary designer. But I'm innovative in the way I always work to dress my woman with new ideas.[1]

As Valentino himself so rightly puts it, he is no innovator in the realm of fashion. Viewed within the broader history of haute couture, he is, however, the recognized champion of a unique silhouette, with a stylistic sensibility uniting supreme grace and timeless allure. Since the debut of his very first collection in Rome, back in 1959, Valentino has always pursued a single goal—that of giving women in general, as well as those in elite circles, an elegance that transcends borders.

Fluid silhouettes, subtle femininity, and refined sensuality are the hallmarks of Valentino's style. His unmistakable designs range from sober, sleek shapes to striking, sophisticated forms. This sensibility—distinguished by a lean, graphic contour—is an integral part of his vocabulary, resulting in styles that are the epitome of understated luxury. His creations unfailingly reflect his ongoing search for expressions of beauty and glamour. Evidence of this is in Valentino's masterful combination of romanticism, modernity, and

classicism in the tradition of Charles Frédéric Worth, the pioneer of haute couture. In the words of fashion critic Hebe Dorsey, "His clothes are not intellectual, hard to decipher clothes. Neither do they carry an intellectual message. Terribly feminine and terribly expensive, they cater to a pampered few."[2]

Yet who, exactly, is the woman Valentino designs for? Throughout his nearly fifty-year career, he has dressed a cosmopolitan coterie of the world's wealthiest women, crowned royalty, and movie stars. These celebrities all live in a protected universe, and love to don the luxuriant uniform distinguished by Valentino's trademark, timeless elegance. According to fashion writer Janie Samet, "Valentino has managed to turn every fashion model into a lady, and every lady into a fashion model. Being his client amounts to becoming the very incarnation of elegance—true elegance. Did these society figures, princesses, and stars give him all that subtlety and love of detail, or did they suddenly acquire their elegance thanks to his designs?"[3]

Valentino's life and career is an uninterrupted flow of successes and achievements. He chose his destiny early on. Like a stage director, he painstakingly builds the fabulous setting for his unique universe, and becomes the hero of his own narrative. With flair and determination, he created a style that is unmistakably his own, and became both rich and famous in the process of making his childhood dream come true. He has indeed fulfilled his fantasy of "gaining access to the universe of incredible women; clothes were but a means to an end."[4]

I was a very, very spoiled child![5]

Valentino Clemente Ludovico Garavani was born May 11, 1932, in Voghera, south of Milan, where his father ran an electrical supply business. His mother named him Valentino as a tribute to Rudolph Valentino, the silent movie star and romantic idol, unwittingly heralding her son's radiant future and status in the eyes of society women. Even as a young child, Valentino was interested in fashion, and his passion was both approved and encouraged by his parents.

While still in his teens, he experimented with his diverse tastes by asking for custom-made sweaters and shoes. He soon set out to improvise his own styles and display his talent in his hometown. Recounting these primary character traits, Valentino recalls, "When I was in lycée in Voghera, I was the little chief of my friends…I belonged to a big group of girls and boys, and I was the one that decided. But I never did it because I wanted to be a chief. I did it because I thought— maybe pretentiously—that the thing that I would choose was the best."[6]

In the postwar period, his older sister Wanda introduced him to Hollywood films. He fell head over heels in love with movies such as The Ziegfield Follies, in which glamorous actresses like Hedy Lamarr, Lana Turner, and Judy Garland wore spectacular gowns and jewels. He already knew where his future lay.

Upon graduation from high school, rather than going to college, he declared that he wanted to become a couturier. With the help of some of his father's connections in Milan, he took courses

in a fashion design school. Six months later, Valentino told his parents he wanted to go to Paris. He was just eighteen years old.

Rome and Paris will always be in my heart, because those two cities made it possible for me to work and express my one and only passion in life—fashion.[7]

Valentino arrived in Paris in 1950, at the height of Parisian haute couture's golden age. Christian Dior reigned supreme with his "New Look," a style launched three years earlier. It marked an abrupt departure from the military look that had preceded it, causing quite an upheaval and foreshadowing a return to luxury. He single-handedly brought fashion manufacturers back into production following the cessation imposed by the war. Dior—*dictateur de la mode*, the absolute leader of fashion—now set the tone, and all other designers followed suit. Valentino had the great privilege of witnessing first-hand a period in which all couturiers gave their own interpretations of Dior's archetypal codes of elegance. Daytime dresses, afternoon dresses, cocktail dresses, evening- and ball gowns were all part of the repertory the young man was swiftly learning to assimilate. Recognizing that he was in the right place at the right time, at the very center of the fashion world, Valentino entered the École de la Chambre Syndicale de la Couture Parisienne.

Upon graduation he applied for apprenticeships at Jacques Fath as well as Cristobal Balenciaga, recognized by his colleagues as fashion's true master. For the interview, he was asked to draw a garment: "It was such a difficult coat—flat in front, big in back. Stupidly, I started with

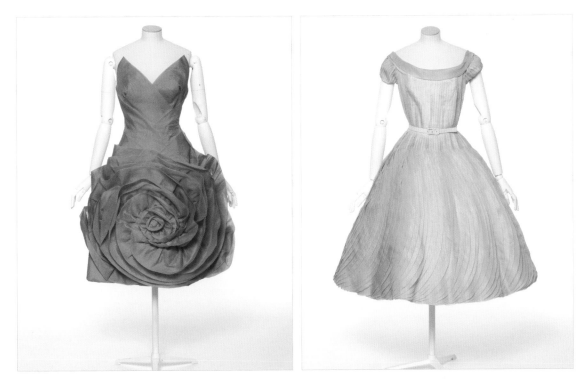

LEFT: ORANGE COCKTAIL DRESS IN SILK ORGANZA. JEAN DESSÈS, 1950-1955. GIFT OF MADAME ZAHARIA LOBEL, 1990. LES ARTS DÉCORATIFS, FASHION AND TEXTILES COLLECTIONS; RIGHT: COCKTAIL DRESS IN WHITE AND ROSE COLOURED GAUZE IN THE FORM OF ROSE PETALS. JEAN DESSÈS, 1950-1955. GIFT OF MADAME ARTURO LOPEZ-WILLSHAW, 1966. LES ARTS DÉCORATIFS, FASHION AND TEXTILES COLLECTIONS (UFAC); PRECEDING SPREAD: VALENTINO IN FRONT OF HIS BOUTIQUE ON RODEO DRIVE, IN LOS ANGELES. NOVEMBER, 1988.

the front and I couldn't get the line. I was so upset."[8] He ended up being hired by Jean Dessès, a designer with a singular place in the world of fashion. In his dictionary of fashion, published in 1952, journalist Lucien François described Dessès in detail: "Raised in Alexandria, this Greek is the most Parisian of Parisians… In collaboration with Guy Laroche, he develops one basic idea every season and steadfastly builds his entire collection around it, in a style that combines Eastern charm and French sobriety."[9] Dessès was a charismatic figure and enjoyed the unwavering trust of his friends, patrons, and associates—prominent figures like André Emviricos and the Marquise de Sourdi d'Escoubleau. Greek shipping magnate Aristotle Onassis was also among them, and once brought Dessès and several of his models to Athens to attend charity events held under the aegis of Queen Frederika.

Dessès's clientele included members of the royal courts of Greece and Egypt, as well as prosperous entrepreneurs and their entourage. Once again in the right place at the right time, Valentino made his debut among crowned royalty, learning the strict rules of their etiquette—a skill that was a major asset when they later became his clients.

Valentino's mentor specialized in resort collections and evening wear, creating delicate-looking cocktail dresses and truly sumptuous evening gowns. His trademark silhouette was characterized by highly sculptural volumes draped in layers of fine fabrics and adorned with beautiful details.

As Valentino tells it, "Guy Laroche was there, too, at Jean Dessès; he had a job more important than mine and eventually he decided to leave the house and to start on his own. One day I met him in the street and he said, 'What? You're still there [at Dessès]? Come work for me!' I said, 'After five years, I am going, too.'"[10]

In 1957, Valentino started his second training period by joining the house of Guy Laroche: "As it was a small house, I dealt with everything, and learnt more and more. I handled all sorts of things—drawings, dressing the models for the runway, and getting into taxis to go and pick up dresses."[11]

Shunning eccentricity of any kind, Guy Laroche became known for younger-looking designs that were more feminine, easy to wear, and full of bright colors such as red and orange. Commenting on his first collection in the newspaper *L'Aurore*, Laroche explained his design philosophy: "I love color. I want to create clothes that sing, suits that are visual symphonies, coats that become colorful little highlights out on the Champs-Elysées… When I design my dresses, my sole guide is the female silhouette… there is no better way to bring out a woman's true beauty."[12] *Color, beauty, and femininity* become the keywords in Valentino's training.

Swept away by an incredibly fresh vitality, the Parisian world of fashion is marked by the emergence of such talented young designers as Yves Saint Laurent and Karl Lagerfeld, who breath new life into the established fashion houses. Saint Laurent succeeds Christian Dior in 1957, and is crowned "prince of haute couture" by the international press. The following year, Lagerfeld becomes artistic director of the house of Jean Patou.

At this key moment, Valentino decides to return to Rome, open his own fashion house, and realize his long-term dream of becoming the Italian couturier par excellence.

This year the newest boy is Valentino, aged twenty-seven, from the neighborhood of Milan, and already a veteran of Paris, with five years at Dessès and two at Guy Laroche behind him. His salon in the apartments of Guglielmo Marconi is the most splendid in Rome, and for his first collection for foreign buyers he presented 120 models.[13]

In his drive to succeed, Valentino also had the unfailing support of his parents. With funds from his father and a business partner, Valentino opens his first couture house at 11 Via Condotti, a stone's throw from the Piazza di Spagna, in Marconi's magnificent drawing rooms. He presents his first collection, called Ibis, for the 1959 spring and summer seasons. Reflecting on it, Valentino confesses, the collection "was full of ideas, but it had no personality… Gradually, everything I did became softer and more elegant."[14] The international press did not hesitate to stress his Parisian training: "His former training at Dessès is revealed by skilled drapings in evening chiffons… Valentino's merit is his effort to give a youthful look to difficult coats and suits."[15]

The following year, as Rome's Dolce Vita era was in full swing, Valentino met the young Giancarlo Giammetti, who soon became his right-hand man, faithful companion, and alter ego. As Giammetti recalls, "It was my second year in architecture school. I often went to the Via Veneto for an ice cream. Everybody always went there to watch the world go by, from the cocktail hour 'til two in the morning. Big cars. Sophia Loren, Gina Lollobrigida, Marcello Mastroianni, Fellini with Anita Ekberg, Elizabeth Taylor and Richard Burton. One evening [July 31] I was sitting by myself at the Café de Paris. It was about eleven p.m. and I was waiting for a nightclub to open up. I suddenly saw three guys show up, one of whom looked vaguely familiar… One of them came up to me and asked if they could sit at my table, as there was no place else… 'Of course,' I said. That's when I found out that one of them was called Valentino."[16]

Quite by accident, they met again ten days later on the island of Capri. After the summer holidays, Giammetti regularly visited Valentino on the Via Condotti. He left his studies in order to help out his new friend, who was having financial difficulties after his father's partner decided to withdraw his initial investment. Giammetti noted, "When our enterprise did not prove an instant success, this gentleman realized that it takes time to make money in the world of fashion. I've no doubt that he also thought Valentino a little extravagant, and wanted his money back, so the house of Valentino found itself on the verge of bankruptcy."[17] Valentino's parents once again came to the rescue, selling their country house to keep their son afloat: "We decided to take everything that was in the Via Condotti and move elsewhere. We even went back one night to steal all the chairs in the salon, because Valentino liked them so much. They were gilded Regency chairs, and I clearly remember taking them to the new salon at 54 Via Gregoriana. It was a fairly large apartment on the first floor, and we took three quarters of it, leaving the remaining quarter to the owner. We held two small salons there, one overlooking the Via Gregoriana, the other right behind it. We had our atelier, office space, fitting rooms, everything."[18] Valentino was soon visited by leading Italian actresses, dressed

Monica Vitti in Antonioni's film *L'Avventura*, and met Elizabeth Taylor on the set of *Cleopatra*.

In the early sixties, Italian fashion had not been around for very long—a mere decade, if that. Until then, it had only existed in the form of small local designer initiatives, with no international scope. It was not until 1951 that Count Giovanni Battista Giorgini, the visionary who gave Italian fashion its national identity, gathered Italian couturiers together to present their work as a non-derivative movement quite distinct from the reigning French fashion of the period. To mark the occasion, and astutely invite the clientele before their budgets were committed to other collections, Giorgini made a point of organizing his first shows a week before the Paris ones, in late February, in his Florentine palazzo. The fifteen participating couturiers provided an alternative to the sophistication of French fashion in the form of a more pragmatic, easier-to-wear approach.

Functional as well as elegant, Italian fashion perfectly suited traditional American tastes. American buyers now found youthful, practical designs impeccably paired with their dynamic lifestyle.[19] Because wages in Italy were particularly low, Italian designs sold for thirty- to fifty per-cent less than the Parisian fashions. What was more, labor was abundantly available, which meant that orders could be delivered within a week, whereas they took at least six weeks in Paris.[20] From 1952 on, the Florentine shows were so successful that they were staged in Palazzo Pitti's prestigious Sala Bianca. *Alta moda* (Italian for haute couture), made a rapid ascent. Its distinctly regional center moved from Florence to Rome, and soon split into three different camps: the couturiers who stood by Giorgini and showed their collections in Florence; the established Roman houses, which preferred to show in their own salons; and the many emerging new talents.

In 1962 the key moment arrived; in the midst of all this competition, Valentino decided to join the Sala Bianca group—a decision that ultimately made him famous.[21] Giammetti still recalls how he took a train to Florence to see Count Giorgini: "[Giorgini told me] 'Yes, I have heard of Valentino; unfortunately I have not got much room left for next season. If you want to show, I can only give you an opening for the last day, at the very end.' Naturally I accepted, and we showed our collection. It was the first time that American buyers stayed on, to see Valentino. We were flooded with orders. Needless to say, the following season we were given the place of honor."[22]

By 1963 Valentino and Giammetti—known simply as the *due ragazzi*, or "two boys"—were traveling to the United States several times a year to show their designs in the major cities. This was a novel initiative at the time, and led to the Valentino name becoming a well-established brand

ANNOUNCEMENT OF VALENTINO'S FIRST FASHION SHOW IN FLORENCE AS IT APPEARED IN WOMEN'S WEAR DAILY, JUNE 25, 1962; PRECEDING SPREAD: VALENTINO IN HIS SALON AT 54 VIA GREGORIANA, ROME.

throughout North America. They reached out to the media, met with powerful buyers from leading department stores as well as representatives of upscale boutiques, and made the acquaintance of such leading society figures as the Duchess of Windsor, Gloria Guinness, Babe Paley, and Jayne Wrightsman, all of whom soon became their loyal clients: "Babe and Gloria would buy about eight to twelve outfits. These were the days when they needed at least forty outfits per season. These women used to change three or four times a day!"[23] From New York to Los Angeles, and Palm Beach to Chicago, Valentino had won over the fashion world. He was in it for the long run, and this was the beginning of his awe-inspiring monopoly.

As Giammetti recalls, "We were offered money in America to design collections, and Valentino returned almost seasonally. He earned a great deal of money that way. I remember the day a buyer from Bloomingdale's called me to order fifty little red coats. It was Valentino's first ready-to-wear production, which we actually produced in our atelier. We also had major buyers, people like Miss Martha who, with her three boutiques in New York, Palm Beach, and Palm Harbor, had an extremely wealthy clientele. We sold 300–400 dresses per season to her alone! Money began to pour in, and soon made the Valentino firm's fortune. Our labor costs were so reasonable that we were able to turn out couture clothes at the price of ready-to-wear."[24]

In September of 1964 Valentino showed his collection at the Waldorf-Astoria Hotel in New York. By then his reputation was well established in prestigious circles, and it was not long before he designed clothes for the most famous woman of them all, Jacqueline Kennedy. With the help of a mutual friend—Gloria Schiff, a *Vogue* fashion editor—a private showing was set up. Valentino seized the opportunity: "I was in touch with Jackie and she wanted to see the clothes. So my assistant went with a model to see her at her place on Fifth Avenue to show her part of the collection. I will never forget what followed, for it was the best day of my life. When they came back, they said to me: "Mrs. Kennedy wants all of the designs in black and white."[25] This event marked a turning point in Valentino's career: "I owe so much to Jacqueline Kennedy. Meeting her meant so much to me. She became a very close friend. I designed her entire wardrobe, and she made me famous."[26]

This turn of events made it possible to develop the Roman couture house. In 1965, as Giammetti recalls, "we opened salons in Milan, with a boutique on the ground floor at 3 Via Sant'Andrea. We hired Elena Villa, who was a saleswoman at Veneziani and already had all of Milan as her customers. By then we had 160 people working for us in our ateliers—100 in Rome, and at least 60 in Milan."[27] The following year Valentino decided not to show at the Sala Bianca, and returned to Rome to show them in his own salon, on the Via Gregoriana.[28] His shows closed the week of events known as the Settimana dell'Alta Moda, which had become the city's main social event. In 1967, he was awarded the prestigious Neiman Marcus Award, an American fashion honor that had previously been bestowed upon Christian Dior. Later on in this eventful year, his success unwavering, Valentino moved down the street to 24 Via Gregoriana, a magnificent eighteenth-century palazzo that belonged to the Vatican.[29]

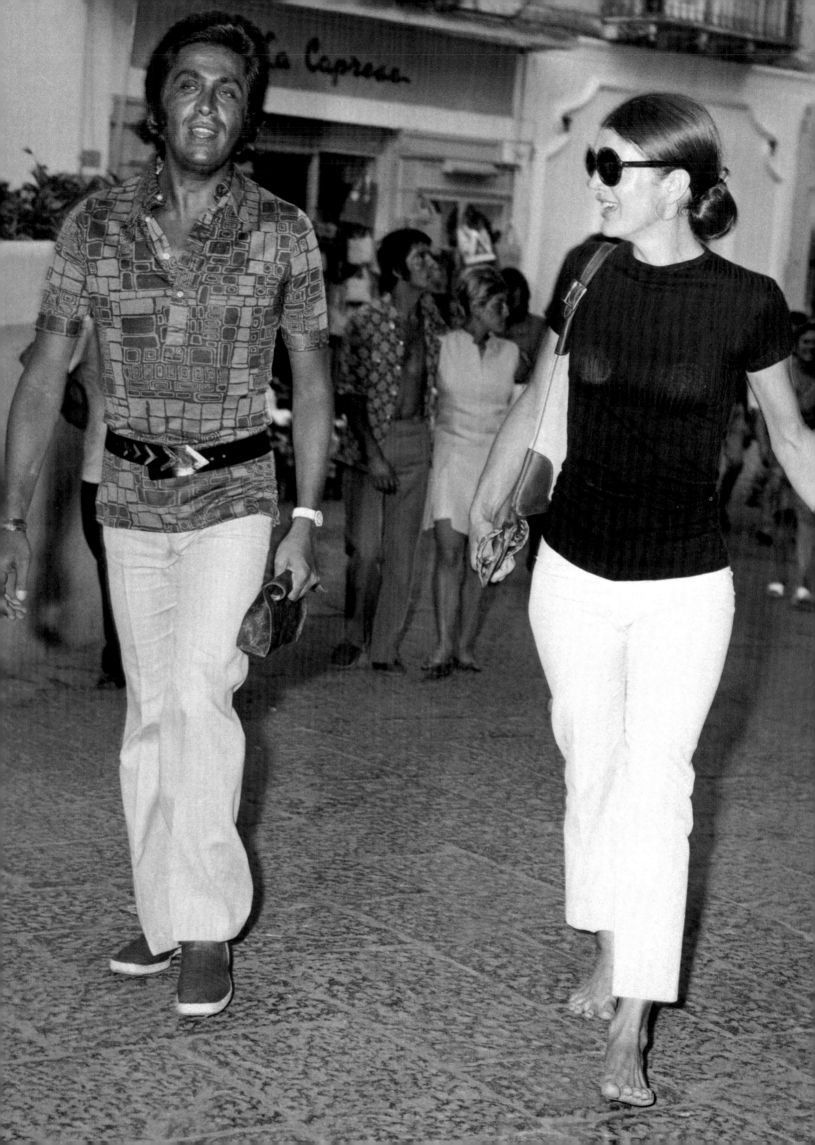

Life looks ever so much sweeter and calmer up the street in the Valentino salon…[30]

The landmark year of 1968 brought Valentino to the pinnacle of his fame. While the world of fashion featured bright and lively colors, in January of that year Valentino showed his famous white collection. That month's *Vogue* wrote, "Valentino's white—the talk of Europe. The cleanliness and distinction of his crisp whites, his lacy whites, his soft and creamy whites, all shown together white on white. And all triumphs for the thirty-five-year-old designer who, pouring out all this beauty, romance, and perfection, has become the idol of the young, a new symbol of modern luxury…."[31] Other articles noted that "Valentino's white does not mean the chalk color that needs a good tan, or the famous Courrèges sheet-white that looked so antiseptic. His white is the color of Devon cream, and the palest girls will be able to wear it."[32]

Apart from the color white, he also included shades of beige and navy, not to mention the color red, which was his firm's hallmark: "It's Valentino's white on white collection… When one bright red costume came on the runway, it was something of a shocker after all the white. Valentino always includes one thing red for good luck, but he really doesn't have to worry. He has that old-fashioned magic, built in."[33]

Amidst the rioting and strikes that paralyzed all of Paris during the events of May 1968, Valentino's first ready-to-wear boutique opened there. *Le Figaro* announced its arrival, noting that "There was not the slightest ulterior motive in Italian designer Valentino's choice of the Avenue Montaigne (number 42), a mere few steps from Dior, for his first boutique in Paris. Minouche Le Blanc and Isabelle de Castellane (Patino), the Duchess de Cadaval and Lays Gauthier are not only underwriting it, but will also run it, while the sales staff will all be young debutantes. An ultramodern décor, very Italian to be sure, that is the work of Valerian Rybar. [It features] a 300-square-foot façade with large windows, and an interior on three levels."[34] This boutique facilitated further development of the Valentino label, provided for the house's growing capital, and strengthened the designer's privileged ties to an already loyal, elite clientele.[35]

Another patron was Jacqueline Kennedy, who by now had become his muse. Giammetti confirms "Jackie really became a muse for Valentino. She was an enormous inspiration, because she was an ideal woman for Valentino—enormously sophisticated and elegant. She was a woman who had responsibilities, a very strong will and enormous discipline."[36] Because she

JACQUELINE AND ARISTOTLE ONASSIS THE DAY OF THEIR WEDDING IN SKORPIOS, GREECE. OCTOBER 20, 1968. SHE CHOSE A DESIGN FROM THE "WHITE COLLECTION" AS HER WEDDING DRESS; OPPOSITE: VALENTINO WITH JACQUELINE ONASSIS IN CAPRI. AUGUST 24, 1970.

bought virtually all her clothes from Valentino, the media naturally concluded that she would wear a Valentino for her marriage to Aristotle Onassis. Indeed, Jackie had already chosen her dress several months before from among the models in the "white collection."[37] She chose a particularly simple design, consisting of a high-necked, long-sleeved blouse with horizontal lace appliqués and a short pleated skirt made of ecru crepe georgette; the subtle contrast between the style's two pieces made it a most distinctive choice. The wedding took place on October 20 on the Greek island of Skorpios. As a result of the unprecedented press coverage, the name Valentino spread beyond elite society and onto the international stage. Having spent some ten years of intense creativity developing his designs, at the age of thirty-six Valentino was now at the very height of his career.

V stands for Valentino—and Victory in Business.[38]

"If Valentino didn't exist… the American buyer and the American fashion press would have created him just so that they'd have an excuse to go to Rome twice a year. With the help of geography, Jacqueline Onassis, America's Kenton Corp. and a 35-year-old business associate (Giancarlo Giammetti) who's one of the shrewdest fashion dealers ever to drop a name or pick up a fortune, Valentino does exist."[39]

As Italian fashion's leader, Valentino single-handedly brought everyone to Rome. *Vanity Fair* spread the claim that "Without Valentino, Rome would be dead. He is absolutely certain about his designs. All the rest of high fashion in Rome is uncertain and boring in comparison."[40] Women would make a bona fide pilgrimage to see his latest designs debut in his salon and spend a few days in the Eternal City. Although everyone seemed to come to them, Valentino and Giammetti refused to rest on their laurels—they took the initiative and reached out to even broader markets. Despite the commercial successes, Valentino had nevertheless remained an Italian designer, and Giammetti felt that the moment had come to expand the firm and turn it into an international business. It was in the particular domain of ready-to-wear fashion that the principal change took place.

Having been produced in private ateliers up to that point, these collections now had to be realized by an experienced manufacturer. Giammetti chose the French garment firm of Mendès, founded in the early twentieth century, which had become the only manufacturer specializing in haute-couture ready-to-wear. It closely collaborated with a dozen French fashion houses, including Jean Dessès, Guy Laroche and, needless to say, Yves Saint Laurent.[41]

The agreement with Mendès Director Didier Grumbach was signed on December 11, 1974. As Grumbach recalls, "It was a contract that had called for tough negotiations. We signed at five o'clock in the morning. Valentino had already become an important label in America, and a well-known one. His fashion house had a special, well-defined character. For a manufacturer like Mendès, this was by far the most attractive Italian label. I think that at that time we were in a

fairly dominant position. We could not have taken on any Italian label other than Valentino."[42]

This partnership gave Valentino his passport to the Parisian and international scenes. While his haute couture fashion shows were still held in Rome, Valentino now showed his ready-to-wear collections in Paris. Between 1972 and 1973 the leading Italian houses left Florence to go and show their collections in Milan, which then became the Italian capital for ready-to-wear

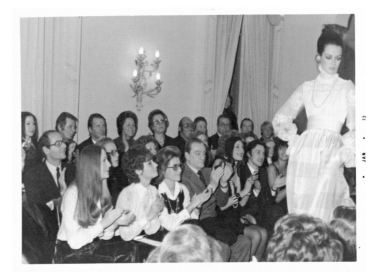

design. Valentino's decision to favor Paris was quite courageous; until then, no Italian designer had ever managed to prosper there on a lasting basis.[43] On April 9, 1975, he showed his Fall-Winter collection at the George V hotel. A *New York Times* reviewer covered the event: "Anyone around here remember elegance? It took Valentino, a foreigner, to revive it the other night, and not everyone was delirious. In Rome, Valentino's showings are as famous for the audience as for the clothes… But besides the weather, there was an element of frigidity…The French are notoriously inhospitable to fashion intruders. Americans and Italians far outnumbered the French observers in the seats along the runway."[44] It must be said that there was a huge variety of choice, and the competition was keen. The press had to cover more than fifty fashion shows over a ten-day period, from March 31 to April 11, with designs by such well-established names as Anne-Marie Beretta, Christian Dior, Karl Lagerfeld for Chloé, Kenzo, Issey Miyake, Sonia Rykiel, Thierry Mugler, Yves Saint Laurent, Emmanuel Ungaro, and others. Additionally, there was the international women's ready-to-wear trade fair at the Porte de Versailles that featured nearly 1,000 participants. As Giammetti recalls that time, "I think the French had a rigidly structured management of their fashion houses; it paid off in the end, because French fashions were

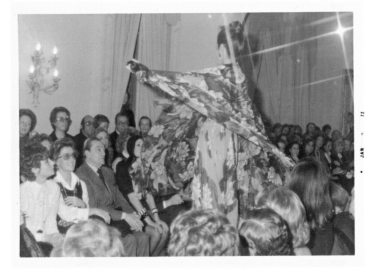

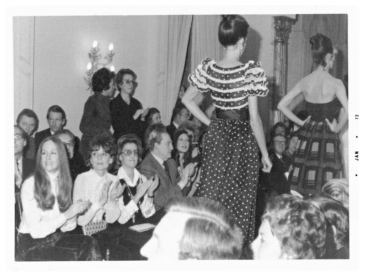

SPRING/SUMMER 1972 VALENTINO FASHION SHOW IN HIS ROMAN SALONS.

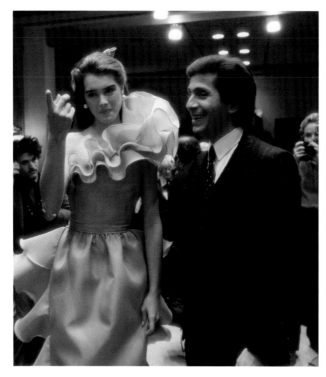
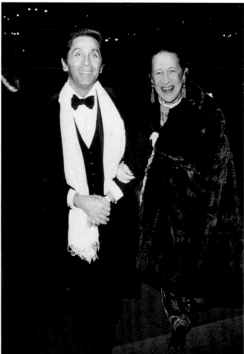

highly respected. The Italian designers were perhaps too flexible, catering too much to their customers, and making too much of a commercial effort —which certainly was not the case with Valentino."[45]

The Italian fashion industry is in trouble. There are some remarkable exceptions, of course. Valentino continues to be one of the most successful fashion designers in the world.[46]

In the seventies, the Italian fashion industry was up against a pernicious political and social situation made worse by the appearance of the Red Brigades. This unstable period signaled the end of the country's Dolce Vita. Cinecittà, the Italian Hollywood, hosted fewer and fewer American mega-productions. Rome was changing. From one day to the next, this cosmopolitan city had reverted to its provincial past. Making the most of a difficult situation, Valentino and his fashion house remained solid; his international renown now granted him entrée any- and everywhere, and he continued to enjoy his manufacturers' deep trust.

Another important step was the launching of the first perfume, naturally named——*Valentino*. It was the product of collaboration with the cosmetics subsidiary of the multinational company Unilever. To celebrate the event, a Parisian soiree was held at the Théâtre des Champs-Elysées on October 16, 1978. To music by Tchaikovsky, the Russian dancer Mikhail Baryshnikov performed Roland Petit's *Queen of Spades* ballet. Following this gala performance, 250 guests went on to dinner at Maxim's and then on to Le Palace, a favorite Parisian nightclub.

In 1979, after five years of partnership with Mendès, their collaboration came to a close. Giammetti transferred the Valentino ready-to-wear production to the Turin-based Gruppo

Finanzario Tessile (or GFT, a major textiles financial group). Until then, no Italian company had been up to the task of meeting the technical and commercial requirements of the house of Valentino.[47] But by the late seventies Italian manufacturers had caught up, and were able to compete with their French counterparts.

In order to develop their activities and diversify, designers now went in for new strategies by creating various franchises; the Valentino brand name was no exception. Handbags, luggage, umbrellas, handkerchiefs, ties, belts, and shoes all carried his label. According to Giammetti, "At one point we had over forty franchises in Japan alone, and that brought in a lot of money. Years later I began to feel we could not continue such vast expansion, and that we had best take the enterprise back into our own hands."[48]

On February 9, 1981 the cover of *Time* magazine carried a photograph of the actress Brooke Shields with the caption "The '80s Look." On the issue's inside pages she wore a red dress by Valentino. Aside from being a characteristic example of the designer's style, this garment also defined the new decade's spirit, and underscored his growing influence.

Under the aegis of Diana Vreeland, fashion's high priestess, his winter collection was shown in New York on September 20, 1982, during a gala evening attended by a select group of 800 VIPs. Once again the *New York Times* covered the event: "Not everyone can give a party in the awesome, vaulting halls and galleries of the Metropolitan Museum of Art. To be allowed to do so, one must be a corporate patron of the museum. Once that hurdle is clear, it is still not everyone who has the imagination, as well as the wherewithal, to toss the party."[49]

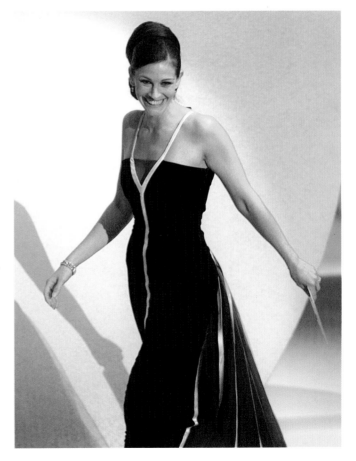

For the Fall/Winter collection of 1983, Valentino ventured from palazzo to piazza; the increasing attendance had outgrown his sumptuous salon, so he moved the show to an outdoor setting just steps away, and in mid-July the collection debuted in the Piazza Mignanelli before a thousand guests of honor. For the following five years, all of his winter collections were shown under a midsummer evening's sky in the piazza.

By 1988 the house of Valentino occupied most of the Palazzo Mignanelli. The expansion had begun long ago, and over a period of twenty years it had slowly grown over the building's four floors, moving into them one by one. With a surface of

JULIA ROBERTS WEARING VALENTINO TO THE 2001 ACADEMY AWARDS WHERE SHE WON FOR BEST ACTRESS; OPPOSITE, LEFT: VALENTINO WITH BROOKE SHIELDS AT HIS FASHION SHOW IN ROME, JANUARY 1981; OPPOSITE, RIGHT: VALENTINO WITH DIANA VREELAND ARRIVING AT A BENEFIT FOR THE BALLET RUSSE EXHIBITION AT THE METROPOLITAN MUSEUM OF ART IN NEW YORK, NOVEMBER 20, 1978.

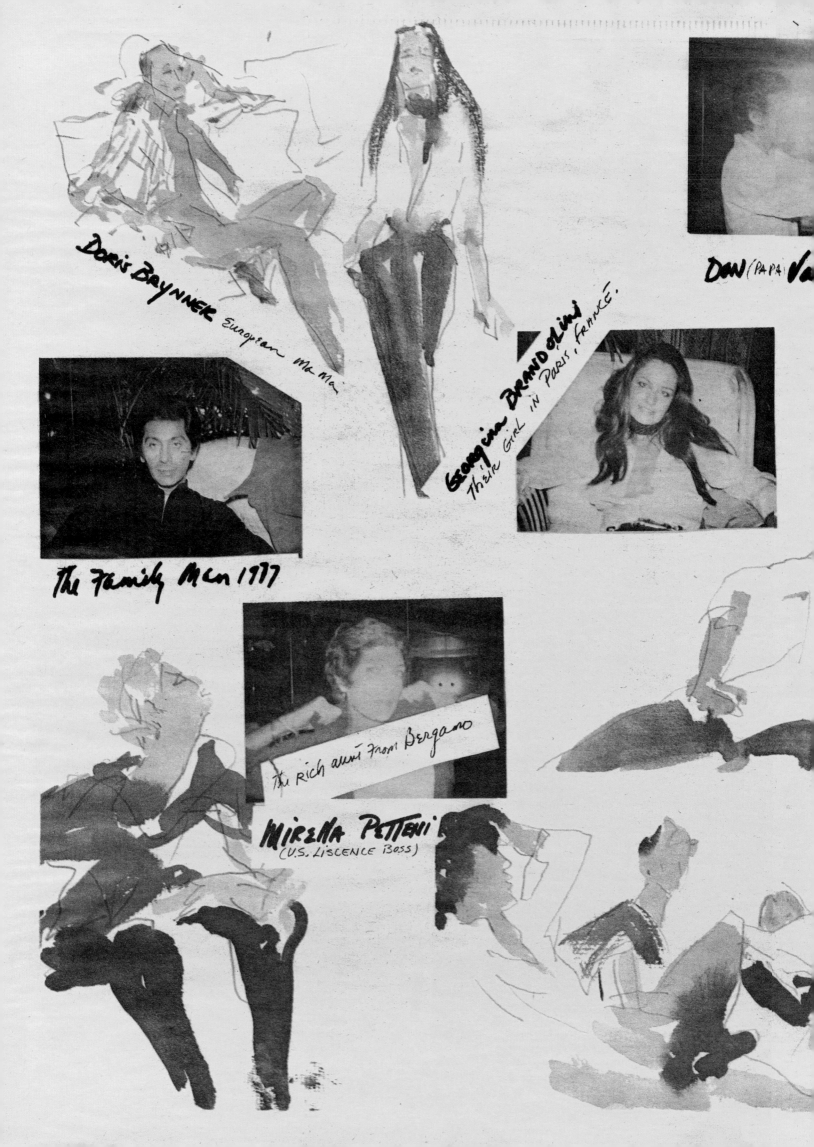

Doris Brynner European Mama

Georgina Brandolini Their girl in Paris, France.

Don (Papa) Va

The Family Men 1977

The rich aunt from Bergamo

MIRELLA PETTENI (U.S. LISCENCE BOSS)

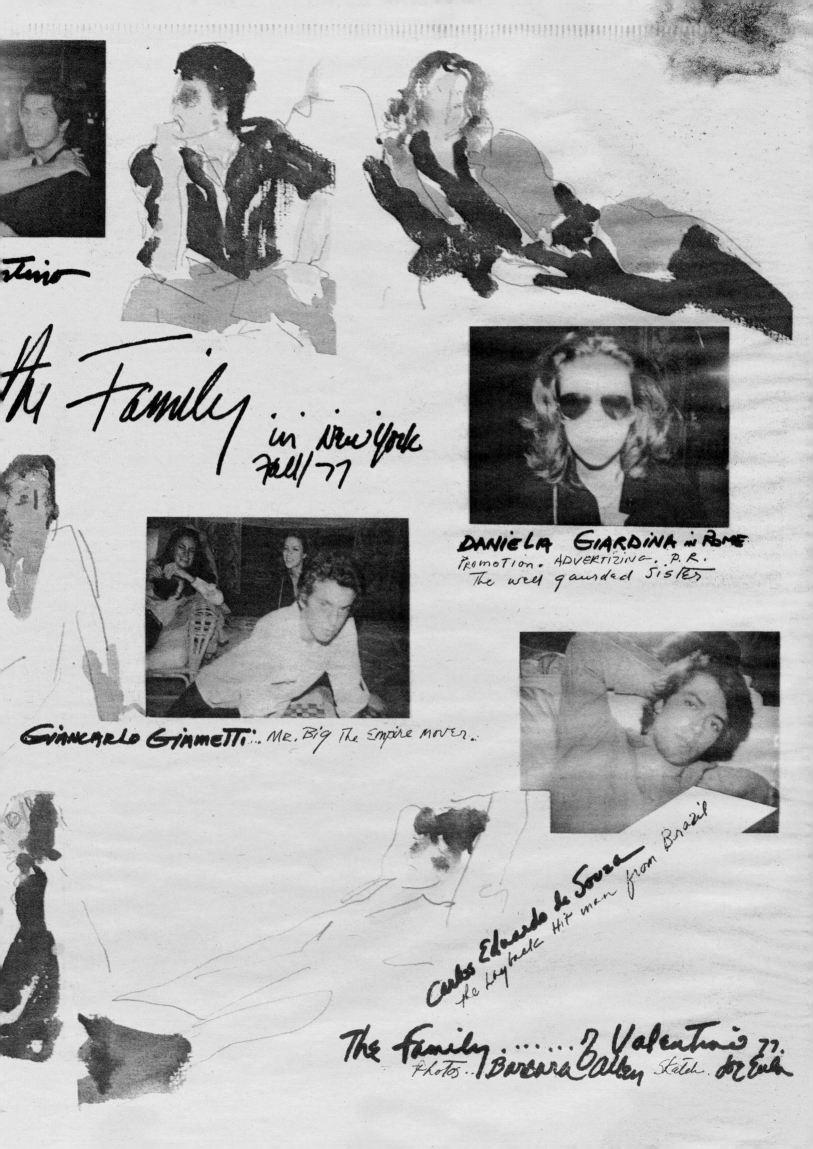

tino

The Family ... in New York Fall/77

DANIELA GIARDINA in ROME
PROMOTION. ADVERTIZING. P.R.
The well gaurded sister

GIANCARLO GIAMETTI... Mr. Big The Empire mover..

Carlos Eduardo de Souza the Layback Hit man from Brazil

The Family by Valentino 77.
Photos.. Barbara Allen Sketch. Joe Euls

some 12,000 square feet, the palazzo became the home base of the company's management, ateliers, showrooms, and administrative services—all now finally grouped together on premises worthy of the Valentino reputation. Valentino had gone from just one floor of this luxurious palazzo, with an unassuming entrance on the Via Gregoriana, to occupy the entire building, including the main entrance overlooking the Piazza Mignanelli. Every single piece of the puzzle was now in place; the only thing left to do was take the final step: take the Valentino élan for *alta moda* to the birthplace of haute couture—Paris. On January 28, 1989 Valentino showed his first haute couture collection at the École des Beaux Arts. *Le Figaro's* Janie Samet wrote, "For Italy, this is treason: for the first time its foremost and most famous designer, Valentino, has chosen to show his haute couture collection in Paris. This is an unusual and courageous move (following, as he does, the Dior, Chanel, Saint Laurent and Givenchy collections suggests that he is sure of himself), and if Valentino comes over here to charm us, he does so above all to cultivate the leading foreign press that takes the trouble to come to Paris, but not to Rome."[50]

When I first started out, I created collections with two hundred thousand ideas. Thirty would have been enough. Over time, I learned to make real dresses, for real women, who also have real needs.[51]

At the dawn of the nineties, Valentino's showmanship was once again called for. To celebrate the thirtieth anniversary of his house, he organized a grandiose event in Rome in 1991. Needless to say, this sumptuous celebration included lunches, gala dinners and dances; to top it all off, two major exhibitions of his designs were also held.

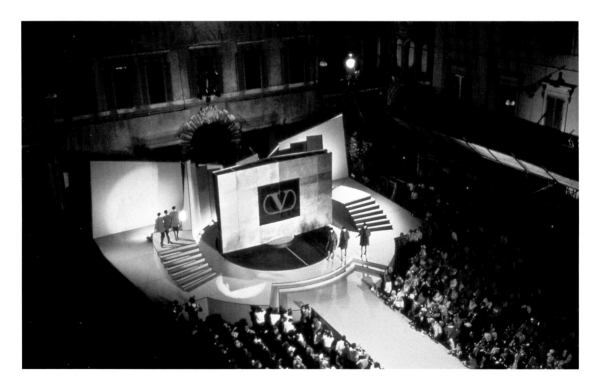

VALENTINO FASHION SHOW ON THE PIAZZA MIGNANELLI, 1984; PRECEDING SPREAD: "THE FAMILY" AS SEEN IN INTERVIEW MAGAZINE IN THE FALL OF 1977.

These events traced the entire course of his unique career, its trajectory, and his way of developing an idea in pursuit of perfect form. Throughout the twists and turns of his career, Valentino has always explored and refined the myriad variations on the themes he took up, all the while adapting them to the dress codes and standards of his contemporaries. The whole of his approach can be summed up in a mere four words: *sensuality, delicacy, glamour* and *grandeur*. Despite having spent thirty years applying his unusual ability to continually reinventing the ephemeral, Valentino never lost sight of what matters most: "When I start putting together a collection, my ideas automatically progress along parallel lines. That is, I first think of a sublime and wonderful, hieratic type of woman who will show my dresses on the runway; but right after that I think of all the women in the world who can wear them. Yes, I do want my dresses to be worn by real women, whether they are beautiful or not so beautiful, but attractive; for what I look at with great attention is not so much physical beauty. Some women have a great deal of character and incredible charm merely due to their intelligence, the way they speak and move or react. And that is worth all the elegance in the world."[52]

Since his first collection, Valentino also distinguished himself by keeping a private life outside of his professional demands. As early as 1959, an Italian periodical wrote, "He does not 'create' a new model while listening to a Bach chorale, and he does not weep in desperation when something is not going right: he works eight hours a day, and when it's a beautiful sunny day he treats himself to a trip up the Pincio."[53] Except when working full-time on his collections, Valentino leads a full life far outside of the world of fashion with his closely knit family and friends. What Valentino most prefers is sharing his lifestyle at the splendid houses he owns in London, New York, Paris, Rome, Gstaad, and Capri. His charm and sensibility help recreate the atmospheres of classic Hollywood sets, and every single one of his homes is a reflection of the dream he has made come true. Valentino lives on a grand scale, offering no apologies for his whims and desires, and wears his success proudly on his sleeve. As a friend of his noted, "Nobody lives like Valentino. I don't know anybody who lives as grandly as Valentino. I mean, nobody has these huge houses everywhere—except people who had them forever, yes. But he just enjoys it so much and that's what's great about it all. He enjoys every second of it, every square inch and every mile. He just enjoys everything he has. He's not at all blasé. Valentino loves beauty; he loves everything that's beautiful. He loves everything he has, which I can't blame him for. I mean, the opulence is unbelievable."[54]

Valentino and Giammetti only saw members of the fashion crowd during the hectic days when collections are being shown. As Giammetti sees it, "The fact that we were based in Rome no doubt kept us from getting entangled in a whole web of relationships. We greatly benefited from not living in a fashion capital; this allowed us to pursue our own course, and was certainly a factor in our longevity."[55]

By the end of the nineties the world of fashion was taken over by such powerful French groups as LVMH (Louis Vuitton Moet Hennesy) and PPR (Pinault Printemps Redoute), with

their monopoly on the market for luxury goods. Giammetti was convinced that, in order for it to develop and remain competitive, the Valentino house had to merge with a leading financial group. The latest transformations occurred in the wake of three successive sales. The first of these took place in 1998, when Valentino and Giammetti sold their business to the Italian holding company HdP (Holding di Partecipazioni Industriale) for some 330 million dollars.[56] *Women's Wear Daily* heralded it as "… the first marriage of fashion with finance in Italy. The evolution of the house of Valentino charts the development of Italy's designer industry."[57] Despite the fact that their new partner was being run by such illustrious Italian names as the Agnelli and Pirelli families, this marriage of convenience did not last, as the group's main focus was not on the world of fashion. Four years later the house of Valentino was sold once more, and became part of the Italian group Marzotto. The *International Herald Tribune* covered the deal: "The future of the company was secured by Giammetti's vision in developing around couture licenses more affordable ready-to-wear, fragrance and ancillary products—and above all by the sale of the company to Marzotto in 2002, which has justified the 340 million, or $400 million price tag, by accelerating growth and profit." The last change came about in 2007, when "Permira Advisers bought a stake in Valentino Fashion Group, in the biggest investment in a luxury brand by a private equity firm. The deal values the maker of dresses worn by the likes of Sophia Loren at $2.6 billion."[58]

Fashion is a passing thing… Elegance is innate.[59]

On January 23, 2008, in Paris, the time had come for Valentino to put an end to his career and say goodbye. The international press attended his last fashion show, which took place underneath a gigantic tent set up in the gardens of the Rodin Museum. Nine hundred guests were invited to this enchanted evening, illuminated by a full moon. Valentino's departure became a reality, but—as usual—the creative genius in him had the last word. No sooner was the show over than a standing ovation rose up from the stands. Highly dignified as always, Valentino appeared and stepped onto the podium to the sound of cheers and loud applause from all the fashion-world elite who had come to pay tribute. The international press was there to watch: "Perhaps Valentino's greatest attribute is to appear timeless, offering the harmony and grace so rare in the cacophony of modern fashion and making this final collection an ode to women."[60]

"Since that last show," says Valentino, "I give the impression that I am quite well. In fact, though, I try to convince myself of that, for what I will miss the most is coming to work. What always interested me most was to be able to sit down and draw."[61] As for Giammetti, "We have always worked so hard, day in day out, always projecting ourselves into the future, so that we have not been able to enjoy the present. We don't have many memories, for we were always so hectically dealing with what came next, and we had little time for day-to-day living. We never looked back, always forward, without any nostalgia. And now? Now we are in 'detox'—detox from fashion!"[62]

In this ideal partnership, the constancy and intelligence of Valentino Garavani and Giancarlo Giammetti have directed their fashion house along a steady a course of action, paralleling the rise of the Italian fashion industry. Before this branch of fashion even came into existence in their country, they spelled out the emerging market's rules. Today, their brand name extends over three distinct cultures: Italian high fashion, Parisian haute couture, and American ready-to-wear. As the premier Italian fashion house to design on an international level, it reached out beyond its borders and showed that fashion is indeed universal. In the never-ending shifts of the fashion landscape, Valentino is a key figure, with rare longevity—a visionary who knew how to bring together past values and present-day requirements. Uniting separate worlds in its own distinctively specific way, Valentino has written one of the most eloquent pages in the history of contemporary couture.

PAMELA GOLBIN

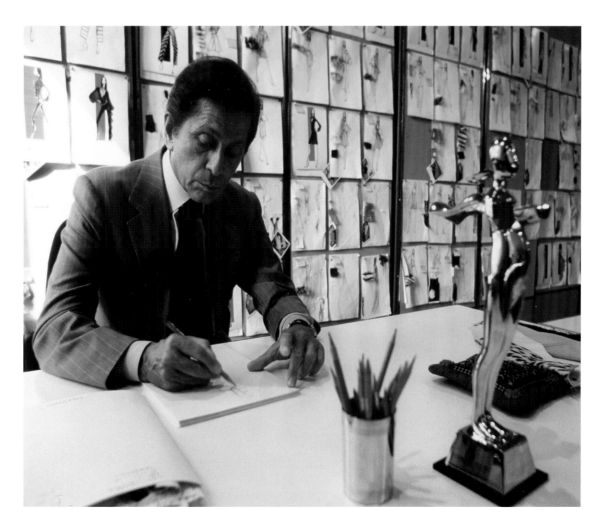

VALENTINO AT WORK IN HIS ATELIER, THE YEAR HE RECEIVED THE CFDA FASHION AWARD. FOLLOWING SPREAD: VALENTINO WITH MODELS IN THE COURT-YARD OF HIS FASHION HOUSE, THE PALAZZO MIGNANELLI, 2000.

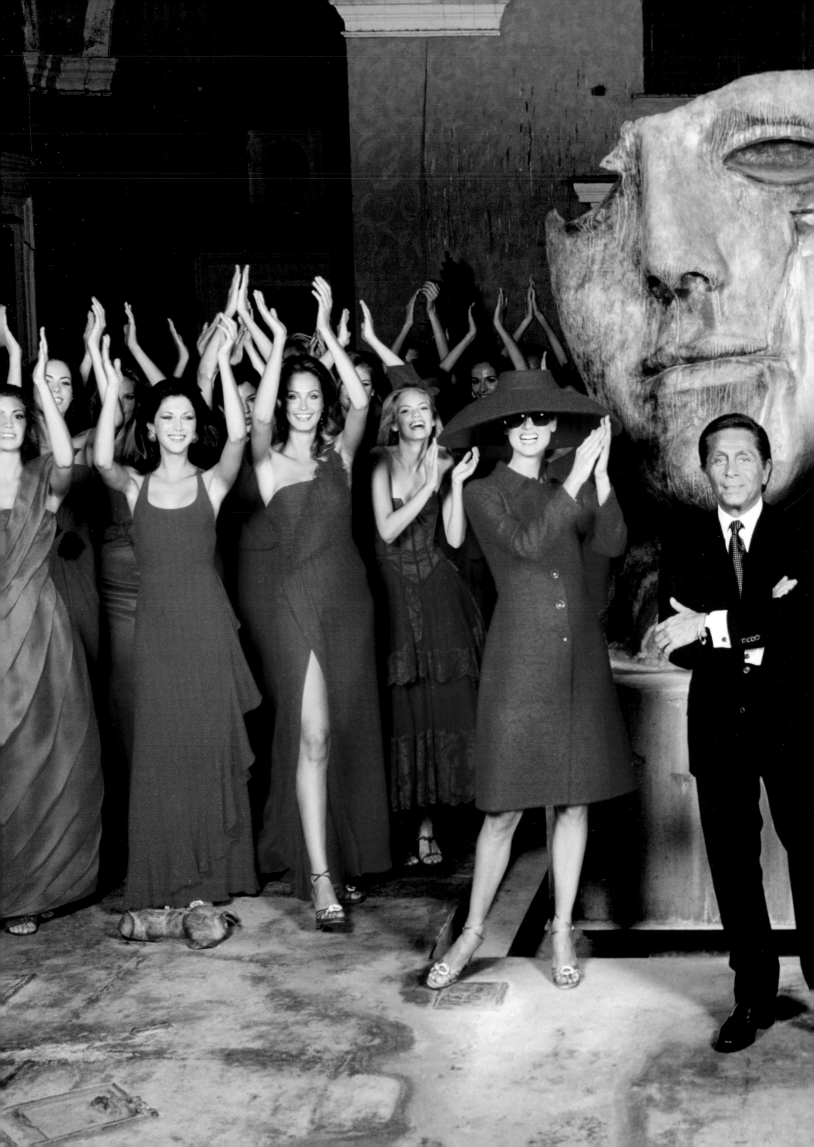

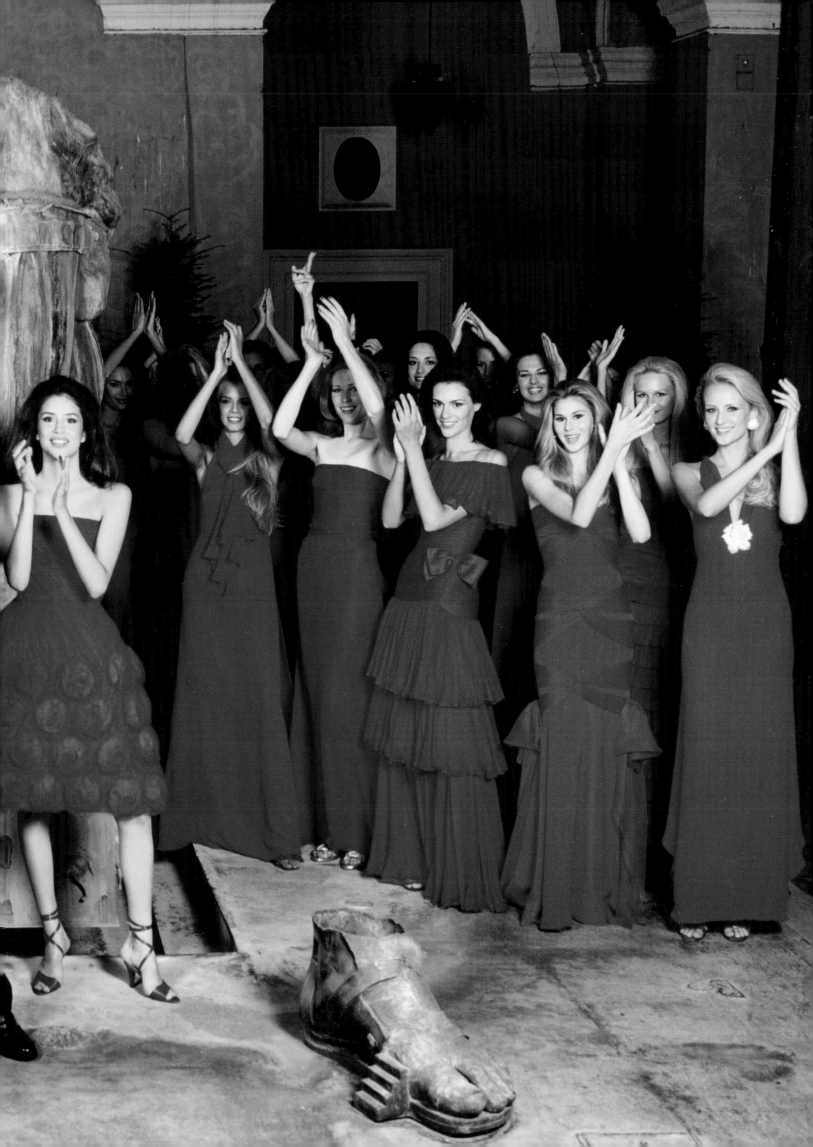

CAMPAIGNS

SPRING/SUMMER 1968 CAMPAIGN. ILLUSTRATOR: SINISEA

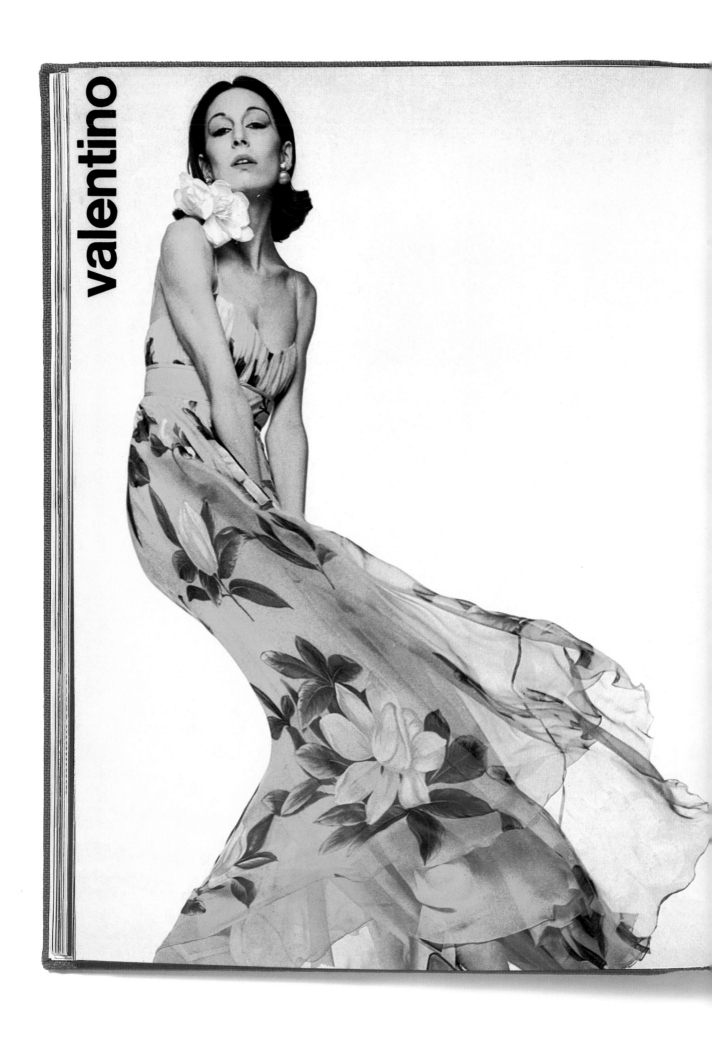

valentino

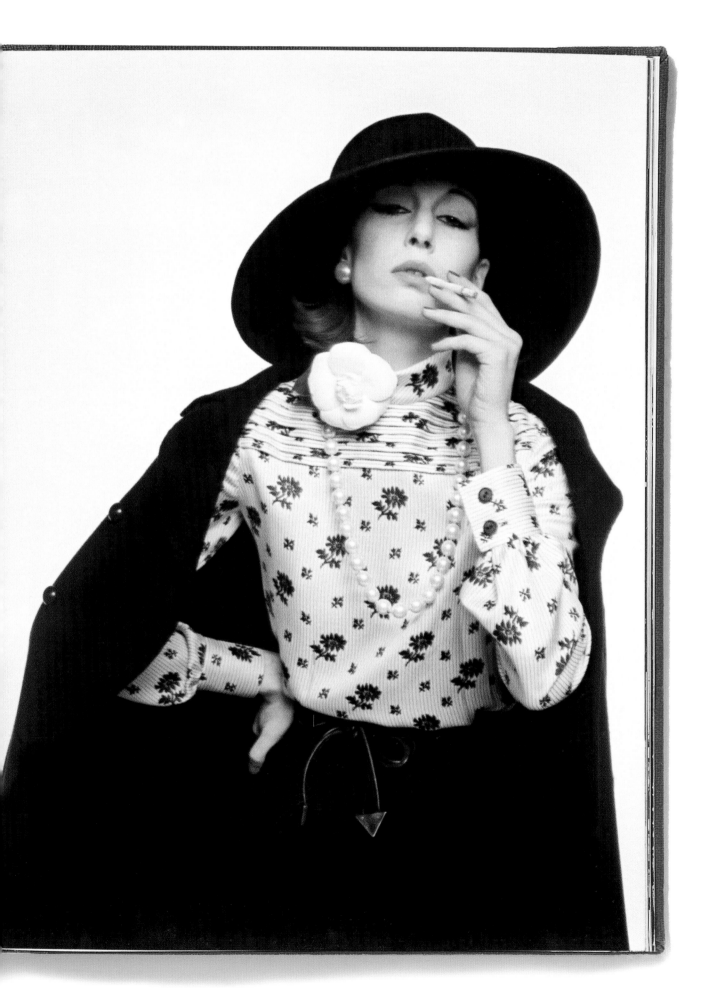

SPRING/SUMMER 1972 CAMPAIGN. PHOTOGRAPHER: GIANPAOLO BARBIERI

valentino

ADRIANO STUCCHI
COMO

ESCLUSIVITÀ
aston
ROMA – VIA PIEMONTE 42
TEL. 4756647

Antonio 74

SPRING/SUMMER 1974 CAMPAIGN. ILLUSTRATOR: ANTONIO LOPEZ

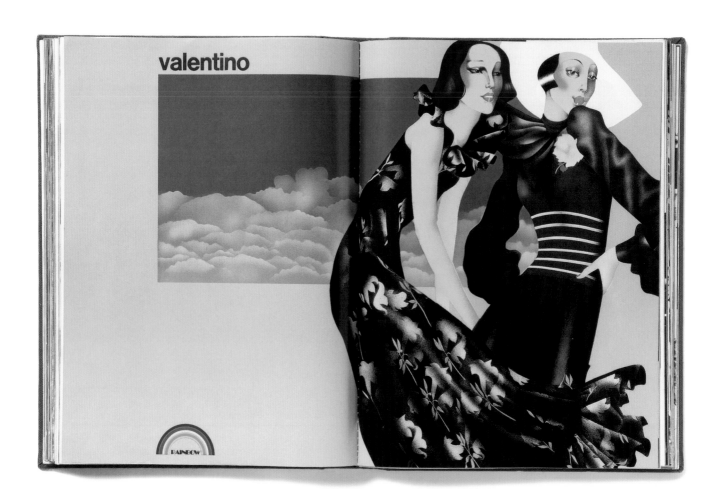

valentino

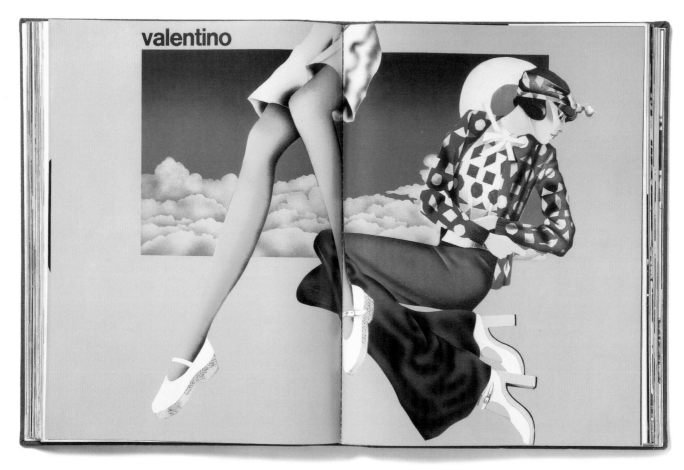

valentino

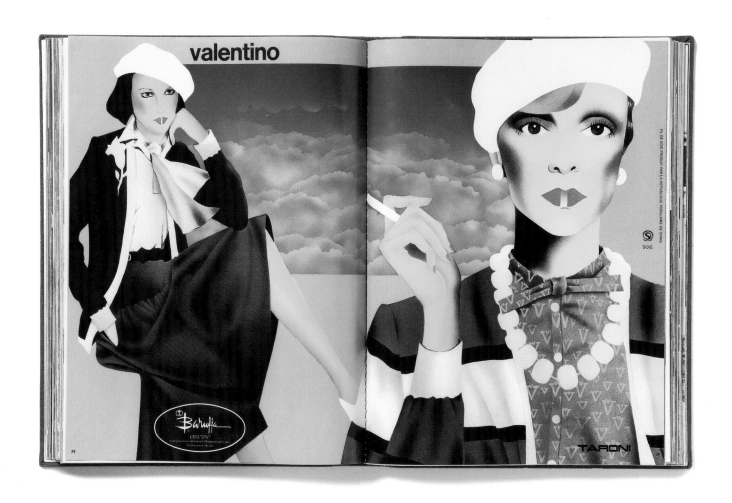

SPRING/SUMMER 1975 CAMPAIGN. ILLUSTRATOR: VALENTINO STUDIO

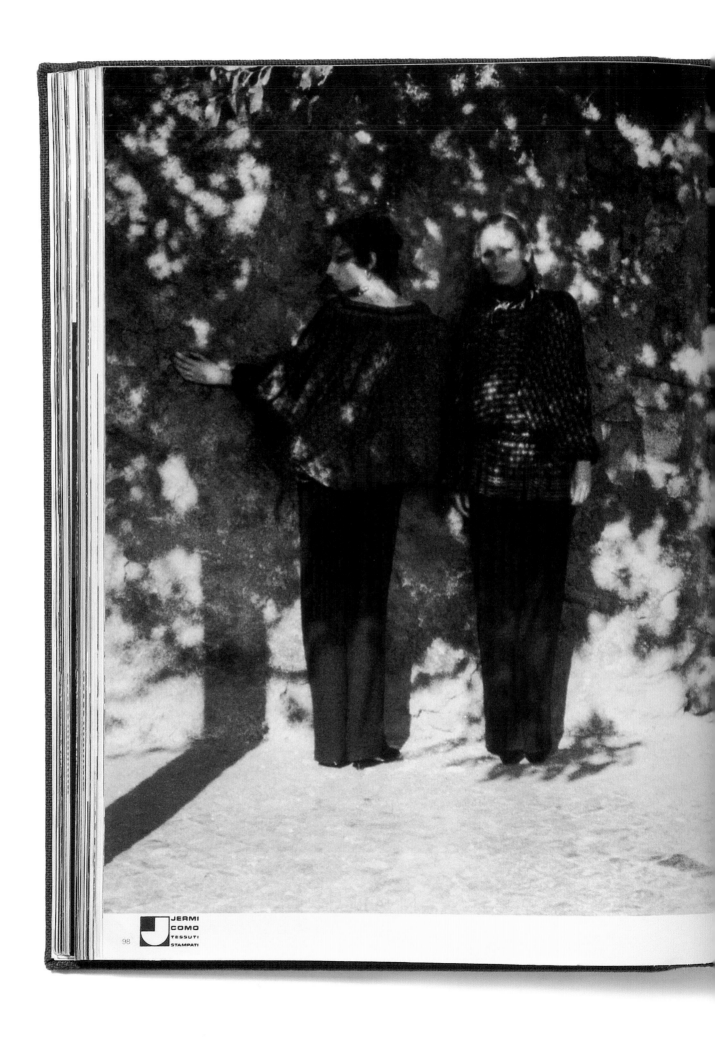

JERMI
COMO
TESSUTI
STAMPATI

98

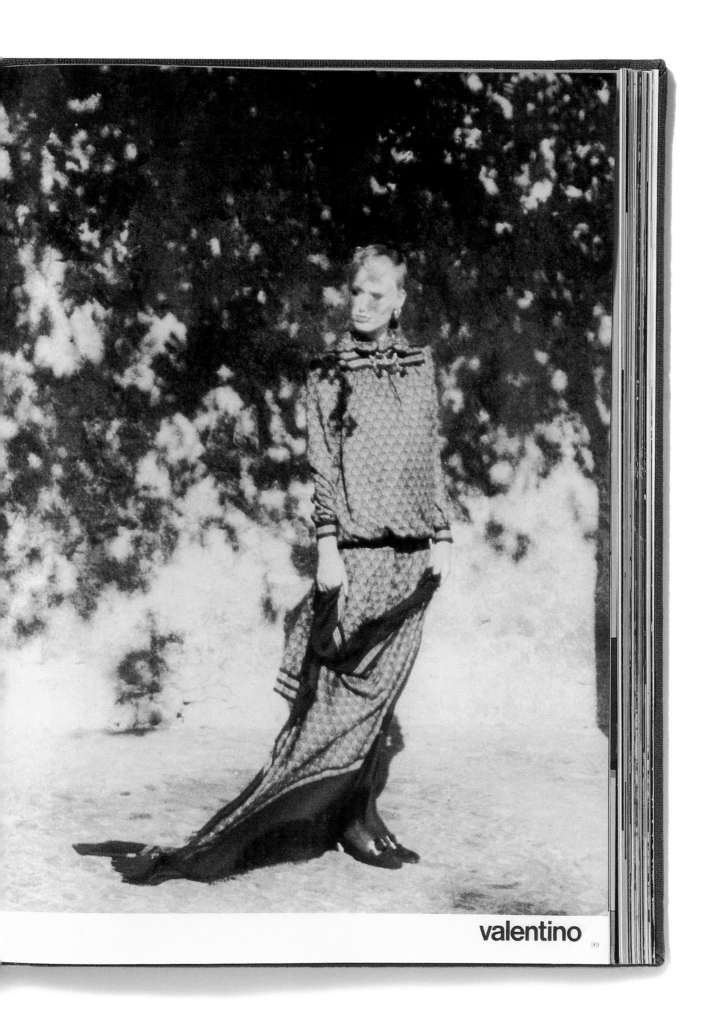

valentino

FALL/WINTER 1977 CAMPAIGN. PHOTOGRAPHER: DEBORAH TURBEVILLE

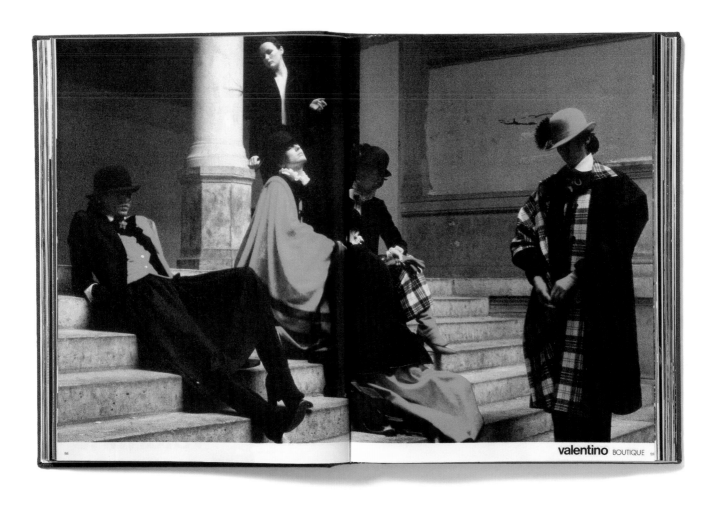

valentino BOUTIQUE

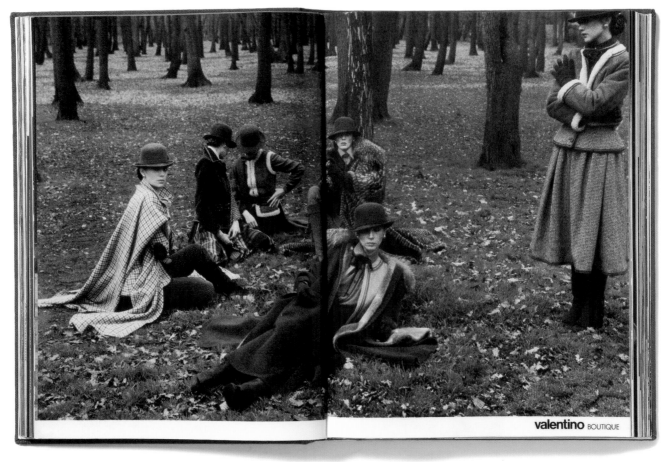

valentino BOUTIQUE

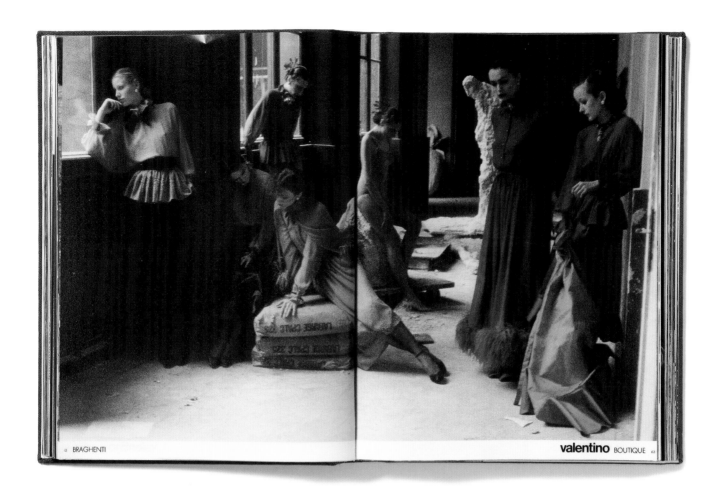

BRAGHENTI

valentino BOUTIQUE

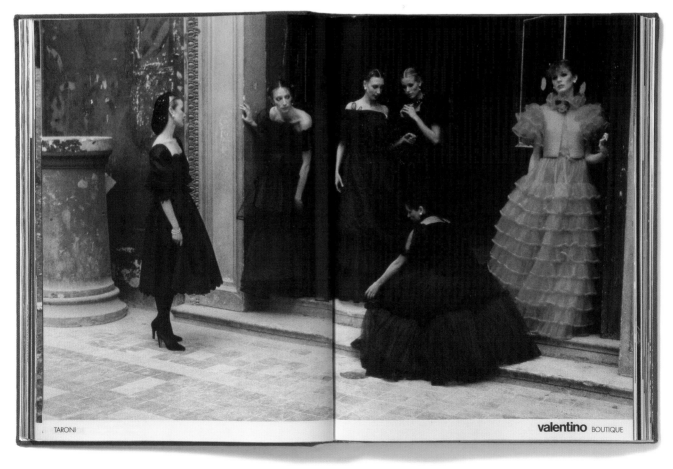

TARONI

valentino BOUTIQUE

FALL/WINTER 1977 CAMPAIGN. PHOTOGRAPHER: DEBORAH TURBEVILLE

TRUCCO / "BLOSSOMS" ULTIMA II
SPRING LOOK DI REVLON

PETTINATURE / SERGIO VALENTE ROMA

GIOIELLI / VALENTINO BIJOUX
VIA BOTERO 15 TORINO

SCIARPE / VALENTINO FOULARDS
VIA S. MARTINO 10 MILANO

SCARPE / RENE' CAOVILLA
FIESSO D'ARTICO VENEZIA

OCCHIALI / VALENTINO

ABITI UOMO / VALENTINO UOMO

FOTO / ALDO FALLAI

valentino

COUTURE

SPRING/SUMMER 1978 CAMPAIGN. PHOTOGRAPHER: ALDO FALLAI

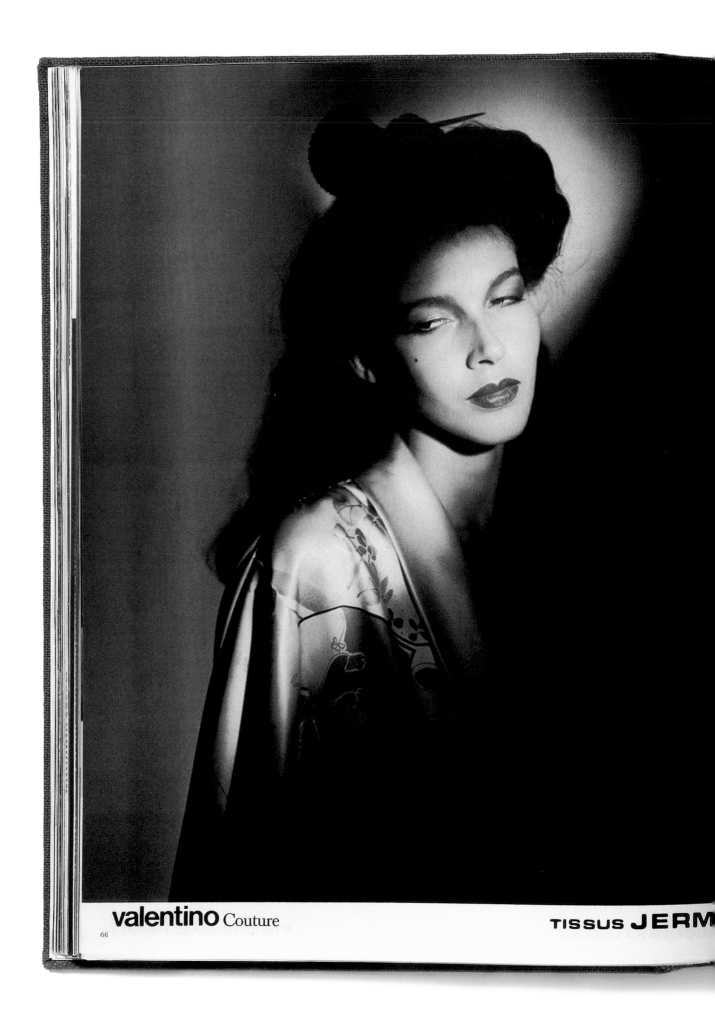

valentino Couture

TISSUS **JERM**

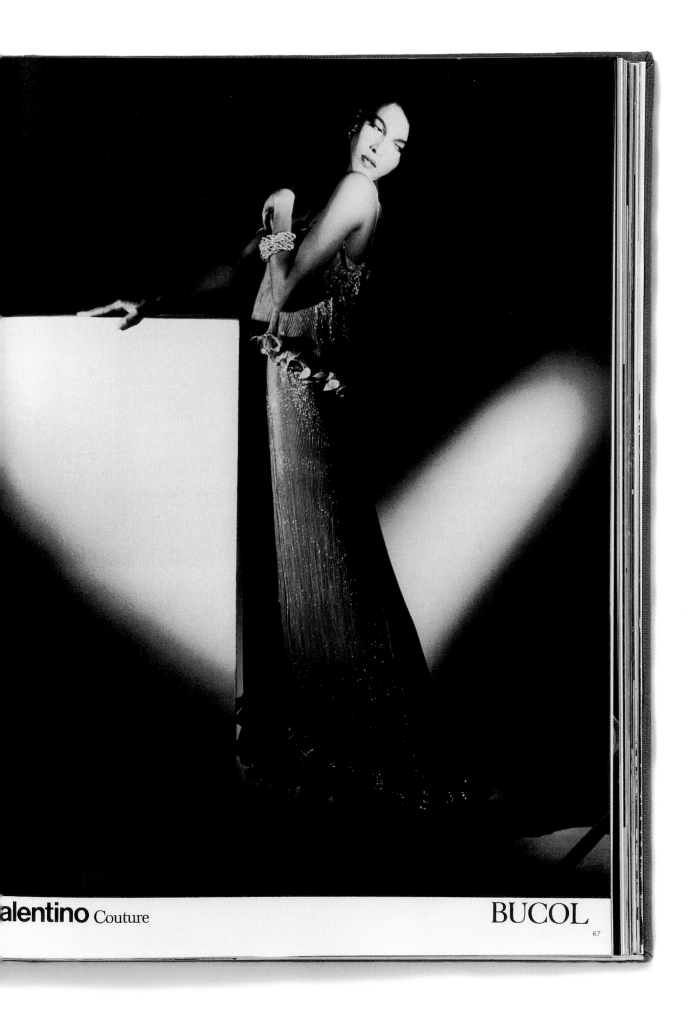

alentino Couture

67

FALL/WINTER 1978 CAMPAIGN. PHOTOGRAPHER: ALDO FALLAI

263

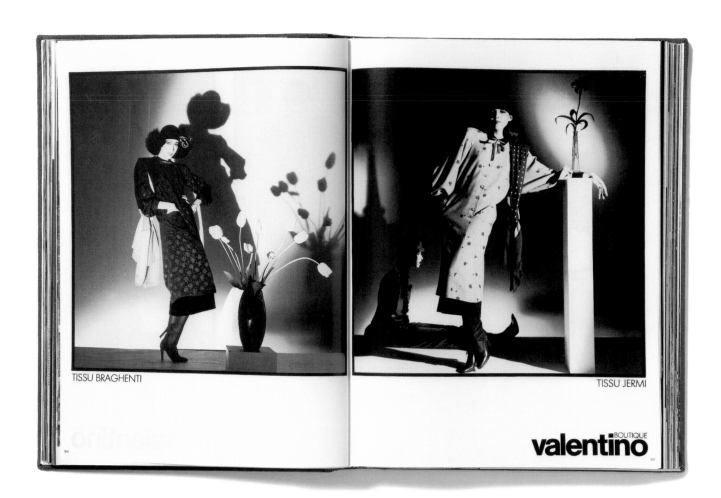

TISSU BRAGHENTI

TISSU JERMI

valentino BOUTIQUE

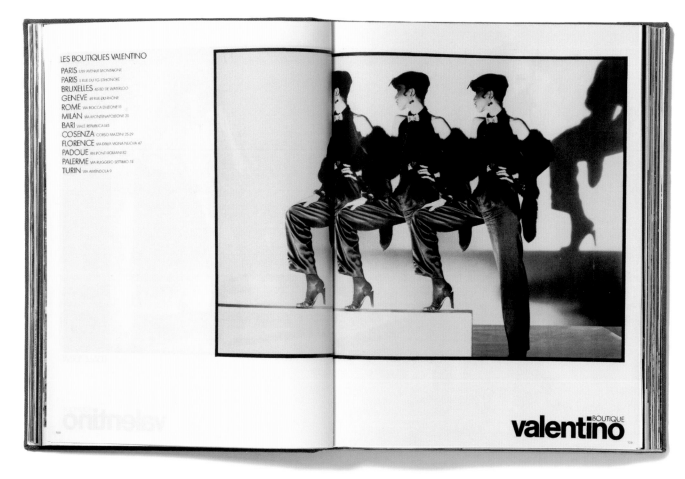

valentino BOUTIQUE

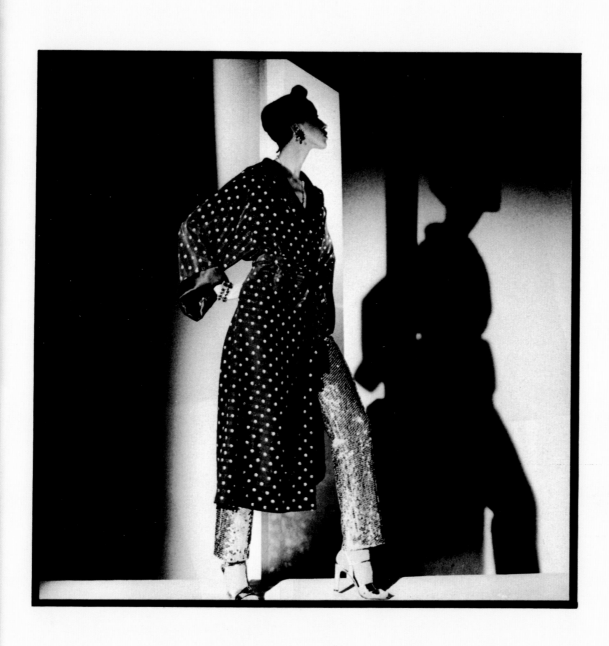

valentino BOUTIQUE

FALL/WINTER 1979 CAMPAIGN. PHOTOGRAPHER: HORST

Jean Paul GOUDE

Norman PARKINSON

Bill KING

Barry LATEGAN

Arthur ELG

Rico PUHLMANN

David BAILEY

Made in W.Germany

FÉVRIER 1983

VOGUE

LES ÉDITIONS CONDÉ NAST S.A. 4, place du Palais-Bourbon - 75007 Paris
Directeur Général : DANIEL SALEM Tél. 550.32.32 - Télex : 260752
...ral : CLAUDE LESAGE Adresse télégraphique : Vopar Paris
 Service abonnements : 16 4 403 44 00

JEAN PONIATOWSKI

FRANCINE CRESCENT
Rédactrice en Chef
 ANNE-MARIE CHALMETON DE CROY
 FRANCELINE PRAT
 Rédactrices en Chef adjointes

Directeur Artistique
JOCELYN KARGÈRE

Secrétaire de Rédaction
URSULA RETZKI

Mode
 MARIE LAVIE-COMPIN
 MARTINE CASTEUBLE
 FABIENNE PINSARD (merchandising)
 ARIANE SAINTE-MARIE
 CAROLE LOCATELLI
 GHISLAINE DE CHAMBINE
 BARBARA BAUMEL

Beauté - Actualités - Tourisme
 SIMONNE BROUSSE (grand reporter)
 LORRAINE BOLLORÉ (beauté)
 MARTINE PAILLARD (beauté)
 AGNÈS WEINBERGER (tourisme)
 PAMELA DA SILVA RAMOS (décoration)
 DIANE DE BRAUX (actualités)
 CAROLINE MISSOFFE (œil de Vogue)
 CATHERINE BERNARD (œil de Vogue)
 PATRICK HOURCADE (réalisation)

Mise en page
 PAUL WAGNER
 SIMONE HIBON
 ALEXIS STROUKOFF
 SERGE RIVIER

Promotions Internationales
 CLAUDE LARCHER Directrice
 BERNADETTE DEUSY

Correspondantes de Province
 CAROLINE PONIATOWSKA (Bordeaux)
 CLAIRE-ALIX PASSERAT (Lyon)
 LUCILE ZARIFI (Marseille)
 LAURENCE BOTTA (Nice)
 MICHÈLE PHILIPPI (Strasbourg)
 VICTOIRE DE MONTESQUIOU (Toulouse)

Correspondants Internationaux
 WILMA LAWSON TURNBULL (Afrique du Sud)
 NICOLAS FEUILLATTE (Australie)
 SYBILLE VAN ZEELAND (Belgique)
 SYLIANE DE VILALLONGA (Espagne)
 MÉREDITH ETHERINGTON-SMITH (Grande-Bretagne)
 MARINA DIMITROPOULOS (Grèce)
 MARY LAI STIRLAND (Hong Kong)
 HIROKO MATSUMOTO BERGHAUER (Japon)
 S.A.R. PRINCESSE FIRYAL DE JORDANIE (Jordanie)
 NICOLAS H. SANCHEZ-OSORIO (Mexique)
 EMILIO ANTING (Philippines)
 Princesse ANNICK DE BENTHEIM TECKLENBURG (R.F.A.)
 GENEVIÈVE ARMLEDER (Suisse)
 ELAINE CHARBIN-LEARSON (New York, U.S.A.)
 CAROLINE WHITMAN (Los Angeles, U.S.A.)

 S.A.R. PRINCE GIOVANNI DE BOURBON-SICILES
 PRINCESSE IRA DE FURSTENBERG
 BIRGITTE DE GANAY
 SHERMIN DAJANI

...MERCIAL BERTRAND FOURCADE
 Directeur Commercial
 UTE MUNDT
 BRIGITTE BURY
 CAROLINE GANDILLOT ⎫ Chefs de Publicité
 CORINNE THULLIER ⎬
 VIOLAINE PERDU ⎭
 CHANTAL MEILLAN - Publicité Aquitaine et Méditerranée
 LUCE BRICTEUX - Publicité Bénélux
 CLAUDE VALLÉE
 Directeur administratif
 Diffusion
 MONIQUE AURAT
 MICHÈLE LACROIX DESMAZES

...PE DES REVUES VOGUE (U.S.A., Grande-Bretagne, France, Italie, R.F.A.)
...NAST COMPREND : VOGUE HOMMES (France)
 HOUSE & GARDEN (U.S.A., Grande-Bretagne)
 MAISON & JARDIN (France)
 CASA VOGUE (Italie)
 GLAMOUR (U.S.A.)
 MADEMOISELLE (U.S.A.)
 BRIDES (U.S.A.)
 BRIDES & SETTING UP HOME (Grande-Bretagne)
 L'UOMO VOGUE (Italie)
 LEI (Italie)
 SELF (U.S.A.)
 GQ (U.S.A.)
 UOMO MARE (Italie)
 VOGUE BAMBINI (Italie)
 TATLER (Grande-Bretagne)
 THE WORLD OF INTERIORS (Grande-Bretagne)
 VOGUE PELLE (Italie)
 PER LUI (Italie)
 VANITY FAIR (U.S.A.)

 Publiées par : The Condé Nast Publications Inc.
 (New York, U.S.A.) (Société mère)
 Président : S.I. NEWHOUSE Jr.
 Condé Nast International Inc. (Europe)
 Président : DANIEL SALEM

 Coordination Internationale : BEATRICE HALPERIN

 Directeur des Éditions : ALEXANDER LIBERMAN

VOGUE AUSTRALIE EST PUBLIÉ PAR BERNARD LESER PUBLICATIONS PTY. LTD.
VOGUE BRÉSIL EST PUBLIÉ PAR CARTA EDITORIAL LTDA.
...IQUE EST PUBLIÉ PAR CARTA EDITORIAL DE ...

V
valentino

Visto da:

DAVID BAILEY

GUY BOURDIN

STANLEY DARLAND

ARTHUR ELGORT

ALDO FALLAI

JEAN PAUL GOUDE

KEN HAAK

HORST

BILL KING

BOB KRIEGER

BARRY LATEGAN

HELMUT NEWTON

NORMAN PARKINSON

RICO PUHLMANN

BEN ROSENTHAL

FRANCESCO SCAVULLO

SNOWDON

TESSA TRAEGER

DEBORAH TURBEVILLE

ALBERT WATSON

YOKOSUKA

9

SPRING/SUMMER 1983 CAMPAIGN. VARIOUS PHOTOGRAPHERS

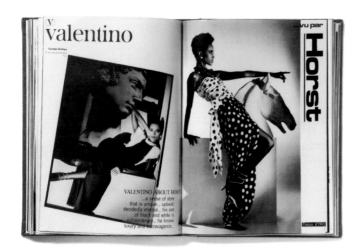

(V) valentino ...vu par **Horst**

VALENTINO ABOUT HORST
...a sense of style
that is unique... upbeat,
decidedly eternal... his use
of black and white is
extraordinary... he knows
luxury and extravagance...

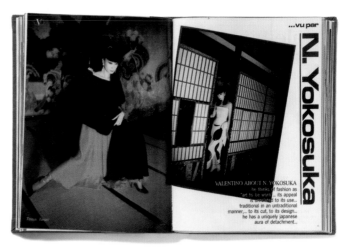

(V) valentino ...vu par **N. Yokosuka**

VALENTINO ABOUT N. YOKOSUKA
...he thinks of fashion as
"art to be worn"... its appeal
is revealed in its use...
traditional in an untraditional
manner... to its cut, to its design...
he has a uniquely japanese
aura of detachment...

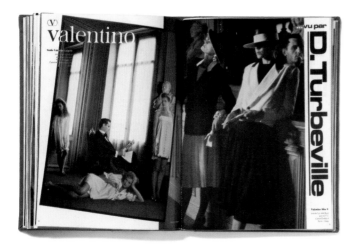

(V) valentino ...vu par **D. Turbeville**

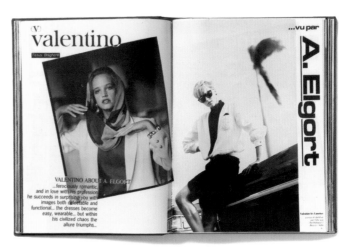

(V) valentino ...vu par **A. Elgort**

VALENTINO ABOUT A. ELGORT
...ferociously romantic,
and in love with his profession...
he succeeds in surprising you with
images both delectable and
functional... the dresses become
easy, wearable... but within
his civilized chaos the
allure triumphs...

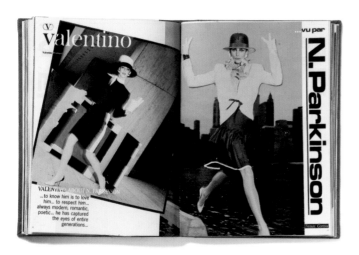

(V) valentino ...vu par **N. Parkinson**

VALENTINO ABOUT N. PARKINSON
...to know him is to love
him... to respect him...
always modern, romantic,
poetic... he has captured
the eyes of entire
generations...

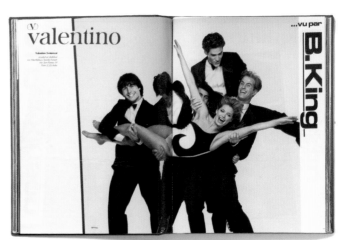

(V) valentino ...vu par **B. King**

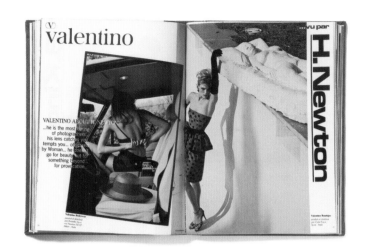

valentino

...vu par **H.Newton**

VALENTINO ABOUT H. NEWTON
...he is the most daring of photographers... his lens catches you... tempts you... obsesses you... by Woman... he doesn't go for beauty but for something beyond... for provocation.

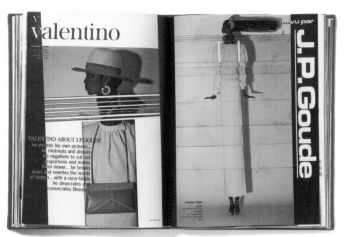

valentino

...vu par **J.P.Goude**

VALENTINO ABOUT J.P.GOUDE
...he violates his own pictures... he mistreats and abuses... his negatives to cut out proportions and makes them newer... he breaks down and rewrites the words of fashion... with a razor-blade he desecrates and consecrates Beauty...

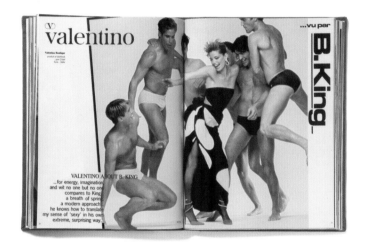

valentino

...vu par **B.King**

VALENTINO ABOUT B. KING
...for energy, imagination and wit no one but no one compares to King... a breath of spring... a modern approach... he knows how to translate my sense of 'sexy' in his own extreme, surprising way...

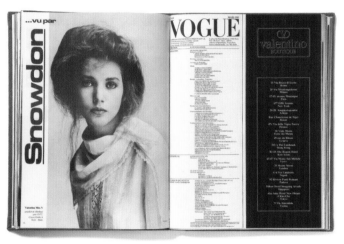

...vu par **Snowdon**

VOGUE

valentino

valentino
BOUTIQUE

22

17-19 Avenue Montaigne. Paris.
Via Bocca di Leone 15. Roma
Via Condotti 13. Roma
Via Montenapoleone 20. Milano.
Via Sparano 2. Bari.
Galleria Cavour 7a. Bologna.
Via della Vigna Nuova 47r. Firenze.
Viale Morin 10. Forte dei Marmi.
Via Calabritto 1d. Napoli.
Via Filangieri 68. Napoli.
Riviera Ponti Romani 82. Padova.
Via Libertà 31. Palermo.
Viale della Libertà 31a. Palermo.
Via Amendola 12. Torino.
San Marco 1474. Venezia.
Viale Marconi 103. Viareggio.
12 Kanari Kolonaki. Athens.
41 Avenue Louise. Bruxelles.

49 rue du Rhône. Genève.
78 rue du Rhône. Genève.
Lauenenstrasse. Gstaad.
The Landmark. Hong Kong.
The Regent Hotel. Kowloon.
160 New Bond Street. London.
174 Sloane Street. London.
7-9 Avenue de Monte-Carlo. Monte-Carlo.
Square Beaumarchais. Monte-Carlo.
Briennerstrasse 11. München.
96 Somerset Road. Singapore.
Münsterhof 12. Zürich.
825 Madison Avenue. New York.
414 North Rodeo Drive. Beverly Hills.
56 Highland Park Village. Dallas.
204 Worth Avenue. Palm Beach.
20a Hazelton Avenue. Toronto.
600 New Hampshire Avenue. Washington.

assisté de CLAUDE ALBARET

E est publié par LES ÉDITIONS CONDÉ NAST S.A.
e du Palais-Bourbon - 75007 Paris
.50.32.32 - Télex 260752. Adresse télégraphique : Vopar Paris.
abonnements : 16 44.03.44.00

Président-Directeur Général : DANIEL SALEM
Administrateur-Délégué : JACQUES LAMBOI
Directeurs généraux adjoints: GÉRALD ASARIA
JEAN PONIATOWSKI
Directeur de la diffusion : PATRICK DELCROIX
Directeur du marketing : MICHEL RIVIÈRE
Secrétaire Général : CLAUDE LESAGE

valenti
V
Studio

23

SPRING/SUMMER 1987 CAMPAIGN. PHOTOGRAPHER: OLIVIERO TOSCANI

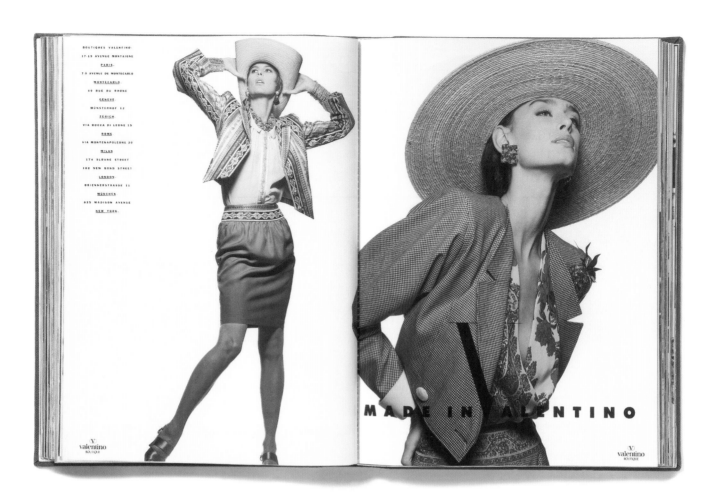

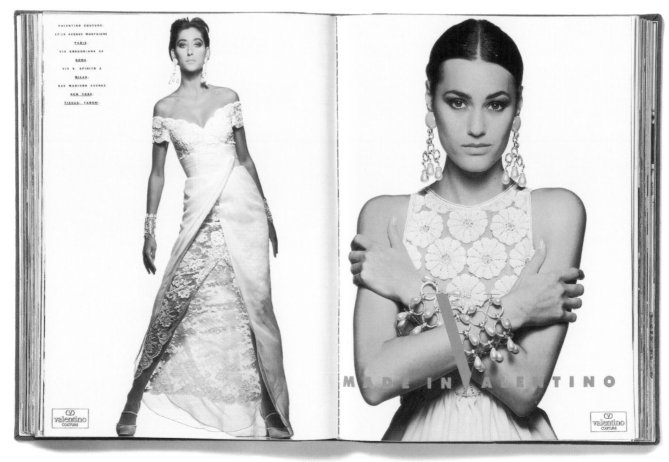

SPRING/SUMMER 1989 CAMPAIGN. PHOTOGRAPHER: WALTER CHIN

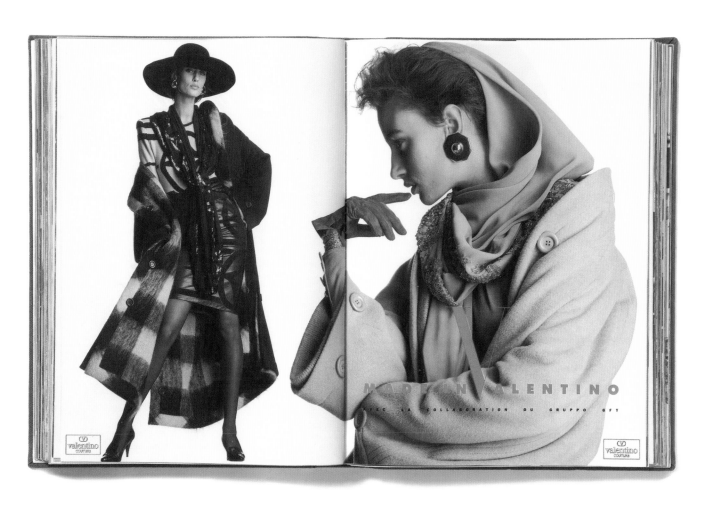

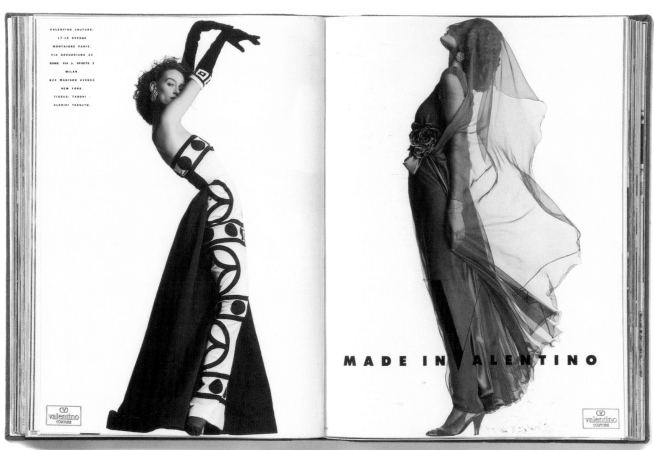

MADE IN

ENTINO

SPRING/SUMMER 1990 CAMPAIGN. PHOTOGRAPHER: DAVID BAILEY

BOUTIQUES VALENTINO: 17-19 AVENUE MONTAIGNE PARIS, 7-9 AVENUE DE MONTECARLO MONTECARLO, 160 NEW BOND STREET LONDON, 174 SLOANE STREET LONDON, 49 RUE DU RHÔNE GENÈVE, MÜNSTERHOF 12 ZÜRICH, BRIENNERSTRASSE 11 MÜNCHEN, RUE CLEMENCEAU BEIRUT, 825 MADISON AVENUE NEW YORK, 2 RODEO DRIVE BEVERLY HILLS.

V
BOUTIQUE

VIVA VALENTINO

FALL/WINTER 1991 CAMPAIGN. PHOTOGRAPHER: TYEN

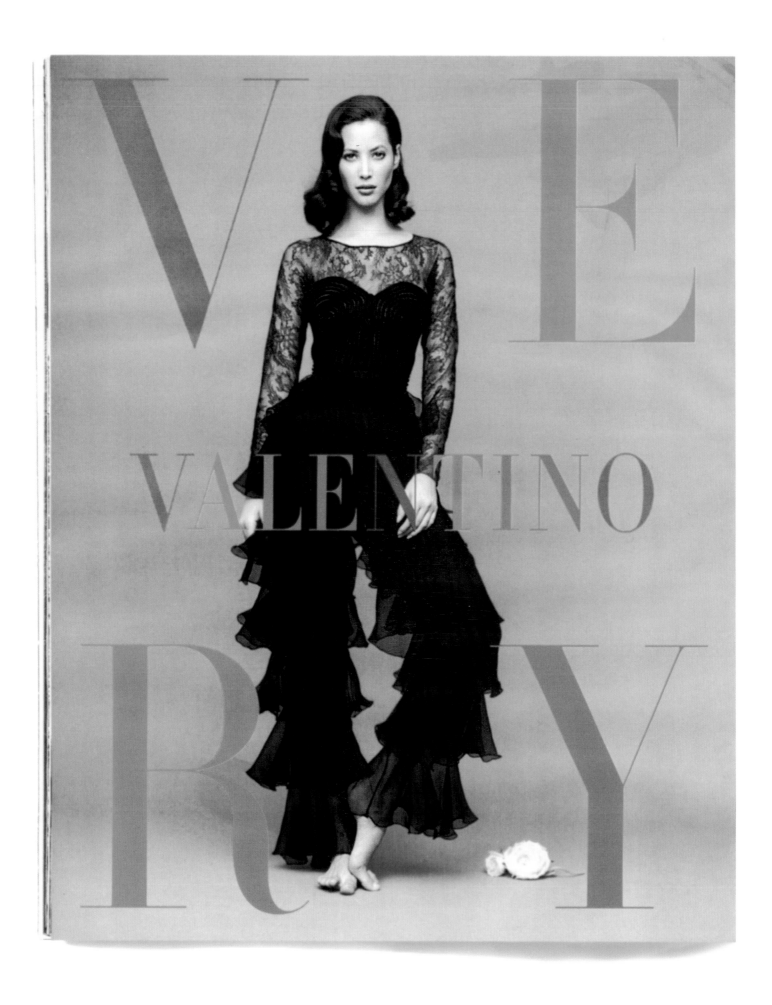

VERY

VALENTINO

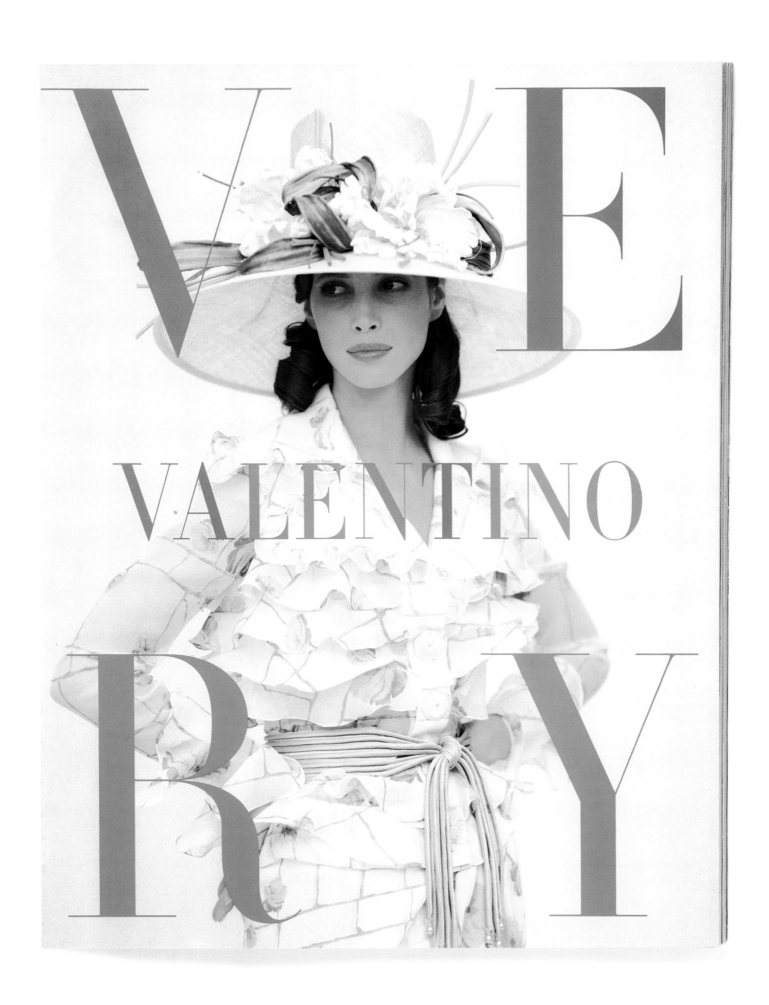

VERY VALENTINO

SPRING/SUMMER 1993 CAMPAIGN. PHOTOGRAPHER: WALTER CHIN

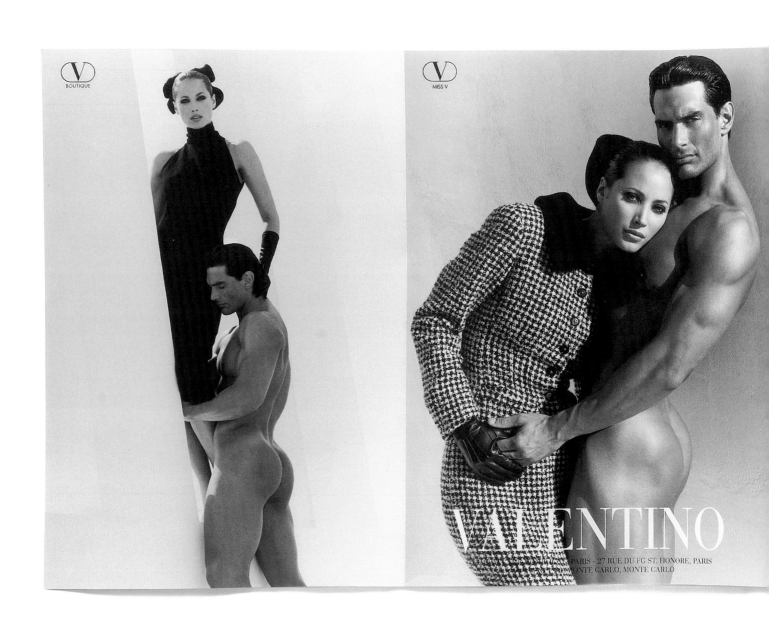

VALENTINO

...PARIS - 27 RUE DU FG ST. HONORE, PARIS
...ONTE CARLO, MONTE CARLO

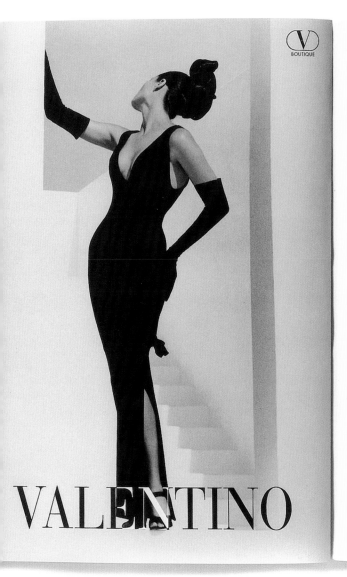

V BOUTIQUE

C'est cet optimisme qui vous a permis de rebondir en 78, après l'insuccès commercial de vos expériences avec Prisunic et Créateurs et Industriels[1].

Peut-être étions-nous trop en avance... Je me suis trouvée dans une sorte de position héroïque : repartir à zéro pour fonder l'agence Ecart International[2].

On dit qu'à côté de vous, «les dix femmes les plus élégantes du monde ont l'air «Chaussée d'Antin». Quelle serait votre définition de l'élégance ?

Aussi fine et affûtée qu'elle soit, l'élégance ne fonctionne que dans la grâce de sa spontanéité et, donc, elle est indescriptible. Et forcément spirituelle. Voyez l'élégance des Portoricains ou des Noirs américains... L'élégance est une liberté, c'est un décalage par rapport à des recettes, par rapport aux idées ridicules sur «le bon goût», une des expressions les plus irritantes que je connaisse ; cette idée qu'on peut copier, tricher...

L'élégance est originelle et originale...

Dans L'Amant, de Marguerite Duras, il y a la description de chaussures de femmes du soir, en or, ces sandales d'été, cette robe en tussor, ce chapeau volé à l'amant je crois... un chapeau d'homme... Je n'ai rien lu de plus élégant que la dégaine de cette petite fille qu'était Marguerite Duras dans ce livre. Les relations que j'ai eues avec Duras, amicales et bizarres, très belles, sont parmi les plus émouvantes de mon existence récente. Là, on est dans l'occasion, dans le hasard, et c'est probablement cela l'élégance. L'impression que c'est n'importe quoi, et que ce n'importe quoi est rare et relève d'une inspiration. Les gens qui ont peur de se tromper font des fautes de goût. Il faut donner l'impression d'être née dans ce que l'on porte. Le trop se voit. L'étalage de la richesse est le contraire de l'élégance.

Des années 60 aux années 90, on a vu toutes les tendances s'exprimer : le futurisme plastoc des seventies, le high-tech revisité au rayon quincaillerie du BHV, le nouveau-classicisme avec ses bergères Louis XVI tendues de peaux de zèbre, le vrai faux japonais fabriqué en Corée, le néo-Pompéi...

J'ai vu des choses effrayantes, énormes et drôles d'ailleurs, des appartements magnifiques sur Park Avenue où on ajoutait des tuyaux d'usine pour faire loft. Passons sur le colonial, le cocooning... Toutes ces choses suscitent chez moi une réelle aversion. Là, je peux être très violente. Cette idée de repli est tellement le contraire de la vie. Un critique littéraire a parlé de littérature «allégée» à propos d'un roman. C'est immensément drôle et d'une cruauté sans nom pour l'auteur mais, aussi, très représentatif de cette invasion d'un mot qui, au départ ne concerne que la minceur, mais qui tout d'un coup veut dire des milliers d'autres choses, toutes inquiétantes.

Dans cette liberté à outrance, plus rien ne fait scandale.

En fait, il y a eu beaucoup de diktats là où l'on croyait voir de la liberté de création. Aujourd'hui, les objets ou les meubles prennent la place des vêtements, ils ne racontent plus une histoire de pouvoir et d'arrogance. En mode, tout le monde aime tout, tout le monde veut tout mettre. Seul les objets et les meubles racontent un peu qui vous êtes. D'ailleurs, les Français découvrent le goût de recevoir, ils montrent leur cuisine, leur cafetière signée d'un architecte illustre... On assiste à l'envahissement de signes douteux parce qu'ils sont arrogants. Ces objets sont rarement aimés pour leur beauté, ils sont des conventions de pouvoir. Oui, le design est malade, il est dans une crise d'identité, il n'a plus de fraîcheur. La question essentielle des designers n'est pas : «Comment vais-je asseoir mes compatriotes ?» ou «Est-il possible de trouver une nouvelle façon de faire des placards ?» Non. C'est : «Suis-je intimidant ?», «Est-ce que je raconte bien le succès de mon propriétaire ?»

Pourquoi aucun courant fort ne réussit à imposer un style ?

Parce qu'il y a un trop grand affolement du «que va-t-on penser de moi ?» C'est une maladie, et elle s'aggrave. L'audace de

la liberté, l'indifférence pour le qu'en-dira-t-on ont disparu. Rien de vivant ne passe. La timidité, l'embourgeoisement, la banalisation en sont venus à être vus comme de l'avant-garde. En 1987, Jérôme Deschamps était l'avant-garde. Aujourd'hui, il est entré dans le quotidien des Français et un défilé Deschiens a eu lieu à la fondation Cartier. C'est curieux. C'est comme si on était mort de honte d'avoir tout raté à ce point-là.

Comment voyez-vous se dessiner le style de l'an 2000 ?

Les gens vont être plus calmes sur les objets signifiant le pouvoir. Je souhaite l'arrivée de cette liberté que j'aperçois déjà à travers de petits signes. Des phénomènes commerciaux et des phénomènes de mode font que quantité de magasins offrent des objets très sympathiques, de toutes origines et souvent abordables. Au lieu de jeter, d'être pris de honte et d'angoisse face à une mode qui obligeait les gens à se séparer de choses qui soit disant «ne correspondent plus», il y aura une sorte de réconciliation d'objets ou de meubles qui n'ont absolument rien à faire ensemble. Si vous êtes sincère dans vos choix, ça fonctionnera évidemment puisque vous êtes le fil qui les relie. Mais votre sincérité est exposée au grand jour, et si vous faites le malin et que tout d'un coup vous avez une faiblesse pour un objet significatif d'une représentation de pouvoir, celui-là ne s'entendra pas du tout avec ses voisins. Je crois à ce mélange d'œuvres ou d'objets aimés, dans la plus grande insolence des époques, avec des confrontations éventuellement comiques, parce que l'humour dans les lieux, le petit accident qui, tout à coup, donne à un coin de pièce un charme très supérieur à l'ensemble, est vital. L'accident est souvent une erreur apparente ; c'est aussi ce qu'on pourrait appeler la «faute de goût», mais pour rire, puisque le bon goût n'existe pas. En fait, la faute de goût est un atout sérieux pour faire de très belles maisons.

L'architecture intérieur sera bientôt aussi révélatrice qu'une analyse ! De l'archi-analyse...

Il faut libérer et affirmer sa personnalité. Avec Freud, la conscience du corps a évolué, les femmes n'obéissent plus aveuglément aux diktats des couturiers. Gamine, je rougissais de honte en voyant mes tantes, lisant Vogue[3], dire : «Mon Dieu, tu as vu, cette saison, c'est le rouge, et les jupes sont à 46 cm». Et ces malheureuses qui suivaient, alors que l'une avait de vilaines jambes et l'autre un teint qui ne supportait pas le rouge.

Ecart est l'anagramme de «trace», quelles traces souhaitez vous laisser ?

Une impression humaine, rien d'esthétique. D'ailleurs, je ne sais même plus ce que ça veut dire «esthétique». Je suis perdue devant l'idée de la beauté. Il faudrait qu'on revienne à une fraîcheur et naïveté de l'objet ou du meuble. Les quakers, par exemple, vivaient prodigieusement leur austérité, leur économie de place : comment chauffer une pièce ? Où prendre les repas ? Comment stocker ses affaires ? Chez ces gens, il y a une méconnaissance totale de l'effet esthétique et de la beauté qui m'intéresse. Tout est en correspondance avec leur âme. Les chaises, on les accroche au plafond quand on n'en a plus besoin, c'est pratique pour laver par terre. Ce côté essentiel existe souvent dans les intérieurs des artistes ou des gens qui ont beaucoup de place dans la vie. C'est cette indifférence à l'effet qui est la grâce même.

GAILLAC-MORGUE

(1) Créé par Didier Grumbach et placé sous la direction artistique d'Andrée Putman, Créateurs et Industriels regroupait des stylistes comme Emmanuelle Khanh, Jean Muir, Christiane Bailly, Issey Miyake, Jean-Charles de Castelbajac, Claude Montana, Thierry Mugler...

(2) Ecart International regroupe de jeunes designers et des rééditions de créateurs du début du siècle (Eileen Gray, Mallet-Stevens, Mariano, Fortuny). Son bureau d'études a réalisé l'architecture intérieure des boutiques Thierry Mugler, Yves Saint Laurent, Lagerfeld. L'aménagement intérieur de la Concorde. L'hôtel Morgan à New York. Le Pavillon français de l'Exposition universelle de Séville...

FALL/WINTER 1995 CAMPAIGN. PHOTOGRAPHER: HERB RITTS

281

CINÉMA

Souvenir de Cannes
par Nadine Gordimer

Elle était dans le jury du festival de Cannes dont les films seront bientôt sur les écrans. Pour l'écrivain sud-africain et prix Nobel, le cinéma c'est l'amour.

C'est avec nostalgie que je fouille dans ma mémoire pour y retrouver, parmi le fatras des films vus tout au long d'une vie, l'image la plus immédiatement évocatrice. Pour moi, c'est une image qui resurgit, plutôt qu'un dialogue ; et peut-être est-ce mieux qu'il en soit ainsi, car l'image animée est la forme d'art inventée par le cinéma qui le distingue des autres arts plastiques, la peinture, la sculpture, la photographie, qui eux aussi offrent une image.

J'imagine que j'appartiens à cette première génération pour qui aller au cinéma faisait partie de la recherche du bonheur. Mon plaisir de la semaine, dans la petite ville minière d'Afrique du Sud où j'ai passé mon enfance, était le cinéma du samedi après-midi. De cette époque surnage dans ma mémoire le spectacle de Fred Astaire et de Ginger Rogers, dansant, toujours dansant. Ils semblent s'envoler vers l'avenir comme sur un nuage rose ; et je croyais que devenir adulte ressemblerait à cet envol. Moi aussi, je m'envolerais du bungalow de mes parents, de la boutique de mon père, du sinistre emploi de dactylo ou d'institutrice qu'on envisageait pour moi, et je danserais, je danserais, très loin, dans les bras d'un homme, sur un vague nuage rose de célébrité.

Il est deux formes d'intimité dans lesquelles s'ébauche le plus souvent l'attirance entre un homme et une femme : le premier repas qu'ils prennent ensemble au restaurant, et la première proximité, côte à côte, dans l'obscurité d'un cinéma. Ils ne se parlent pas, ils partagent les images d'une autre vie sur l'écran, conscients de la présence du corps, de la respiration, des pensées secrètes du voisin, que l'on connaît à peine, et qui est pourtant si proche. Une seule fois, je compris le charme et murmurai une remarque. J'aurais pu dire quelque chose d'inapproprié, de maladroit. Je ne le fis pas ! Le film était *Casque d'or*, et une image exquise de la campagne française me rappela un tableau de Pissarro. Je ne résistai pas au plaisir de faire part de cette réminiscence à mon compagnon. Il se trouvait qu'il aimait beaucoup la peinture des impressionnistes ; et ainsi, dans l'intimité spéciale qu'offre le cinéma, à la faveur d'une image dans un film, s'établit entre nous un lien de complicité qui fut le début d'une longue histoire d'amour.

Mais l'image qui me revient en mémoire comme mon « moment de vérité » au cinéma n'est pas liée à l'évocation de ce genre de souvenirs personnels, mais une autre qui s'impose avec éclat parce qu'elle relève de l'art que je pratique moi-même, celui de l'écrivain. Elle date d'un an ou deux, dans le film d'Emir Kusturica, *Papa est en voyage d'affaires*. C'est l'histoire d'une femme qui a épargné jusqu'au dernier sou et consenti tous les sacrifices pour emmener ses enfants voir leur père, emprisonné pour un délit supposé d'ordre politique, qu'une ironie du sort lui a attribué alors qu'il ne faisait que courir un jupon. Le seul endroit où les deux époux peuvent se rencontrer est une gare isolée près du camp de prisonniers. Ils n'ont d'autre choix que de passer la nuit sur des bancs dans un petit hangar. Leur jeune fils est somnambule (mais l'est-il vraiment ? Rusé, tortueux, sous une apparence trompeuse d'innocent, c'est lui le principal personnage du film). Pour l'empêcher d'errer dans la nuit, on attache une clochette à son gros orteil ; s'il bouge, il réveillera quelqu'un qui lui évitera de courir un quelconque danger. Après une longue abstinence, les parents ont une envie folle de faire l'amour, mais dès qu'ils commencent, la clochette se met à tinter ; dès qu'elle s'arrête, ils recommencent – et la clochette se remet à tinter. L'image du visage du garçon, petit monstre séraphique, aux lèvres mi-souriantes, les yeux soigneusement fermés (mais dort-il vraiment ?), me revient à l'esprit, pour mon plus grand plaisir de spectatrice, auquel s'ajoute ma vive admiration envers un autre créateur de fiction, dans une discipline artistique différente de la mienne.

Satyajit Ray a dit un jour dans une interview que le secret de ses grands films était le détail significatif ; c'est aussi le secret de la grande littérature. Tous les conflits et les frustrations, les émotions contrariées, les circonstances désespérantes qui débouchent sur le ridicule, sont captés dans la seule image de cet enfant : c'est tout l'art de ce film.

Je m'efforce d'atteindre ce genre de révélation par un enchaînement de mots ; le cinéaste y parvient avec une image. ∎

Traduction de Claude Baudier

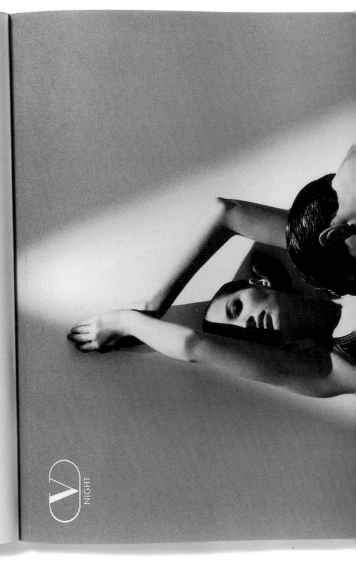

V NIGHT

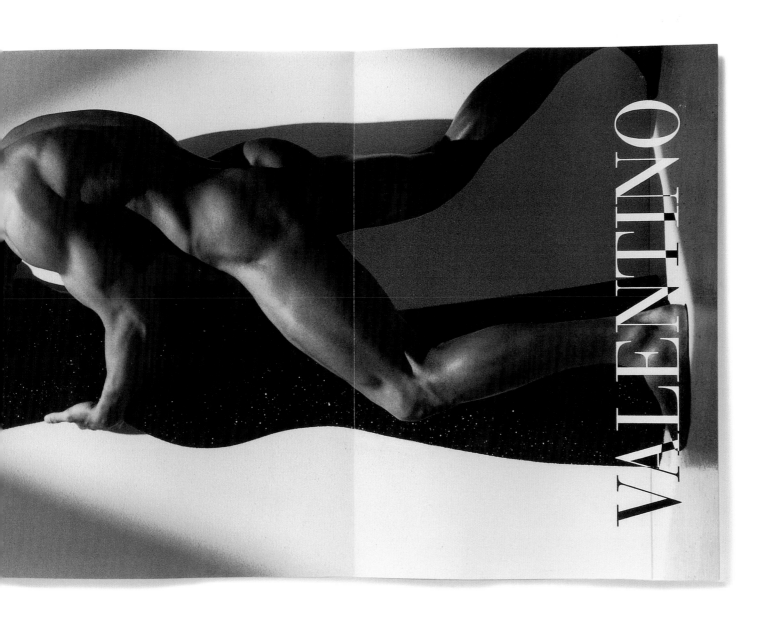

FALL/WINTER 1995 CAMPAIGN. PHOTOGRAPHER: HERB RITTS

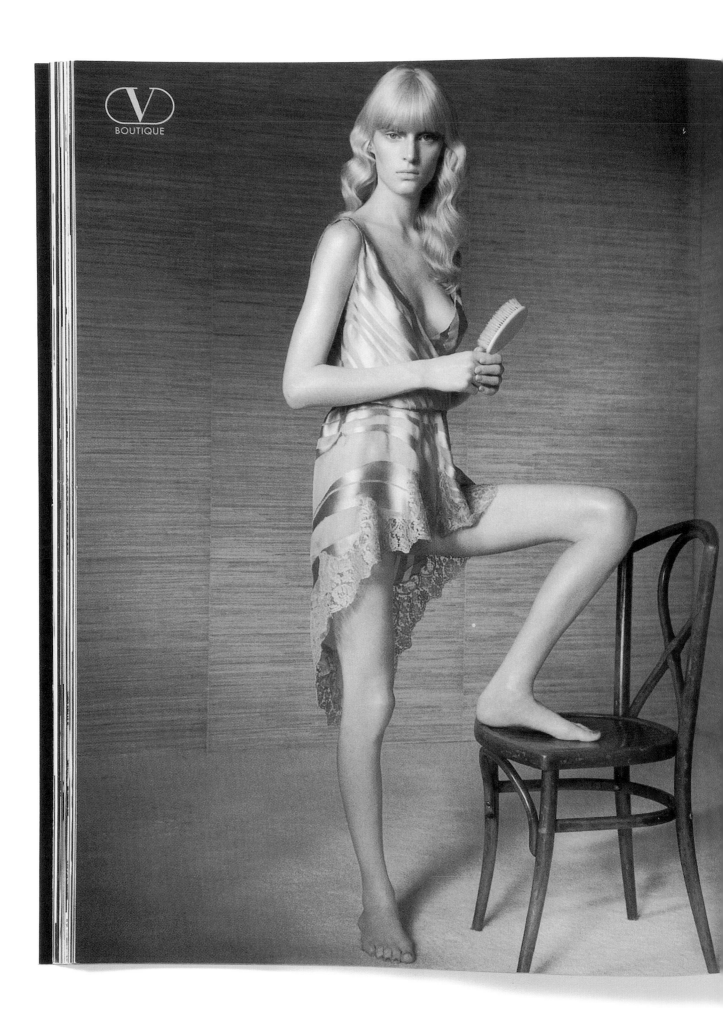

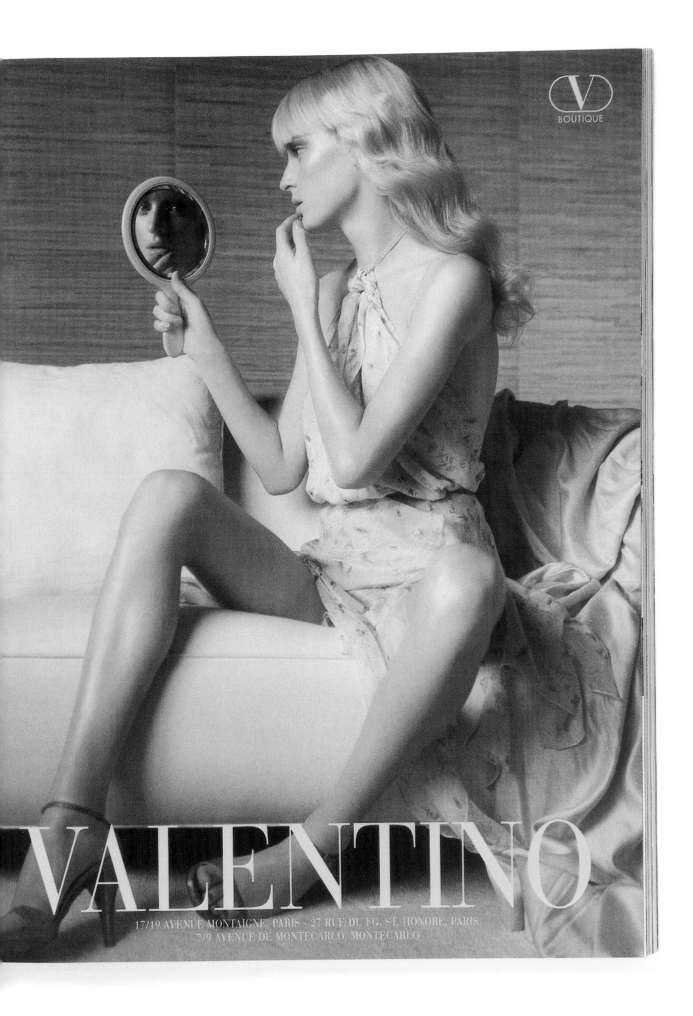

VALENTINO

17/19 AVENUE MONTAIGNE, PARIS - 27 RUE DU FG. ST. HONORE, PARIS
7/9 AVENUE DE MONTECARLO, MONTECARLO

SPRING/SUMMER 1997 CAMPAIGN. PHOTOGRAPHER: STEVEN MEISEL

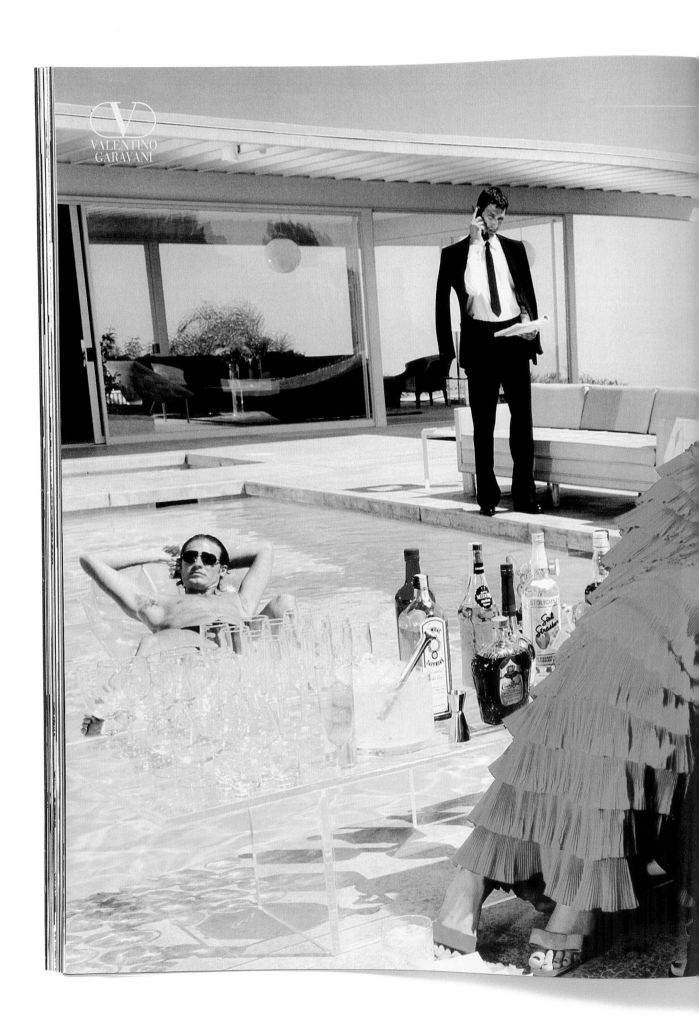

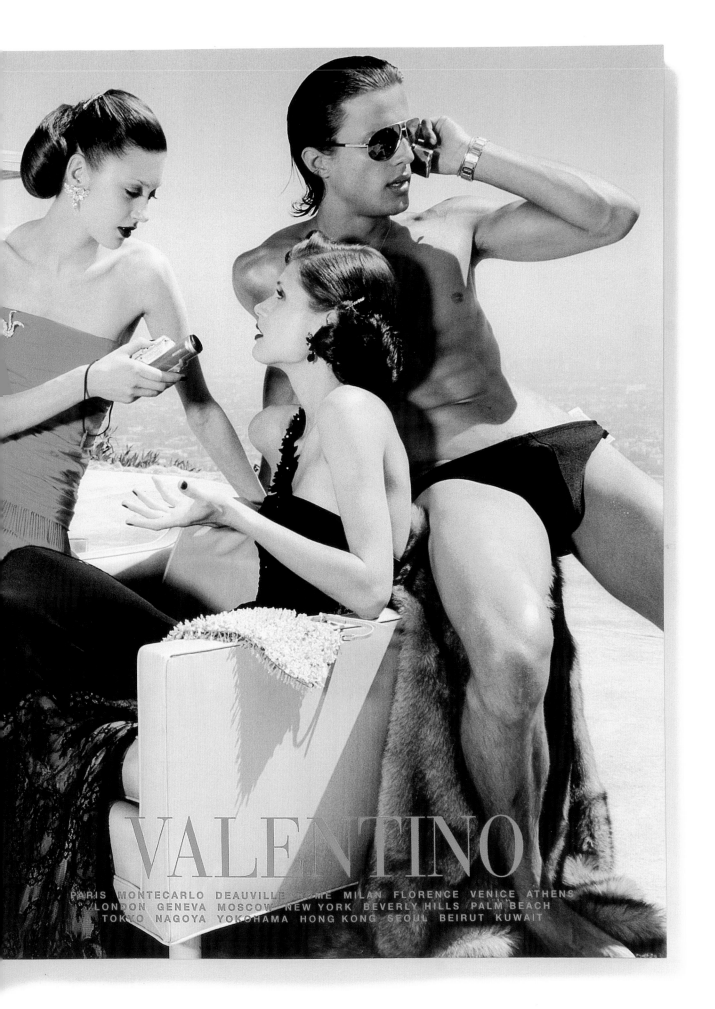

VALENTINO

PARIS MONTECARLO DEAUVILLE ROME MILAN FLORENCE VENICE ATHENS
LONDON GENEVA MOSCOW NEW YORK BEVERLY HILLS PALM BEACH
TOKYO NAGOYA YOKOHAMA HONG KONG SEOUL BEIRUT KUWAIT

FALL/WINTER 2000 CAMPAIGN. PHOTOGRAPHER: STEVEN MEISEL

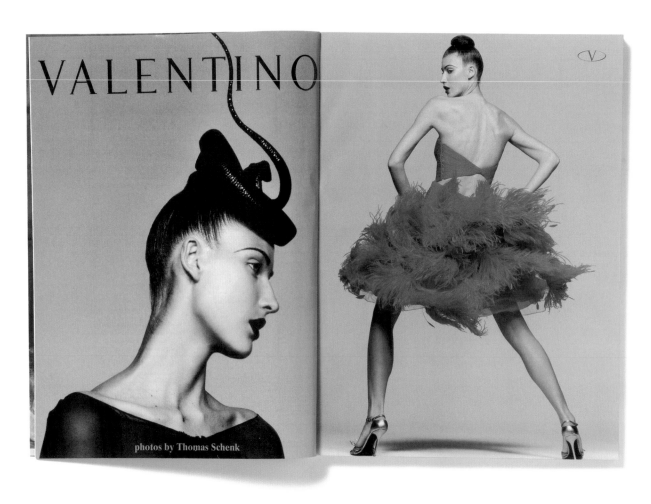

VALENTINO

photos by Thomas Schenk

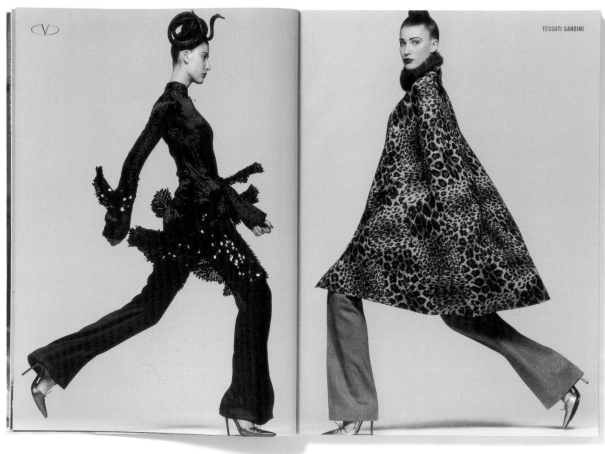

TESSUTI GANDINI

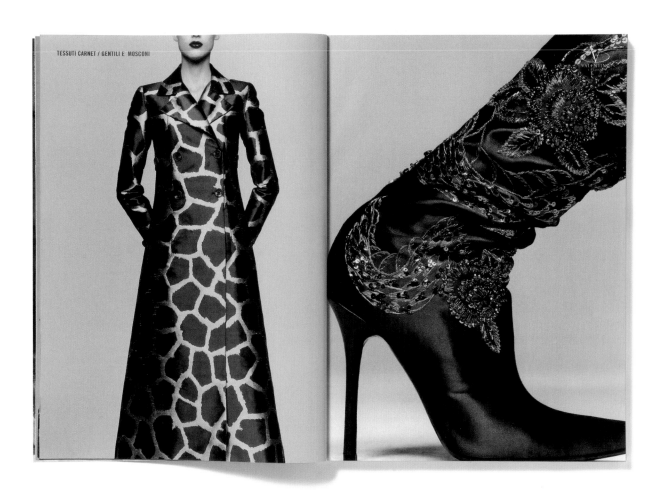

TESSUTI CARNET / GENTILI E MOSCONI

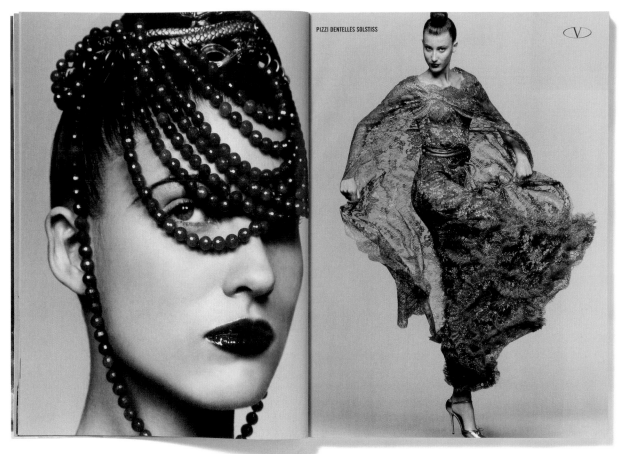

PIZZI DENTELLES SOLSTISS

FALL/WINTER 2002 CAMPAIGN. PHOTOGRAPHER: THOMAS SCHENK

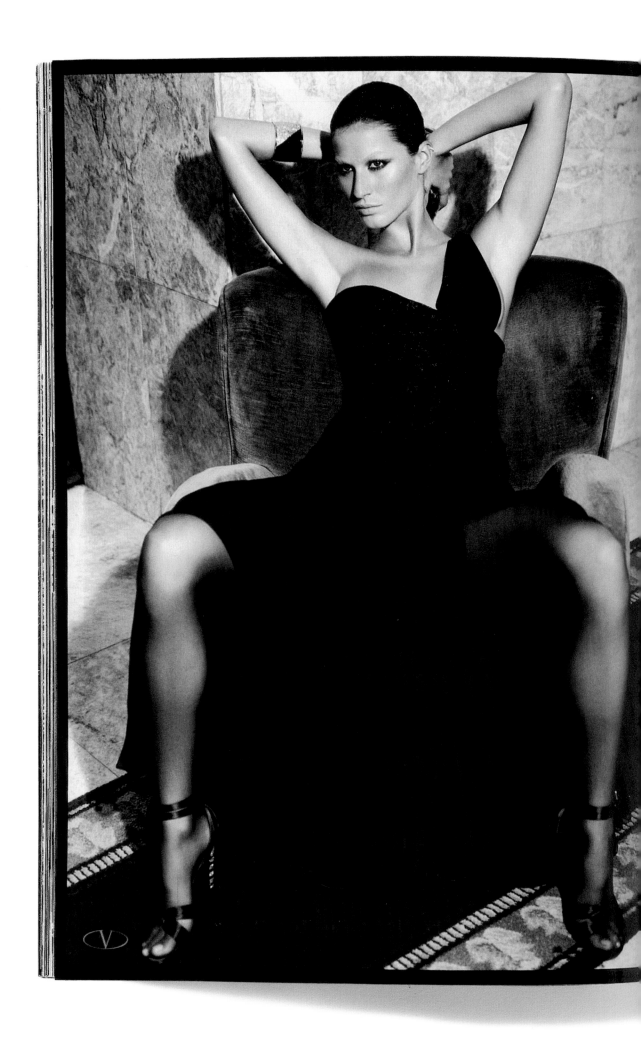

VALENTINO

ROMA MILANO FIRENZE PARIS CANNES MONTECARLO GENEVE LONDON MADRID MOSCOW NEW YORK BEVERLY HILLS
BAL HARBOUR LAS VEGAS NAPLES PALM BEACH TOKYO NAGOYA HONG KONG SINGAPORE TAIWAN SEOUL JAKARTA BEIRUT KUWAIT CITY DUBAI

FALL/WINTER 2004 CAMPAIGN. PHOTOGRAPHER: MARIO TESTINO

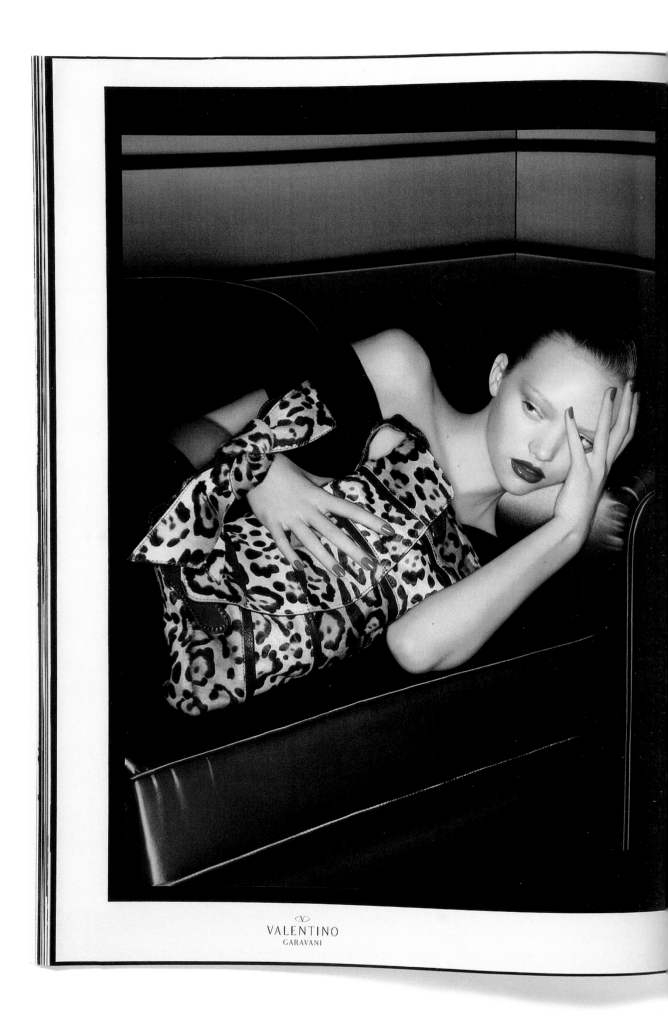

VALENTINO
GARAVANI

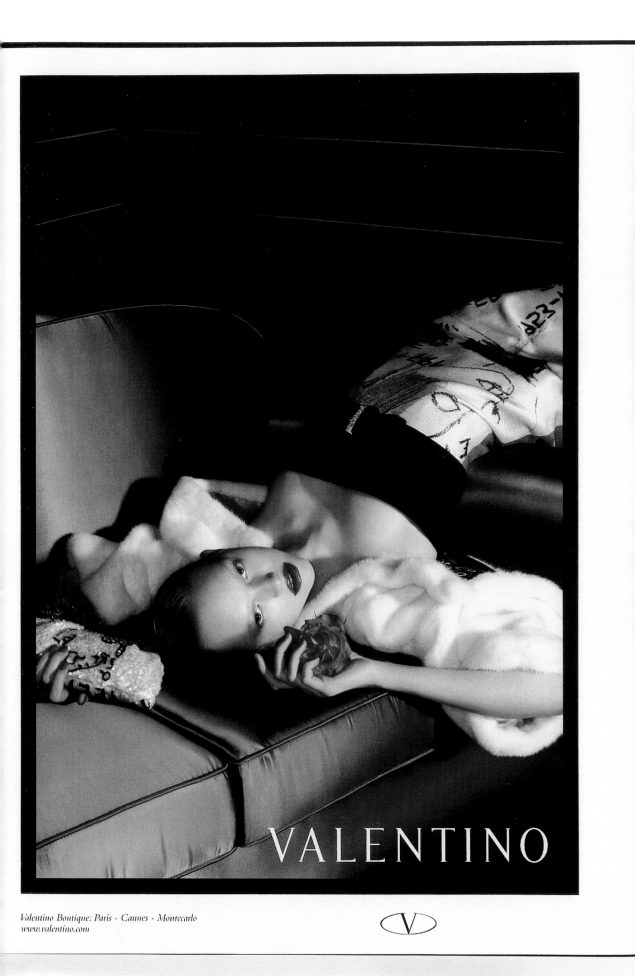

VALENTINO

FALL/WINTER 2006 CAMPAIGN. PHOTOGRAPHER: MERT ALAS & MARCUS PIGGOTT

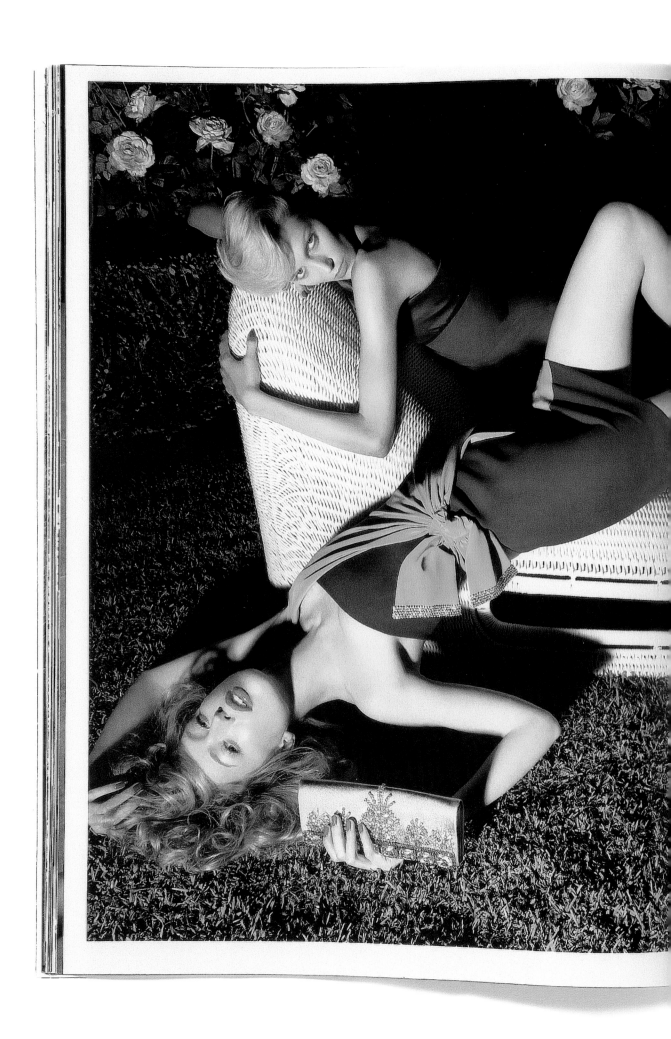

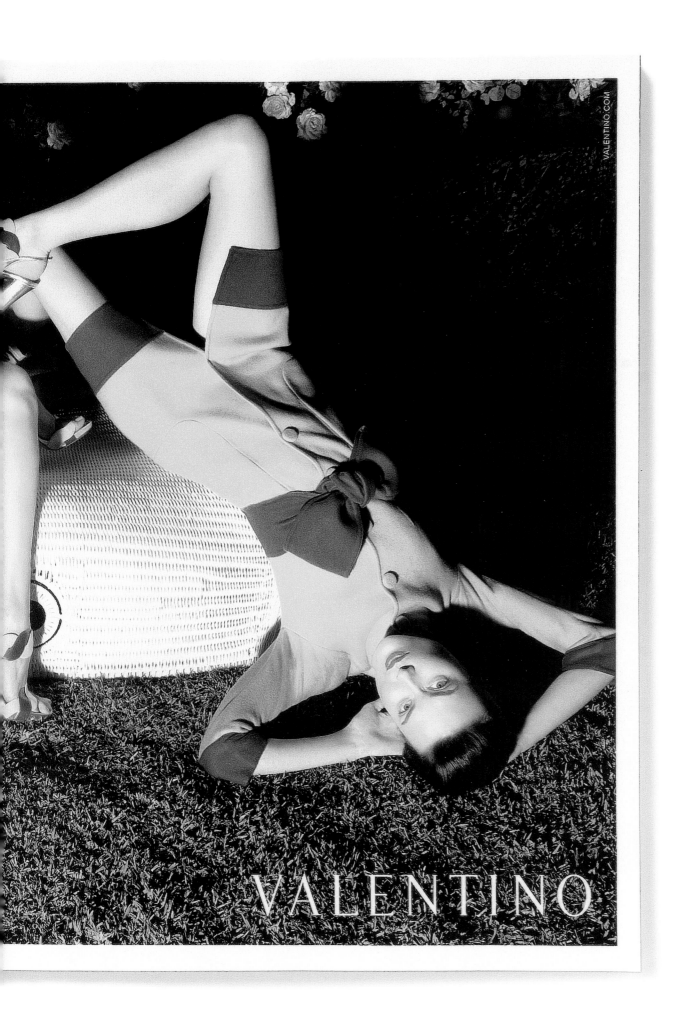

VALENTINO

SPRING/SUMMER 2008 CAMPAIGN. PHOTOGRAPHER: INEZ VAN LAMSWEERDE & VINOODH MATADIN

BIOGRAPHY

11 MAY 1932
Valentino Clemente Ludovico Garavani is born
in Voghera (Lombardy), to Mauro Garavani,
director of an electrical supply business,
and Teresa de Biaggi.

1952–1957
He receives his diploma from the Chambre
Syndicale de la Couture Parisienne in 1952,
and is hired by Greek couturier Jean Dessès.

1957–1959
In the autumn of 1957 he begins work for
Guy Laroche, Jean Dessès's former assistant.

1959
The Valentino house opens in Rome,
at 11 Via Condotti.

1960
In July he meets Giancarlo Giammetti.

1961
The Valentino house moves to 54 Via Gregoriana.

1962
On July 19th Valentino shows his collection
for the first time in Florence, at the Sala Bianca
of the Palazzo Pitti.

1965
Valentino opens an atelier in Milan, at
3 Via Sant'Andrea.

1966
From now on the collections are presented
in Rome, in his salons at 54 Via Gregoriana.

1967
Valentino moves to 24 Via Gregoriana, on the
third floor of the Palazzo Mignanelli.

Valentino is awarded the Neiman Marcus Prize
in Dallas on February 9th.

1968
The White Collection (Spring/Summer 1968)
debuts.

Jacqueline Kennedy wears a design from the
White Collection for her wedding to Aristotle
Onassis on October 20th.

The Paris boutique, at 42 Avenue Montaigne,
opens in May.

1969
Valentino launches his first line of menswear.

1974
A collaboration with the French group Mendés,
who manufactures the ready-to-wear line,
begins in December.

1975
The ready-to-wear line is shown in Paris for the
first time, at the Hôtel George V, on April 9th.

1978
The Valentino perfume, produced in partnership
with Unilever, is launched at a gala soirée held
at the Théâtre des Champs Elysées in Paris.

1982
Upon the invitation of Diana Vreeland,
Valentino presents his Fall/Winter collection
on September 20th at the Metropolitan Museum
of Art, in New York.

1984
The Italian Olympic Committee selects Valentino
to design the athletic uniforms for the Olympic
Games in Los Angeles.

1985
One of Italy's most prestigious ranks,
Grand'Ufficiale dell'Ordine al Merito, is
bestowed upon Valentino by Sandro Pertini,
President of the Italian Republic. The following
year he receives Italy's highest honor, the
Cavaliere di Gran Croce.

1988
Valentino's collection is presented at the
Twentieth Century Fox studios in Hollywood.

1989
His haute couture line is presented in Paris
for the first time, on January 26th, at the
École des Beaux-Arts.

1990
Together with Giancarlo Giammetti, Valentino
founds L.I.F.E., (a foundation whose initials stand
for *Lottare, Informare, Formare, Educare—*

To Fight, to Inform, to Form, to Educate), with the support of Elizabeth Taylor, to aid children infected with HIV.

1991
In June the Valentino house of fashion celebrates its thirtieth anniversary; an exhibition and accompanying catalogue titled *Valentino: Thirty Years of Magic* is organized by the mayor of Rome, and a retrospective of his designs is presented by the Accademia Valentino.

1993
The Chinese government invites Valentino to present his collection in Beijing.

1995
On January 14th Valentino presents his collection in Florence, at the Stazione Leopolda. For the occasion, the mayor of Florence awards him a special prize for Art in Fashion.

1996
Valentino is granted the rank of Cavaliere del Lavoro—the equivalent of knighthood.

1998
The Italian company HdP (Holding di Partecipazioni Industriali) acquires the Valentino house of fashion.

2000
Valentino receives the Lifetime Achievement Award from the Council of Fashion Designers of America.

Forty red styles are presented in a show held on the Piazza di Spagna in Rome, representing Valentino's forty years of creativity.

2002
The Valentino house of fashion is acquired by Marzotto, standard-bearer of Milan's textile manufacturers.

2005
He receives the Superstar Award from the Fashion Group International.

The Valentino Fashion group (Vfg) enters the stock market on July 1st.

2006
Valentino is awarded the prestigious Légion d'Honneur by the French Minister of Culture, Renaud Donnedieu de Vabres, on July 4th; he is the first Italian premier couturier to receive this distinction.

He appears as himself in the film *The Devil wears Prada*.

2007
Valentino presents his latest haute couture collection in Rome on July 7th, in an anniversary soirée held in the Villa Borghese.

The exhibition *Valentino in Rome: 45 Years of Style* is held at the Museum of the Ara Pacis in Rome.

Permira, a British private equity firm, acquires Valentino.

Valentino announces his departure on September 4th.

2008 Valentino presents his final collection at the Musée Rodin in Paris on January 23rd.

On January 24th, the Mayor of Paris, Bertrand Delanoë, awards Valentino the Grande Médaille de Vermeil de la Ville de Paris.

SELECTED BIBLIOGRAPHY

MONOGRAPHS

Chitolina, Armando, Matt Tyrnauer, and Suzy Menkes. *Valentino Garavani. Una grande storia italiana*. Cologne: Taschen, 2007.

Pelle, Marie-Paule and Patrick Mauries. *Valentino: Thirty Years of Magic*. New York: Abbeville, 1991.

Sozzani, Franca. *Valentino's red book*. Milan: Rizzoli, 2000.

Talley, André Léon. *Valentino*. Milan: Fro Maria Ricci, 1982.

Zeri, Federico, Jean-Paul Scarpitta, Bonizza Giordani Aragno, Glorai Bianchino, Maria Pezzi, and Guido Vergani. *Trent'anni di magia, Le opere*, Milan, Bompiani, 1991.

Trent'anni di magia, Le imagini, Milan, Bompiani, 1991.

SURVEYS

Alfonsi, Maria-Vittoria. *Leaders in fashion, I grandi personaggi della moda*, Bologne, Cappelli editore, 1983.

Bianchino, Gloria, Graziella Butazzi, Alessandra Mottola Molfino, and Arturo Carlo Quintavalle. *Italian Fashion, vol. 1: The Origins of High Fashion and Knitwear*. Milan: Electa, 1987.

Davanzo Poli, Doretta, and Marco Tosca. *Alta Moda, grandi abiti da sera degli anni 50–60*. Venice: Arsenale Edizioni, 1984.

Giordani Aragno, Bonizza. *40 Years of Italian Fashion: 1940-1980, Original Drawings and Sketches of the Most Famous Italian Fashion Designers* (catalogue). New York: Trump Tower, 1983.

Giordani Aragno, Bonizza. *Moda Romana dal 1945 al 1965. Storia di moda*. Rome: De Luca, 1998.

Gnoli, Sofia. *Moda italiana 1950–1970*. Rome: Società Dante Alighieri, 2000.

Gnoli, Sofia. *Un secolo di moda italiana: 1900–2000*. Rome: Meltemi, 2005.

Golbin, Pamela. *Fashion Designers*. New York: Watson-Guptill, 2001.

Grumbach, Didier. *Histoire de la mode*. Paris: Editions du Seuil, 1993.

Steele, Valerie. *Fashion, Italian Style*. New York: The Fashion Institute of Technology, 2003.

Vergani, Guido. *The Sala Bianca: The Birth of Italian Fashion* (catalogue from the Palazzo Strozzi, Florence; exhibition held 25 July through 25 September 1992). Milan: Electa, 1992.

FOOTNOTES

THEMES
1. Christa Worthington, "VaVa Vavoom!" *European Travel and Life*, March 1988, page 70.
2. Marie-Paule Pellé, *Valentino: Thirty Years of Magic*. New York: Abbeville, 1991, page 114.

VARIATIONS
1. *Women's Wear Daily*, 3 January 1968.
2. Conversation with Mr. Valentino in Rome, 18 February 2008.
3. Marrie-Paule Pellé, *Valentino: Thirty Years of Magic*. New York: Abbeville, 1991, page 126.

VALENTINO: THEMES AND VARIATIONS
1. Christa Worthington, "VaVa Vavoom!" *European Travel and Life*, March 1988, page 75.
2. Hebe Dorsey, "Valentino Hones Deluxe Look," *International Herald Tribune*, 23–24 July 1983.
3. Conversation in Paris with Janie Samet, 11 February 2008.
4. Pascale Renoux, "Le sultan de Rome," *Numéro*, November 2000, page 169.
5. Estelle Colin, Luis Marques and Olivier Robert, "Valentino, le defilé d'une vie," France 2, 4-8 February 2008.
6. Armando Chitoliona and Matt Tymauer, *Valentino Garavani. Una grande storia italiana*. Cologne: Taschen, 2007, page 722.
7. From a speech given by Valentino at the Paris Town Hall, 24 January 2008.
8. Suzy Menkes, *International Herald Tribune*, 4 July 2006, page 9.
9. *L'Aurore*, Petit Dictionnaire de ceux qui font la Mode Universelle, 16 January 1952.
10. Chitoliona and Tymauer, page 722.
11. *ibid*.
12. *L'Aurore*, January 24, 1957.
13. Ernestine Carter, "The Flurry that was Rome," *The Sunday Times*, November 1959.
14. Eugenia Sheppard, "The stars shine for Valentino," *New York*, 1968, page 38.
15. *Women's Wear Daily*, 20 July 1959.
16. Chitoliona and Tymauer, page 722.
17. Conversation with Giancarlo Giammetti in Rome, 18 February 2008.
18. *ibid*.
19. Many leading Italian designers participated in this first event: Simonetta, Carosa, and Fontana came from Rome; Veneziani and Manicelli from Milan; and Emilio Pucci from Florence. This first group showing of Italian fashion attracted fifty or so leading American buyers. For the following collection in July, over 250 buyers and journalists stormed the shows.
20. "La bombe de Florence a ébranlé les salons de la haute couture parisienne et menacé son monopole (The Florentine Bomb has Shaken Parisian Haute Couture and Threatens its Monopoly)," *Paris-Presse L'Intransigeant*, 5–6 August 1951.
21. "The show that appeared to impress buyers the most was a late entry, Valentino, who showed on the very last night." *Rome Daily American*, 24 July 1962.
22. Conversation in Rome with Giancarlo Giammetti, 18 February 2008.
23. Natasha Fraser-Cavassoni, *Vogue* Italy, October 2006.
24. Conversation with Giancarlo Giammetti in Rome, 18 February 2008.
25. Chitoliona and Tymauer, page 723.
26. *Vogue*, June–July 2007, page 209.
27. Conversation in Rome with Giancarlo Giammetti, March 12, 2008. The Milan branch definitively closed in 1996.
28. In 1967, Alta Moda collections stopped being shown at the Sala Bianca. Since then, only ready-to-wear and luxury collections are shown.
29. He only occupied the building's third floor at first, as the other floors were being rented to various other companies. In 1988, Valentino occupies the entire palazzo, and the main entrance is on the Piazza Mignanelli.
30. Gloria Emerson, "Valentino and de Barentzen: Tricks from the 1940s," *New York Times*, 16 July 1968.
31. *Vogue* USA, 15 September 1968, page 94.
32. Gloria Emerson, "Creamy, Dreamy and Very Neat Sums Up Valentino's New Look," *Montreal Star*, 17 January 1968.
33. Eugenia Sheppard, *Women's Wear Daily*, January 1968.
34. *Le Figaro*, 2 May 1968.
35. In October of the following year, a five-floor boutique opened in New York, at 801 Madison Avenue. The decorator was Italian architect Aldo Jacober.
36. Giancarlo Giammetti, quoted in Chitoliona and Tymauer, page 724.
37. Unlike most designers, Valentino did not follow the usual ritual of closing each fashion show with a wedding gown. At a client's request, he might transform a particular dress in his collection into a wedding gown, or else he would dream up a specific design for each and every future bride. The dress that Jacqueline chose was not initially meant to be a wedding dress, but the publicity around this high-profile wedding meant that the dress was reproduced to order, and approximately sixty were sold to other customers—an unusual number in the world of haute couture.
38. Marylou Luther, "V stands for Valentino—and Victory in Business," *Omaha World Herald*, 2 February 1973.
39. *ibid*.
40. *Women's Wear Daily*'s Adrianna Grassi as quoted in *Vanity Fair*, April 1970, page 63.
41. The grandson of the Mendès firm's founder, Didier Grumbach, had also launched the production of ready-to-wear garments for the couture houses of Castillo, Givenchy, Jacques Heim, Jeanne Lanvin, Jean Patou, Madleine Rauch, Jean-Louis Scherrer, Emmanuel Ungaro, and Philippe Venet. Grumbach is now president of the Fédération Française de la couture du prêt-à-porter des couturiers et créateurs de mode (French Federation of Ready-to-Wear and Fashion Designers' Couture).
42. Conversation with Didier Grumbach in Paris, 6 February 2008.
43. By 1962 the leading Roman designers Simonetta, Fabiani, and Roberto Capucci felt so encouraged by their success in Italy that they decided to move their respective firms to Paris. They met with little success—soon all three closed down and moved back to Rome.
44. Bernardine Morris, "Valentino Touches all Bases with Class," *New York Times*, 11 April 1975.
45. Conversation with Giancarlo Giammetti in Rome, 18 February 2008.
46. Jonathan Kandell, *New York Times*, 6 August 1977, page 18.
47. Conversation with Didier Grumbach in Paris, 6 February 2008.
48. Conversation with Giancarlo Giammetti in Rome, 18 February 2008.
49. Carrie Donovan, "A Show of Success," *New York Times*, 19 September 1982.
50. Janie Samet, "Valentino fait du charme à Paris," *Le Figaro*, 27 January 1989.
51. Marie-Paul Pellé, *Valentino: Thirty Years of Magic*. New York: Abbeville, 1991, pages 289–290.
52. Conversation with Mr. Valentino in Rome, 18 February 2008.
53. *Grazia*, 1959. The Pincio is a major hill in the heart of Rome, near the Villa Medici.
54. Dorys Brynner, quoted in Chitoliona and Tymauer, page 725.
55. Conversation with Giancarlo Giammetti in London, 12 March 2008.
56. An earlier attempt took place in 1969, in a deal with the American company Kenmore, which soon went bankrupt and led Valentino and Giammetti to buy their company back.
57. *Women's Wear Daily*, 12 January 1998, page 14.
58. *International Herald Tribune*, 16 May 2007.
59. Diana Vreeland with Christopher Hemphill, *Allure*. New York: Bullfinch Press, 1980.
60. Suzy Menkes, "Valentino Says Goodbye with Flowers," *International Herald Tribune*, 23 January 2008.
61. Conversation with Mr. Valentino in Rome, 18 February 2008.
62. Conversation with Giancarlo Giammetti in London, 12 March 2008.

This publication accompanies the exhibition Valentino, Thèmes et Variations
organized by Les Arts Décoratifs, Paris
17 June – 21 September 2008

The exhibition was curated by Pamela Golbin
curator-in-chief for the Fashion and Textiles collections at Les Arts Décoratifs

LES ARTS DÉCORATIFS
Hélène David-Weill, President
Sophie Durrleman, General Director Béatrice Salmon, Museum Director Renata Cortinovis, Director of Development

First published in the United States of America in 2008 by
RIZZOLI INTERNATIONAL PUBLICATIONS, INC.
300 Park Avenue South, New York, NY 10010
www.rizzoliusa.com

ISBN-13: 978-0-8478-3172-2 LCCN: 2008925158

Editor: Dung Ngo
Production: Maria Pia Gramaglia (Rizzoli) & Elena Gaiardelli (Pizzi)

Photography Credits:
The Last Collection: Francois Halard Dress/Mannequin Photography: Jean Tholance
Magazine Advertisement Photography: Jean Tholance

Page 6: © Francois Halard; 46: © Marc Hispard; 57: Henry Clarke, © 2008 Artists Rights Society (ARS), New York/ADAGP, Paris;
71: © Ruven Afanador, courtesy Art Department; 91: Isa Stoppi: Chris von Wangenheim/Italian Vogue, © Condé Nast Publications;
121: © Mario Sierra; 130-131: Antonio Lopez, © 2008 Artists Rights Society (ARS), New York/VEGAP Madrid, courtesy the Estate
of Antonio Lopez and Juan Ramos; 142: © Gianpaolo Barbieri; 153: © Andrea Klarin; 160: Henry Clarke, © Condé Nast Archive/
CORBIS; 175: Henry Clarke, © 2008 Artists Rights Society (ARS), New York/ADAGP, Paris; 194: Veruschka: Franco Rubartelli/Italian
Vogue, © Condé Nast Publications; 203: Henry Clarke/Vogue, © Condé Nast Publications; 209: Henry Clarke, © Condé Nast Archive/
CORBIS; 218: Henry Clarke/Vogue, © Condé Nast Publications; 223: Henry Clarke, © 2008 Artists Rights Society (ARS), New York/
ADAGP, Paris; 224: © Gianni Giansanti/ SYGMA/CORBIS; 227: courtesy Les Arts Decoratifs; 230-231: courtesy Valentino Archive;
234: © Bettman/CORBIS; 235: © Bettman/CORBIS; 237: courtesy Valentino Archive; 238 left: ©Vittoriano Rastelli/CORBIS; 238
right © Larry C. Morris/New York Times Co./Getty Images; 239: © Timothy A Clary/AFP/Getty Images; 240-241: courtesy Valentino
Archive; 242: courtesy Valentino Archive; 245: © Gianni Giansanti/SYGMA/ CORBIS; 246-247: © Pascal Chevallier/WIB Paris.
All efforts have been made to identify and notify all photographers, models, and copyright holders of the images in this publication. Omissions
and erratas will be corrected in subsequent editions.

Photo research: Antonio Davanzo (Rome); Delphine Saurat (Paris); Mandy DeLucia (New York)

DESIGN BY SAM SHAHID

Distributed to the U.S. trade by Random House, New York
Printed and bound in Italy by Arti Grafiche Amilcare Pizzi, Milan

2008 2009 2010 2011 2012/ 10 9 8 7 6 5 4 3 2 1

I would like to express my most sincere gratitude to Mr. Valentino Garavani and Mr. Giancarlo Giammetti,
without whom this project would not have been possible.

My special thanks go to the following individuals for their precious assistance on this book:
Teri Agins, Antonietta de Angelis, Bonizzia Giordani Aragno, Marisa Berenson, Olivia Berghauer,
Paul Caranicas, Ximena Cortez-Munoz, Daphne Cousineau, Antonio Davanzo, Hélène David-Weill, Betty Eng,
Deanna Farnetti, Jorge Ferrari, Daniela Giardina, Adrianna Giobbe della Ditta, Didier Grumbach,
Jasmine Habeler, Grazia Martino, Charles Miers, Mme Arnaud de Montbrison, Elide Morelli, Dung Ngo,
Christina Passariello, Pauline and Stefan Reyniak, Béatrice Salmon, Janie Samet, Domitilla Sartogo,
Delphine Saurat, Sam Shahid, Angelo Tarlazzi, Violante Valdettaro.

And finally, I would like to thank Jean-Francis Laget for his invaluable support throughout this adventure.

Pamela Golbin